Women on Philosophy of Art

Britain 1770–1900

ALISON STONE

Great Clarendon Street, Oxford, OX2 6DP,
United Kingdom

Oxford University Press is a department of the University of Oxford.
It furthers the University's objective of excellence in research, scholarship,
and education by publishing worldwide. Oxford is a registered trade mark of
Oxford University Press in the UK and in certain other countries

© Alison Stone 2024

The moral rights of the author have been asserted

All rights reserved. No part of this publication may be reproduced, stored in
a retrieval system, or transmitted, in any form or by any means, without the
prior permission in writing of Oxford University Press, or as expressly permitted
by law, by licence or under terms agreed with the appropriate reprographics
rights organization. Enquiries concerning reproduction outside the scope of the
above should be sent to the Rights Department, Oxford University Press, at the
address above

You must not circulate this work in any other form
and you must impose this same condition on any acquirer

Published in the United States of America by Oxford University Press
198 Madison Avenue, New York, NY 10016, United States of America

British Library Cataloguing in Publication Data
Data available

Library of Congress Control Number: 2024934374

ISBN 9780198917977

DOI: 10.1093/9780198918004.001.0001

Printed and bound by
CPI Group (UK) Ltd, Croydon, CR0 4YY

Links to third party websites are provided by Oxford in good faith and
for information only. Oxford disclaims any responsibility for the materials
contained in any third party website referenced in this work.

Contents

Acknowledgements	vii
Timeline	viii

1. Women and Philosophy of Art in Nineteenth-Century Britain ... 1
 1.1 Introduction ... 1
 1.2 The Context of Nineteenth-Century Women's Writing on Art ... 3
 1.3 The Character and Evolution of Women's Thinking About Art ... 13
 1.4 How This Book Relates to Existing Literature ... 18
 1.5 Questions of Method ... 23
 1.6 Women's Intellectual Relations ... 28
 1.7 Omissions ... 32

2. Anna Barbauld as a Philosopher of Art ... 35
 2.1 Introduction ... 35
 2.2 Stages on Barbauld's Way ... 37
 2.3 Barbauld's Paradox of Fiction ... 39
 2.4 Devotional Taste: Religious Aesthetics, Aesthetic Religion ... 44
 2.5 Barbauld, the Novel, and the Canon ... 50

3. Joanna Baillie's Theory of Tragedy ... 58
 3.1 Introduction ... 58
 3.2 Baillie Rises, Falls, and Rises Again ... 59
 3.3 *Plays on the Passions* ... 63
 3.4 Baillie on the Passions ... 66
 3.5 Baillie, Barbauld, and Sympathetic Curiosity ... 68
 3.6 Baillie's Voluntarism and Optimism ... 73

4. Harriet Martineau on Literature, Morality, and Realism ... 78
 4.1 Introduction ... 78
 4.2 From Barbauld to Martineau's *Illustrations* ... 79
 4.3 Martineau on Scott and the Moral Purpose of Literature ... 81
 4.4 Beyond Romance to Realism ... 85
 4.5 *Illustrations of Political Economy* ... 88
 4.6 Martineau on Bad Art ... 94

5. Aesthetics and Ethics in Anna Jameson's *Characteristics of Women* ... 100
 5.1 Introduction ... 100
 5.2 *Characteristics of Women*: Moral Philosophy by Aesthetic Example ... 104
 5.3 Jameson's Taxonomy of Female Characters: Moral Psychology by Aesthetic Example ... 107
 5.4 Jameson, Baillie, and Martineau on Virtue and the Emotions ... 110
 5.5 The Aesthetics of *Characteristics*: Aesthetic Wholes and Moral Examples ... 115

6. Anna Jameson and *Sacred and Legendary Art* — 123
 - 6.1 Introduction — 123
 - 6.2 Greek and Gothic Art — 127
 - 6.3 How Jameson Decodes Christian Art — 131
 - 6.4 Religion and Aesthetics in *Sacred Art* — 137
 - 6.5 Religious, Aesthetic, and Moral Value in *Sacred Art* — 140
 - 6.6 Jameson, Ruskin, and the Canon — 144

7. Frances Power Cobbe, Female Genius, and the Hierarchy of the Arts — 148
 - 7.1 Introduction — 148
 - 7.2 Cobbe and Female Genius — 149
 - 7.3 Power, Genius, Gender, and Race — 156
 - 7.4 Cobbe's Three Orders of Art — 161
 - 7.5 Cobbe on the Forms of Art — 165
 - 7.6 Cobbe on Art, Religion, and Morality — 169

8. Emilia Dilke's Journey from Art Philosophy to Art History — 173
 - 8.1 Introduction — 173
 - 8.2 Dilke's Historicism — 175
 - 8.3 Dilke's Aestheticism — 177
 - 8.4 Aestheticism and Historicism in Tension — 185
 - 8.5 The Uses of Pictures — 187
 - 8.6 History and Aesthetics Part Company — 192
 - 8.7 Dilke versus Jameson — 194

9. Vernon Lee, Art-Philosophy, and True Aestheticism — 197
 - 9.1 Introduction — 197
 - 9.2 Art Beauty versus Religion and the Supernatural — 201
 - 9.3 Lee's Anti-Ruskinism — 205
 - 9.4 Lee's Qualified Aestheticism — 211
 - 9.5 Lee's True Aestheticism in 'Art and Life' — 216

10. The Fate of Nineteenth-Century Women Philosophers of Art — 222
 - 10.1 Introduction — 222
 - 10.2 The Aesthetic, the Beautiful, and Art Hierarchies — 224
 - 10.3 How These Women Disappeared — 231

11. Additional Women Philosophers of Art: Beyond the Frame — 240
 - 11.1 Introduction — 240
 - 11.2 Callcott and Merrifield — 240
 - 11.3 Ellis — 242
 - 11.4 Eastlake — 244
 - 11.5 Anstruther-Thomson and Naden — 247
 - 11.6 Final Remarks — 250

Bibliography — 251
Index — 273

Acknowledgements

I owe many people thanks for their help as I was writing this book. I received extremely thoughtful, detailed, and generous comments from two anonymous reviewers, which enabled me to improve the manuscript. Peter Momtchiloff at Oxford University Press has been supportive, efficient, and encouraging. Very helpful conversations with Kali Israel, about Emilia Dilke and her interlocutors, pointed me to Dilke's book donations to Somerville College library and the Victoria and Albert Museum, London. I have learnt from conversations with many others, including Christine Battersby, Carol Bensick, Emily Brady, Sally Blackburn-Daniels, Sue Brown, Rachel Cooper, Sophia Connell, Stacie Friend, Linda Hughes, Frederique Janssen-Lauret, Derek Matravers, Lydia Moland, Chris Partridge, Bihani Sarkar, Clare Stainthorp, and Emily Thomas. I discussed Joanna Baillie at the philosophy research seminar at New College of the Humanities, London, and at the undergraduate Philosophy Society at Lancaster, and I benefited from audience responses and questions on these occasions; I thank Christoph Schuringa and Diana Diaconescu for organizing these events. Two terms of academic research leave from Lancaster University assisted my work on this book. Lucia Cappelli from the Vernon Lee Collection at the British Institute of Florence helped me to access Lee's book donation, and Oliver North and Angie Goodgame at the Bodleian Library provided digital scans of Emilia Dilke's correspondence and the letters between Anna Jameson and Annabella Byron.

Parts of this book draw on the following publications: Alison Stone, 'The Aesthetic Theory of Frances Power Cobbe', *British Journal of Aesthetics* 62.3 (2022): 387–403; Alison Stone, 'Emilia Dilke on Aesthetics', *Estetika* 60.1 (2023): 1–18; Alison Stone, 'Aesthetics and Ethics in Anna Jameson's Characteristics of Women', *Journal of Modern Philosophy* 5.1 (2023): 1–16; and Alison Stone, 'Joanna Baillie's Theory of Tragedy', *Journal of Aesthetic Education* 58.1 (2024): 25–45. An earlier version of part of Chapter 9 was presented at the conference *Vernon Lee, Aesthetics, and Empathy* organized by Derek Matravers and Sally Blackburn-Daniels in September 2023.

Extracts from the correspondence between Annabella Byron and Anna Jameson are reproduced by permission of Paper Lion Ltd. and the Estate of Ada Lovelace. John Gibson's bust of Anna Jameson in Chapter 5 is reproduced with permission of the National Portrait Gallery under an academic book licence. Harriet Hosmer's *Zenobia* is reproduced with permission of The Huntington Library, Art Museum, and Botanical Gardens.

Above all, I am grateful to John and Elinor for their love, interest, and understanding.

Timeline

1773	Anna Aikin, *Poems*, and with John Aikin, *Miscellaneous Pieces, in Prose*
1775	Anna Barbauld, *Devotional Pieces*, including 'Thoughts on the Devotional Taste'
1789	French Revolution
1790	Archibald Alison, *Essays on the Nature and Principles of Taste*
1792	William Gilpin, *Three Essays: On Picturesque Beauty; On Picturesque Travel; and On Sketching Landscape*
1793–1815	England at war with France
1798	Joanna Baillie (anonymous), *Plays on the Passions*, vol. 1, including her 'Introductory Discourse'; William Wordsworth and Samuel Taylor Coleridge (anonymous), *Lyrical Ballads*
1810	Anna Barbauld, ed., *The British Novelists*, including 'On the Origin and Progress of Novel-Writing'
1812	Anna Barbauld, *Eighteen Hundred and Eleven*
1817	Samuel Taylor Coleridge, *Biographia Literaria*
1822	Harriet Martineau ('Discipulus'), 'Female Writers on Practical Divinity', *Monthly Repository*
1824	The National Gallery opens in London
1825	Anna Barbauld, *Works*, edited by Lucy Aikin
1826	Anna Jameson (anonymous), *Diary of an Ennuyée*
1832	Great Reform Act; Harriet Martineau, 'Characteristics of the Genius of Scott', *Tait's Edinburgh Magazine*; Anna Jameson, *Characteristics of Women: Moral, Poetical, and Historical*
1833	Harriet Martineau, 'Achievements of the Genius of Scott', *Tait's Edinburgh Magazine*
1832–34	Harriet Martineau, *Illustrations of Political Economy*
1834	Anna Jameson, *Visits and Sketches at Home and Abroad*
1836	Maria Callcott, *Essays Towards the History of Painting*
1837	Accession of Queen Victoria
1839	Foundation of *The Art-Journal*
1842	The Female School of Design opens in London
1843–60	John Ruskin, *Modern Painters*, 5 volumes (vols. 1 and 2 signed 'by a Graduate of Oxford')

1845–46	Anna Jameson serializes 'Sacred and Legendary Art' in *The Athenaeum*
1846	Anna Jameson, *Memoirs and Essays Illustrative of Art, Literature, and Social Morals*
1848	Formation of the Pre-Raphaelite Brotherhood
1848–52	Anna Jameson, *Sacred and Legendary Art*, first 4 volumes
1849	Anna Jameson, 'Some Thoughts on Art', *The Art-Journal*
1851	The Great Exhibition is held in London; Joanna Baillie, *Dramatic and Poetical Works*
1852	Elizabeth Eastlake (anonymous), *Music and the Art of Dress*
1854	Anna Jameson, *A Commonplace Book of Thoughts, Memories, and Fancies*; Mary Merrifield, *Dress as a Fine Art*
1855	Charles Eastlake becomes first Director of the National Gallery; Rosa Bonheur, *The Horse Fair*
1857	Over 1.3 million people visit the Art-Treasures exhibition in Manchester; Elizabeth Eastlake (anonymous), 'Photography', *Quarterly Review*
1859	Harriet Hosmer, *Zenobia in Chains*
1860	Laura Herford is the first woman admitted to the Royal Academy schools
1861	William Morris begins the commercial manufacture of furniture and decorative objects
1862	Frances Power Cobbe, 'What Shall We Do With Our Old Maids?', *Fraser's Magazine*
1864	Anna Jameson and Elizabeth Eastlake, last 2 volumes of *Sacred and Legendary Art*
1865	Frances Power Cobbe, 'The Hierarchy of Art', *Fraser's Magazine*
1866	Sarah Stickney Ellis, *The Beautiful in Nature and Art*
1867	Edmonia Lewis, *Forever Free*
1869	Emilia Dilke (anonymous), 'Art and Morality', *Westminster Review*
1873	Emilia Dilke (anonymous), 'The Use of Looking at Pictures', *Westminster Review*; Walter Pater, *Studies in the History of the Renaissance*
c.1875	Edmonia Lewis, *The Death of Cleopatra*
1876	Eleanor Creathorne Clayton, *English Female Artists*
1877	Grant Allen, *Physiological Aesthetics*
1879	Emilia Dilke (Mrs Mark Pattison), *The Renaissance of Art in France*
1880	Vernon Lee, *Studies of the Eighteenth Century in Italy*; Edmund Gurney, *The Power of Sound*
1881	Vernon Lee, *Belcaro: Being Essays on Sundry Aesthetical Questions*
1882	William Morris, *Hopes and Fears for Art*

1884	Constance Naden, 'The Evolution of the Sense of Beauty', presented at Mason Science College Union
1886	Vernon Lee, *Baldwin: Being Dialogues on Views and Aspirations*
1893	The Royal Academy schools admit women to life classes
1896	Vernon Lee, 'Art and Life', *Contemporary Review*

1
Women and Philosophy of Art in Nineteenth-Century Britain

1.1 Introduction

This book is about seven women who wrote on philosophy of art in Britain between 1770 and 1900: Anna Letitia Barbauld (1743–1825), Joanna Baillie (1762–1851), Harriet Martineau (1802–76), Anna Jameson (1794–1860), Frances Power Cobbe (1822–1904), Emilia Dilke (1840–1904), and Vernon Lee (1856–1935). Barbauld migrated from Enlightenment towards Romantic aesthetics, while her friend Joanna Baillie was a Romantic dramatist and theorist of tragedy. Both Barbauld and Baillie were role models for Harriet Martineau, who became a key exponent of aesthetic moralism, the view that art should serve moral purposes. Anna Jameson, who was Martineau's friend but later fell out with her, authored many studies of art which blended German Romantic influences with Christianity and virtue ethics. For Jameson, the aesthetic and moral aspects of artworks were connected, but there should be a perfect balance between the two. Influenced by Jameson but critical of her, Frances Power Cobbe celebrated female genius and set out a systematic hierarchy of the arts. She sought a middle way between moralism and aestheticism, or 'art for art's sake'. Likewise critical of Jameson, Emilia Dilke put forward a powerful case for aestheticism, only to abandon the philosophy of art and turn to materialist art history instead. Finally, Vernon Lee, another opponent of Jameson, produced a vast and rich body of work in 'art-philosophy', developing a 'true aestheticism' which she distinguished from decadence.

These seven were not the only women to produce philosophical work on art in this time-period, but they were important, well known, and influential and are the focus of this book. Each of them engaged with at least some of the others, so that their ideas unfold in a continuous history running from the late Enlightenment era to the threshold of modernism. This period largely coincides with the long nineteenth century, that is, the period from 1790 to 1914, so I shall often talk about 'the nineteenth century' for simplicity. More precisely, my narrative goes back to 1773 to encompass Barbauld's earlier writing on aesthetics, while at the other end the narrative stops in 1896. Lee continued writing into the 1930s, but 1896 is an appropriate endpoint, since it marked a transition in her thought, after which she moved into a more twentieth-century register.

Philosophers have neglected the history of women's contributions in the philosophy of art—indeed, 'totally ignored' would not be much of an exaggeration. Currently, there is considerable momentum to diversify contemporary aesthetics and include a wider range of voices in it. But we also need to revisit the history of aesthetics, change our narratives about this history, and rediscover women aestheticians and philosophers of art from earlier centuries. So far, aestheticians, even feminist ones, have done little of this. In 2003, introducing a special issue of the journal *Hypatia* on *Women, Art and Aesthetics*, Peg Brand and Mary Devereaux observed that feminist aestheticians had barely looked at women in the history of aesthetics (2003: xviii–xx). Since then, there has been more work on twentieth-century women philosophers of art, such as Susanne Langer (see, e.g., Guentchev 2018; Innis 2009) and Iris Murdoch (e.g., Clifton 2017; Gomes 2013). Stacie Friend has discussed a group of founding women in twentieth-century analytic aesthetics (Friend 2023). But examination of earlier-century women philosophers of art remains thin on the ground.

Additional factors lie behind the neglect of women philosophers of art from nineteenth-century Britain in particular. Nineteenth-century philosophy is less studied than early modern and twentieth-century philosophy, and when the nineteenth century is studied, it is usually in the German-speaking tradition.[1] Our narratives about the history of philosophy in Britain typically run to the early 1800s, tail off, then pick up again around 1900 as analytic philosophy emerges. Nineteenth-century British and Anglophone philosophy has fallen into a hole produced by the standard tripartite division between early modern philosophy (up to 1800 including Britain), post-Kantianism (from 1800 onwards in German-speaking contexts), and history of analytic philosophy (from the 1890s onwards, centring on Britain and America). A few outliers receive attention, such as John Stuart Mill and Henry Sidgwick; yet, overall, interest in nineteenth-century British philosophy is limited. Inevitably, this has limited interest in women philosophers of this period as well, including women philosophers of art.

People may have been further dissuaded from investigating these women philosophers due to the idea that the nineteenth century was when women were most heavily excluded from philosophy. Eileen O'Neill (2005) calls it the 'pivotal era' for women's disappearance from philosophy and its history (187). Carlo Ierna (2022) claims that this century was when women were 'written off'. Even Kristin Gjesdal and Dalia Nassar (2021), in their important recovery of nineteenth-century German women philosophers, imply that in Britain, unlike Germany, women were excluded (1). Scholarship on women in nineteenth-century British culture suggests otherwise. I shall suggest instead that women

[1] See, for instance, the breakdown of recent academic publications on 'Nineteenth-century philosophy' on Philpapers.org: American philosophy: 9343 books and articles; Austrian: 4698; British: 3458; and German: 26,066.

were retrospectively omitted from twentieth-century narratives about nineteenth-century British philosophy.

Philosophers may not have looked much at women's historical philosophies of art, but there has been a rich interdisciplinary conversation about nineteenth-century aesthetics amongst scholars of literature, cultural and art history, the history of ideas, and neighbouring fields. Some of this scholarship illuminates women's thought about the arts. But even in this body of scholarship women's contributions have not been fully integrated into general narratives about aesthetics in this period. I shall also try to move the discussion into a more specifically philosophical and less literary and cultural register. This is because nineteenth-century women tackled questions about art not only indirectly, in literary and poetic practice, but also directly at a reflective philosophical level.

To bring women's philosophical thinking about art into view, we first need to familiarize ourselves with the distinctive publishing and intellectual culture of nineteenth-century Britain. Without knowing about this culture, it can be hard to find, contextualize, and interpret women's philosophical writings about art.[2] So let us dive into this context.

1.2 The Context of Nineteenth-Century Women's Writing on Art

Nineteenth-century Britain had a flourishing print culture. Not only were thousands of books published every year, it was also 'the age of periodicals', according to the novelist Wilkie Collins (1858: 222). The philosopher and prolific periodical author John Wilson observed: 'The whole day is one meal, one physical, moral and intellectual feast; the Public goes to bed with a Periodical in her hand and falls asleep with it beneath her pillow' (Wilson 1829: 950). A staggering 125,000 journals, magazines, and newspapers were published over the century. Journals blended into newspapers and magazines, as journals had a general readership and involved fast-paced exchanges of opinions.

Certain journals were heavyweight standard-bearers of serious thought. For the first half-century, the dominant three of these were quarterlies: the liberal *Edinburgh Review*, the conservative *Quarterly Review*, and the radical *Westminster Review*. Towards mid-century, monthly magazines took the lead, especially *Fraser's*, *Macmillan's*, and *Cornhill Magazines*. Later in the century, *The Nineteenth Century* and the *Contemporary Review* came to the fore. There were important weekly periodicals as well, such as the liberal *Spectator* and conservative *Saturday Review*.

[2] See, for example, Susan Hamilton (2006, 2023) on the impact of periodical culture on the philosophy of this period, with particular reference to Cobbe.

These heavyweight journals and their array of more popular counterparts gave rise to a distinctive intellectual world in which journal articles were as significant as books. Periodicals mediated the reception of books since they contained many book reviews; many books were expansions or collections of articles, or began life serialized in periodicals as did Mill's *Utilitarianism*, which was first published serially in *Fraser's Magazine*; and journal articles commonly blended essay and review in the 'review-essay'. Laurel Brake et al. (2022) speak of the 'bleeding of review into essay; [and] the resulting overlap of critics and reviewers' within British periodical culture (157). The review-essay became more essay-like over the century (Robinson 2000: 168–169), but throughout the period, the review format was often merely a 'formal convention' that actually gave authors 'the occasion to debate important...issues' (Oražem 1999: 40). For example, as we will see, authors like Martineau and Dilke used reviews to forward their own views. If we brush these aside as 'mere reviews', we will miss some of women's philosophizing.

The periodicals were general, not specialist. The reigning assumption was that 'Minds of the first rank are generalizers; of the second, specializers' (Eastern Hermit 1878: 268). Many journals therefore included essays on a wide variety of topics, and sometimes they contained fiction and poetry alongside non-fiction. Specialism began to replace generalism later in the century, but this shift came in against considerable resistance, such as that of 'Eastern Hermit'—the poet William Allingham, writing pseudonymously.

Allingham's pseudonym in turn points to another distinctive feature of the culture. Until at least the mid-1860s, non-fiction periodical contributions were normally anonymous, a convention that facilitated women's participation (for a comprehensive study of this, see Easley 2004). After all, editors had no reason to reject or avoid contributions from women when contributions were unsigned anyway. However, from the mid-1860s onwards signature and the associated 'theory and practice of personalised criticism' came in (Brake and Demoor 2009: 19). This trend went along with the rise of specialism, which depended on expertise and credentials that were advertised by the writer's signature. Nevertheless, many journals retained anonymity for as long as possible, and many authors adopted pseudonyms, like 'Eastern Hermit'. These pseudonyms could be creative, like Anna Kingsford's 'Colossa' or Conor McHugh's 'Thalassoplektos'. They might hint at the author's standpoint, like Martineau's 'From the Mountain', Barbauld's 'Balance', or John Ruskin's 'Kata Phusin' ('according to nature'). Pseudonyms could be male, as when the poet and essayist Alice Meynell wrote as 'Francis Phillamore' or William Clark Russell wrote as 'Sydney Mostyn'; or female, as with Meynell's 'Alice Oldcastle' and William Thackeray's 'Dorothea Ramsbottom'. Women used male pseudonyms more often than men used female ones, but the latter did happen (and not uncommonly—Gaye Tuchman estimates that in the 1860s and 1870s, more men wrote fiction under female names than women

did under male names (Tuchman 1989: 119)).³ Initialled publication, as with Barbauld's 'A. L. B.', Martineau's 'V.', and Meynell's 'A. M.', was common too.

Anonymity and pseudonymity helped women to participate, yet the unfortunate longer-term legacy of these conventions was to hide who said what in nineteenth-century print culture. Moreover, this entire culture largely fell from sight in the earlier twentieth century, until Victorianists began to rediscover it from the later 1950s onwards. This rediscovery was spearheaded by the *Wellesley Index to Victorian Periodicals* (Houghton 1966–87; Slingerland 1989) followed by the *Victorian Periodicals Newsletter* (1966–79), later *Victorian Periodicals Review* (1979–2024). Initially, the scale of nineteenth-century journals was greatly underestimated. For instance, Patrick Scott in 1975 reported that 'there were upwards of eighteen thousand periodicals' in the period (Scott 1975). By 2010, the best estimate was 125,000 (VanArsdel 2010).

Research into Victorian periodicals has unearthed the substantial journal contributions of many women, albeit gradually. At first, it was assumed that there must have been few women periodical contributors, given the patriarchal context (Onslow 2000: 1–3). Marysa Demoor pointed out in 2000 that the *Wellesley Index* of Victorian periodicals 'failed to change the current assumptions about the gender of the typical Victorian reviewer' (Demoor 2000: 3). Carol Christ (1990) estimated that 13% of periodical authors identified in the *Wellesley Index* were women (21). Of these female authors, *Wellesley* revealed eleven to have been very prolific, with Cobbe, Lee, and another art theorist Elizabeth Eastlake authoring more than fifty essays each (Hamilton 2006: 6). But as a whole, *Wellesley* underestimated women's contributions, for instance listing only five articles for Geraldine Jewsbury, who in fact authored over 2,300 contributions for the journal *Athenaeum* alone (Fryckstedt 1990: 13). Likewise, *Wellesley* identified just eight journal contributions by Jameson, who authored at least forty-two. As Alexis Easley, Clare Gill, and Beth Rodgers (2019) have concluded, Wellesley's identifications capture 'only a fraction of the large number of women who contributed to the...periodicals...of the Victorian era' (5).

These omissions came about partly because *Wellesley* only covered a selection of the most prestigious journals. This means that *Wellesley* did not comprehensively capture men's contributions either. Nonetheless, women's contributions have been underestimated more than men's. Anonymous authors have often been presumed to be men until proven otherwise, and women's identities have been harder to disentangle due to their changing surnames by marriage, greater use of initials and pseudonyms, and the lesser availability of archival sources on women,

³ Heather Hannah's (2018) detailed empirical study substantiates this suggestion. Hannah points out that men using female pseudonyms has been under-researched, owing to our entrenched assumptions that only women had reasons to use pseudonymity.

caused by decades of disinterest in their work.[4] Despite these hurdles, over time more of women's work has been de-anonymized and their multiple and complex pseudonyms and signatures decoded. Digitization has expedited this process, making journals and out-of-print books readily available and allowing for data searches that help to disclose women's reception and influence (see Brake et al. 2022: 156). I therefore suspect that the true proportion of female authors exceeds 13%: for example, it has already been found that women authored 20% of content in the prominent *Cornhill Magazine* (Harris 1986).

Whatever exact percentage of authors they were, women had a bigger presence in the periodicals than earlier generations of scholars believed possible. This bears on philosophy since the journals, being non-specialist, included discussions from what have since become many different disciplines, including philosophy. Furthermore, the non-specialist culture meant that one did not have to work as a philosopher at a university or even have a university education to publish philosophy in the journals. Mill, after all, was not a professional philosopher and neither was another central figure, Herbert Spencer.

Thus, the fact that women could not obtain a university education was not necessarily an obstacle to their publishing philosophy, and they regularly contributed. Consequently, the study of Georgian and Victorian periodicals bears on nineteenth-century women's philosophy. Unlike early modern women who often did philosophy outside the public sphere, or twentieth-century women who mostly worked within professional academic philosophy (Connell and Janssen-Lauret 2022: 199–200), nineteenth-century women philosophers in Britain thought and wrote in the *pre-specialist public sphere*. This was an intellectual and cultural world not yet carved up along hard-and-fast disciplinary lines. So when recent scholars assume, for instance, that Vernon Lee 'dabbled in aesthetics, but...did not have the training in philosophy that...would have given her work credibility with the academic establishment' (Cohen 2007: 22), this anachronistically projects later requirements for academic credentials onto an era where one did not yet have to be a professional academic to do credible work in philosophy.

Once we know where to look, we find journals full of female voices. Martineau, Jameson, Cobbe, Dilke, and Lee published extensively in the periodicals. They published books as well, but these regularly drew on and repackaged their journal contributions. With Barbauld and Baillie things are slightly different, since their key writings on the philosophy of art appeared in books. Yet journals were crucial in transmitting and mediating Baillie's reception: we learn how celebrated she was from the many lengthy reviews of Baillie's work (itemized in Bugajski 1998). In Barbauld's time, from the 1770s to 1810s, journal culture was still

[4] For example, as Jessica Gregory (2020) critically observes, Dilke's work is archived not in its own right but, partially, within the archives of her two husbands—the (Charles) Dilke Papers and (Mark) Pattison Papers. These archival biases are compounded for ethnic minority women (see Bressey 2010).

forming, a process in which her brother and collaborator John Aikin had an important hand. He edited several early journals, including the influential liberal *Monthly Magazine*, which later published Charles Dickens' *Sketches from Boz*. Through John, with whom she co-wrote several works, Barbauld was connected to the periodical world during its gestation, and she authored more periodical contributions than scholars have realized until recently (see McCarthy 2015). Overall, we need to appreciate the role of journals to contextualize and understand women's thought.

Clearly, nineteenth-century women's voices were not entirely suppressed or absent, as people have often assumed, believing that women were totally oppressed in the bad Victorian past with its infamous doctrine of 'separate spheres'. 'Separate spheres' was more an ideology than a consistent reality, as Benjamin Dabby (2017), Amanda Vickery (1993), and others have shown. However *our* belief in the oppressive power of separate spheres is entrenched. Consider a study, using big data, which found that women declined from around half of all fiction authors in 1850 to just a quarter by 1950. The authors were surprised: 'How can we explain a trend that runs directly against our assumptions about social progress?' (Underwood et al. 2018: 5). The *Guardian*, reporting on the study, was clear about the explanation, quoting the novelist Kate Mosse: 'a sea change from the Enlightenment through to Victorian values, so women are freer in the time of Jane Austen…, but then Victorian values—the angel in the house—take over' (Flood 2018). 'Victorian values' are allegedly to blame for the dramatic *post*-Victorian reduction in women authors!

The alternative hypothesis favoured by Ted Underwood et al. (2018) is that women published less fiction after 1900 as they were now able to publish more non-fiction (23). But this explanation presupposes that women were more excluded from non-fiction publishing in the nineteenth than the twentieth century. The evidence does not necessarily bear this out. We have seen that women authored at least 13% of all nineteenth-century journal content. In contrast, taking for instance the *Philosophical Review*, its proportion of women-authored content fell from 11% in the 1910s to just 2% from 1950–70 (Katzav 2020). Even now, only around 14% of articles in philosophy journals are by women (Wilhelm et al. 2018). Of course, philosophy is only one discipline, but Meaghan Clarke (2005) has likewise found that women's opportunities to publish on art declined after 1900 as 'art criticism became more established' and 'avant-garde art criticism acquired an increasingly masculine status' (159–160). Contrary to Underwood et al., it may have been easier for women to publish non-fiction prose in the nineteenth century than the twentieth. We simply have to relinquish our ingrained belief in linear progress.

This is not to say that women authored non-fiction on the same scale as fiction. Confirming the findings of Underwood et al., women authored around two-thirds of novels around 1862 (Buchanan 1862: 132)—one reason why men started

to use female pseudonyms. Similarly, women authored up to 70% of all ghost stories in periodicals, another genre where statistics are available (Salmonson 1989: x). And women's poetry was 'respected in the nineteenth century as [it] never [has] been since' (Armstrong 1993: 321). Though women's non-fiction output did not reach these heights, some individuals were very successful. Cobbe, for instance, was literally given a 'room of her own' by the high-circulation newspaper *The Echo*, for which she wrote three leaders a week (Onslow 2000: 47). I mention this instance because, famously, Virginia Woolf ([1929] 2014) declared that women had never had rooms of their own for thinking and writing (43). Woolf asked:

> How...could it [genius] have been born among women...? Yet genius of a sort must have existed among women...Now and again an Emily Brontë...blazes out and proves its presence. But certainly it never got itself onto paper....Indeed, I would venture to guess that Anon, who wrote so many poems without signing them, was often a woman....Currer Bell, George Eliot, George Sand, all the victims of inner strife as their writings prove, sought ineffectively to veil themselves by using the name of a man. Thus they did homage to the convention...that publicity in women is detestable. Anonymity runs in their blood. The desire to be veiled still possesses them. (40–41)[5]

Woolf was wrong on many levels. Anonymity and pseudonymity were standard for prose articles by women *and* men; on the whole these conventions were enabling, not disempowering, for women;[6] anyway, some women published much of their work signed, as did Martineau, Jameson, and Cobbe; and women *have* kept getting their views onto paper, one way and another.

This is not to deny that women's intellectual participation was hampered. Women often had limited or no formal education, they were barred from universities for most of the century, and many scientific and discussion societies openly excluded them. At the same time, better-off women sometimes benefited from periods of formal education (for instance, Baillie attended boarding school in Glasgow), and their home education could be excellent. They frequently had access to well-stocked libraries in family homes, and through their families, relations, and friends they were part of social circles and networks that gave them access to current intellectual debates.

These women tended to overstate how parlous their education had been. Consider Jameson's response to her confidante Annabella Byron (Ada Lovelace's mother) about what early reading had most influenced her. Jameson explained

[5] For an excellent account of how Alice Walker turns Woolf's critique inside-out to recover the oral philosophizing of African-American women, see Stewart (2023).

[6] On this point, see also Dumbill (2020).

that as a child she read tirelessly, liking Shakespeare, Milton, the Bible, and ancient Greek and Roman history, devouring the *Iliad* and *Odyssey* by the age of eight, and having 'for a governess one of the cleverest women I ever knew' (AJ to Byron, [c.1841], in Jameson 1834–53: 36–40).[7] Incredibly though, Jameson summed up, 'as you may perceive, I had really no *education*' (41)! Jameson and others had their reasons for making these self-deprecating statements. To admit that their informal education was impressive would have undermined the case that women needed access to formal and higher education. Yet these statements have fooled us into thinking that these women could not have had the knowledge to make credible intellectual interventions.

Even women's exclusion from most of the professions, such as law, medicine, and the church, was a double-edged sword. This exclusion drove a high number of middle- and upper-class women into writing, for unlike law, medicine, and the church, periodical and book publishing *were* open to women, especially given the convention of anonymity. It is important to remember that these better-off women generally had domestic servants relieving them of many routine household tasks and leaving them with comparative freedom to read, think, and write. Moreover, even these privileged women sometimes needed ready money (book and periodical writing were paid), and they needed work to occupy their time, minds, and energies.[8] A combination of informal education, access to intellectual networks, and lack of other professional openings gave these better-off women the opportunity and motivation to publish, and in some cases to publish philosophy.

How did this bear on women's opportunities to read, think, and write about art and philosophy of art? General periodicals such as *Fraser's Magazine*, the *Athenaeum, Westminster Review, Contemporary Review, The Academy* and others routinely included articles on art and reviewed art books. This was especially true of the *Athenaeum*, which was 'unusually devoted to art' (Israel 1999: 48). Other journals were specifically about art, most notably *The Art-Journal*, founded in 1839, the longest-running and highest-profile Victorian art journal. Whereas *The Art-Journal* was 'intellectually elite', the *Magazine of Art*, founded in 1878, was relatively lightweight (Brake and Demoor 2009: xviii). There were hundreds more shorter-lived and niche art serials, such as the *Aesthetic Review* edited by Jane Ronniger which came out from 1876–80 (for a comprehensive list of these art-related journals, see Roberts 1970). Women used all these channels to publish on art. We find interventions on art by the women discussed in this book in

[7] All quotations from the correspondence between Byron and Jameson are reproduced with the permission of Paper Lion Ltd and the Estate of Ada Lovelace.
[8] Admittedly, the pay was not always great. Still, Martineau, Cobbe, and to an extent Jameson managed to support themselves by writing.

Fraser's Magazine, the *Athenaeum*, the *Art-Journal, Westminster Review, Magazine of Art, Contemporary Review*, and more.

But still, in being excluded from universities for most of this period, how did women obtain the knowledge to publish credible reflections on art? The answer is that the mostly informal education that women received skewed heavily towards languages and the arts. It usually covered several European languages plus painting, drawing, musical performance, poetic composition, and art appreciation. Proficiency in the arts was a conventional attainment for middle- to upper-class women. As Pamela Nunn observes:

> A middle-class woman was expected to possess or cultivate sensitivity and an interest in 'culture'...'An English lady without her piano, or her pencil, or her...favourite French authors and German poets, is an object of wonder...and pity', wrote the author of *The Habits of Good Society* (1859). (Nunn 1987: 5)

Another part of this constellation was that women were expected to *be* aesthetically pleasing, to look attractive and follow fashion. But arguably they could not make themselves into pleasing aesthetic objects without having the taste to judge and discriminate what makes for a pleasing object. For instance, Mary Merrifield advised women that raising their dress into an art required a sound grasp of the principles behind the harmony of colours (Merrifield 1851, 1854). Even women's aesthetic objectification was thus turned around to qualify women as aesthetic subjects and judges.

Admittedly, the sword could cut back the other way again. One of Jameson's female fans (of whom there was quite an army) wrote to her sister that she had 'observed some *redhaired* ugly, *red faced* woman...[an] ugly old woman...Judge of my consternation when I...was presently informed it was—*Mrs Jameson!* One of my greatest admirations' (Emily Mason, quoted in Thomas 1967: 117). Surely a woman of exquisite aesthetic taste must be an exquisite aesthetic object, Mason felt (and she duly concluded that actually Jameson *was* attractive, when seen closer-up). Well used to criticisms of her appearance, Cobbe (1894) disarmed them at the start of her autobiography: 'I have inherited a physical frame...defective even to the verge of grotesqueness from the aesthetic point of view' (vol. 1: 2). By pre-emptively objectifying herself, she demonstrated that she could apply aesthetic categories dispassionately and with humour, turning herself back from an object into a subject.

By the nineteenth century, then, associations between women, the arts, and beauty were entrenched. This was especially the case for upper-class women, for aesthetic sensitivity and the ability to appreciate art were something of a badge of class honour, marking households out as having enough freedom from immediate material needs to attend to life's aesthetic side. These contextual factors meant that art was a topic on which better-off women felt relatively free to contribute,

and growing numbers of women turned to it. For example, Jameson adroitly drew on these background cultural associations to position herself as an arch-connoisseur of art, bringing a woman's fine aesthetic sensibility to the judgement of artworks. She appealed both to women's association with taste, and to the idea that people could improve and better themselves through art, to suggest that as a woman she was perfectly placed to educate the aspiring public about art.

For some women, though, informal home education in the arts was not enough. Formal art education was needed, and they campaigned for it. A first step was the foundation of the Female School of Design, later the Female School of Art, in 1842. Dilke studied there in 1859–61, by which point the School, which passed through a series of names and premises, had become part of the National Art Training School.[9] Women flocked to study art and acquire the training to become practising artists, which pressurized other schools to admit women, as the General Practical School of Art did, for instance. By 1851, around 934 women were listed as artists in the census (Thomas 2022: n. 35). Eventually even the Royal Academy Schools had to accept women, following Laura Herford's admission in 1860. She applied by submitting her drawings initialled 'L. H.', to conceal her gender—another case where anonymity worked to women's advantage.[10] The next focus of campaigning was for the Academy Schools to allow women to study and draw nude and semi-nude models, which they were barred from doing on grounds of feminine modesty. Only in 1893, after twenty years of petitioning (in which Dilke was involved),[11] did the Royal Academy finally open life classes to women. By then, women had been able to study and take life classes at the more egalitarian Slade School of Art since its foundation in 1871.[12] The combined effect of these developments was that by 1911 there were around 9,000 practising women artists, a dramatic increase compared to 1851 (Thomas 2022: n. 35).

Women's penetration into art schools did not displace the other more informal mechanisms by which women studied art. Women could and did visit museums, churches, and galleries around the world. Women such as Maria Callcott, George Eliot, Elizabeth Eastlake, Jameson, Cobbe, Dilke, and Lee travelled widely to view artworks in Europe and beyond and in public and private collections (see Anderson 2020). Dilke's abundant letters to Gertrude Tuckwell and Eleanor Smith, for instance, report on her many negotiations and arrangements to view

[9] On the School's early history, see Chalmers (1995).
[10] Herford's admission followed an 1859 petition for the Academy to admit women, signed by thirty-eight women, including Jameson ('H' 1859: 581–2). However, while women were formally excluded before Herford, the reality was more complicated. On the 'hidden history' of women's earlier presence in the Royal Academy, see Vickery (2016). She finds that (for example) in 1777, women comprised 8% of exhibitors and 7% of painters.
[11] Dilke corresponded on the issue with the Royal Academy President, Frederic Leighton (Clarke 2005: 66).
[12] On women's campaigns to study at and take life classes at the Royal Academy, see Bluett (2021). For comment at the time on women's freedoms at the Slade, see Weeks (1883).

privately held works. Of course, these women could only undertake these travels due to their privileged class position and connections, which opened the doors of various private collections to them.

More positively, these women's travels shed light on the fact that Britain's intellectual culture was quite cosmopolitan and not narrowly self-contained. Jameson and Cobbe were born in Ireland (Jameson's family moved to England when she was four, and Cobbe moved to England, and then Wales, as an adult). Lee was born in France to an English family whose peripatetic lifestyle took them around various European countries before they settled in Italy. This remained Lee's base in her adulthood, though she always spent periods in Britain and published in British as well as Italian journals. Dilke spent long periods in France, and her library, which she donated to the Victoria and Albert Museum, consisted very largely of French, German, and Italian books.[13] Jameson's travels were the most extensive of all. She toured the US, Canada, and much of Europe, especially Germany and Italy, travels that allowed her to develop her exceptional knowledge of art. Cobbe, too, spent regular periods in Italy and was the Italian correspondent in the 1860s for the *Daily News*, a newspaper founded in 1846 by Charles Dickens.[14]

In addition to these travel opportunities, the rapid expansion and opening-up of art collections in this period helped women to access art. In 1850 there were under sixty art museums in Britain, but by 1887 there were 240, enabled by public funding (Hoberman 2016). The National Gallery opened in 1824 and, after moving to enlarged premises in 1838, it began to attract around 500,000 visitors annually (Teukolsky 2009: 13). The 1857 Art-Treasures exhibition in Manchester attracted an astonishing 1.3 million visitors, many of them working class.

Women did not only benefit from this opening-up of collections, they also encouraged it. Jameson advocated a more coherent organization of gallery spaces and authored popular guidebooks on existing collections. She was speaking to a rising public demand for knowledge of art. As more art became available, 'the audience for art and the interest in learning about art expanded significantly, as did the appetite for knowledge about the lives of artists' (Álvarez 2020: 39, referring to Fraser 2014: 12). Art journals began publishing prints of artworks and reviewing more and more collections, which further enlarged the audience interested in art, creating more momentum to publicize art and review it, and so on.

[13] Dilke's library is available at the V&A Catalogue, indexed as the 'Lady Dilke bequest' (see https://nal-vam.on.worldcat.org/discovery). I thank Kali Israel for directing me to this.

[14] On nineteenth-century women's engagement with Italy in particular (including by Jameson, Cobbe, and Lee), see Chapman and Stabler (2002). Of course, just as Britain was not hermetically sealed off from the rest of Europe, nor was Europe from the rest of the world. But women's engagement with non-Western art is beyond this book's scope, though several women such as Maria Callcott and Sarah Stickney Ellis wrote on non-Western art (based on extensive travels in Callcott's case; on both of them, see Chapter 11).

The culture took an increasingly 'pictorial turn' with a 'flood of reproducible images enabled by new media technologies' (Teukolsky 2009: 19, 20). In tandem, art journals and art writing gained in influence, prestige, and power to the point where art critics could make or break artists' careers (Flint 2000: ch. 7). Women such as Jameson, who introduced an inaugural series of art prints in the *Art-Journal*, and Dilke, who regularly reviewed art exhibitions for the periodicals, were important to this process in which art came to pervade the public sphere more than ever before.

Nineteenth-century women, then, encountered limitations on their ability to study art, *and* they steered around these limitations and refused to be held out of public conversations on art. Indeed, Barbauld, Jameson, and Dilke rose to be amongst the most qualified critics and judges of their times. In terms of the Humean idea that the qualified art critic needs a breadth of experience of art-works, these women were qualified and were recognized for it.[15] This was made possible by the rapid and dynamic expansion of print culture and the accompanying growth in the production, transmission, consumption, and theorization of art. These expansive developments enabled women to navigate through and beyond gender-based restrictions.

1.3 The Character and Evolution of Women's Thinking About Art

Nineteenth-century women were able to write and publish on art. But what did our seven women say about it? Amongst other topics, they asked why we enjoy watching tragedies and reading about the sufferings of fictional characters; what makes certain dramatic narratives tragic; whether it is enough for art to entertain or whether art must also be morally beneficial; what the moral benefits of art and literature are; what art's purpose is, especially whether it is to be moral or beautiful or both; how art relates to religion and history, and how beauty relates to goodness; what characteristics distinguish the different art-forms; what genius is, and whether women can possess it.

As this list of topics suggests, these women's central and overarching concerns were with the relations between art and morality and, in turn, between art and religion, since morality and religion were widely viewed as interdependent in this period. On art, morality, and religion, I will trace two trajectories over time in this book.

[15] Caroline Palmer (2009) traces how women developed positions as connoisseurs and art judges from the late eighteenth to late nineteenth centuries. Meaghan Clarke and Francesco Ventrella (2017) likewise chart the emergence of 'a definition of the art expert that allowed women to address the public authoritatively and with the endorsement of male critics as well' (6).

Art and morality. In 1773 Barbauld suggested that when we enjoy the suffering of fictional characters, the source of our enjoyment is twofold: we enjoy feeling sympathy for a fellow-being, and we enjoy the cultivation and refinement of this feeling which fiction provides with its carefully stage-managed scenarios. Yet fiction manages the stage so carefully that the sympathies it arouses may not transfer into real life. In 1810, Barbauld proposed that literature must be realistic enough to avoid this problem, but illusory enough to provide cultivation and refinement. In the early nineteenth century, Baillie gave dramatic and tragic literature a more emphatic moral purpose. For her, tragedy educates us about the passions, in others and ourselves, and it strengthens our powers of sympathy and self-regulation. In the 1830s, Martineau saw the moral purpose of art and literature in starker terms still: art should illustrate moral principles, and the aesthetic features of artworks should always instil ethical lessons. Art that fails morally is bad art—art that is falling short of its proper purpose. These views of Martineau's represented the high point of a trend towards aesthetic moralism.

After Martineau, Jameson pursued a renewed balance between the moral and aesthetic qualities of artworks. She approached this balance in different ways over time. In her work from the 1830s, she proposed that characters in artworks can only serve as moral examples if these characters are presented as wholes, which requires artworks to be wholes in turn. Since wholeness confers aesthetic value, aesthetic and moral value go together. In her later work on sacred art from the 1840s onwards, she shifted ground and argued that art can only be poetically meaningful and expressive if it embodies the moral aspirations of its era, so that aesthetic and moral value again coincide.

For Cobbe, in the 1860s, Jameson had not given enough weight to 'art for art's sake'. Artists may safely pursue beauty alone, Cobbe thought, since true beauty comes from God, and God is good, so that true beauty is necessarily good too. But for Emilia Dilke in 1869 and the younger Vernon Lee from the late 1870s to early 1880s, all such attempts to balance art's aesthetic and moral qualities only compromised art's proper purpose: the unswerving pursuit of sensory beauty. This marked the peak of a turn away from moralism towards aestheticism, and both Dilke and Lee subsequently moved on. Dilke began to recognize other values in art besides beauty, including moral value, while Lee qualified her aestheticism repeatedly until by the 1890s she had transformed it into an account of art for life's sake.

Art and religion. Art's links with religion, as with morality, tightened from the late eighteenth century onward. Barbauld connected the two through the concept of devotion, while religious convictions informed Baillie's account of tragedy[16] and Martineau's conception of the moral principles that art is to illustrate. But

[16] See Colón (2009: 38–50). Baillie's religious convictions were serious: in the 1830s she wrote a theological treatise on the interpretation of the New Testament (see Baillie [1831] 1838).

Jameson most heightened the art–religion connection, treating Christian art and iconography as the epitome of poetic expressiveness and meaningfulness. She was perfectly in tune with the *Zeitgeist*, as the first instalments of her book series on *Sacred and Legendary Art* came out near-simultaneously with the zenith of church attendance in Britain in 1851 (Crockett 2000: 7). Not surprisingly, Jameson's book series was phenomenally successful. Cobbe then continued the religious orientation, appealing to God as the source of both beauty and goodness in art. Dilke and the earlier Lee broke away and insisted that art beauty had nothing to do with religion. At this point, Lee even argued that art beauty and religious meaning are antithetical: an artwork cannot possibly be beautiful *and* religious, because beauty requires presentation, but religious meaning requires a sense of what lies beyond presentation. But when Lee subsequently revised her aestheticism, she argued that art expands and enriches us spiritually in a way that increases the overall harmony of the universe. This was a step back in a more spiritual direction.

On both morality and religion, then, the pendulum swung first towards their ever-tightening union with art and the idea that art could only be good art if it was morally and religiously good. Then the pendulum swung the opposite way, towards aestheticism and the view that art could only be good as art (i.e., beautiful) if it separated from morality and religion. Then the pendulum began to swing back towards the middle ground.

From this anticipatory summary, several other features of these women's thought on art start to become apparent. These women were interested primarily in the arts, as distinct from aesthetic experience. Whereas many eighteenth-century British aestheticians had mapped out taxonomies of taste, judgement, the imagination, the beautiful, and the sublime (see Costelloe 2013: part I), these women largely equated the aesthetic domain with the arts and concentrated their attention on the latter. This tendency became especially marked from Baillie onwards, to such a point that Cobbe came to classify even our aesthetic experience of nature as receptive *art*. The artistic, aesthetic, and the beautiful tended to be run together, which came out clearly in the aestheticism of Dilke and Lee: art's purpose is to be beautiful, beauty gives us aesthetic pleasure, and the pursuit of beauty defines art as art. These equations *aesthetic–art–beauty* meant that collectively these women said little about the sublime or about aesthetic experience of nature or everyday life. And they primarily focused not on *our* faculties and powers as subjects of aesthetic experience but on the meanings and characteristics of *art objects*.

One might therefore wonder whether these women are rightly classified as doing philosophy of art at all, rather than art criticism, art evaluation, art history, or art theory more broadly. After all, these women wrote in a non-specialist culture where they did not have to be philosophers exclusively. In interpretive literature on their work, we mainly find them described either vaguely as 'writers'

(Barbauld, Baillie, Martineau, Jameson, Cobbe, and Lee), or more precisely as 'art historians' or 'art critics' (Jameson, Dilke, Lee), but not usually as philosophers of art. Perhaps this is with good reason, one may think.

I shall put forward an alternative interpretation. These women were doing a distinctive *kind* of philosophy of art, not only in that they wrote largely about the arts but in other ways as well. Their general philosophical reflections on the arts blended seamlessly into their criticisms, interpretations, and evaluations of particular artworks and art movements and traditions. Reciprocally, those critical interpretations informed their general claims and arguments. This reflects the fact that modern-day divisions amongst philosophy of art, art history, and art criticism did not yet exist in these women's time (although this need not prevent us, the modern-day interpreters, from focusing on the more philosophical or the more art-critical sides of their work).

These women did not only theorize and analyse art, they also produced it. Baillie wrote tragedies, Barbauld poems; both were renowned for their artistic work. Martineau's numerous book-length tales illustrating moral and political principles were best-sellers. Jameson's first book was a faux-autobiographical novel, likewise well received, and her oeuvre included travel writing of a partly autobiographical nature. The same is true of Lee, who also wrote stories, including the supernatural stories for which she is now most remembered. Dilke, too, wrote short stories (see Israel 1999). All these women, in fact, met with success as literary authors of various types. Cobbe, the exception, stuck almost entirely to non-fiction. But even she published a few fictional writings—and innovative ones, such as a story from a dog's point of view and a science-fiction dystopia set in Britain in 1977.

On the whole, for these women the boundary between art practice and art theory was porous. Barbauld ranged freely across poetry and prose, fiction and non-fiction, crossing different writing styles in changing combinations, and a century later Lee likewise blended fiction and non-fiction in variable proportions, for instance when presenting her philosophical views in the literary form of the dialogue. Baillie reflected on tragedy in connection with her own tragic plays, and Martineau put her view of art's moral purpose into practice in her tales. Jameson's art-historical writing blended into the travel writing in which she described artworks she had encountered at first-hand, descriptions that also occupied a good amount of her early novel. The writing on art of Cobbe and Dilke was more firmly distinguished from their literary projects, but they were still writers of great versatility across forms and genres. When these women reflected on art, then, the particular artworks informing their reflections were sometimes their own productions, which in turn were philosophically infused. Practice and reflection shaped one another, and the writing *of* art filtered into writing *about* art and back again.

To put this together, these women (i) focused on philosophy of the arts, (ii) in a non-specialist manner, (iii) interweaving general reflections and particular interpretations, and (iv) moving freely between art thought and art practice, between artistic writing and writing about art. In many ways, Lee (1881) encapsulated this tradition in saying that she engaged in 'a sort of art-philosophy' (9). This philosophy was not only about art, sometimes it *was* art, taking the form of artworks that explored philosophical ideas. Lee elaborated:

> Art questions should always be discussed in the presence of some definite work of art, if art and its productions are not to become mere abstractions, logical counters wherewith to reckon; also,...discussions should be, what real discussions are, a gradual unravelling of tangled questions,...not a mere exposition of a cut and dry system. I have always, in putting together these notes, had a vision of pictures or statues or places, had a sound of music in my mind, or a page of a book in my memory. (8)

This 'sort of art-philosophy' was not unique to these seven women. We find something similar practised by many of their male contemporaries: William Wordsworth, Samuel Taylor Coleridge, William Hazlitt, Matthew Arnold, William Morris, Walter Pater, and Oscar Wilde, to mention just a few. Pater (1873) came out of and distilled this tradition when he began his *Studies in the History of the Renaissance* by saying that he was not attempting a definition and general account of beauty, but reflecting on his personal encounters of and experiences with beautiful objects (vii–ix)—a statement of approach that had a great influence on Lee. Much of John Ruskin's work can be considered as 'art-philosophy' in this same sense, albeit that he leaned rather more towards a systematic mapping of aesthetic value and experience (see Landow's (1971) excellent account).

The fact that many men adopted a similar approach suggests that the non-specialist print and periodical culture, above all, made this kind of philosophy of art possible. The culture allowed authors to publish across manifold topics, styles, and fields, and to blend fiction and non-fiction, poetry and prose. The resulting kind of philosophy of art was well suited to women's participation, since it was closely linked to literary and poetic writing, drew on particular experiences of artworks, and moved away from the potentially forbidding territory of the systematic treatise into more experimental, open, and creative forms of writing and thinking. Accordingly, women could join with men in shaping the tradition of nineteenth-century British philosophy of art.

Others have noted the distinctiveness of this tradition. Costelloe (2013) classes many of the above male authors as 'Victorian critics', observing that they 'focused primarily on understanding and appreciating the form and content of creative work' (208). And for Benjamin Morgan (2017): 'Victorian aesthetic theory was

not primarily pursued in the idiom of philosophy...[but] at the intersection of multiple discourses and practices, including art history, the novel, interior design, physiology, and evolutionary biology' (5). Where I differ somewhat from Morgan is that I think some of this interdisciplinary discussion *was* philosophical. Writers need not stand in a line of descent from Alexander Baumgarten and Immanuel Kant to count as doing aesthetics—which, after all, long predated Baumgarten as is pointed out by Costelloe (2013: 3)—or to count as doing philosophy of the arts in my sense.

British philosophy of the arts did not take this form out of parochialism or ignorance. Dilke (1869) may have disparaged the German 'meshes of transcendental *Aesthetik*' and claimed that the English had taken the right route by foregrounding instead 'the relations of art to morals' (149), but she remained very well read in German aesthetics, and continental aesthetics more widely. Jameson's main theoretical influences were German, while Cobbe was an avid reader and disseminator of Kant. Going back earlier, Barbauld and Baillie were versed in European literature: Baillie read Schiller, for instance (see Baillie 1999: vol. 2: 701, 1049), as well as Racine, Voltaire, Corneille, and so on (Slagle 2002: 67). Martineau (1877) documented her reading of the classics, French literature, and 'a good deal of history, biography, and critical literature' (vol. 1: 48, 53). Lastly Lee, being based in Italy, read and wrote in Italian as well as English, besides being very widely read in German and French thought. These women's art-philosophizing thus drew on a cosmopolitan mixing of sources.

It is by now well established that we need to expand disciplinary boundaries to include women in the history of philosophy generally. Holding academic positions as professional philosophers was not an option for pre-twentieth century women; women were less likely than men to employ the form of the systematic treatise; and women were more likely to do at least some of their philosophizing in the medium of literature.[17] The same need for open-mindedness applies to nineteenth-century British women philosophers of art. Recognizing that there have been diverse ways of thinking philosophically about art and aesthetics is important if we are to make their contributions visible.

1.4 How This Book Relates to Existing Literature

Highly esteemed as these women were in their time, there has been no comprehensive modern-day study of their theoretical contributions in the philosophy of art. This is the gap in our knowledge that I hope to fill. But, of course, this book does not come out of nowhere. I draw on several fields of scholarship: studies of

[17] See, inter alia Ezekiel (2020), Gardner (2012), and O'Neill (2005).

these seven women; analyses of the print, artistic, and intellectual culture in which they wrote; work on women in the history of philosophy; feminist aesthetics; and histories of aesthetics in Britain.

I draw on these fields to different degrees. Literary, cultural, and historical scholarship on the seven women figures most heavily, followed by wider studies of the print and periodical culture and of the art-writing of a broader range of women beyond this book's seven protagonists.[18] These important studies have been vital in bringing women's writings and ideas on art back into view. What I hope to add is an account of their specifically philosophical side.

Conversely, although this book contributes to the philosophy of art, studies of nineteenth-century British aesthetics will remain in the background, for rich and insightful as these studies are, and important in bringing out the sophistication and diversity of the British aesthetic tradition, they usually say little about women. This is true both of work looking at aesthetics as part of culture and of more specifically philosophical work. For example, Thomas Albrecht (2009), Rachel Kravetz (2017), Sebastian LeCourt (2018), and David Thomas (2004) all include only one woman amongst the historical thinkers they consider: George Eliot. Zachary Samalin (2021) includes only Charlotte Brontë, while Rachel Teukolsky (2009) mentions Jameson and Merrifield, but her major theoreticians remain Ruskin, Pater, and Roger Fry. Jonah Siegel (2016) gives a concise account of Victorian aesthetics, tracking its central aestheticism/moralism divide, but the only woman discussed—alongside Kant, Schiller, Ruskin, Robert Browning, Arnold, and Pater—is, once more, Eliot (Elizabeth Barrett Browning and the New Woman novelist 'Victoria Cross', i.e., Annie Cory, are briefly mentioned). Timothy Costelloe's account of the British aesthetic tradition covers only men: theorists of the picturesque (William Gilpin, Uvedale Price, Richard Payne Knight, and Humphry Repton), Romantics (Wordsworth, Coleridge, Percy Shelley, and John Keats), and Victorian critics (Hazlitt, Mill, Ruskin, and Pater) (Costelloe 2013: chs. 4–6). The parts of Paul Guyer's three-volume history of modern aesthetics which are on nineteenth-century Britain discuss Coleridge, Wordsworth, Shelley, and Mill; Ruskin and Arnold; Pater and Wilde; Bernard Bosanquet; Spencer; and, in a final chapter, Vernon Lee's early twentieth-century work (Guyer 2014).

Two cases should be noted where authors substantially discuss women other than Eliot. Morgan (2017) discusses the aesthetics of Lee and her co-author Clementina Anstruther-Thomson in depth, more briefly bringing in Constance Naden and Eliot. (Morgan also looks at many then-important but now-neglected

[18] Amongst these broader studies are Anderson (2020), Cherry (2000), Clarke (2005), Fraser (2014), Hughes (2022a), Kanwit (2013), Palmer (2009), Price (2009), Schaffer (2000), and Thomas (2022). Scholarship on the seven women protagonists will be introduced in their corresponding chapters.

male aestheticians: George Field, David Hay, Herbert Spencer, Grant Allen, Alexander Bain, and James Sully.) And Stefano Evangelista (2009), who examines the aestheticists' engagement with ancient Greece, makes Lee and 'Michael Field' (pseudonym of the collaborative authors Katherine Bradley and Edith Cooper) just as central as Pater and Wilde.

I do not mean to suggest that contemporary historians are to blame for focusing so heavily on men. They inherit a situation where over the twentieth century women have been comprehensively written out of the historical record, mentioned only in dismissive and slighting terms, if at all. There is no tradition of scholarship to alert modern-day researchers to these women's existence, and so researchers have no motivation to investigate them; existing scholarship effectively tells them that there is no one there to be investigated. These women have been relegated to 'unknown unknowns', but only once a figure is a 'known unknown' do we have reason to research them. In turn, it becomes tempting to rationalize the apparent absence of past women by supposing that they must have been prevented from writing and publishing by the forces of patriarchy. But as I shall show over the course of this book, these women have been excluded from twentieth-century histories, not nineteenth-century realities.

It might be objected that these women are *not* unknown unknowns, for there is a significant body of scholarship on women who wrote about art (e.g., by Meaghan Clarke, Caroline Palmer, and Hilary Fraser), conclusively demonstrating nineteenth-century women's significant intellectual presence in this area. Yet this work has had only limited uptake within studies of aesthetics and philosophy of art in general. The near-total omission from general studies of Jameson, one of the most influential of all nineteenth-century British writers on art, is striking. Kimberly Adams (2001) remarked twenty years ago that: 'The Victorians listened to Jameson as well as to Carlyle, Ruskin, Newman…; it is time for her voice to be represented in studies of this period' (50). But this has not yet happened.[19] I can see several possible reasons for this. Past women are sometimes assumed to have been exclusively occupied with feminist and gender issues, as Carol Bensick (2022) points out (168). In addition, historians of aesthetics will only have the motivation to read scholarship on Jameson and others if they are already aware that these women contributed to thinking about art. Without that awareness, there is no reason to consult this scholarship, especially if one assumes that any nineteenth-century women authors must have written primarily on feminism.

Ironically, even feminist aestheticians have sometimes taken for granted that all the historical philosophers of art were men. An example is the now-classic anthology *Feminism and Tradition in Aesthetics* by Peg Brand and Carolyn

[19] However, the Bloomsbury series *Aesthetics and Religion in Nineteenth-Century Britain,* edited by Gavin Budge, included Jameson's *Legends of the Madonna* as Volume 3. Volume 6, *Miscellaneous Writings,* also included Cobbe's main essay on philosophy of art.

Korsmeyer (1995). The premise of Arthur Danto's foreword to the book is that the philosophical tradition was exclusively masculine until recent feminist challenges arose (Brand and Korsmeyer 1995: xi). In their introduction, the editors comment on the limited conversation between aesthetics and feminist philosophy. They then sketch the shape of the European 'aesthetic tradition', accepting, albeit with caution, that this tradition 'consists of so-called classics or canonical texts': Plato, Aristotle, Hume, Kant, and so on (4). Although they rightly emphasize the diversity of the tradition and the multiple currents that feed into it, they do not mention any women contributors to these currents. Feminism then comes in as a 'departure' from the tradition (17).[20]

In contrast, I start out from Eileen O'Neill's insight that women have been excluded from philosophy's historiography, rather than its history (O'Neill 1998, 2005). In historical reality, women have always done philosophy, but subsequent narratives and canons have left them out. By implication, women have always thought and written about the philosophy of art as well.

Are we looking for past *feminist* philosophers of art, or past *women* philosophers, feminist or not? As O'Neill (2019) points out, recovering past women philosophers is an inherently feminist project (14–18). It is about listening to women, taking what they said seriously, and giving women's claims and ideas equal respect and attention with those of men. These feminist motivations for recovering past women philosophers mean that much recovery literature has focused on feminist figures.[21] Nonetheless, if we look only at women who were feminists, or at the feminist parts of their work, then we are ignoring much else that they had to say, and we may inadvertently reinforce the perception of non-feminist scholars that these women's writings cannot be of interest to them (Bensick 2023: 175). In the name of the feminist commitment to paying attention to women, we need to explore what women have said about other topics besides feminism, including art.

[20] To give two other examples: first, Bonnie Mann (2006) remarks that 'while male philosophers have been explicitly writing about sublime experience for well over three hundred years, women seem to have entered this discussion only when feminist interest in the sublime emerged...three decades ago!' (31). Second, Stephanie Ross, reviewing Babette Babich's edited collection on Hume on taste, suggests that 'women could not function as Humean ideal critics because women were excluded from public affairs' (Ross 2022). Or rather, Ross attributes this view to Korsmeyer, whose argument in the article in question is that, in Hume's day, women could not gain exposure to a wide enough range of artworks to become ideal critics, because this conflicted with norms of feminine modesty (Korsmeyer 1995: 59). Korsmeyer's analysis is helpful in specifying what women needed to do to become ideal critics. But I suggest that the historical evidence is that certain women satisfied this criterion: they *could* access enough art to qualify as reputable critics. Contra Ross, they were not straightforwardly 'excluded from public affairs'.

[21] Indeed, the inquiry into past women thinkers originated in the search for the intellectual foremothers of modern feminism, which reignited interest in Mary Astell, Mary Wollstonecraft, Harriet Taylor Mill, and Simone de Beauvoir. For example, in Shanley and Pateman (1990) the chapters on women/feminists were on Wollstonecraft, John Stuart Mill and Harriet Taylor Mill, Beauvoir, and Hannah Arendt.

Having said this, most if not all of our seven women protagonists were feminists, and Jameson's and Cobbe's interests in feminism and art converged in places, as when Cobbe defended female genius and Jameson sought out positive representations of women in Shakespeare's plays and in Christian art.[22] Even so, this book is not about how Jameson, Cobbe, or anyone else might be read retrospectively as feminist philosophers of art. Cobbe and Jameson, like the other women covered here, also wrote about art generally. It is their views of art as a whole that I want to illuminate.

Even when these women were feminists, their agendas do not always align with recent feminist aesthetics. Jameson and Dilke consolidated existing male-focused art canons. There were efforts in their time to build up canons of female artists—for instance by Elizabeth Ellet (1859) and Eleanor Creathorne Clayton (1863, 1876)—while Cobbe held up Elizabeth Barrett Browning, Rosa Bonheur, and Harriet Hosmer as artists equal to any man. But the dominant approach was to accept the mainly-male canon. Barbauld's canon of British novelists was one-third female, but she still devoted the other two-thirds to men, at a time when women had recently become the majority of novelists. By and large, too, the women discussed here accepted the hierarchical and implicitly gendered ranking of the five 'fine' arts—literature, painting, music, sculpture, and architecture—above the 'minor' arts and crafts.

In contrast, recent feminist aestheticians have critiqued these hierarchies, along with the biased standards that have led women artists to be devalued, ignored, and relegated to minor status (see, e.g., Korsmeyer 2004; Parker and Pollock 1981; Pollock 1988). These criticisms have been hugely important. Yet, if we are to restore past women philosophers of art to our collective memory, then we need to accept that they did not always approach art with the same critical iconoclasm as late twentieth-century feminists.[23] To satisfy our feminist concern to hear historical women philosophers, we need to bracket another feminist impulse: the desire to find historical theorists who shared present-day concerns with subverting and critiquing art hierarchies. This desire can lead us to overlook and devalue past women philosophers of art who did not share these concerns.

At times, the work of these women shines a critical light on recent feminist aesthetics. In particular, contrary to the view that the idea of genius is structurally male-biased, I will suggest that ideas of genius and gender were contested in the nineteenth century; that female genius was quite commonly recognized; and that genius was not seen as univocally male. We can see this both from the work of women philosophers of art, and from the more celebratory responses both to

[22] The word 'feminism' only entered the English language in 1898, but Jameson and Cobbe are still recognizably feminists, like many other pre-1898 women. They criticized male suprematism, defended women's achievements and virtues, and urged that women's social position must be reformed. For this approach to identifying past women as feminists, see O'Neill (2019).
[23] This point is also well made by Hilary Fraser (2014: ch. 1).

these women and to other women artists of the time. Some of these celebratory responses came from men. In several such ways, the study of earlier women calls us to revise what have become standard feminist interpretive frameworks. This is not to disparage feminist aesthetics, which has made this project possible and has been a source of inspiration to me. Rather, I hope for my criticisms to be constructive, and to help push feminist aesthetics in new directions.

In sum, I intend this book to fill a gap where several existing bodies of scholarship do not quite join up: where feminist aesthetics has not yet extended to the study of historical women philosophers of art; where historians of women philosophers have not looked greatly into aesthetics or nineteenth-century Britain; where the history of aesthetics has largely omitted women; and where cultural and literary history has not always gone into the philosophical side of women's thought about art.

1.5 Questions of Method

A familiar strategy for reintroducing neglected women into the history of philosophy is to relate them to their better-remembered male interlocutors, as with Elisabeth of Bohemia and Descartes. This strategy has advantages. It is historically accurate, since women often engaged preferentially and publicly with men, who had the greater authority. The strategy immediately shows the significance of women's contributions, insofar as they revise, criticize, build on, and respond to claims by canonical men whose significance is already well established. And the strategy helps us to locate and make sense of women's work by placing it into an accepted narrative.

Yet the strategy has downsides. Often women were influenced by other women, even when they did not advertise the fact openly. When we relate women primarily to men, these inter-women relations remain submerged, while we continue to amplify the reputation of the male figures. We risk implying that women's ideas can have value only in relation to those of men, and that an association with a prestigious male is the accepted path along which a woman thinker can achieve significance. This in turn may reinforce the assumption that men are the 'major' and women the 'minor' thinkers.

So perhaps we should pursue a second, alternative strategy, and examine women's ideas either in their own right or in primary relation to the ideas of other women, relegating male interlocutors to the background.[24] The problem with this

[24] This strategy has been adopted more often in the study of women as literary authors than philosophers. For example, Isobel Armstrong said of Romantic women's poetry: 'It will take some time for this work to become fully visible, and this may justify a one-sided study of women's poetry in isolation from male poetry. The next step will be to look at the interaction of the two—but let us postpone this until women's work is known better' (Armstrong 1995: 32).

is that in historical reality women did not generally think in a women-only bubble, and if we neglect male interlocutors, we may struggle to appreciate the significance of women's ideas. For instance, unless we compare Dilke's aestheticism to that of Pater we will not realize that she articulated aestheticism earlier, and more systematically, than he did.

Since each strategy has its strengths and weaknesses, I have tried to steer a middle course between them, but I am not exactly halfway in-between: despite its problems, I lean more towards the second strategy. One reason is that much existing literature on our seven women focuses on their relations with men. If one wants scholarship on Baillie's relations to Adam Smith, or Lee's relations with Pater, much good work is available already (for example, on Lee and Pater, see Evangelista (2009: ch. 2), or on how Lee was informed by Pater, Ruskin, and William James, see Martin (2013)). What we really lack is a genealogy of women's intellectual relations with one another as philosophers of art. All the same, Baillie *did* draw on Smith and Pater *was* important for Lee, so omitting these women–men relations altogether would be misleading. Moreover, showing where women went beyond their male influences can help to establish that these women produced work that was original and is worth reading. After all, if Barbauld merely duplicates an idea from Edmund Burke, then we might as well keep reading Burke. Or, if what she says has no point of connection with Burke, then we may not know what to make of her work. But if Barbauld builds on Burke *and* goes beyond him, then we have a stronger case for reading Barbauld. For these reasons, I will bring in some of women's male influences—but, in order to begin to shift our narratives and canons more substantially, I try to spend at least as much time on women's relations with one another.

One reason for relating women to one another is to explore whether they approached art with a distinctly feminine voice. Did they write on art *as* women? This issue of 'feminine voice' has been a major preoccupation in scholarship. Some theorists have identified ways in which these women adopted a female speaking position (see, e.g., Dalley 2010; Fraser 2014; Larson 2003).[25] Others have examined the rhetorical manoeuvres by which women claimed authority in a context where authority was presumptively male (see, e.g., Mansfield 1998, on Dilke). The need for authority pushed some women to assume a gender-neutral voice. For instance, Lee adopted her pseudonym and identity 'Vernon Lee' because it was gender neutral. Other women such as Jameson and Cobbe, however, were comfortable writing in an overtly female voice and signing much of their work with their female names. This reflects the fact that art history

[25] These debates come out of discussion of whether nineteenth-century women wrote novels and poetry with an identifiable female voice (see, e.g., Armstrong 1993: ch. 12).

'was not...a discourse that women felt prohibited from engaging in, or indeed defining', as Hilary Fraser (2014) observes (30).[26]

Whether or not women took on a female voice at the rhetorical level, did they hold their substantial views of art because they were women? In one sense, no: I have already suggested that the kind of art-philosophy these women did was also engaged in by their male contemporaries. But in another sense, gender was relevant. As we have seen, women felt able to write with confidence on art due to 'separate spheres' ideology and its consequences. By limiting women's other options, this ideology drove many better-off women towards writing and publishing; it meant that their informal education was usually arts-orientated; and the idea of the 'angel of the house' motivated women to be virtuous and useful, perhaps by educating people using drama or novels, or by disseminating an improving knowledge of Europe's artistic heritage. To this extent, women wrote about art because it chimed with their social role. More than that, women focused on art's relations with morality and religion because that focus chimed with their social role. Women, more than men, were expected to be virtuous, and virtue and piety were often thought to be co-dependent. Thus, even when our seven women were overtly critical of women's assigned social role, that role still led them to highlight art's relations to morality and religion. Beyond this, women disagreed heavily, with Martineau taking a strong moralist stance whereas Dilke embraced an equally strong aestheticism. Women's social role affected which questions they concentrated on, but it did not determine their answers to these questions or how they defended those answers.

Another inescapable methodological divide faced by any historian of philosophy is between past- and present-centred approaches. O'Neill has recently given a helpful restatement of the options (O'Neill and Lascano 2019: 9–10). We can (i) mine women's writings for answers to current problems—for example, to refresh debates about aesthetic moralism—and 'read past philosophical texts through the lens of our own current philosophical aims, assumptions and standards of evaluation' (9). Or we can (ii) take a 'pure historical' approach, 'aiming foremost to reconstruct and critically evaluate the arguments and projects within a text, and entire philosophical programs of past thinkers, in light of the motives,

[26] Fraser's (2014) remark complicates her own claim that women occupied a 'liminal status at the edges of the profession' of art history (33), resulting in 'categorical differences between the way men and women looked at or wrote about art' (177). Others have found no such differences, despite searching. Antje Anderson (2020) admitted that she initially approached the art writing of Jameson, Eastlake, and Eliot assuming that, as women, they were excluded 'from certain realms of knowledge, agency and influence' (179), and so would write about art differently from men. Instead, she found that 'Jameson, Eastlake, and Eliot would not typically address the fact that they were...writing as women....[It] took me by surprise that all three opted to repeat or at best amplify already-established opinions, and that they rarely protested the limitations they were under' (180). But perhaps this is because it stood out to them more that as women they *could* think, write, and publish about art—that the limitations they faced were surmountable.

presuppositions, and argumentational strategies and standards of the past era' (10). I prefer the second approach, on several grounds.

First, we have an inherited sense today of which philosophers and thinkers are important, and generally these 'major' thinkers are all men. Yet past figures who now seem minor or even negligible to us, such as Jameson, were considered major figures in their day. Only if we try to see the Victorian period as the Victorians saw it can we appreciate this fact. We need to look at historical sources such as William King's 1903 encyclopaedia of women's achievements:

> As a writer on matters of art and taste Mrs. Jameson probably surpassed all other women writers and on the literature of art she is conceded by many to stand next to Ruskin. She possessed an intense love of the beautiful, a cultivated and discriminating taste, and her breadth of knowledge was almost phenomenal. Added to these were her natural and cultivated powers of eloquent description. In quantity her writings were surpassing as quality, and the former does not seem to have impaired the latter. (King 1903: 369)

Talia Schaffer (2000) has made a related point about the women of the Aesthetic Movement, that is, the wider artistic and cultural movement corresponding to the idea of art for art's sake:

> Our critical categories often do not correlate with the lived experiences of the period. In many cases, men and women who had similar status in the 1890s [or 1820s or 1850s] have wildly divergent images today.... Critics once considered Ouida...and Alice Meynell the equals of Oscar Wilde, Thomas Hardy, Henry James... The gulf between the foremost and the forgotten is our experience, not theirs. (6–7)

To rediscover women in the status they once had, we need to reconstruct the lived experiences of their periods, bracketing present assumptions.

Second, as well as restoring neglected women, the past-centred approach can shift our perceptions of men's relative importance. Not infrequently, women engaged with and referred to men who have been forgotten, as when Barbauld responded to Joseph Addison rather than to David Hume for explanation of why we enjoy the sufferings of fictional characters. Dilke referred approvingly to such now-neglected philosophers as Bain (1865) and Spencer (1872), while Lee engaged with Allen (1877) and Edmund Gurney (1880) amongst others. A pure historical approach can unearth these crowded landscapes of debate beyond the few individuals who have been memorialized as 'big names'.

Third, a past-centred approach illuminates the print and periodical culture that shaped the character of these women's art-philosophical writing. From a present-centred perspective, information about publication contexts counts merely

as unnecessary and incidental detail, but I believe that it helps to make sense of how these authors thought about art.

Fourth, to reconstruct women's relations with one another we have to go into biographical detail and consult their correspondence, since women rarely cited one another explicitly. Women deliberately made their mutual influences invisible, as I will explain in the next section. So, to bring these buried influences to light, we must search behind the scenes of visible publications. What might look like biographical trivia from a present-centred perspective, from a past-centred perspective is important historical evidence about women's interconnections.

Fifth and finally, I prefer the past-centred approach because, as a feminist, I want to listen to historical women and pay attention to their own words. I wish to hear what these women said in the conceptual vocabularies they adopted, and to learn what they judged to be important, rather than reconstructing their work in light of what is considered important today. Then we can think *with* these women, rather than remodelling them into what we might want them to have been.

My goal of understanding these historical women in their own terms means that a considerable amount of this book will be descriptive: laying out what women claimed, following the order in which they presented their points, and quoting them to make their voices better known. I try to be reasonably synoptic and present as much of their work as I can, in order to familiarize readers with their little-known theories and to make clear the scope and scale of their philosophical interventions. I hope, though, that there is enough analysis to show that these women had well-thought-out reasons for their positions. And I hope also to show that these women's theories of art have value. Together, these women made many claims that are original, interesting, and repay investigation. Not all their arguments succeeded, and I shall point out some problems. Nor did they cover everything: as I've mentioned, they said relatively little about nature or the sublime. But collectively their work still adds up to a substantial body of thinking about art.

My historical orientation means that I do not engage in this book with contemporary philosophy of art, with the exception of feminist aesthetics, noted previously. Readers might find this frustrating, particularly as there is currently much discussion about art and morality. For some, literature and art are powerful moral agencies, expanding our sympathies and insights into other minds and exploring the particular contexts of moral decision-making (e.g., Nussbaum 1990). Others consider the harms inflicted by morally undesirable or vicious artworks (e.g., Dixon 2022) and the grounds on which we may legitimately engage with morally flawed works (Liao 2023; Willard 2021). Others consider how far moral flaws in artworks are aesthetic flaws (e.g., Gaut 2007). These contemporary discussions could be enriched by a sense of the long historical background of debates about art and morality and the female voices in those debates. Baillie, Martineau, Jameson, and the others offer many ideas and arguments that remain

relevant: how to translate sympathy for fictional characters into sympathy for real-life others, how literature can expand our sympathies for wrongdoers such as Lady Macbeth without condoning their wrongs, and how tragedy enlarges our understanding of other minds, to give just three instances. But I myself will not attempt to insert these women's voices into contemporary frameworks. I hope instead to give a clear and accessible account of these historical figures which can serve readers as a springboard for finding parallels with the present day.

1.6 Women's Intellectual Relations

I have alluded to the fact that the convention in the nineteenth century was not to reference female authors in published work. Indeed, authors did not reference one another much at all. The academic disciplines were not yet professionalized, so there was no obligation to meticulously acknowledge all one's sources to satisfy one's peers and adhere to norms of good practice. Even against this background, women were cited less than men.[27] Ruskin (1856a), for instance, made some barely disguised criticisms of Jameson in the third volume of *Modern Painters*, maintaining that much of the art Jameson extolled as full of sacred meaning was not genuinely sacred at all (64–65). Once we know Jameson's views, the reference to her is unmistakable, yet Ruskin does not mention her name.[28] Not only did men refrain from citing women, so did women themselves. In the work of our seven women, references to other women are few and far between. This complicates the attempt to reconstruct the intellectual relations amongst them.

The sparse use of references was the natural companion of the conventions of anonymity and pseudonymity: the author's name and the names of their reference-points were suppressed together. Our seven women made free use of these conventions. Barbauld used a mixture of signature, anonymity, pseudonymity, and initials. Baillie initially launched her plays anonymously, and a substantial proportion of Martineau's numerous journal contributions were anonymous or pseudonymous, especially during the 1820s. Dilke published anonymously when she could, failing that as the neutral 'E. F. S. Pattison' (Pattison being her surname by her first marriage), or even 'Mrs Mark Pattison'. She used 'Lady Dilke' (her second marital surname) only later, once she felt that her reputation was secure. Lee used her pseudonym almost without exception, although as early as 1878 the journal *Academy* found out that 'Vernon Lee' was a pseudonym and placed it in inverted commas, which became a widespread practice.[29] But Lee stuck with it,

[27] I have documented this pattern extensively before; see Stone (2023: ch. 1).
[28] On Ruskin's criticisms of Jameson, see Chapter 6, section 6.6.
[29] See VL to Mrs Jenkin, 18 December 1878, in Lee (2017: 244).

using the name 'Vernon' in private as well: she *identified* as Vernon Lee.[30] Even Cobbe and Jameson, who published much of their work signed, first launched themselves using anonymity, as Baillie had done. Cobbe's first book, the *Essay on Intuitive Morals*, was anonymous, as was Jameson's *Diary of an Ennuyée*—indeed, some readers were outraged to learn that the author had not pined away from melancholy as the diary portrayed, but was alive, well, and basking in her literary success (Thomas 1967: 36–37).

These conventions around names and references meant that these women made only very limited published reference to one another, more limited than the reality of their intellectual and personal connections might have predicted. Barbauld and Baillie were neighbours and good friends, and Barbauld did reference Baillie, notably in her visionary poem *Eighteen Hundred and Eleven* (Barbauld in McCarthy and Kraft 2001: 165, li 100–112). But Baillie did not refer to Barbauld when she theorized tragedy, although, I will suggest in Chapter 3, Baillie tacitly engaged with Barbauld's account of our sympathy for fictional characters. Jameson did occasionally reference Baillie (e.g., Jameson 1834: vol. 1: 285), with whom she became very close in the 1830s, but Jameson cited Barbauld scarcely at all. This belies the reality, which Jameson disclosed to Annabella Byron, that both Barbauld and Baillie were major influences on Jameson's aesthetics. For instance, in Jameson's letter to Byron about her formative reading, Jameson said that Barbauld's (and John Aikin's) *Evenings at Home* had shaped her 'perception of the beauty of natural objects', and 'pious feelings' (AJ to Byron (c.1841), in Jameson 1834–53: 38, 37). As Judith Johnston points out, Jameson's account to Byron contrasts revealingly with the published version, 'A Revelation of Childhood', in Jameson's 1854 *Commonplace Book*. The latter omits Barbauld outright and professes a deep love of Wordsworth, whom Jameson did not mention to Byron at all (Johnston 1997: 42–43). This confirms the gap between public and private writing, and our need to look at letters to fill out women's intellectual connections.[31]

Martineau was another friend of Baillie's, but an even more significant influence on her was Barbauld, who was (with Hannah More) the subject of Martineau's very first article, 'Female Writers on Practical Divinity' of 1822. This article shows that Barbauld's aesthetic essay 'Thoughts on the Devotional Taste' was a key influence on Martineau. In the 1830s, Martineau and Jameson also

[30] As Sally Newman explains: 'Vernon Lee was much more than a pseudonym; it was, as Lee's executor, Irene Cooper Willis, makes clear in the following [1951] letter, her chosen name and identification...: "I must ask you to call [the catalogue] the Vernon Lee issue. Except to mere acquaintances she was never known as Miss Paget: and she would have objected to being referred to as Violet Paget in connection with her writings and papers. She was always known and thought of by her friends and readers as Vernon Lee"' (Newman 2005: 51).

[31] When citing letters I include the details parenthetically, except when I'm citing more than one letter in quick succession. In such cases I put the details in footnotes, to avoid over-cluttering the text. The seven women protagonists are initialled for economy.

became friends, and their correspondence shows that they discussed philosophy intensely (see Erskine 1915: ch. 10; Macpherson 1878). As these letters document, they fell out in the 1840s and their different views of art and the emotions were a factor in this.

Cobbe, for her part, did not refer to Jameson when writing on art. But she had closely read Jameson's *Commonplace Book* (Mitchell 2004: 77), much of which concerned art, and Cobbe framed her account of beauty and religion in implicit contrast to Jameson. Dilke makes even less reference to the other women. Even her correspondence barely mentions other women theorists of art, and I have found only one reference to Jameson in her work, although Jameson would have been Dilke's main model of a woman writing ambitious large-scale works on art. Still, the reference confirms that Dilke knew Jameson's work. This is hardly surprising, given Jameson's standing and the fact that Dilke's second husband, Charles Dilke, was the grandson of the Charles Wentworth Dilke who had edited the journal the *Athenaeum,* steered it to prominence, and serialized there the first instalments of Jameson's major book series *Sacred and Legendary Art*.[32] For Emilia Dilke, Jameson's *Sacred and Legendary Art* was 'important and ambitious' but 'sentimental and not scientific' (Dilke 1870a: 636). Dilke thus wanted to study art differently from Jameson and to treat art 'scientifically': as the outcome of material processes of production, rather than as an expression of ideas and feelings.[33]

Dilke was completely silent about Lee, and reciprocally. Dilke and Lee moved in overlapping social circles in the 1880s, yet neither of them mentions the other in either their published work or their correspondence. This is frustrating, given their considerable common ground. Both Dilke and Lee embraced aestheticism for a while before qualifying it, they both celebrated the Renaissance as a period when art escaped from religious and moral strictures, and they were both at pains to distinguish their aestheticism from decadence and coarse sensuality. Yet if they knew one another's work, they did not say so. On the other hand, Lee knew Cobbe well, and they debated secularism in print. Even here, Lee engaged with Cobbe in the guise of dialogues between the fictitious 'Baldwin' (Lee's mouthpiece) and his (Cobbeian) interlocutors Vere, Agatha, and Michael. Lee thereby avoided actually mentioning Cobbe's name. Unsurprisingly as well, in view of Lee's early separation between art beauty and religion, she admired Martineau's later work after she had become a secularist. Having just read Martineau's *Autobiography*, Lee exclaimed: 'What a fine career, but what a feminine sort of masculine woman.... Miss Martineau was so strong a character... reading Miss

[32] Charles knew of the journal's record under his grandfather. In his 'Memoir' about it, Charles noted that Jameson had been one of the *Athenaeum*'s significant contributors, along with other women including Martineau (C. Dilke 1875: 71).

[33] My thanks to Kali Israel for very helpful conversations about Dilke and Jameson which have informed this book.

Martineau's chapters about the beginning of her fame ought to wake up and stir up to something' (VL to Linda Villari, 30 July 1879, in Lee 2017: 253–254). Lee also read Martineau's 1851 *Letters on the Laws of Man's Nature and Development*, her strong statement of atheism (co-authored with Henry George Atkinson) which aroused great controversy in its day.[34]

In contrast, Jameson was a figure from whom Lee pointedly distanced herself. Lee adopted her gender-neutral pseudonym to make plain that her aesthetic writing was *not* like that of 'Mrs Jameson':

> There is an universal and very well founded distrust in women's critical powers, they…have hitherto been such miserable…Mrs Jamesons on matters of art & art history, that the fact of a work on aesthetics being by a woman, is enough to…prevent my taking it up. I don't want people to take me for a man, but I don't want to unnecessarily thrust forward the fact of my being a woman. I wish to be the author of this and that, and no more…[35]

She added: 'Vernon Lee remains a perfectly abstract, impersonal, sexless creature',[36] unlike 'Mrs' Jameson, whose name, after all, indicated that she wrote as a respectably married woman.[37]

For Cobbe, Dilke, and Lee, Jameson was a figure to react against, so much so in Lee's case that anti-Jamesonism motivated her sexless persona. But Jameson remained important for these three, even if reactively. Jameson was thus the nodal figure amongst our seven women. She united the influences of the three earlier-century theorists, Barbauld, Baillie, and Martineau; and all three later-century figures—Cobbe, Dilke, and Lee—carved out their stances against her. Jameson's nodal status is no surprise. She was unavoidable, the best-known and most successful nineteenth-century woman to write on art.

To tease out the connections amongst these women I will use biographical and historical scholarship about their friendships and networks, as well as published and unpublished correspondence. Although women avoided referencing one

[34] The book is in Lee's donation to the British Library at Florence: see www.britishinstitute.it/en/library/the-archive/vernon-lee-collection.

[35] VL to Linda Villari, 11 September 1878, in Lee (2017: 240).

[36] VL to Linda Villari, after October 1878, in Lee (2017: 242–3). Lee also claimed to adopt her pseudonym because she was 'sure that no one reads a woman's writing on art, history or aesthetics with anything other than unmitigated contempt' (VL to Mrs Jenkin, 18 December 1878, in Lee 2017: 244). This remark is often noted—for a non-exhaustive sample, see Colby (2003: 2), Ferguson (2020: 43), Gunn (1964: 66), Maxwell and Pulham (2006: 9), Maxwell (2018: 283), Mitchell (2004: 266), Stone (2023: 181), Zorn (2003: 15). But Lee's remark cannot be taken at face value, given that women such as Jameson were well-known authorities and *not* obviously held in contempt. I will suggest an alternative explanation in Chapter 10 (note 12).

[37] In reality Jameson's marriage was a short-lived disaster. She lived separately from her husband, branding their union 'a real mockery of the laws of God and man' (AJ to Robert Jameson, February 1836, in Macpherson 1878: 108).

another in publications in the supposedly masculine 'public' sphere, letters were different, since they counted as 'private' (despite the ambiguity that letters were often circulated and read out in groups, and could leak to the press). Like Jameson's letters to Byron, or Lee's letter about 'miserable Mrs Jamesons', correspondence often tells a different story from published work: it discloses inter-women influences, and not always positive ones.

As we search for these women's mutual relations, we should bear in mind that they were well known in their day, and sometimes positively famous (as I shall chronicle later in their individual cases). They were not publishing little-read and obscure works that 'fell dead-born from the press' or were 'left to the gnawing criticism of the mice'.[38] They were big names, the equivalents of celebrated later intellectual women like Beauvoir or Hannah Arendt. This makes it inconceivable that, say, Dilke did not know Jameson's work, or that Jameson did not know Barbauld's work. It does not automatically follow that these women had painstakingly scrutinized one another's arguments. But they knew enough about at least some of the others to take up intellectual positions in relation to them.

1.7 Omissions

There are inevitably women whom this book does not cover. One is a writer whose thought on art has already received much more attention than her female contemporaries: George Eliot. Besides wider-ranging books on nineteenth-century aesthetics in Britain that include Eliot, there have been numerous studies of Eliot's conceptions of sympathy, the novel, realism, and more.[39] Since Eliot's thought has been so heavily scrutinized already, I have judged it important to shine the spotlight on figures who are less familiar today but were once as well known as Eliot. That said, I will briefly discuss Eliot's artistic differences from Martineau, although more for the light they shed on Martineau than on Eliot. My desire to foreground lesser-known authors similarly leads me to omit Mary Wollstonecraft, although she had an account of the imagination and she engaged critically with Edmund Burke's gendered conceptions of the beautiful (pleasing, small, feminine) and sublime (grand, powerful, masculine).[40]

However, there are other nineteenth-century women who wrote on art and who are even less familiar than my seven protagonists. Four of these lesser-known

[38] As Hume and Marx respectively said of their *Treatise of Human Nature* and *German Ideology* (Hume [1777] 1889: 2; Marx [1859] 2000: 246).

[39] For just a few examples, see Freadman (1985), Fulmer (2019), Loesberg (2001), Norton (1991), and Nünning (2015). Eliot is so comparatively popular because she survived into the twentieth-century canon as a novelist. She has never entirely disappeared, even though her philosophical background and contributions were overlooked for a long time.

[40] On these aspects of Wollstonecraft's thought, see Price (2023) and Reuter (2017). For Burke's gendered associations, see Burke (1757: 91, 98, 100–2).

authors are Maria Callcott, Mary Merrifield, Clementina Anstruther-Thomson, and Constance Naden. I have left them out of my narrative either because much of their writing on art was non-philosophical (as with Callcott and Merrifield), or because they did not write a great deal on philosophy of art (as with Naden, who authored only one essay on the topic), or a mixture of the two (Anstruther-Thomson).

None of those considerations apply to two other omissions: Elizabeth Eastlake and Sarah Stickney Ellis. Eastlake was at the centre of the Victorian art world and wrote voluminously on art. She completed Jameson's *Sacred Art* book series and was nearly as renowned for her art writing as Jameson herself. Like Jameson, Eastlake ranged widely over art history and art and literary criticism, interweaving general reflections with specific art-critical analyses. I have omitted her because the proportion of general philosophical reflection is relatively low: compared to Jameson's work, more of Eastlake's writing is empirical rather than conceptual. In addition, I find Eastlake less readable than such consummate stylists as Barbauld, Jameson, and Cobbe; some of Eastlake's writing is rather indigestible.

Ellis, too, wrote a substantial amount on art, and writings such as her book *The Beautiful in Nature and Art* (1866) are squarely philosophical. Indeed, *The Beautiful* was the only female-authored book included in Vladimir Price's eight-volume series of reissued works in nineteenth-century British aesthetics (Price 1999). Ellis is not in my main narrative, I confess, simply because I do not find her arguments in *The Beautiful* very rich theoretically, and I would struggle to say much about them.

A final factor in my omission of both Eastlake and Ellis is politics. Eastlake and Ellis were relatively conservative. Eastlake published heavily in the conservative *Quarterly Review*, sometimes adopting an unpleasantly vitriolic tone: 'Her stance on the matters of the day was…conservative' (Sheldon 2022: 449). Ellis wrote some very widely read conduct books, such as *The Women of England* (1839), treating 'the minor morals of domestic life' (7) as fundamental to England's national character and to the maintenance of its class system (14–15).[41] These political views were not incidental to their thought on art. For Ellis, the practice and study of art inculcated and reinforced women's domestic virtues, while one of Eastlake's best-known writings on art was a scathing and insulting critique of *Jane Eyre* which deeply upset Charlotte Brontë.

These reasons for omitting Eastlake and Ellis may seem to conflict with my earlier case for attending to all that women thought and wrote, not only their

[41] Ashley Carlson argues that in their context Ellis's writings count as progressive and even proto-feminist in places, and that Ellis (2011) has been unjustly demonized as an anti-feminist. Even so, Ellis's approach to enlarging women's sphere is very cautious in comparison with overt feminists like Jameson and Cobbe.

views on gender and political issues. But as I also argued, the goal of listening to historical women has feminist motivations, which means that there is a tension in attending to women who were unsympathetic to feminist projects or attacked other women. We can, of course, tease out and bring forward the more congenial elements of Ellis's and Eastlake's thought, but inevitably feminist and pro-woman authors such as Jameson and Cobbe are going to have a more straightforward appeal. It is easier to respond to their work with the enthusiasm needed for pushing these neglected figures forward into the present.

Still, despite their conservatism, I do not want to exclude Eastlake or Ellis completely, nor the other four neglected women I mentioned. Chapter 11 therefore provides a brief account of some of their main writings, ideas, and arguments. After all, it would be inconsistent to critique the exclusion of women from the canon without acknowledging that my narrative produces its own exclusions, and making explicit what some of these are. In this connection, it bears repeating that my seven women protagonists were all upper-class white women. Cobbe, for instance, was born into the aristocracy, and Dilke married into it, while the others were highly privileged as well. Jameson's position was the most complicated. Early in adulthood she worked as a governess, and later, after her estranged husband stopped providing her with any financial support and then cut her out of his will, she was given an annuity by her friends and a pension from the Queen (Macpherson 1878). Despite the financial instability Jameson experienced, the support she received shows how embedded she was within the social elite—after all, her close friend Annabella Byron owned a vast fortune. These women's material advantages allowed them to philosophize about art, through their informal education, social connections, access to books, freedom from material labour, travel opportunities, and their cultural association with taste and refinement. The conversation about art was not equally open to all women; it reflected the inequalities of the social world in which it took place.

In the rest of this book, I will move through the ideas of the seven women in chronological order. I devote a chapter to each woman, with two on Jameson because of the central and nodal position that she held. I hope that my discussions will arouse readers' interest in these forgotten figures, and will inspire others to read and engage with their work and ideas.

Women on Philosophy of Art: Britain 1770–1900. Alison Stone, Oxford University Press. © Alison Stone 2024.
DOI: 10.1093/9780198918004.003.0001

2

Anna Barbauld as a Philosopher of Art

2.1 Introduction

In the late eighteenth century, Anna Letitia Barbauld was famous. The Enlightenment philosopher Joseph Priestley rated her 'one of the best poets' in Britain, the French revolutionary Jean-Paul Marat wanted to marry her, and the young Samuel Taylor Coleridge walked forty miles to meet her and seek her literary advice.[1] She remained a household name throughout the nineteenth century, began to disappear as the century ended, fell into oblivion over most of the twentieth century, and was finally rediscovered from the 1980s onwards. Thankfully, she is now the subject of a definitive biography (McCarthy 2008), several books,[2] and numerous journal articles. Her writings now feature in anthologies of the Romantic period and narratives of the history of English literature.[3]

The same pattern—fame, rising then falling, twentieth-century oblivion, then twenty-first-century recovery—applies to most of the women discussed in this book. This challenges our usual assumption that women's intellectual life was suppressed in the nineteenth century until the twentieth century ushered in a welcome emancipation. On the contrary, this book will suggest that the *twentieth* century was when long-nineteenth-century women philosophers of art were erased.

I want to add to the recent recovery of Barbauld by rediscovering her as a philosopher of art.[4] I should, however, note one place where contemporary philosophers of art have already taken note of Barbauld: as a theorist of the sublime. This is based on the essay 'On the Pleasure derived from Objects of Terror', attributed to Barbauld in several anthologies (or rather to Aikin, as she was before marriage).[5] The complication is that this essay was probably written by Barbauld's brother John Aikin. The essay appeared in the collection *Miscellaneous Pieces, in Prose*, which both siblings signed. John assembled this collection, soliciting writings

[1] See Priestley (1806: 49), Ternant (1922: 53), Coleridge (1956: 341, n.1).
[2] See Clery (2017), James and Inkster (2011), Janowitz (2004), McCarthy and Murphy (2014), and Watkins (2012).
[3] See, e.g., Haekel (2017), Wilson and Haefner (1994), Stabler (2002), and Wu (2012: 34–54).
[4] I build on studies of Barbauld's aesthetics by Anne Mellor and Isobel Armstrong. According to Armstrong (2014), her aesthetics centred on the 'association of ideas, sympathy, the social, the sublime', and 'responsiveness of the sensoria to the empirical world' (79). For Mellor, Barbauld saw literature as educating us in how to balance reason and feeling, mind and heart (Mellor 2002: ch. 4). See also Schurch (2022) on how empiricism influenced Barbauld's poetic practice.
[5] Namely Clewis (2019), Norton (2000), Parisot (2020), and Sandner (2004).

from Anna and adding some of his own (see McCarthy 2008: 111). John and Anna Aikin were content to put their names to this joint work without advertising who authored which parts, and they 'made no effort in their lifetimes publicly to identify who wrote what' (Krawcyzk 2009: 30). Nonetheless, we have evidence about who wrote which pieces from John's and Anna's annotated original manuscript copies and the assignments made by Barbauld's niece Lucy Aikin when she edited the 1825 edition of Barbauld's works, as William McCarthy explains (2008: 583).[6] These sources indicate that John wrote the terror essay. For this reason, I shall not discuss this essay here.

When exploring Barbauld's philosophy of art, we should bear in mind that she was not exclusively a philosopher. In her day, one could still speak with authority while writing in multiple genres, as she did: she crossed poetry with prose, fiction with non-fiction, and ranged over literary criticism, politics, education, philosophy, and religion. If Harriet Martineau was present, a generation later, at the birth of what would subsequently become distinct academic disciplines (see Sanders and Weiner 2017), Barbauld wrote even before this. So, although a significant amount of her work concerned art and aesthetics, she was not a philosopher of art in the modern sense of a professional philosopher specializing in aesthetics (and nor were the other women covered here). Instead, Barbauld was a versatile all-round writer and intellectual, and an accomplished prose stylist—like many of her rough contemporaries whom we now remember as philosophers, such as Mary Wollstonecraft or Edmund Burke.

Readers might ask why Barbauld features in a book that is largely about the nineteenth century. After all, even taking the nineteenth century in the 'long' sense, that is, as beginning with the French revolution in 1789, some of Barbauld's most significant writings on aesthetics came out well before this. And though she continued writing into the 1810s, and her works edited by Lucy Aikin came out in 1825, the 1760s and 1770s were her formative decades, so that McCarthy calls her 'the voice of the Enlightenment'. Nonetheless, Barbauld belongs here for several reasons. Her work had a huge nineteenth-century influence, especially through her category of devotional taste. She linked aesthetics and religion through the idea of devotion, and this proved decisive for the subsequent century. In addition, her collection *The British Novelists* helped to establish the novel as a legitimate art-form and was 'one of the instituting moments in a history of the British novel' (Johnson 2001: 167). Finally, Barbauld stands at the start of a continuous series of women who engaged with one another on art over the course of the nineteenth century.

Barbauld's thought went through several distinct stages. It is worth setting these out, in order to contextualize her views on art and, more broadly, to

[6] Further evidence that Barbauld did not author the terror essay comes from Grace Ellis, whose information came partly from Lucy Aikin (Ellis 1874: 50–2).

indicate how the optimism, rationalism, and political energy of the late eighteenth century transitioned into the religious, historical, and moral seriousness of the Victorian era.

2.2 Stages on Barbauld's Way

Barbauld was born Anna Aikin in Leicestershire, to a family that was at the heart of religious Dissent in Britain. Her father, John Aikin senior, was an Arian: he did not consider Jesus Christ to be fully divine (Wykes 2011: 32). This unorthodox view left him few career options, despite his distinguished theological background, so he ran a Dissenting academy for boys from the family home. This meant that although Anna was only informally educated, her education still covered Latin and Greek, the Bible, the classics, English literature, French, and Italian.

In 1758, her father became tutor in languages and literature at the Warrington Academy, a leading Dissenting school and intellectual centre whose atmosphere was formative for Anna. Joseph Priestley taught there from 1761–67, becoming a close family friend and a major influence on and admirer of Anna. Initially a fellow Arian, Priestley came to the stronger view that Jesus, though morally exemplary, was not divine at all (see Priestley [1783] 1812). Priestley thereby became a Unitarian, rejecting the doctrine of the Trinity. He also gave Unitarianism a pronounced Enlightenment orientation. For Priestley, nature follows invariant laws laid down by God. By learning about nature's laws and workings, we are understanding God's will: faith, reason, science, and freedom of inquiry all go together. This Enlightenment form of Unitarianism went on to be very influential.

In 1773 Anna's *Poems* were an overnight success, swiftly followed by the collection co-authored with her brother John, *Miscellaneous Pieces in Prose*. Two of its essays on aesthetic topics, Barbauld's 'On Romances' and 'An Enquiry into those Kinds of Distress which Excite agreeable Sensations', will be discussed in Section 2.3. Barbauld consolidated her reputation in 1775 with *Devotional Pieces*, a selection of Psalms prefaced by 'Thoughts on the Devotional Taste, on Sects, and on Establishments', in which she put forward a new aesthetic category, the *devotional*, examined in Section 2.4.

By then Anna had married a Warrington Academy graduate, Rochemont Barbauld. When he became head of the Palgrave Academy for Anglican and Dissenting boys in Suffolk, Anna shared in the school's teaching and management. This role, as well as her adoption of John's son Charles, motivated her to write for children. She brought out the four-volume series *Lessons for Children* (1778–79), then *Hymns in Prose for Children* (1781), then the six-volume collection of stories, poems, and dialogues *Evenings at Home* (1792–96), co-authored again with her brother John.

These children's writings hugely influenced nineteenth-century culture. At one point, nearly every better-off household owned a copy of *Evenings at Home*, according to the later nineteenth-century children's author Mary Molesworth (see Hahn 2015). Harriet Martineau attested: 'In those days we learned Mrs Barbauld's Prose Hymns by heart' (1877: vol. 1: 34). Barbauld's children's writing put the category of devotional taste into practice.[7] Along this route, her category helped to shape the aesthetic tastes of nineteenth-century Britons. This is another reason why our account of nineteenth-century women's thought on art must begin with Barbauld.

In the 1790s, by which time the Barbaulds had left the Academy and moved to London, Barbauld turned to politics. This was an intensely political decade: America had won the war of independence; the French revolution was underway; a conservative reaction against the ideals of the French and American revolutions was also underway; and in 1793 England and France went to war. The conservative reaction ushered in a new hostility to Dissenters, expressed in the 1791 Church and King riots, with Priestley's house burnt down over his support for the French revolution. Courageously, Barbauld began to defend religious toleration and freedom of religious thought, in pamphlets with such signatures as 'A Dissenter' and 'A Volunteer'. She declared herself against slavery, criticized fashion as a system of despotism, and reflected on education and prejudice in anonymous articles in *The Monthly Magazine*, a journal her brother had founded.[8]

During the 1800s, Barbauld's orientation changed again, as she became interested in the flourishing new genre of the novel. In 1810, she edited a massive and influential fifty-volume selection of British novels, discussed in Section 2.5. Besides introducing each novelist, she prefaced the set with the essay 'On the Origin and Progress of Novel-Writing', tracing the history of the novel, defining its canon, and defending it as a legitimate art-form.

Barbauld's final phase was a turn to history, expressed above all in her visionary poem *Eighteen Hundred and Eleven*, published in 1812. I will not discuss it at any length here (nor Barbauld's political writings), but it reflects the nineteenth-century turn to history.[9] Barbauld (in Kraft and McCarthy 2001) portrayed a

[7] On how the devotional aesthetic underpins these works, see, e.g., Krawczyk (2009: 35).

[8] As explained in Chapter 1, anonymity was standard for prose writing in journals at this time, for men and women alike. The *Monthly Magazine*, founded in 1796, was edited by John Aikin until 1806 and continued publication until 1843, featuring many Romantic writers and the earliest published fiction of Charles Dickens. During Barbauld's political period, she continued to write on aesthetic topics, but since I lack space to cover everything, I shall not discuss her prefaces to Mark Akenside's didactic poem on the *Pleasures of the Imagination* (Barbauld 1795) or to the poetic works of William Collins (Barbauld 1797b).

[9] An excellent full-length treatment of the poem is Clery (2017); on Barbauld's political writings, see McCarthy (2008: chs. 12–14).

Spirit moving through a series of historical civilizations, leading first one then another to the fore:

> There walks a Spirit o'er the peopled earth,
> Secret his progress is, unknown his birth... (169, li 215–216)

Barbauld did not see Spirit's movement as culminating in modern Europe. For her, the incessant wars amongst European nations, and their complicity in colonization and slavery, showed that they were on the wane, in Britain especially. Barbauld (in McCarthy and Kraft 2001) foresaw Spirit draining out of Europe and rising in South America.

Barbauld gave Joanna Baillie a prominent place in history:

> Then, loved Joanna, to admiring eyes
> Thy storied groups in scenic pomp shall rise;
> Their high soul'd strains and Shakespear's noble rage
> Shall with alternate passions shake the stage....
> The tragic Muse resume her just controul,
> With pity and with terror purge the soul.
> While wide o'er transatlantic realms thy name
> Shall live in light, and gather *all* its fame. (165, li 101–112)

For Barbauld, Baillie's tragedies expressed the potency of Spirit in Britain in the late 1790s, at the turning of the tide, after which Britain had degenerated into a corrupt, militaristic society from which Spirit was ebbing away.

Across Barbauld's varied interests, then, art and the aesthetic were a constant strand—from her early essays, to her applied devotional aesthetic in her children's writing, to her theory of the novel, to her final poetic speculation on world history. I will begin our more detailed examination with her early essays.

2.3 Barbauld's Paradox of Fiction

Many of the essays in the 1773 collection *Miscellaneous Pieces, in Prose* concerned questions in aesthetics. These included, by Barbauld (or rather Anna Aikin): 'On Romances, an Imitation', and 'An Enquiry into those Kinds of Distress which Excite agreeable Sensations, with a Tale'; as well as 'On the Province of Comedy' and 'On the Pleasures derived from Objects of Terror', by John.[10]

[10] Barbauld did not asterisk 'On Romances' as hers in her annotated copy of the *Pieces*, but John so marked it in his copy and Lucy Aikin attributed it to her, so the balance of evidence suggests it is hers.

'On Romances' and the 'Enquiry' both tackle an apparent paradox in our relation to fiction. In real life we feel distressed when other people suffer, since we are social beings who naturally sympathize with one another. Yet when reading fictional works, we encounter suffering characters and we enjoy reading about their trials. Barbauld sets out to make sense of this 'paradox of the heart' (Aikin and Aikin 1773: 44). It is not the same as the paradox of fiction, as it has become known since Radford (1975): that is, why we care about fictional characters although we do not believe that they are real. Barbauld's paradox is much closer to the 'paradox of tragedy', as it is now called: why do we enjoy watching tragic protagonists suffer, when normally we do not like to see other people suffering? Barbauld considers this apparent paradox with regard not to tragedies but 'romances'. Though she would later distinguish pre-modern romances from modern novels (Barbauld 1810: 3–10), in these earlier essays she uses 'romance' indifferently for both.

In 'On Romances', Barbauld first notes people's many reasons for enjoying romances: they are interesting, do not call for specialist knowledge, deal with 'passions which all have felt', and 'it is...no ways extraordinary that the mind should be charmed by fancy, and attracted by pleasure' (Aikin and Aikin 1773: 42). However, given our sympathetic nature, we should expect tales of people's misery to distress us. Why do we 'listen to the groans of misery, and...choose to fill the bosom with imaginary fears, and dim the eyes with fictitious sorrow?' (44)

Barbauld was far from alone in tackling this paradox, to which many British and French authors before her had ventured solutions. The issue was 'a preoccupation for writers through the end of the eighteenth century', as Timothy Costelloe observes (2013: 46). For David Hume ([1757] 2017), the pain of seeing characters suffer was converted into pleasure by our enjoyment of the artistic imitation. Barbauld does not discuss Hume's solution, but she appears to reject Joseph Addison's hypothesis, put forward in 1712, that we take pleasure from 'the secret Comparison which we make between ourselves and the Person who suffers' (Addison, Steele, et al. 1945: vol. 3: 298). Or, as Barbauld expresses that view, reading about fictional sufferings reconciles us to our own problems, as we see imaginary characters undergoing worse (Aikin and Aikin 1773: 44). She does not spell out quite why she disagrees, only that she finds 'yet deeper refinement' in the alternative hypothesis that we 'feast upon the consciousness of our own virtue' in commiserating with the characters. That is, their sufferings call on our sympathy, and since sympathy is a virtue, we thereby gain a pleasing awareness of our own virtue. Yet this 'reduces the sympathetic emotions of pity to a system of refined selfishness', which gets human psychology wrong. For in reality, when reading a romance we are lifted out of ourselves and our selfish preoccupations drop away: 'So far from being indifferent to the miseries of others, we are, at the time, totally regardless of our own' (45). Having undermined both the first and second hypotheses, the essay abruptly ends, leaving the problem unsolved.

Whereas 'On Romances' was short and purposefully slight, Barbauld enlarged on her solution to the paradox in the 'Enquiry into those Kinds of Distress which Excite agreeable Sensations'. Taking novels rather than long-form poetry or drama as her focus, she criticizes sensationalist fiction-writers who shore up readers' flagging interest over a long work by heaping misery upon misery upon their hapless protagonists (Aikin and Aikin 1773: 191–192). She was perhaps thinking of Samuel Richardson's *Clarissa*, the archetypical novel in her eyes. These tales of woe seem to arouse and gratify our cruelty and spite so that, since these feelings ought not to be indulged, such tales should be neither written nor read.

However, Barbauld argues, really narratives of this kind appeal to our better nature (194–195). What we enjoy in tales of woe is feeling sympathy for a fellow-being (195); we enjoy this because we are naturally sociable and sympathetic. Here Barbauld is very close to Burke (1757),[11] who, rejecting both Hume's and Addison's solutions to the paradox, instead holds that our pleasure comes from the exercise of our powers of sympathy and fellow-feeling: 'pity is a passion accompanied with pleasure, because it arises from love and social affection' (24). Imitation, he argues contra Hume, has nothing essential to do with it, for we feel the same pleasure in witnessing a public execution as watching a tragedy: he imagines a theatre audience rushing out en masse to observe an execution next door (26). Their motivation is not ghoulishness, though, but the pleasure of feeling sympathy with the victim, a pleasure wisely implanted in us by God to ensure that we treat one another with benevolence.

Barbauld is at pains to make this position morally palatable, explaining that unfortunately the character's suffering is necessary because it is only when others suffer that our sympathy for them is aroused. This is why she concludes with a faux-Greek fable in which Jupiter commands Love to marry Sorrow and their union produces Pity, in whom 'the sullen and unamiable features of her mother were so mixed and blended with the sweetness of her father, that her countenance, though mournful, was highly pleasing' (Aikin and Aikin 1773: 217). The suffering of a fictional character (Sorrow) is necessary for sympathy (Pity), though the sympathy is pleasurable not due to the sorrow that prompts it but because it embodies sociability (Love).

Isn't this the very solution Barbauld previously rejected, that we enjoy sympathizing with suffering characters because it assures us that we are virtuously sociable? Not quite: for Barbauld, we enjoy feeling sympathy with others, *not* any derivative awareness of our own virtue as sympathizers. But her solution, just like Burke's, has a different problem. The solution applies generally; not only to fictional cases. It suggests that if I feel sympathy for a homeless person on the street

[11] On Burke's influence on Barbauld in this period, see McCarthy (2008: 112, 155).

(for instance), this arousal of my powers of sympathy will give me pleasure. Burke (1757) frankly accepts this conclusion (see, for example, 27), and yet it is repellent. The problem could be avoided if weight were placed on the fictional status of the suffering characters, but Burke, as we have seen, denied that imitation was a factor.

However, on closer inspection Barbauld does deviate from Burke by building in the fictional status of the characters. She does this indirectly, through a series of restrictions that she imposes on what kind of characters can properly arouse our sympathies. We can only sympathize with those whom we find virtuous, she says (Aikin and Aikin 1773: 196), so fiction ought not to elicit our sympathy for unjust and wicked individuals. Neither can we sympathize with someone perfect:

> Pity seems too degrading a sentiment to be offered at the shrine of faultless excellence. The sufferings of martyrs are rather beheld with admiration and sympathetic triumph than with tears; and we never feel much for those whom we consider as themselves raised above common feelings. (208)

Nor can we sympathize with people who are physically unattractive or disabled: 'Deformity is always disgusting, and the imagination cannot reconcile it with the idea of a favourite character' (202). The characters may not be poor or working-class:

> Poverty, if truly represented, shocks our nicer feelings; therefore whenever it is made use of to awaken our compassion, the rags and dirt, the squalid appearance and mean employments...must be kept out of sight, and the distress must arise from...the shock of falling from higher fortunes. (Aikin and Aikin 1773: 203)

Finally, the characters should not be depicted undergoing physical harms or brutal, coarse shocks. Their distresses should be of a more subtle and emotional nature (196–198).

All these restrictions apply, for Barbauld (1775), because the purpose of novels is to *refine* and cultivate our sympathies, by leading us to sympathize with nuanced and complex plays of emotions in characters' lives (similarly, in her 'Thoughts on the Devotional Taste' (1775) she praises devotion for 'powerfully refin[ing] the affections from every thing gross, low, and selfish' (24)). This is why we should not be led to sympathize with characters suffering from squalor and miserable poverty, or brutal physical harms or pains, or dramatic shocks. Barbauld's claims here shift across descriptive and normative registers. Sometimes she says that our sympathies just *do not* extend to poor people, so fiction will be ineffective if it attempts this extension. At other times her point is more that fictions *ought not* so to extend our sympathies because it coarsens rather than

refines us. It leads us to feel sympathy only for immediate physical harm and distress, rather than educating us about more subtle affairs of the heart.

These points indicate a second source of our pleasure in the sufferings of fictional characters: the pleasure of having our sympathies educated. We enjoy sympathizing because it is in our nature, and we also enjoy having our sympathies refined because we are all perfectible by education and we enjoy being educated and improved. For Barbauld the latter source seems ultimately to trump the former: we may enjoy sympathizing, but, even more, we prefer (or ought to prefer) cultivated sympathizing, having our feelings exercised *and* educated at the same time.

This last point demarcates Barbauld from Burke, and it pertains to the characters' fictional status, for in real life one cannot readily keep sympathy within boundaries. We are liable to encounter and sympathize with people who are morally flawed, or in severe economic distress or ill-health. The novelist, in contrast, can control what excites the reader's sympathy and ensure that it is always being educated and refined at the same time. Thus, Barbauld says, 'fictional distress must be managed to render it pleasing' (210). This explains why it is only fictional characters whose sufferings give us pleasure. We may sympathize with people who are suffering in real life, but we do not enjoy it because our sympathies are not thereby undergoing the carefully controlled cultivation and refinement which only fiction provides.

Yet the consequence of this difference between fiction and real life is to limit fiction's moral power. Barbauld bites this bullet, again departing from Burke, for whom tragedy has more emotional and moral power 'the nearer it approaches the reality, and the further it removes us from all idea of fiction' (Burke 1757: 26). On the contrary, Barbauld argues that fiction should be at a remove from reality and is therefore morally limited, in two ways.

First, because fictional sufferings give us pleasure, we do not feel any motivation to act to alleviate them. This spills over and encourages us not to act to assuage other people's suffering in real life either (Aikin and Aikin 1773: 210–212). Here Barbauld differs from what would become a huge trend in nineteenth-century thinking about literature: that the moral virtue of fiction is to expand our sympathies for fictional characters, leading us to act more benevolently towards real-life people as well. As we will see in Chapter 4, both Harriet Martineau and George Eliot took that view, as did others like Elizabeth Gaskell and Charles Dickens. In contrast, Barbauld suggests that fiction's moral virtues have been over-egged. Actually, fiction cultivates passivity rather than activity in the face of suffering.

Second, 'the objects of pity in romance are as different from those of real life as our husbandsmen from the shepherds of Arcadia' (213). That is, the fiction writer must circumscribe the reader's sympathy so that it only falls on virtuous, refined, idealized characters, and so fiction encourages readers to form

similarly limited sympathies in reality. We will only sympathize with people of ideal virtue, who are rare in real life. Moreover, readers will learn to see the minor slights and aggravations amongst the upper class as deserving greater sympathy than the pervasive misery faced by poor working people. These patterns of partial sympathy are endemic to fiction, according to Barbauld. Relevant here is a short journal article from 1797 by 'Solomon Sympathy', whom McCarthy convincingly shows was Barbauld (McCarthy 2015: 236). She argues, tongue-in-cheek, that philosophers have neglected the accumulated misery of small everyday dissatisfactions suffered by 'persons of distinction', meaning the upper classes. 'How many are cut to the heart to reflect...that the brilliant assemblage of persons of fashion which they were prevented from joining, may never meet again?' (Barbauld 1797a: 96).

Barbauld's view of the moral limitations of fiction has purchase. Consider the following passage from Mary Elizabeth Braddon's ([1862] 1998) best-selling sensation novel *Lady Audley's Secret*:

> The shabby room, the dirt, the confusion, the figure of the old man, with his grey head upon the soiled tablecloth, amid the muddled debris of a wretched dinner, grew blurred before the sight of Robert Audley as he thought of another man [Sir Michael Audley, whose wife, unknown to him, is a bigamist], as old as this one, but, ah, how widely different in every other quality! who might come by and by to feel the same, *or even a worse*, anguish...(136; my emphasis)

In short, the emotional suffering of a hugely wealthy baronet when he learns that his wife is not legally married to him is worse than an old man's year-on-year experience of grinding poverty, deprivation, and failing health. If these partial sympathies make *Lady Audley's Secret* morally flawed, they also explain its success and power as a work of fiction, from Barbauld's perspective. For her, fiction-writers may cover ill-health, poverty, and unrelieved misery but then they will cease to provide the carefully controlled and cultivating exercise of sympathy that gives the greatest enjoyment. The enjoyability constraint limits the moral potential of fiction.

2.4 Devotional Taste: Religious Aesthetics, Aesthetic Religion

In 1775 Barbauld published the signed essay 'Thoughts on the Devotional Taste, on Sects, and on Establishments'. It introduced a new aesthetic category, the *devotional*. The devotional does not usually appear on recent lists of aesthetic categories: the sublime, beautiful, picturesque, grotesque, tragic, comic, horrific, and so on. But this absence should not blind us to the great influence that Barbauld's category had on nineteenth-century culture and aesthetic tastes. If her

conception of refined sympathy was very much of the Enlightenment, her category of devotional taste looked ahead to Victorian religious intensity.

Barbauld's immediate precursor in theorizing devotion was Priestley, whose 1767 sermon 'On Habitual Devotion' she attended.[12] In the published version, Priestley urges his audience to cultivate habits of religious devotion: to train their minds and associations of ideas so that they see God everywhere and are ever mindful of his presence. Priestley's claims rest on his associationist theory of mind, taken from David Hartley. Associations of ideas are malleable, and so we can make our chains of association better warranted by, for instance, ensuring that the correlations between particular ideas hold reliably, across changing circumstances, and are not merely accidental. In this way we can educate our minds; perfectibility is a core part of Priestley's associationism.

On this basis, Priestley ([1782] 1820) holds that we can train ourselves to associate everything we perceive with God, by attaching the idea of God to all our other ideas, so that we 'habitually regard him as the ultimate cause, and proper author of everything you can see, and the disposer of all events that respect yourselves or others' (114–115). A person so trained 'sees God in every thing, and he sees every thing in God'. This has an emotional aspect, for Priestley encourages his reader to associate the idea of God 'with all the strongest emotions of your mind'. By affixing all emotions to the idea of God, 'your whole stock of devotional sentiments and feelings will be increased', for 'all those strong emotions…will coalesce with the idea of God' (116). Joy, hope, sorrow, disappointment, and so on, can all be associated with God, by seeing him as the source of our joy, or as a comforting presence when we are sorrowing. With practice, all the emotions can assume a devotional quality and become, in part, emotions *of* devotion.

Priestley does not say this to fan the flames of religious passion. On the contrary, he considers inflamed passions a danger to mental and social equilibrium. Converting the passions into devotional emotions *soothes* them. When we are sad, the comforting idea of God reduces our distress; if we feel grateful to God when we are joyful, this steadies and sobers our happiness (109–110). Priestley accordingly recommends 'devotional exercises' (114), in which we learn to regulate our passions by attaching the moderating idea of God to all of them.[13]

Priestley wants us to perceive God's hand everywhere, but he opposes religious zealotry. In his view, the religious zealot looks beyond the world, devaluing it for the kingdom to come, and cultivating excessive emotional fervour (119–120). Priestley's contrasting programme is to learn to see God *within* all the things of the world, including our own emotional fluctuations, however powerful. This

[12] The sermon inspired her poem 'Address to the Deity' (McCarthy 2008: 43, 75).
[13] Martineau developed this spiritual practice in her first book *Devotional Exercises*, signed 'by a Lady' (Martineau 1825). The title recalls Barbauld's *Devotional Pieces*; Barbauld greatly influenced Martineau, as we will see.

gives us confidence in the uniformity of God's workings, imparting something of their uniformity to our own minds and emotions (116).

Barbauld transforms Priestley's idea of devotion into an aesthetic category. To justify this, she states (drawing on John Gregory [1765] 1772: 210) that religion has three aspects: (1) epistemic, as a system of opinions, (2) moral, as a set of principles for regulating conduct, and (3):

> a taste, an affair of sentiment and feelings, and in this sense it is properly Devotion. Its seat is in the imagination and the passions, and it has its source in that relish for the sublime, the vast, and the beautiful...; rendered more lively by a sense of gratitude. (Barbauld 1775: 2)

This aesthetic aspect of religion has become neglected and is 'at a very low ebb', she laments (3). Both theologians and Enlightenment rationalists regard religion too narrowly in terms of truth, reason, opinion, and belief (under her several descriptions; 1–2, 6). But religion's aesthetic side is needed too, and our lives are impoverished without it.

This aesthetic side of religion is needed, according to Barbauld, because devotion underlies all exercise of poetic imagination and all refined enjoyment of art and literature. 'Those who want this taste, want a sense, a part of their nature. No one pretends to be a judge in poetry or the fine arts, who has not both a natural and a cultivated relish for them' (5) (that is, for devotional feelings). But why should devotion be needed for aesthetic appreciation or creation? Barbauld's answer is that devotion just *is* the mental movement to rise beyond sensory things to the spirit and to apprehend spirit as animating these things. Devotion is therefore integral to, indeed co-extensive with, the exercise of the imagination. Without devotion, in which we constantly link everyday things to God, we will never rise mentally beyond our immediate physical surroundings. 'There is a devotion… which assimilates man to higher natures, and lifts him "above this visible diurnal sphere"' (4). Thus in cultivating devotion, we cultivate our imagination, and without devotion, our imaginative powers will languish undeveloped. We will be merely 'the narrow-minded children of earth absorbed in low pursuits [who] dare to treat as visionary, objects which they have never made themselves acquainted with' (5). We will lack the imaginative capacities to appreciate and judge art and literature, or to recognize aesthetic qualities in nature. This is why devotion is necessary for aesthetic perception, appreciation, and judgement.

We may be unconvinced. Surely, we might think, we can imaginatively link two different empirical things—say, the perceived stain on Lady Macbeth's hand and the crime she urged her husband to commit—without having to ascend to a spiritual or divine level. Barbauld might reply that we see the physical stain as standing for Lady Macbeth's moral guilt, where guilt and conscience exist on a spiritual level, connected with God and the soul. More generally, for Barbauld, whenever we exercise the imagination to pass beyond some finite, given item to a

further meaning not itself directly given to the senses, we go from the natural to the supernatural, the sensory to the super-sensory—and this is an intrinsically devotional, or more broadly religious, movement. The religious dimension remains when we descend to perceive the supernatural in sensory things, as we then imbue them with spiritual meaning.

If aesthetic imagining is intrinsically religious, equally religion in its felt, emotional aspect is intrinsically aesthetic, because habits of devotion rely on the imagination, and they engage and affect our emotions. Conversely, theologians and philosophers 'represent the Deity in too abstracted a manner to engage our affections' (12). They raise God 'too high for our imaginations to take hold of,… [which] destroys the affectionate regard which is felt by the common class of pious Christians' (10). Trying to imagine a God conceived under the divine attributes of eternity, infinity, omniscience, and omnipotence, we fail: we can frame no concrete mental picture of what these attributes mean. We then feel as if God is utterly beyond our ken, which dispirits us and alienates us from religion.

We might wonder whether this God of the philosophers is sublime, for Barbauld says that in the struggle to imagine an infinite, eternal being 'our imagination cannot here keep pace with our reason' (12). This might sound like the Kantian sublime, but Barbauld's essay on devotion preceded Kant's Third Critique, and her understanding of the sublime and the beautiful drew from British sources,[14] such as Burke (see McCarthy 2008: 112, 155, 314) and, in particular, Shaftesbury.[15] Notwithstanding, if the philosophers' God is indeed sublime, that might in turn suggest that Barbauld rejects the sublime. In fact, though, she regards the sublime as an important part of a felt aesthetic religion, saying that the relish for the sublime is one source of the devotional taste (Barbauld 1775: 10–12). Whereas we try to imagine the philosophers' God and are simply defeated, when we experience God as sublime, our imaginations keep rising towards him, leaping ever higher *without* defeat.

Barbauld evokes this rising movement in her 1773 poem 'A Summer Evening's Meditation'. She ascends in thought from the stars low in the sky, to the upper sky spread across with stars, to the moon and planets, the depths of space, and onward 'To the dread confines of eternal night, / To solitudes of vast unpeopled space, / The deserts of creation, wide and wild' (Barbauld in McCarthy and Kraft 2001: 101, lines 93–95). It is God who draws her on: 'What hand unseen / Impels

[14] Barbauld had little relish for Kant or German Idealism, saying apropos of Germaine de Staël's *Germany* 'in…the German schools, there seems to be…a design to reinstate the doctrine of innate ideas, which the cold philosophy (as they would call it) of Locke discarded'. She preferred Priestley and William Paley, she added—in other words, the British empirical tradition (AB to Mr and Mrs Estlin, December 1813, in Ellis 1874: 288).
[15] Barbauld was undoubtedly influenced by Shaftesbury's evocation of the sublime in *The Moralists*, for she included the relevant sections in her anthology of writings for young women, *The Female Speaker* ([1811] 1824: 276–8), titling them 'Address to the Creator' and 'Apostrophe to the Sun'. In these passages Shaftesbury's (1709) character Theocles rises to an ecstatic sense of God as the 'sole-animating and inspiring power' behind all the workings of the universe (178–86).

me onward...Where shall I seek thy presence?' (lines 90–91, 101). Finally her soul sinks back down, but replenished, not defeated, having for a time drawn closer to God. In short, in the sublime side of devotion we ascend towards God, whereas philosophical abstractions inhibit ascension by suggesting that we can never imagine anything that comes near to God's infinity or eternity.

Having said this, for Barbauld (1775) the sublime is only part of devotion. As well as 'unbounded views' we need 'home views and nearer objects...not such a vast extensive range of country as pains the eye to stretch to its limit, but a beautiful well-defined prospect, [which] gives the most pleasure' (13). And so the soul that flew up through the depths of space returns 'and seeks again the known accustom'd spot, / Drest up with sun, and shade, and lawns, and streams, / A mansion fair and spacious for its guest' (Barbauld in McCarthy and Kraft 2001: 102, lines 114–116). Sublime feelings of awe, exaltation, and reverence should co-exist with closer feelings of trust and confidence in God's neighbourly presence. Devotion thus unites the sublime—going upwards from the finite to God—with the beautiful—going downwards to the finite things in which God dwells.

In the second half of her essay on devotional taste, Barbauld appears to move away from aesthetics to offer some proto-sociological reflections on sects *versus* establishments (1775: 26–39). Dissenting sects are relatively devout and passionate, having to vindicate their beliefs in the teeth of outside opposition (27). Established churches make fewer demands and, to command attachment in the absence of deep feeling, they offer pomp, splendid buildings, and rituals (33). They foster superstition, whereas sects foster enthusiasm (35). The ideal, for Barbauld, is an attitude of devotion midway between the two, warmer than establishments and less fevered than sects.[16]

This shows how Barbauld's religious typology hangs together with her devotional aesthetic. Presently, she thinks, there is too little emotion in religion; but how can we have greater emotional warmth without sectarian zeal? Devotion is the answer, because in it we do not merely move rapturously beyond the world but also perceive God's regulating, steadying presence everywhere in the world (40).

Like Priestley, then, Barbauld sought the mid-point between an excess and a deficiency of religious emotion. Yet he warned her that she had leaned too far towards excess:

> No person can have practical religion much at heart, who has not a value for religious truth....Those who are indifferent to religious truth...have the least of a devotional spirit. It gives me...much concern, that...a person of your acknowledged genius...should have...[adopted] a turn of thinking which is

[16] As Jon Mee (2003) says, 'for Barbauld, "devotion"...was...to negotiate the treacherous ground between enthusiasm and cold formalism' (174).

very seducing, and, I think, very alarming and dangerous...(Priestley to AB, Dec. 20, 1775, in Rutt 1831: vol. 1: 284–285)

Priestley was alarmed because Barbauld's opening premise was that religion's aesthetic, imaginative, emotional side was at a 'low ebb'—*not* that her compatriots were suffering from too much reason on the one hand and too much emotion on the other. Even if her account of sects and establishments implied as much, she spoke at the start of an excess only of reason. Moreover, her conception of devotion differed from Priestley's. For him, devotion regulates and quietens dangerous passions, whereas for Barbauld devotion not only soothes (the beautiful) but also arouses awe and reverence (the sublime).[17]

In accentuating the emotions more than Priestley, Barbauld was transitioning from Enlightenment to Romantic aesthetics. Her view that the imagination couples the finite and the infinite resonates with Romanticism, recalling Meyer Abrams' (1971) famous capsule phrase for British Romanticism (taken from Thomas Carlyle), 'natural supernaturalism': 'the general tendency to naturalize the supernatural and to humanize the divine' (68). This migration towards Romantic aesthetics was one way that Barbauld's essay had an influence; another was her privileging of devotional feeling over theological doctrine. As Julie Melnyk (1998) has shown, nineteenth-century women often used devotional writing to tackle religion without trespassing on the male territory of the treatise. Barbauld's essay illustrated and vindicated this move. Her union of religion with aesthetics served women well, since women were becoming associated not only with sensibility and taste but also with practical piety. Barbauld's devotional aesthetic gave reassuring confirmation that in judging, consuming, and even producing art and literature, women were exercising the same imaginative powers that supported and depended on religion. This was, to be sure, the 'acceptable Barbauld' (Clery 2017: 7), the Barbauld who spoke to Victorian religious concerns. But we should not judge this too dismissively. Religion was very important to many nineteenth-century Britons, and we should approach their ideas with an open mind.

An even bigger way that Barbauld's essay had an influence was through her subsequent application of the devotional aesthetic in her writing for children, as I mentioned earlier. In 1778 and 1779 she published the anonymous *Lessons for Children*, a set of age-graded reading books. The idea of books *for* children, adjusted to their level, was a radical novelty. The books started with very simple words and gradually added longer ones. The words were addressed by a mother to her son, specifically 'Charles', Barbauld's son. The subject-matters were homely objects, animals, and natural phenomena such as the seasons. The books led the

[17] Martineau (1877) appreciated these two sides of devotion, saying of Barbauld's Hymns that 'there were parts of them which I dearly loved, but other parts made me shiver with awe' (vol. 1: 34).

child's mind up from these things towards God, while reciprocally showing God always at hand in what is most familiar and comforting—devotion in its two-fold movement.

Barbauld's 1781 *Hymns in Prose for Children* continued the same pattern. As she said in the preface, she intended the *Hymns* 'by deep strong and permanent associations, to lay the best foundation for practical devotion in later life' (Barbauld in McCarthy and Kraft 2001: 238). The hymns move through the cycle of seasons. For example, in high summer:

> The cattle can lie down to sleep in the cool shade, but we can do what is better; we can raise our voices to heaven; we can praise the great God who made us. He made the warm sun, and the cool shade…We need not raise our voices to the stars, for he heareth us when we only whisper…He that filleth the heavens is here also. (246)

Unlike cattle, we can raise our minds from slumber and sensations to the God who made us. But, after all, we need not leap utterly beyond nature, making a noisy sectarian clamour, for God 'is here also', so close that he can hear us whisper.

These writings for children spawned countless imitations. Generations of schoolchildren used them to learn to read (see Lim 2019). Indeed, by 1869, Charlotte Yonge estimated that 'three-fourths of the gentry of the last three generations have learnt to read' using Barbauld's books (Yonge 1869: 234). Frances Power Cobbe, for one, learnt to read using Barbauld's *Lessons for Children*, alongside writing by Sarah Trimmer and Jane Taylor (author of 'Twinkle, Twinkle, Little Star'), both of whom Barbauld had influenced (Mitchell 2004: 29–30). Barbauld's devotional aesthetic thus had a much wider influence than if she had articulated it in philosophical essays alone.

To sum up, Barbauld's concept of devotional taste united religion and aesthetics. Within aesthetics, it combined the sublime (the ascending movement beyond finite things towards God) and the beautiful (the descending movement to apprehend God in the finite world). Barbauld saw the imagination as central to aesthetic experience and maintained that imagination and religiosity were co-dependent and virtually co-extensive. But if the imagination was intrinsically religious, reciprocally the religion in question was already aesthetic. It was not a matter of theological doctrine but an emotional and imaginative attitude of devotion that, ideally, should animate our everyday lives.

2.5 Barbauld, the Novel, and the Canon

In 1810, Barbauld edited the fifty-volume anthology *The British Novelists*. It was not the first attempt to demarcate a national canon of novels; there had been

at least three precursor anthologies. But Barbauld's collection 'was the first...to make comprehensive critical and historical claims' (McCarthy and Kraft 2001: 375).

These canons were being formed because the novel was booming, and critics had to engage with it. Between 1770 and 1800, the number of new novels published annually doubled from around forty to eighty. That number held steady until 1830, with novels usually having print runs of 500–750 copies (Garside 2000: 38–39; Raven 2000: 26–27). Most novel-readers were women, who also overtook men as a proportion of authors after the 1780s. Whereas 60% of identified novelists were men up until the 1770s, women's share gradually rose, so that from 1800–30 52% of identified novelists were women (Garside 2000: 72; Raven 2000: 48–49). Thereafter women's share remained largely constant (Underwood et al. 2018) until the closing decades of the nineteenth century, when it fell sharply (see Gupta 1996).[18]

The rise of the novel was attended by a growing anxiety that novels were low-quality and morally degrading, especially to young women. Barbauld (1810) begins her long, signed introduction to *The British Novelists*, 'On the Origin and Progress of Novel-Writing', by addressing these moral anxieties: 'A Collection of Novels has a better chance of giving pleasure than of commanding respect.... It might not perhaps be difficult to show that this species of composition is entitled to a higher rank than has been generally assigned it' (1). Yet her ensuing statement of the grounds for its 'higher rank' is ambiguous:

> To measure the dignity of a writer by the pleasure he affords his readers is not perhaps using an accurate criterion; but the invention of a story, the choice of proper incidents, the ordonnance of the plan, occasional beauties of description, and above all, the power exercised over the reader's heart by filling it with the successive emotions of love, pity, joy, anguish, transport, or indignation, together with the grave impressive moral resulting from the whole, imply talents of the highest order, and ought to be appreciated accordingly. (2–3)

That is, one might think that a novel must do more than merely please, but actually pleasure *is* the right criterion for assessing the novel, once we analyse the features that arouse pleasure: inventiveness, skilful design, beautiful description, emotional power, and the way these features convey a moral message. We need not ask more of the novel than pleasure, because pleasurableness anyway depends on a complex of artistic and aesthetic qualities, including moral meaning.

[18] A complication is that many novels were anonymous: 72% in the late eighteenth century and around 50% in the early nineteenth century, a further proportion being pseudonymous (Raven 2000: 42, Garside 2000: 66). I therefore say 'identified' novelists, including those who have been identified retrospectively. If we assume that women were more likely than men to publish anonymously, then their share of the output would be higher.

Barbauld defends this thesis by first tracing the history of the novel and identifying some of its formal properties, although her principal concern is with the moral features that these properties embody (Moore 1986: 387). The novel, she argues, emerged out of the earlier 'romance', defined as a fictitious adventure in prose (Barbauld 1810: 3). Having travelled from Persia to the Gothic world (3–8), the romance fused with medieval chivalry in the Arthurian legends and tales of the Crusades (9–11). Cervantes shattered these romantic illusions and initiated a process in which the depiction of present-day reality gradually prevailed over heroism and exalted sentiment (14–15). This turn to reality defined the eighteenth-century novel: 'A good novel is an epic in prose, with more of character and less (indeed in modern novels nothing) of the supernatural machinery' (3). The modern novel's hallmark is realism; this distinguishes it from earlier romances.

Yet the modern novel is not entirely realistic. Real life involves a 'chance-medley' of events with no overarching pattern, whereas a novel is a structured whole 'in which the fates and fortunes of the personages are brought to a conclusion'. Vice is shown defeated and virtue rewarded (55). Real life offers no such proportioning of happiness to virtue. Furthermore, fictitious characters exhibit stronger emotions in constant succession than real people; the novel's emotional temperature is raised compared to ordinary life (53). The combination of heightened emotions and narrative structure makes novels interesting, whereas much of real life is boring, dreary, and humdrum (54–55).

These features of the novel established, Barbauld returns to 'the end and object of this species of writing'. People often defend the novel on the grounds that it advances serious moral truths in an appealing fictional wrapping. But she declares:

> For my own part, I scruple not to confess that, when I take up a novel, my end and object is entertainment; and as I suspect that to be the case with most readers, I hesitate not to say that entertainment is their legitimate end and object. (46)

Entertainment is a legitimate end, indeed a good, she explains, because we are often burdened with troubles. Reading about fictitious adventures relieves us, taking us out of ourselves and temporarily removing us into an imaginary domain. The novel 'wins the attention' away from distress, and 'make[s us] forget the subject of [our] own complaints'. Novels comfort us as they 'distribute, like a ruling providence, rewards and punishments which fall just where they ought to fall' (47). Entertainment is a good, then, because when reading novels we entertain imagined possibilities different from the mostly unsatisfactory, distressing, tiresome, and imperfectly just realities of our everyday lives. So the novel needs no exalted moral purpose to give it value; it benefits us just by giving pleasure.

However:

> It is sufficient therefore as an end, that these writings add to the innocent pleasures of life; and *if they do no harm*, the entertainment they give is a sufficient good. We cut down the tree that bears no fruit, but we ask nothing of a flower beyond its scent and its colour. (48; my emphasis)

The value of entertainment or pleasure is sufficient as long as the pleasure is innocent. But if novels *do* give pleasure in immoral ways, they should be condemned. Certain novels that celebrate 'gross sensual pleasure' are 'totally unfit to enter a house where the morals of young people are esteemed an object' (Barbauld 1810: 30). This raises a question about whether Barbauld really considers entertainment sufficient after all. If entertainment is only sufficient when a novel conforms with morality, then the minimum standard of value seems to be that a novel not only entertain but also be morally innocuous.

In any case, she proceeds to argue that most novels offer more than mere entertainment: 'It is not necessary to rest the credit of these works on amusement alone, since it is certain they have had a very strong effect in infusing principles and moral feelings' (48). A key moral benefit of novels is to arouse our sympathetic feelings for the protagonists, training us to respond with sympathy to other people's troubles in real life (48–50). The transference of our sympathies into real life occurs because novels are realistic, depicting people and situations that resemble the ones we meet with in reality. But novels are also emotionally heightened compared to real life, and so novels arouse our sympathies more readily. The novel's combination of realism and irrealism is therefore key to its moral effect.

Evidently, Barbauld has changed her mind about sympathy and the novel since 1773. Previously she stressed the novel's distance from reality, its idealization and stage-management, which limited how far it could enlarge our sympathies in real life. Yet this earlier view already implied that the way for the novel to realize its moral potential was to become more realistic. Then the sympathies it called up *would* transfer to reality. Following out this line of thought, Barbauld now holds that the novel (unlike the romance) mixes realism and irrealism, and so the characters for whom it calls up sympathy are close enough to real-life people that the sympathy carries across to the latter. At the same time, novels remain sufficiently *un*like life that Barbauld can avoid saying that we derive the same enjoyment from real people's suffering as we do with fictional characters.

Reading novels, then, contrary to the critics, is morally beneficial, the more so because novels also provide a safe way for readers, especially young women, to become acquainted with bad sorts and learn to spot and avoid them in real life. This is much safer than having to learn about such people through bitter real-life experience (51). However, novelists need to tread carefully: depicting vicious

characters as entirely vicious will disgust the reader; but making them look appealing is even worse, romanticizing bad behaviour. The novelist must avoid both brute realism (disgusting vice) and irrealism (romanticized vice) (51–54). This leads to another dilemma: by portraying life as fuller of romance and excitement than it really is, the novel may poorly prepare young women for lives that are largely uneventful, dispassionate, and humdrum (54). The novel needs to offer enough excitement and glamour to entertain, arouse our emotions, and assuage real-life boredom; but enough realism that it does not foster exaggerated expectations that only make real life seem worse than it did before.

Barbauld concludes that worries about a sea of literary trash have been overstated. There are some low-quality novels but, given the moral qualities inherent in the novel as a form, their harms are not as great as critics have made out (58). And, offsetting these instances, novels have gained in quality over time as the form has matured. They are becoming more morally serious, especially with Maria Edgeworth, whose works stand on a higher ground than mere entertainment and herald what is to come (58–59).

Barbauld's overall position on entertainment, then, is this. The best novels, like Edgeworth's, do more than merely entertain and enshrine higher moral values; but some novels provide entertainment alone and this still gives them value. However, it only gives value because on close inspection entertainment *already* depends on moral features: a narrative structure in which events reach a morally just conclusion; a heightened emotionality which fosters our sympathies; a careful avoidance of anything coarse; and a combination of realism and irrealism which provides safe education about vicious characters, enlivens without instilling unrealistic hopes, and permits our sympathies to transfer into real life. Low-level moral features are embedded even in the deceptively simple purpose of providing entertainment: there is more to entertainment than meets the eye. And this is why the best novelists, such as Edgeworth, can produce morally edifying works. They are only developing further the moral features already embedded in the basic form of the novel.

Having some success when it appeared and running to a second edition (McCarthy 2008: 430), Barbauld's anthology gradually dropped from sight until, by the twentieth century, it was scarcely remembered at all. Walter Allen's classic study, *The English Novel* (1954), makes no mention of Barbauld. Another classic mid-century history, Ian Watt's *The Rise of the Novel* (1957), does mention Barbauld, but as a biographer and interpreter of Richardson, not for her own views. One reason for Barbauld's omission was that while the *novel* has long been recognized as having had a history (partly through Barbauld's efforts), the *history* of the novel was not always recognized as having likewise had a history. Recent scholars have remedied this, as with Brian Corman's (2008) '"history of histories" of the novel', charting continuities and shifts in canons of the novel from the eighteenth to mid-twentieth centuries (5). He gives Barbauld a central role,

remarking that 'the history of the English novel is a Regency invention; the tastes and values of the Regency historians set the tone for all subsequent study', and placing Barbauld first among these historians (29).

Barbauld, notably, was a canon-former, not a canon-critic. At first glance, this separates her from the many contemporary feminist aestheticians who have questioned and rejected artistic canons that exclude women. Numerous twentieth-century histories of the novel are exclusive in this way, such as Allen's: his account centres on 'the four great novelists' of the eighteenth century, Richardson, Henry Fielding, Tobias Smollett, and Laurence Sterne (Allen 1954: 40). Allen then discusses eight further males before squeezing his only women—Ann Radcliffe, Fanny Burney, and Charlotte Smith—into a few pages, adding that anyway Burney's 'achievement has been overvalued' (95). Burney is also said to 'represent the entry of the lady into English fiction' (96). No wonder, as almost all the other women have been pruned out! Or consider John Richetti's (1998) *The English Novel in History, 1700–1780*. Although he includes Aphra Behn, Delia Manley, and Eliza Haywood (in ch. 2), he classes them as writing 'amatory' fiction; his core chapters (3–6) cover Daniel Defoe, Richardson, Fielding, and Smollett; then he returns to the women who set about 'transforming' the male tradition (ch. 7), a 'male' tradition, however, that is a retrospective artefact. The most glaring case is Watt (1957), who states that the novel was a male preserve until the challenges of Burney and Austen. Watt concedes, 'the majority of [late] eighteenth century novels were actually written by women', but apparently this was 'a purely quantitative assertion of dominance' (298).

Feminist aestheticians can respond to these artificially male canons in at least two ways (Pollock 1999: 6). One response is to build up expanded and reworked canons that restore and include women. For example, Dale Spender in *Mothers of the Novel* (1986) recovered a hundred women novelists before Jane Austen, nearly all omitted by Allen, Watt, et al. This project was close in spirit to Barbauld, whose canon was one-third female. Specifically, her *British Novelists* were: men— Richardson, Defoe, Fielding, Horace Walpole, Francis Coventry, Oliver Goldsmith, Samuel Johnson, John Hawkesworth, Henry Mackenzie, Smollett, Richard Graves, John Moore, and Robert Bage; women—Clara Reeve, Charlotte Lennox, Frances Brooke, Elizabeth Inchbald, Charlotte Smith, Fanny Burney, Ann Radcliffe, and Maria Edgeworth (no Jane Austen, because *The British Novelists* came out a year before Austen's first novel *Sense and Sensibility*). Moreover, Barbauld believed that the most recent women novelists, such as Edgeworth, were perfecting the genre: the novel's future was female.

A different feminist response is to criticize and reject the very idea of a canon. For example, in her earlier work Griselda Pollock (1998) maintains that:

> The attempt...simply to annex a woman artist to the existing canon of art history does not, indeed cannot, shift its masculinist paradigm. The woman artist

is framed in a relative, secondary position by the patriarchal discourses of art history and their celebration of heroic individual creativity. (97)[19]

Whereas the first feminist view was that exclusions are contingent and we can add women back in, for Pollock women's exclusion is no accident but an inescapable effect of the very project of building a canon. The whole idea of picking out the 'best which has been thought and said' (Arnold 1889: viii) is to weed out everything not deemed 'best'. Yet clearly our canons have not simply carved reality at its joints, neutrally discerning what really is the best, otherwise these canons would have not omitted virtually everything made by women, people of colour, and other minoritized groups. Gender, racial, and other biases have pervaded the value-judgements shaping the canon. Barbauld's and Spender's project was to avoid such biases and craft more accurate canons, but Pollock's rejoinder is that canons are structurally exclusive, and that in an unequal world these exclusions will inevitably follow such fault-lines as gender and race. So it is no coincidence that although Barbauld included many women novelists, subsequent canons increasingly pushed women out, down to the nadir at the mid-twentieth century.[20] Claudia Johnson (2001) has pointed out how Barbauld's 'diverse, inclusive, and politically vanguard agendas were foreclosed as the novel...gained in prestige' (167). Perhaps this foreclosure was no accident.

However, there is a risk in rejecting canons outright. If we refuse to engage with them, then we cannot add women into them, which inadvertently leaves intact the white male membership of the canons we are turning our backs on. Then, when people's minds stray back to canons, which after all are ingrained, their minds will revert to the usual white male suspects. Nor is it only that canons are ingrained: the world is so rich and complex that we need simplifications, some texts and figures picked out as landmarks to help us navigate through culture. These thoughts supply a pragmatic case for holding on to canons of some sort.

But can we do so without setting up new exclusions or consolidating old ones? Perhaps a way forward is to treat canons as provisional formations for particular purposes. This was Barbauld's (1810) strategy. As she made clear, she did not intend to put forward *the* canon for all time, but a selection, guided by her personal preferences, publishing constraints, and the need for variety. She acknowledged: 'No two people probably would make the same choice, nor indeed the same person at any distance of time...the list was not completed without frequent hesitation' (61). Barbauld was conscious that different interests and circumstances

[19] Pollock (1999) has since developed a different approach to the canon, but her earlier statement remains exemplary.
[20] On the process of reaching that nadir from the 1890s onwards, see Tuchman and Fortin (1984), Gupta (1996), and Schaffer (2000: 9–10).

would yield a different canon. She frankly admitted that copyright was a factor, a nod to the subtle pressure of economic factors on what may appear to be disinterested assessments of value.

Barbauld's approach might seem to undermine the very idea of a canon, if we take it that a canon picks out what has enduring value, standing above merely temporary and provisional considerations. But Barbauld suggests that canons need not be so conceived: they can be more malleable and flexible. Taking inspiration from Barbauld, we might approach canonical narratives on the model of a kaleidoscope. We rotate the cell, and one configuration comes into view while other pieces fall to the margins; but we remain aware that we could twist the cell again, and a new configuration would surface. For instance, my narrative in this book centres on seven women from Barbauld to Lee, while I have pushed others such as Elizabeth Eastlake and Sarah Stickney Ellis into the margins, partly on political grounds, as I explained in Chapter 1. But one could rotate the cell and construct a different narrative in which Eastlake and Ellis come forward. The women from Barbauld through Lee are not the only ones who reflected philosophically about art in this place and period; they form one line of descent amongst others. Perhaps we could come to view all canons in this way: as partial selections for particular purposes, guided by individual commitments, and offering one possible way, not *the* way, of looking at history.

Women on Philosophy of Art: Britain 1770–1900. Alison Stone, Oxford University Press. © Alison Stone 2024.
DOI: 10.1093/9780198918004.003.0002

3
Joanna Baillie's Theory of Tragedy

3.1 Introduction

Joanna Baillie was the most celebrated British playwright of the earlier nineteenth century. She came to instant fame in 1798 with the first volume of her *Series of Plays, in which it is attempted to Delineate the Stronger Passions of the Mind*—under their short title, the *Plays on the Passions*. As well as being a practicing writer, Baillie theorized drama. She prefaced the 1798 volume of plays with a seventy-page 'Introductory Discourse' setting out her account of drama and, within it, tragedy. Baillie was partly explaining the rationale for her own tragedies, but she designed them based on her general understanding of the purpose of tragedy, so that her claims also concern tragedy in general.

In this chapter I will reconstruct Baillie's theory of tragedy and argue that it was original and interesting. I hope thereby to make her theory available for philosophical analysis, so that Baillie might start to be included amongst the theorists of tragedy whom philosophers typically discuss and reference, such as Aristotle, David Hume, G. W. F. Hegel, Friedrich Hölderlin, Arthur Schopenhauer, and Friedrich Nietzsche. As that list reveals, contemporary efforts to diversify and broaden the philosophical canon have scarcely touched the canon of tragic theorists. Baillie's theory would repay comparison with these already-canonical accounts. But before we can make meaningful comparisons, we need to acquaint ourselves with her theory in its own right.

I will expand on Baillie's fame in her own time in Section 3.2, and outline the project of the *Plays on the Passions* in Section 3.3. In Section 3.4, I will explain Baillie's view that all human beings are subject to powerful and dangerous passions that they should learn to regulate. Drama, especially tragedy, can help with this and serve an educative purpose. Tragedy presents us with protagonists who repeatedly fail to check the growth of a particular passion, such as jealousy or hatred. We witness the passion gain ever more hold over the character's psyche until he or she succumbs utterly and is destroyed. This offers the reader a salutary warning about the dangers of unrestrained passion. Baillie's theory of tragedy is therefore a moral theory, though we are not meant to stand in condemnatory judgement over the tragic protagonists. On the contrary, for Baillie, tragedy's effects depend on us sympathizing with the protagonists. Our sympathy leads us to recognize that we feel the same passions with which the characters are struggling, motivating us to develop our powers of self-control, as I explore in Section 3.5.

Baillie is thus also a voluntarist: she believes that we all have free will, and that tragedies show the disastrous consequences of bad choices, as discussed in Section 3.6.[1]

Baillie's voluntarism represents a striking departure from many theories of tragedy on which necessary and inevitable suffering is at its core. For Baillie, instead, the sufferings undergone by characters in tragedies could have been avoided had the characters made better choices earlier on. In each play the key tragic twist—Baillie's equivalent of Aristotle's *peripeteia*—comes when the character is in a crisis where they need to withstand their passion but, due to their previous choices, it is too late. The passion is now too strong and overpowers them. Such narratives alert us, the audience members, to get control of our psyches and avoid similarly dismal fates.

3.2 Baillie Rises, Falls, and Rises Again

The first volume of Baillie's *Plays on the Passions* came out anonymously and caused a sensation. The author was generally assumed to be a man, but Baillie's identity emerged. The third edition of 1800 came out signed, and thereafter she enjoyed a 'fame almost without parallel', according to Harriet Martineau, with whom she later became friends (Martineau 1877: vol. 1: 270). Baillie published ten further *Plays on the Passions*, several more relatively short theoretical statements, thirteen *Miscellaneous Plays*, and several volumes of poetry, all assembled in the 1851 'Monster book' of her *Dramatic and Poetical Works* published shortly before her death.[2] During her lifetime, Baillie was consistently compared to Shakespeare (Dowd 1998: 482). There was widespread agreement with Walter Scott's assessment that Baillie was 'the best dramatic writer whom Britain has produced since the days of Shakespeare'.[3]

Contrary to the view that genius has always been a male preserve, Baillie was frequently described as a genius. For Scott, she was 'the highest genius of our country'.[4] Anna Barbauld (1802) spoke of 'a genius like Miss Baillie's, soaring far above contemporary dramatists' (680).[5] Martineau (1877) celebrated 'really able women—women sanctified by holy genius...Joanna Baillie' (vol. 1: 266). Similar language pervaded the many review-essays on Baillie's work in the

[1] On Baillie's moralism and voluntarism and their religious sources, see Colón (2009). Colón's approach to Baillie is the closest to mine, and I am informed by her work.
[2] As Baillie described her *Works*; JB to Margaret Hodson, 7 January 1851, in Baillie (1999: vol. 2: 203).
[3] Walter Scott to Sarah Smith, 4 March 1808, in Scott (1894: vol. 1: 99).
[4] As reported in Lockhart (1829: ch. 6).
[5] This is in an anonymous review of *Plays on the Passions* Volume 2, published in the short-lived *Annual Review* which came out between 1802 and 1808 and was edited by John Aikin's son Arthur. For the attribution of this review to Barbauld, see McCarthy (2008: 644).

periodicals: 'in point of genius, [she] is inferior to no individual on the rolls of modern celebrity' (Harness 1824: 162); her plays have a 'plan which only the noblest genius could have achieved' (Wilson 1836: 9); 'the genius of this distinguished woman...' (Anonymous 1851b: 246); and so on.

Yet by mid-century Baillie was beginning to fall from view. She lamented to Anna Jameson:

> I have for many years past been so completely put out of sight, that nothing but great partiality can ever hope for more for me than a place in the corner of some *great* Library that would not be reckoned quite complete if any books that ever had any considerable reputation were wanting. (JB to AJ, 28 January 1841[?], in Baillie 1999: vol. 2: 1028).

But this was only relative to her previous fame, for when her *Works* came out in 1851, the *Athenaeum* remarked that 'even so rich and varied a half century as this...has not put our...high-hearted Scottish poetess and dramatist out of sight or out of mind' (Anonymous 1851a: 41). Indeed, despite Baillie's lamentations, even by the end of the century she was not entirely forgotten. Her achievements were applauded, for example, in William King's (1903) encyclopaedic *Woman: Her Position, Influence, and Achievement* (346). Almost simultaneously, however, Alice Meynell (1899) writing as 'A. M.' in the *Pall Mall Gazette*, described Baillie's *Plays* as 'shunned by later generations and then...forgotten...' (3). Meynell urged her contemporaries to go back to Baillie, but to little avail. After this point Baillie's reputation dwindled further, and for most of the twentieth century she was utterly forgotten. Barbauld (in McCarthy and Kraft 2001) in her visionary poem *Eighteen Hundred and Eleven* had anticipated that even after Britain had fallen into decline Baillie's fame would live on in South America, the land of the future:

> Then, loved Joanna...
> ...wide o'er transatlantic realms thy name
> Shall live in light,
> And gather *all* its fame. (165, li 101–112)

Barbauld's prediction was sadly far from the mark.

Several factors lie behind Baillie's twentieth-century disappearance. As literary canons consolidated in the late nineteenth century, the canon of British Romanticism contracted to the so-called 'big five' (William Wordsworth, Samuel Taylor Coleridge, George Gordon Byron, Percy Shelley, and John Keats).[6]

[6] See, e.g., *The English Romantic Poets* (Raysor 1950), which covers only the 'big five'. Later William Blake was added, to yield a 'big six'. Northrop Frye's *Fearful Symmetry* (1947) pioneered the rediscovery of Blake. (Frye's book came out shortly before Raysor's; it took a while for the impact of Frye's work to be felt.)

This eliminated a host of other once-popular figures including numerous women: Barbauld, Baillie, Charlotte Smith, Mary Robinson, Felicia Hemans, Letitia Landon, and others. To compound the problem, Baillie conceived of drama as a form of moral writing, as morally educative and instructive, which was anathema to the modernist sensibilities of the earlier twentieth century. These two factors fed into one another, for the modernist exaltation of pure, autonomous art went along with the elevation of a select band of 'great artists' who were deemed to achieved purity. These trends peaked in works like F. R. Leavis's *Great Tradition*. For Leavis there had only ever been four great English novelists: Austen, Eliot, Henry James, and Joseph Conrad (Leavis [1948] 1950: 1). This was a far cry from Barbauld's expansive and inclusive canon from 150 years earlier.

Another factor is that even in Baillie's lifetime her plays were rarely performed. There were some productions: in London, Liverpool, Edinburgh, New York, Baltimore, Philadelphia, and other UK cities (Slagle 2002: 27–33). But Baillie's plays did not transfer well to the stage, as they dealt with inner psychological conflicts. This led to the accusation that she was a 'closet dramatist', 'closet drama' being a Romantic genre of plays for reading rather than performance (on this genre, see Purinton 1994). Baillie rejected the 'closet drama' charge and in 1812 made proposals for making dramatic productions smaller-scale, and more intimate and subtle, so that her plays could be staged effectively.[7] But in 1836, seeing no change to dramatic practice, Baillie conceded the charge and gave up on seeing her plays regularly performed.[8]

Finally, as Elizabeth Kraft and William McCarthy (2001) have said regarding Barbauld's similar fall into twentieth-century oblivion, 'we have convinced ourselves of the powerlessness of women in the "patriarchal past" to the degree that we sometimes fail to perceive the actual influence exerted by women writers of Barbauld's generation upon their contemporaries' (29). That is, the twentieth- and twenty-first century feminist perception of the nineteenth century as the high-tide of patriarchy has led people to assume that there cannot possibly have been influential and powerful women intellectuals back then. For example, Marilyn Gaull described Baillie as 'an uneducated and inexperienced lady,…whose sheltered life conformed to the expectations of her sex and age, [and who] wrote twenty-six plays on passions she could not have experienced' (Gaull 1988: 102). For Gaull, so overbearing were patriarchal expectations in the 1800s that Baillie must have led a sequestered and isolated life, deprived of the life-experience to write compelling tragedies. In contrast, a reviewer in 1836 judged Baillie to be a genius in part *because* she could so vividly imagine

[7] This was in 'To the Reader', her preface to the 1812 third volume of *Plays on the Passions*. See Baillie ([1851] 1976: 228–35).
[8] See her 'Preface' to *Dramas*, 1836 (in Baillie [1851] 1976: 312). On Baillie and 'closet drama', see also Burroughs (1997).

dramatic situations she had not herself experienced (see Milman 1836). On this occasion, the nineteenth century was more hospitable to female artistic achievement than the twentieth—a pattern that I have found to be quite widespread.

Fortunately, in the twenty-first century Baillie has been rediscovered by literary and cultural historians and theorists, restored into Romanticism along with other women,[9] and her plays revived. Baillie may not yet have reattained the fame of Wordsworth and Coleridge, but she is at least now covered in standard anthologies and histories of British Romanticism, in several monographs, and in many articles and chapters. New editions of her letters and plays have come out.[10] Linda Brigham (2004) has spoken of an 'explosion of critical attention' to Baillie (419).

However, the recovery of Baillie has not yet reached the philosophy of art and aesthetics, where she remains largely unknown. I hope to rectify this, by showing that Baillie had a philosophical theory of tragedy. I will draw on literary and cultural historians and theorists who have examined Baillie's work and explored her philosophical influences. But sometimes these interpreters treat Baillie as being influenced by philosophy but not herself *doing* philosophy. For instance, in his edition of *Plays on the Passions*, Peter Duthie includes excerpts from a line of 'moral writers' who influenced Baillie, all men; the only woman featured, but in a separate section, is Mary Wollstonecraft (see Baillie 2001). Mydla Jacek regards philosophy as 'male terrain', and so claims that Baillie as a woman had to effect a 'transmutation' of her philosophical influences into a different register (Jacek 2014: 130–131). Perhaps a lingering association between 'philosophy' and 'maleness' is at work here.

Alternatively, the philosophical nature of Baillie's theory may have been hidden by the *kind* of philosophy of art that she did. Like many of the women discussed in this book, and like many nineteenth-century British male philosophers of art such as Coleridge, William Morris, and Oscar Wilde, Baillie thought about art in conjunction with her artistic practice. She was a dramatist who reflected theoretically on her art, and whose theorizations shaped her practice.

Baillie's theory and practice were interwoven, but reconstructing her theory of tragedy is distinct from examining how she applied that theory in her works and how successful the application was. Baillie certainly saw her works as applying her theory: she was a concept-driven, indeed a moral concept-driven, dramatist. Her plan when writing a tragedy was 'to conceive the great moral object and outline of the story; to people it with various characters under the influence of various passions; and to strike out circumstances and situations calculated to call

[9] See, e.g., Wilson and Haefner (1994) and Winckles and Rehbein (2017).
[10] See, for instance: anthologies and histories: Crochunis (2004), Stabler (2002), and Wu (2012); monographs: Burroughs (1997), Colón (2009), and Slagle (2002); letters: Baillie (1999, 2010); modern editions: Baillie (2001, 2007).

them into action' (Baillie [1798] 1806: 61). Thus the plan went from moral intent (warning about the passions), to main characters embodying a particular passion, to secondary characters setting the protagonist off, to plot. It has been argued that this concept-driven approach resulted in dramatically unsuccessful works, because Baillie reduced plot to a subordinate element. Audrey Insch claims that this accounts for the 'flatness' of Baillie's plays, of which critics have complained ever since Baillie's own time (see Insch 1958). I will suggest, however, that Baillie builds in dramatic shape in her own way, through her characters exercising free will.

Yet that latter feature has given rise to another criticism from Christine Colón (2009). To offer a moral warning, Baillie's characters must fail to control their passions; but these failures undermine Baillie's intended moral that we can and should gain emotional self-control (82–83). Thus, Colón argues, the plays undercut their intended moral message by showing that the passions are too powerful to be regulated. I disagree; as I will argue, from Baillie's perspective, the characters only fail due to having made the wrong choices earlier on, which confirms the reality of our free will.

3.3 *Plays on the Passions*

Baillie ([1798] 1806) opens the 'Introductory Discourse' with the bold announcement that the plays presented are part of an 'extensive design...which...has nothing exactly similar to it in any language:...which a whole life's time will be limited enough to accomplish' 1). As Table 3.1 shows, each play depicts a particular passion, and each passion is presented under both tragic and comic variants. In the tragic variants, the passion escalates leading to the protagonist's downfall. In the comedic variants, the character's one-sided pursuit of their passion leads to misunderstandings and follies, but eventually the character realizes their error and relinquishes their passion, so that all ends well. In both cases the passion's growth is dangerous, but the comedies end with fortunate reprieves, whereas the tragic characters either die, descend into madness, are ruined, or are destroyed in some other way.

Baillie said there was 'nothing exactly similar' to her plays, but there had of course been earlier plays that dealt with single passions, such as Jacobean revenge dramas. However, the originality of Baillie's literary practice is that she conceives of an *entire* series, with each play devoted to a single passion, embodied in a central leading character, where the plot unfolds their passion and the whole dramatic action flows from this. Moreover, her series dealt with a wide range of passions: love and hatred, hope and fear, ambition and jealousy, and remorse. We have other passions as well besides these seven but, Baillie ([1851] 1976) explained in 1812, the others are unsuitable for dramatic presentation. Anger, joy, and grief

Table 3.1 Design of Baillie's *Plays on the Passions*

Date	Volume	Plays	Passions depicted	Genre
1798	A Series of Plays Volume 1	Basil The Tryal De Monfort	Love Love Hatred	Tragedy Comedy Tragedy
1802	Series of Plays Volume 2	The Election Ethwald The Second Marriage	Hatred Ambition Ambition	Comedy Tragedy Comedy
1812	Series of Plays Volume 3	Orra The Dream The Siege The Beacon	Fear Fear Fear Hope	Tragedy Tragedy Comedy Musical drama
1836	Dramas, including three further 'plays on the passions'	Romiero The Alienated Manor Henriquez	Jealousy Jealousy Remorse	Tragedy Comedy Tragedy

are 'too transient to become the subject of a piece of any length'; pride is insufficiently 'turbulent'; envy cannot arouse our sympathy; and revenge is already covered along with hatred (230–231). So for Baillie her series dealt with all the passions that admit of dramatic representation.

In each of Baillie's tragedies the character's passion progresses in the following way. At first it troubles them, yet they retain the power to nip it in the bud; however, they fail to do so. The passion strengthens, again going unchecked and gaining still more power. Eventually a crisis comes, and external circumstances put the character under pressure. The character is now at the mercy of the passion whose growth they have failed to check. They desperately need to repel it but cannot, and it overpowers them. Or as Baillie [1798] 1806) puts it much more poetically:

> To Tragedy…it belongs, to unveil to us the human mind under the dominion of those strong and fixed passions, which, seemingly unprovoked by outward circumstances, will, from small beginnings, brood within the breast, till all the better dispositions, all the fair gifts of nature, are borne down before them…(29–30)

> It is a characteristic of the more powerful passions, that they will increase and nourish themselves on very slender aliment; it is from within that they are chiefly supplied with what they feed on…(38)

> Representing the passions, brings before us the operation of a tempest that rages out its time and passes away. We cannot, it is true, amidst its wild uproar, listen to the voice of reason, and save ourselves from destruction; but we can foresee its coming, we can mark its rising signs, we can know the situations that will most expose us to its rage, and we can shelter our heads from the coming

blast....Above all, looking back to the first rise, and tracing the progress of passion, points out to us those stages in the approach of the enemy, when he might have been combated most successfully; and *where the suffering him to pass may be considered as occasioning all the misery that ensues*. (42; my emphasis)

For example, in Baillie's most acclaimed tragedy *De Monfort*, of 1798, the protagonist De Monfort discloses to his sister Jane that ever since childhood he has felt hostile towards his rival Rezenvelt, for whom he now feels 'hate! black, lasting, deadly hate!' (Baillie 2007: 29).

> Oh! That detested Rezenvelt!
> E'en in our early sports, like two young whelps
> Of hostile breed, instinctively reverse,
> Each 'gainst the other pitch'd his ready pledge,
> And frown'd defiance. (29)

As they grew older, De Monfort found Rezenvelt ever more 'detestable and odious' (30). People began to praise Rezenvelt and he won wealth and titles, and De Monfort was driven frantic. He challenged Rezenvelt to a duel and lost; Rezenvelt's magnanimity in victory only made De Monfort feel worse. His obsessive hatred of Rezenvelt has by now taken over his personality. He is constantly suspicious of and hostile to others, with only occasional flashes of his original warm and generous nature breaking through. Jane persuades him to attempt a reconciliation with Rezenvelt, but then unexpectedly Rezenvelt wants them to embrace in their new-found friendship and De Monfort cannot. Rezenvelt makes light of the awkward moment; De Monfort feels that Rezenvelt is laughing at him, and his hatred deepens even more. Then the opportunist Conrad, looking to profit from the situation, exploits it by pretending to De Monfort that Jane and Rezenvelt are in love. Driven mad with hatred, De Monfort murders Rezenvelt in a forest at night and in turn is captured, arrested, and dies of remorse. The power of hatred over his mind started small and grew worse and worse by steps. The *peripeteia* comes when De Monfort needs to resist Conrad's deception but cannot, having already let his hatred become too powerful. He needed, in Baillie's metaphor, to build up his defences so that in a crisis he could resist the surge of hatred; but having 'suffered the enemy to pass' earlier on, he cannot now hold it back.

Baillie's 1812 play *Orra* has a similar narrative shape. Orra, a joyful and playful heiress, has the weakness of constantly indulging her love of ghost stories ('Orra' is, after all, a near-homophone of 'Horror'). She loves undergoing pleasurable shudders at the stories, letting fear gain growing hold on her mind. Then her supposed protector, Hughobert, punishes her for refusing to marry his son by banishing her to a remote and gloomy castle reputed to be haunted. Not surprisingly,

she is terrified. Her champion Theobald hatches a rescue plan: he will use the legends to his advantage and pretend to be the fabled ghost so as to break into the castle and save Orra. The plan backfires: when he bursts in disguised as the ghost, Orra is so overwhelmed by fear that she plunges into madness and cannot rise back out, losing touch with reality and now seeing nothing but ghosts and the risen dead all around her. The basic narrative structure is the same as in *De Monfort*. Orra has not learnt to resist her passion of fear, but has instead indulged it, so that when a crisis comes—incarceration and Theobald breaking in to rescue her—she cannot repel the ensuing flood of fear but gives way to it irreversibly.

In claiming that tragedies show characters borne down by their passions, Baillie is partly explaining her particular tragic plays, and partly claiming that this is how tragic drama works in general. For as she stresses throughout the 'Introductory Discourse', she intends her plays to be faithful to the true nature of dramatic art and restore tragedy to its proper purpose. That purpose is to depict the disastrous effects of unmastered passions, dealing directly with the reality of our emotional lives. This view that art should take its source from real-life passions—from human nature, not from artistic conventions—makes Baillie a Romantic, not least because her views helped to define Romanticism in the first place.[11] But the broader point is that she designed the *Plays on the Passions* in line with her account of the general purpose of drama and tragedy. Let us now draw out the philosophical structure of her account.

3.4 Baillie on the Passions

The concept of the passions, which is central to Baillie's tragic theory, comes out of the early modern philosophical tradition.[12] As Susan James points out, when early modern philosophers 'describe states...that are nowadays identified as emotions and desires, they usually call them passions or affections' (James 1997: 29). In the early modern period there was an overarching view of the passions 'as an overbearing and inescapable element of human nature, liable to disrupt any civilized order...unless they were tamed' (James 1997: 1). Albert Hirschman argues that this preoccupation with the passions tied in with the rise of capitalism, and with a programme of making selfish passions manageable and socially beneficial by converting them into interests. Giambattista Vico, for instance, remarked that: 'Out of ferocity, avarice, and ambition, the three vices which lead all mankind astray, [society] makes national defense, commerce, and politics'

[11] For instance, her work influenced Wordsworth's view that good poetry is the spontaneous outflow of emotion in his 'Preface' to the *Lyrical Ballads*; see Crisafulli and Pietropoli (2007: 4), and Wordsworth (1800: xxxiii).

[12] Peter Duthie (2001) and Colón (2009: ch. 1) likewise make the connection to early modern philosophies of the passions.

(quoted in Hirschman 1977: 17). There was a wide spectrum of views on *how* to tame the passions and render them publicly beneficial. In the previous chapter we encountered one answer, Joseph Priestley's therapeutic practice of habitual devotion. Though Priestley's answer came out of the empiricist tradition, the concern to regulate the passions cut across the rationalist/empiricist divide. Descartes, for instance, likewise believed that we should be guided not by our passions but our judgements and that we should learn to master our passions with the aid of our power of judgement. As he wrote to Elisabeth on 1 September 1645, 'When we feel ourselves moved by some passion we'll suspend our judgement until it calms down' (Descartes and Elisabeth 1643–49: 29).[13]

Philosophers were not alone in seeking to regulate the passions. So did legislators, politicians, doctors, and artists, including dramatists. Coming out of this tradition, Baillie ([1798] 1806) assigns drama an instructive and therapeutic role, holding that: 'The theatre is a school in which much good or evil may be learned' (57). Drama, she adds, is a species of 'moral writing', along with philosophy, history, novel-writing, and poetry (14). All these types of writing rest on and use the same knowledge of human nature: namely, the knowledge of the common stock of passions with which everyone must contend (2). Tragedy uses this knowledge in a particular way. By showing us characters gradually falling under the grip of damaging passions, tragedies teach us to decipher these passions at work in the intricacies of people's actions and words, in all those 'minute and delicate traits which distinguish them in an infant, growing, and repressed state' (58). This educates us to recognize the inner murmurings of our own passions and inhibit their growth early.

Baillie follows tradition, too, in categorizing these dangerous passions into opposing pairs: love and hatred; hope and fear; revenge and remorse; joy and grief; pride and envy; ambition and jealousy. Her taxonomy partly shows the indirect influence of Aquinas, whose eleven basic passions were love and hatred, desire and aversion, joy (or pleasure) and sorrow (or pain), hope and despair, fear and courage, and anger (Aquinas 2006: I–II, Q.22–48). Baillie compresses that list and adds some further passions that were frequent targets of early modern concern: pride, envy, ambition, jealousy, revenge, and remorse. Notably, all these are competitive, acquisitive passions of self-interest, except for remorse which reacts against and counteracts the others.

We may wonder which particular early modern authors on the passions influenced Baillie. It is hard to tell, since her 'Introductory Discourse' has very few references or footnotes. Baillie explains that her influences are too numerous to cite, while acknowledging only some of them would unjustly omit others ([1798] 1806: 68–69). To compound the difficulties, no correspondence of Baillie's

[13] For a reading of Descartes along these lines, see Brassfield (2012).

survives from before 1800 and very little from before 1804. However, we know from her later letters that she read widely, and not only in dramatic literature (Slagle 2002: 67, 223–224). Scottish moral philosophy was a major influence, partly because Baillie was originally Scottish, only moving to England in 1784. Peter Duthie identifies Francis Hutcheson, Adam Smith, and Dugald Stewart as influences on Baillie's view of the passions (see Baillie 2001: appendix A). Adam Smith, in particular, was friends with Baillie's family, and she is known to have defended his work from a critic (Carhart 1923: 13, 70). To Duthie's list of influences, Colón adds Shaftesbury, Hume, and the American Unitarian theologian William Ellery Channing (Colón 2009: ch. 1). Baillie's brother, the distinguished physician Matthew Baillie, was another influence (see Burwick 2004 and Monsam 2017). Overall, Duthie (2001) admits: 'Whether or not [Joanna] Baillie actually read Hume or Hutcheson, we cannot absolutely be certain. But we can see in her work the philosophical moral tradition that they helped shape' (33).

3.5 Baillie, Barbauld, and Sympathetic Curiosity

The Scottish connection leads on to another key component of Baillie's theory: her conception of sympathy. Sympathy was significant for many Scottish Enlightenment thinkers, but plausibly Smith was most important for Baillie.[14] For Smith (1759), sympathy is not properly speaking a passion but our ability and propensity to take on and feel the passions of others. Sympathy, so understood, is fundamental to his moral theory, as he makes clear by launching straight into the topic on the first page of *The Theory of Moral Sentiments*. We are sociable by nature, he declares, interested in the well-being of others as well as ourselves. This interest is underpinned by sympathy, 'our fellow-feeling with any passion whatever' (6). But we can only form an idea of what others are feeling by imagining what we would feel in their situations (2–3). Imagination and sympathy therefore go hand-in-hand, and both are necessary for morality.

This view provides Baillie ([1798] 1806) with a justification for the moral role of imaginative drama. We enjoy drama, she maintains, because—following Smith—we are sociable and have a basic human disposition towards 'sympathetick curiosity' (4). Sympathetic curiosity combines a cognitive element—curiosity, the desire to understand and interpret what others are feeling—and an affective element—sympathy, the propensity to feel as others feel. On the cognitive side, we enjoy tracing the characters of other people, reading their 'slight traits in...words and...actions' (11) and detecting the passions that are motivating people's actions. We like interpreting, understanding, and making sense of

[14] For more on how Smith's *Theory of Moral Sentiments* influenced Baillie, see inter alia Colón (2009: ch. 1), Murray (2003), and Whalen (2013).

other people, especially people gripped by strong passions.[15] Just as sympathy depended on the imagination for Smith, likewise for Baillie sympathy depends on curiosity. We can only feel as others feel once we have understood and made sense of them. For Baillie, though, the dependence is mutual: we can only fully understand others *by* coming to feel as they do. 'In examining others we know ourselves', Baillie says, and vice versa (11–12). We make sense of De Monfort's suspicious and erratic behaviour by coming to recognize that he is afflicted by hatred, a passion we can then notice in ourselves. Doing so, we understand better what De Monfort is experiencing, just as in deciphering what he is experiencing we gain more insight into the seeds of hatred in our own minds. We map our minds onto De Monfort's and vice versa.

It follows that we can feel 'only for creatures like ourselves'; only from them do 'we receive the instruction of example' (32). Consequently, Baillie stresses, dramatic protagonists must participate in a common human nature, however highborn they are. They must not be too remote or perfect but must be flawed like the rest of us. We could not sympathize with De Monfort if he was entirely good: 'To a being perfectly free from all human infirmity our sympathy refuses to extend' (32). In addition, to be like everyone else tragic characters must speak in natural, unaffected language and visibly display the same psychology as other people. When these conditions are met, 'The Drama improves us by the knowledge we acquire of our own minds, from the natural desire we have to look into the thoughts, and observe the behaviour of others' (36).

Indeed, we feel the greatest curiosity of all about people who are dealing with 'extraordinary situations of difficulty and distress' (5). Baillie's examples are prisoners awaiting execution and convicted criminals mounting the scaffold to be hanged. It is our fascination with these individuals, Baillie says, that draws large crowds to attend public executions and trials. The crowds congregate not out of cruelty, vindictiveness, or bloodthirstiness, but from their eagerness for clues about how people feel in these situations. How do people cope with fears of death and punishment, remorse about their crimes, and powerful hopes for forgiveness and redemption in the afterlife? For Baillie, the appeal of tragic drama is essentially the same: we enjoy seeing how a character copes with strong passions, especially when placed in very challenging circumstances.

Baillie, then, sees no significant difference between interpreting the minds of fictional characters and those of real-life criminals or convicts. Indeed, nowhere in the 'Introductory Discourse' does she directly thematize the fictional status of tragic characters or events at all. This relates to her Romanticism: she sets out directly to copy the real-life flow of human emotion and action. She sees her plays as holding up a mirror to life, and therefore downplays their artistry.

[15] On this cognitivist side of Baillie's views, see Bergen (2014) and Richardson (2004).

In making sense of the inner lives of tragic characters, we use the same powers as we do for making sense of other people in real life, so that tragedy develops the capacities for curiosity and sympathy which underpin our real social relations.

On Baillie's Scottish Enlightenment side, she believes that we are inherently sociable and not motivated exclusively by self-love, just as Smith does. This is why we enjoy sympathizing with the sufferings of others: it expresses our essentially sociable nature. However, Baillie also pushes sympathy out of this Enlightenment register into a distinctly Romantic one. We can bring this out by comparing Baillie's view of sympathy to Barbauld's in the 'Enquiry into those Kinds of Distress which Excite agreeable Sensations', examined in Chapter 1. Barbauld's Enquiry plausibly influenced Baillie, since the two women became friends and close interlocutors after they met in the 1790s.[16] They became neighbours as well after Baillie moved to Hampstead in 1799, although this post-dated her 'Introductory Discourse'.[17]

There are some immediate similarities between Barbauld's and Baillie's views. Both women ask why we should enjoy reading about or watching characters suffer, given that we are naturally sociable and sympathetic. Barbauld's explanation is that our enjoyment does not stem from malice or cruelty. Rather, we enjoy the exercise of our powers of sympathy, though unfortunately these powers cannot be drawn into play unless we see a character suffering. So far Baillie agrees, adding that we enjoy understanding such characters and, correspondingly, ourselves.

The differences concern Barbauld's view that literature also cultivates our sympathies by keeping them within proper boundaries. As we saw in Chapter 1, for Barbauld, these boundaries are essential for our distress to be enjoyable, for what we enjoy above all is having our sympathies refined—not, after all, the bare exercise of these powers, but their refined exercise. Stories of characters undergoing brute shocks, violence, or tempests of passion, or falling into wretched states and giving way to vice, fail to refine us and so do not bring pleasure.[18] It is telling that Barbauld, to whom Baillie gave advance notice of the contents of *Plays on the Passions* Volume 3, could not imagine how there could be a leading hero or heroine whose passion was fear. 'Joanna has a volume ready for the

[16] According to Baillie's biographer Judith Slagle, 'Around the late 1790s or shortly before, Baillie met...Anna Barbauld' (Slagle 2002: 63). Alfred Miles (1907) suggests they met earlier in the 1790s. Barbauld's niece and editor Lucy Aikin remembers first meeting Baillie 'at Mrs. Barbauld's' when Lucy 'was a young girl'. Since Lucy was born in 1781, this points towards an earlier date (see Breton 1864: 7). Either way, Baillie and Barbauld knew one another while Baillie was working on her first volume of *Plays on the Passions* and formulating its concept, a process that went back to 1791 and possibly even earlier (Slagle 2002: 58). Of course, Baillie may well have read works of Barbauld's, such as *Miscellaneous Pieces*, before that.

[17] Accounts of Baillie's philosophical influences have neglected women. When Baillie is related to other women, they tend to be described as 'writers', not philosophical thinkers (e.g., Clery 2000; Purinton 1994: ch. 5, esp. 131, 133; Wilson and Haefner 1994; Winckles and Rehbein 2017).

[18] Barbauld observed these limitations in her 1773 *Poems*, in which 'there is hardly any reference to "passion" or any extreme emotions' (Janowitz 2004: 19).

press... The subject is to be the passion of fear. I do not know what sort of a hero that passion can afford!' (AB to Mrs Kenrick, [May 1811?], in Thackeray 1883: 39). For Barbauld, fear is a vice, so we cannot possibly sympathize with fearful individuals, who cannot count as heroes or heroines for us.[19]

In Baillie's dramatic work, these restrictions largely fall away. For her, we feel the keenest sympathetic interest in those undergoing exceptional distress and plagued by especially strong passions: real-life convicted murderers and malefactors and their fictional equivalents. Between them, Baillie's dramatic characters commit murder (De Monfort), kill their spouses (Romiero), lead their peoples into unnecessary wars and abandon their intended spouses (Ethwald), abandon the armies they are leading in war to pursue a flirtatious romance (Basil), and give way to their fears and worst imaginings (Orra). Many of her dramatis personae are thus the titanic, passionate, larger-than-life characters we associate with Romanticism. Baillie extends sympathy beyond Barbauld's limits, encouraging us to sympathize with people whose minds are *not* well-ordered or carefully regulated but riven with overpowering emotions. The emotional landscape shifts from cultured refinement into the gothic: brutal passions run riot, people descend into madness, and the environment gives brooding embodiment to these tumultuous affects.[20]

This enables Baillie to go some way to overcoming the moral limits which Barbauld found in fiction in her 1773 essay. For Barbauld, fictional narratives have to circumscribe our sympathies carefully, and therefore differ so greatly from real life that they do little to enhance our sympathy for people's real-life sufferings. By giving tragic drama an expanded emotional scope, Baillie takes it that fiction *can* hold up a mirror to our real emotional lives in all their messiness. In turn, this gives tragic drama the power to develop our real-life powers of compassion and understanding (Baillie [1798] 1806: 14). For Baillie, exposure to tragedies makes us better and more compassionate judges, politicians, medical doctors, and so on (14). So whereas Barbauld thinks that fiction's moral benefits have been overstated, Baillie restores an important moral mission to tragedy.[21]

Of course, Barbauld would deny that we can enjoy these fictional narratives about terrible passions, just as she could not conceive of how a person in the grip of fear could be an engaging heroine. But Baillie's reply is that we enjoy the exercise of our sympathetic curiosity, and we enjoy it more, not less, when applied to people in severe emotional straits. For what we enjoy is the expansion of our understanding of other people and ourselves, and the expansion of the scope of

[19] Barbauld's view here was informed by her neo-Stoicism, on which see Chapter 4.
[20] On Baillie and the gothic, see Clery (2000: ch. 3) and Cox (1992).
[21] These differences did not stop Barbauld 'prais[ing] the plays with all her heart' to Baillie in 1798, without knowing that she was the author. Baillie somehow kept the secret (Ellis 1874: 231–2). As I argued in Chapter 1, Barbauld was more optimistic about fiction's moral powers in her later *British Novelists*. Perhaps this reflected Baillie's influence.

our sympathies. Whereas for Barbauld we enjoy having our sympathies cultivated and *refined* within a carefully controlled fictional environment, for Baillie we enjoy having our sympathies *enlarged* by a dramatic environment in which passions explode beyond human control.

Although Baillie would have us sympathize with her tragic characters, they are not models to emulate. On the contrary, they afford warnings: their submission to passion furnishes a lesson in what to avoid. Thus, although we see ourselves as being like De Monfort in feeling the same passions at work in ourselves, we should use this enhanced self-knowledge to nip these passions in the bud. This shows a further respect in which we are like the tragic characters: they have free choices about how to handle their passions, and so do we. Seeing the characters make bad choices, we recognize that we can make choices regarding our own passions and, ideally, better choices than De Monfort, Orra, and the others. But for Baillie we can only get to this point by first sympathizing with the characters, and so appreciating that we are like them—and, like them, are at risk of being ruined if we give way to our passions. Baillie's challenge to Barbauld is that if literature restricts our sympathies too heavily, ironically, it will *prevent* us from learning to regulate our passions. We will only grasp the need to do so if we observe cases where things go terribly wrong; the very sorts of cases that Barbauld thought were out of place in fiction.

We can now spell out Baillie's solution to the paradox of tragedy. Seeing no significance in the fact that tragic characters are fictitious, she explains why we enjoy tragedies by simultaneously considering why people enjoy going to public executions. In both cases, we seem to derive a perverse pleasure from watching others suffer. Indeed, Victoria Myers (2004) argues that despite herself Baillie produces a 'theatre of cruelty', replete with 'voyeurism, invasion, and inquisition…[and] primitive torture', which escapes and complicates her moral intentions and exposes the cruelty at the heart of morality itself (88). Yet it is important to keep Baillie's actual moral intentions in mind. She maintains that, really, we enjoy tragedies and hangings due to our *sympathy* with the protagonists and/or criminals—where sympathy is morally desirable and praiseworthy—and our *curiosity* about these people's states of mind in these extreme situations—curiosity also being desirable and praiseworthy, as it enables us to better understand ourselves and others. Unfortunately, we need to observe individuals in extreme distress and crisis for our powers of sympathy and curiosity to be drawn into full play and enlarged. But we do not enjoy seeing these people suffer as such; rather, the enjoyment comes from our expanded understanding of human nature and our broadened and deepened feeling for our fellow-humans.[22]

[22] Compared with Barbauld, Baillie was closer to Burke, who said of tragedy that 'The nearer it approaches the reality, and the further it removes us from all idea of fiction, the more perfect is its power' (Burke 1757: 26). Like Burke, Baillie held in consequence that we also derive enjoyment from

Yet this line of thought throws up a further moral challenge. Are watching tragedies and attending executions morally bad, after all, since they elicit our sympathy for morally depraved individuals such as criminals and murderers? No, Baillie answers, for we sympathize with these individuals only insofar as they are not completely or irredeemably bad (not even a murderer about to be executed). We sympathize with De Monfort because he remains at his core an essentially good and noble man, despite his raging hatred. The passion deserves execration, not the man, according to Baillie ([1798] 1806: 62). She reiterates this defence of her later tragic protagonist Romiero, whose out-of-control jealousy leads him accidentally to kill his wife Zorada when lunging to kill the man he thinks is her lover but who is actually her father. Baillie insists that even Romiero is at base good: 'This, it appears to me, is a jealousy dealing particularly with the affections of the heart, not being afraid or suspicious of more ignoble wrongs; and therefore jealousy that...might belong to a noble nature' (JB to Margaret Hodson, 1836, in Baillie 1999: vol. 2: 718–719).[23] Conversely, if Romiero were rotten to the core, then we could not sympathize with him, and we would find his downfall not tragic but just and rightly deserved.

3.6 Baillie's Voluntarism and Optimism

As we can see from the fact that Baillie's protagonists make bad choices, her theory and practice of tragedy are premised on her belief in free will. Her contemporaries recognized this, and not always approvingly:

> If Joanna Baillie had known the stage practically, she would...give them [i.e., her characters] that air of fatality which, though peculiarly predominant in the Greek drama, will also be found to a certain extent in all successful tragedies. Instead of this, she contrives to make all the passions of her main characters proceed from the wilful natures of the beings themselves. (Campbell 1834: 208–209)

For this critic, Thomas Campbell, Baillie's voluntarist commitments make her plays 'flat' and devoid of dramatic interest.

Baillie takes the opposite view, and controversially holds that the *Greek* tragedies lack action, passion, and interest because they depict the unfolding of an

real-life encounters with people in terrible distress. I suspect that she was influenced by Burke, who similarly compared the appeal of tragedies to that of public executions (26–7). But Baillie tried harder to show how this position was morally acceptable.

[23] In fact, many readers were unmoved by Romiero's death (his father-in-law kills him to avenge Zorada), for they *did* find him undeserving of sympathy—see, e.g., Milman (1836: 494–5). Baillie tried to defend Romiero, but to little avail; see Baillie (1836) and, for discussion, Slagle (2013).

inevitable fate (Baillie [1798] 1806: 26–27). The Greek characters have no choice or free agency, so things in Greek tragedies cannot possibly go otherwise than they do, there is no dramatic tension, and events simply roll to a pre-ordained conclusion. Unlike ancient Greek tragedy, modern tragedy rests on the premise that individuals have free will to use for good or ill. To Baillie's mind, this premise is crucial to dramatic action being dramatic, since it means that there are many steps in the action and at each step things could go otherwise if the character chose differently. So we keep hoping that they will, although in tragedies that hope is disappointed. For instance, in *Basil* we keep hoping that the protagonist will abandon his flirtatious romance and remember his military mission and leadership role. But he only does so after it is too late, his army has proceeded into battle without him, and his career and reputation are ruined.

This is not to say that Baillie employs voluntarism merely as a device to generate dramatic tension. As I have tried to show, voluntarism is at the heart of her account of tragedy's moral purpose. Because the tragic characters have free will, and we sympathize with them, we recognize that we too have the free will to regulate our passions or let them lead us to destruction. Baillie's belief in free will was bound up with her theological view that we can all perfect ourselves and attain salvation (a view she took from Channing; see Colón 2009: 44, 180).

Moreover, for Baillie, tragic drama's voluntarist premise is crucial to its being tragic. To see why, let's revisit the structure of some of her plays once again. In *De Monfort*, a pivotal incident galvanizes De Monfort to murder Rezenvelt: when Conrad tells De Monfort that Jane and Rezenvelt are in love and De Monfort cannot pause, reflect, and see through the deception. At this juncture, external circumstances put De Monfort under pressure and he needs to rise above his hatred, but cannot, his passion already being too powerful. The same structure applies in *Orra*. When Theobald comes to rescue Orra in ghostly disguise, she needs to overcome her fear so as to recognize him and accept his help. Instead, her fears are already so powerful that they overcome her. For a final example, take Osterloo in *The Dream*, whose troubling passion is fear (as with Orra). He is so terrified of his imminent death by execution—as punishment for a murder he committed years before that has recently come to light—that he expires of sheer fright on the way to his death, just as he was about to be reprieved.

In each play a point comes when the character is in a crisis but could potentially rise to this challenge if they had their passion under control. Since they do not, the crisis instead creates the opening for the passion to surge forth decisively. At these points, the audience realizes that the time is now past when the character could have mastered the passion. Its power is now irreversible, and from this point onwards the characters can only descend to death, madness, or both.

Baillie's comedies have a different structure. The central character, driven by their passion, pursues a progressively more damaging course of action. Finally a crisis occurs in which the character needs to abandon their passion in order to

come through, and some fortunate external factor enables them to do so. For instance, in *The Election* Baltimore abruptly relinquishes his hatred for Freeman, with whom he was about to duel, on being informed that they are really brothers. In *The Second Marriage* Seabright abandons his disastrous ambition because, even though he has just undergone financial ruin, his daughter Sophia continues to shower him with innocent love. Baillie's comedies thus end with last-minute conversions in which a happy accident (a *deus ex machina*) enables the protagonist, however improbably, to cast aside the passion they have repeatedly indulged.

This shows, by contrast, what makes Baillie's tragedies tragic. Even when help is offered—for example, when Theobald attempts Orra's rescue, or Osterloo is about to be reprieved—the protagonist cannot receive the help, since by now they perceive everything through the distorting lens of their ruling passion. This confirms that the passion's hold over their mind is now irreversible.

But since the passion is now beyond control and will drive the character ineluctably to their doom, doesn't that mean that for Baillie, after all, tragedies are tragic because it ends up inevitable that the character is destroyed? Not quite. While it is *now* inevitable that the passion will destroy them, this state of affairs could have been avoided had the character learnt to resist and regulate their passion earlier on. The now-inevitable defeat is the result of avoidable bad choices that the character made previously. For example, De Monfort's speech telling Jane about the history of his enmity with Rezenvelt is vital, showing us what De Monfort could have done differently in the past to bring him to a different place today. In *Orra* the clue is the character's constant demands to hear scary ghost stories: had she acted differently at this point, a different outcome would have become possible later on.

Baillie's understanding of the tragic dovetails with some everyday uses of the word, such as the language used in the UK regarding the 'Baby P' case, in which a toddler, Peter Connelly, was killed by his family after sustaining terrible injuries over many months. People often say that Baby P's death is tragic because it could have been avoided had social workers and medical practitioners spotted the warning signs of child abuse earlier on. Aestheticians tend to complain that such uses of 'tragic' are misuses, on the grounds that to be tragic a course of events must run to a bad end with inexorable necessity (see, e.g., Rorty 1992). On this view, it is precisely when the terrible conclusion could not possibly have been avoided that it qualifies as tragic.[24] This tallies with Campbell's criticism of Baillie: her plays do not unfold with invariant necessity, so they are not truly tragic. Baillie disagrees. For her, a course of terrible events counts as tragic when its later stages could have been prevented although, not having been prevented,

[24] Some would add that this condition can only be met if the course of events is fictional, since only plotted events can unfold with necessity. For Iris Murdoch: 'Real life is not tragic.... Strictly speaking, tragedy belongs to literature' (Murdoch [1992] 2003: 93). Clearly, Baillie would reject this stricture.

they have now become inevitable. There is a further strand to her view too. For the turn of events to be tragic it must be the protagonist him- or herself who could have prevented it (here the Baby P analogy ceases to hold). For Baillie, the course of terrible events qualifies as tragic when things could have gone otherwise, and life could have gone well for the protagonist, but instead they have thrown everything away and made their own destruction inevitable.

For Baillie, tragedies show us courses of suffering that could have been avoided given better choices from the protagonists. This means that ultimately her theory of tragedy is an optimistic one. To bring out this aspect of her theory and its originality we can briefly contrast her view to those of two much more canonical tragic theorists, Schopenhauer and Nietzsche. For Schopenhauer ([1844] 1977), tragedy shows us the inevitability of suffering in human existence in general, and as crystallized in the fate of representative individuals such as Oedipus or Iphigeneia. The destruction of these individuals, and their inescapable fates, bring home that we *cannot* avoid suffering, ultimately because it is built into the deep structure of reality: namely the will, which manifests itself in human life as our interminable pursuit of desire after desire. 'The tragic spirit consists in this: it leads to resignation' (510). Tragedies show us that suffering cannot be avoided, only accepted. Tragedy thus rests on a pessimistic metaphysics and guides us to appreciate the truth of pessimism.

The only possibility of escape that Schopenhauer sees is that, recognizing that suffering is inescapable, we can learn to deploy our will against itself to cancel itself out, thereby relinquishing our attachment to our desires. Nietzsche ([1886] 1999) came to reject this view as nihilistic, advocating not a Schopenhauerian 'pessimism of weakness' but a 'pessimism of strength', which he thought was inculcated by classical Greek tragedy (4). According to Nietzsche's account in his 1872 work *The Birth of Tragedy*, tragedy shows us the inevitable destruction of the tragic characters under a veil of beautiful appearances. This veil encourages us to embrace and affirm our existence, terrible and full of suffering as it is. Nietzsche thus agrees with Schopenhauer that tragedy presupposes metaphysical pessimism, but for Nietzsche the tragic spirit is one not of resignation but affirmation, the attitude 'life is terrible – I would have it no other way!'

Baillie's position is far removed from these accounts. For her, tragedies show that we are *not* powerless in the face of suffering, and so we need neither resign ourselves to inevitable suffering nor cultivate the strength to affirm it. Instead, tragedies show us that we can flourish if we cultivate self-knowledge and sympathy for others, learn to interpret our own minds and those of others, and learn to make the right choices and get control of our passions. The tragic spirit is practical, helping us to develop the capacities and skills to lead flourishing lives and overcome the dangers that arise along life's way.

It may seem paradoxical that Baillie draws this optimistic lesson from an artform that depicts characters going to their death and destruction. But for Baillie,

it is precisely by showing us the disastrous consequences of the characters' bad choices that tragedy alerts us to make better choices ourselves. If the characters' poor choices were without serious repercussions for them, then tragedy's power of moral instruction would be compromised. In this way optimism, voluntarism, and moralism are interlocking components of Baillie's view. They yield a distinctive and important theory, which deserves a place alongside other philosophical accounts of tragedy.

Women on Philosophy of Art: Britain 1770–1900. Alison Stone, Oxford University Press. © Alison Stone 2024.
DOI: 10.1093/9780198918004.003.0003

4
Harriet Martineau on Literature, Morality, and Realism

4.1 Introduction

In the first half of the nineteenth century Harriet Martineau was Britain's most famous female public intellectual. Her huge body of discipline- and genre-defying work spanned political economy, sociology, history, politics, philosophy, and religion. In addition she wrote fiction, including the twenty-four novellas that catapulted her to stardom, the *Illustrations of Political Economy*, which came out monthly from 1832–34.[1] Summing up the public response, the *Spectator* observed: 'The first day of each month is marked by no publication of more importance than Miss Martineau's *Illustrations of Political Economy*' (Anonymous 1832: 853). In their day the *Illustrations* even outsold Charles Dickens: by 1834, each *Illustration* was selling 10,000 copies, compared to 3,000 for Dickens's latest serial instalments (Dalley 2012).

Literary historians have insightfully analysed Martineau's fiction, but there has been relatively little analysis of her *theory* of literature and of art, one exception being the excellent chapter 'Harriet Martineau's Theory of Fiction' by Valerie Sanders (1986: ch. 1). Building on Sanders, I shall reconstruct Martineau's account of the purpose of literature. I will focus mainly on this account insofar as it informed and underpinned Martineau's *Illustrations*. She intended these tales to illustrate the principles of political economy. She thought that these principles were moral as well as economic, and that literature ought to illustrate them because art's purpose was to exemplify moral principles and so promote moral behaviour.

Martineau never gave this position a single unified statement, so we have to piece it together from several textual sources. These include the places where she engaged with Anna Barbauld (Section 4.2) and Walter Scott (Section 4.3). These fed into Martineau's case for literary realism, the view that literature must provide a sympathetic portrayal of ordinary working people. In this way, Martineau expanded the moral scope of literature beyond Barbauld's limits, though it was a different expansion from the one effected by Joanna Baillie (Section 4.4).

[1] Her other fictions included *Poor Laws and Paupers Illustrated* (1833–34, four stories), *Illustrations of Taxation* (1834, five stories), *Deerbrook* (1839), the *Playfellow* (1841, four stories), and *Forest and Game Law Tales* (1845–46, three stories).

These lines of thought converged in Martineau's *Illustrations,* but as they were woven from several strands the *Illustrations* also contained tensions (Section 4.5). These tensions were one factor leading later novelists such as George Eliot to take realism in different directions, which Martineau condemned as bad art (Section 4.6). Her criticisms of other novelists make clear that her moral commitments always underlay and motivated her realism. For her, the aesthetic must always be subordinated to the moral. This, I will suggest, was the ultimate source of the tensions in her project.

Martineau wrote less directly on the philosophy of art than the other six women covered in this book, so my decision to include her may seem doubtful. But she belongs here for several reasons. She was a uniquely influential intellectual woman, and she reflected on the purpose and nature of art in concert with her literary practice, so that her thought exemplifies the kind of philosophy of art developed by the women discussed in this book (as by many nineteenth-century British writers on art generally). Martineau belongs here, too, because she was such an exemplary aesthetic moralist. For her, the aesthetic aspects of artworks must serve moral purposes, and art must be morally good to count as good art. Martineau was therefore important to the moral turn in mid-nineteenth-century British aesthetics. Anna Jameson and John Ruskin became more closely associated with this moral turn in the public mind. But Martineau was a more unequivocal moralist than them, and her work best illustrates the aesthetic moralist stance.

4.2 From Barbauld to Martineau's *Illustrations*

Martineau grew up in a Unitarian family that had close ties with Barbauld's natal family, the Aikins. In 1801 Barbauld wrote 'On the Death of Mrs Martineau' to commemorate her friend, the recently deceased Sarah Meadows Martineau, Harriet's grandmother (Barbauld in McCarthy and Kraft 2001: 149). Thomas Martineau, Harriet's father, was educated by the Barbaulds at the Palgrave Academy. According to one of Harriet's sisters, 'from Mrs Barbauld he acquired the strong political leanings, and the firm principles of nonconformity' (quoted in Webb 1960: 57). The adult Thomas remained in touch with the Barbaulds, and Harriet recalled their childhood visits, saying that she and her siblings 'had all grown up with a great reverence for Mrs Barbauld...and, reflectively, for Dr Aikin, her brother,...far more industrious, but without her genius' (Martineau 1877: vol. 1: 78). Martineau also said: 'Our generation feasted, all through childhood, on "Evenings at Home" [by John Aikin and Anna Barbauld]; I cannot read them now without strong delight' (HM to R. H. Horne, 13 April 1844, in Martineau 2007: vol. 2: 275–276).[2]

[2] On Barbauld's importance for the young Martineau, see also James (2010: esp. 88, 103) and on the Aikin–Martineau family connections, James and Inkster (2011) and Sanders (2002: esp. 65).

Barbauld was not merely one influence among others; she was central. Martineau (1822b) found her writing 'forceful and elegant' (749), the model of the writing Martineau aspired to produce. She aimed to be, just like Barbauld, 'a forcible and elegant writer on religious and moral subjects' (Martineau 1877: vol. 3: 33). Late in life, Martineau (1861) remembered: 'I knew the Miss Berrys, and the Miss Baillies, and the empress of her sex in her own time and after—Mrs Barbauld' (176).[3] Later still, she listed her female role models: Maria Edgeworth, Joanna Baillie, Mary Somerville, 'and glorious Mrs Barbauld (the very first of the order)' (HM to the Beauforts, 9 June 1867, in Martineau 2007: vol. 5: 178).

No surprise then, that Martineau's first two-part article, 'Female Writers on Practical Divinity', was half on Hannah More and half on Barbauld (see Martineau 1822a, 1822b). Signed 'Discipulus' to indicate that Martineau was Barbauld's and More's disciple, the essay appeared in the radical Unitarian journal the *Monthly Repository*, where Martineau published many philosophical essays during the 1820s. In 'Female Writers' Martineau (1822b) saluted 'the genius of our first living female poet, Mrs Barbauld' (748). She then praised several of Barbauld's writings before focusing on Barbauld's essay 'On the Devotional Taste'. Martineau summed up Barbauld's case for an aesthetic religiosity, and concurred: 'She meets our ideas, and seems to express what had passed through our own minds, much more forcibly than we ourselves could have done.'

Thus, from the start Martineau placed her writing career under the sign of Barbauld's aesthetics. Indeed, the two-way devotional aesthetic informed the *Illustrations*. Their every detail was meant to raise our minds upward to the general, invariable determining laws of the universe, specifically the laws governing our economic lives. Reciprocally, moving downward, we are to apprehend these laws at work in the tangible events befalling particular characters. Take the first *Illustration, Life in the Wilds*, which illustrated the Scottish Enlightenment theory that all societies must pass through successive stages of economic development. A group of European settlers, ambushed in South Africa, have to rebuild their civilization from scratch. They make an accelerated journey from hunter-gathering, through basic animal husbandry and then agriculture, before re-entering commercial society. This was a 'picture', not a theoretical restatement, of stadial theory, as Martineau explained:

> The works already written on Political Economy...give us its history; they give us its philosophy; but we want its *picture*.... We cannot see why the truth and its application should not go together—why an explanation of the principles which regulate

[3] Mary Berry was an art connoisseur of the late eighteenth to early nineteenth century. Amongst other things, she edited Horace Walpole's writings and discussed aesthetics with the picturesque theorist Uvedale Price. See Palmer (2009: ch. 3).

society should not be made more clear and interesting...by pictures of what those principles are actually doing in communities. (Martineau 1832a: xi–xii)

The thread back to Barbauld's devotional aesthetic may seem thin. But it thickens when we consider that for the early Martineau invariable laws derived from God, whom she regarded, following Priestley, as the origin of an orderly and intelligible universe (Martineau 1877: vol. 1: 111). To grasp determining laws, and perceive them instantiated concretely, is simultaneously to grasp God's regulating power and take comfort in his omnipresence. This was very similar to Priestley's conception of habitual devotion, though Martineau took the idea from Barbauld as well as Priestley.

Admittedly, by the time of the *Illustrations*, Martineau was moving away from religion, which she finally abandoned in the late 1840s (see Stone 2023: ch. 2). But she always retained a belief in invariable laws, which reflected the enduring influence of Barbauld. In addition, on the moral side Martineau's *Illustrations* were informed by another of Barbauld's writings which Martineau praised, her 1773 essay 'Against Inconsistency in our Expectations'. Defending neo-Stoicism, Barbauld declared:

Upon an accurate inspection, we shall find, in the moral government of the world,...laws as determinate, fixed, and invariable as any in Newton's Principia....The man, therefore, who has well studied the operations of nature...will acquire a certain moderation and equity in his claims upon Providence. (Barbauld in McCarthy and Kraft 2001: 187)

For Barbauld, we can lead happier lives if we avoid making unrealistic demands of life and re-educate our desires to conform with the invariant laws of the universe. Then we will demand only what is really possible, and no more. Likewise, in the *Illustrations*, Martineau sought to educate people about the laws of political economy so that they could adjust their desires and actions to what was possible given these laws. This would allow people to attain happiness on a reliable basis, rather than making unrealistic demands that would only lead to frustration and misery (Martineau 1834: 1–2). Martineau's *Illustrations*, then, were imbued with the temperate spirit of Barbauld's work.

4.3 Martineau on Scott and the Moral Purpose of Literature

One may still feel that there is quite a jump from Barbauld's devotional aesthetic to Martineau's *Illustrations*. So there is, partly due to other influences that flowed into Martineau's project besides Barbauld. Important among them was Martineau's engagement with Walter Scott.

This engagement came to fruition in two essays, 'Characteristics of the Genius of Scott' and 'Achievements of the Genius of Scott', written in late 1832 while Martineau was also hard at work on the *Illustrations*.[4] The two essays appeared, signed, in the new liberal periodical *Tait's Edinburgh Magazine*, respectively in December 1832 and January 1833.[5] Later, Martineau made them the opening pair of 'Philosophical Essays' in her 1836 two-volume collection *Miscellanies*. In 1832, she told the journal's sub-editor, William Tait, that her essays were meant to conduct 'an inquiry [into] what kind of fiction is now required...to subserve the purposes of our *sloughing* society'. She added that the essays were 'of some importance, in as far as they may tend to direct a new and powerful engine [i.e., literature] upon those social objects which every good member of society now has to heart'.[6]

Martineau clearly intended the essays to give a general account of literature's moral purpose and of the form that literature must take to fulfil that purpose in the modern age. Why, then, did Martineau frame the essays around Scott? Aside from the fact that Scott and Jane Austen were her favourite authors, part of the answer is that the periodicals employed a porous 'essay-review' format, as I noted in Chapter 1. This format allowed contributors to use their reviews of other authors to advance their own views. Moreover, it was typical of much nineteenth-century British philosophy of art to move seamlessly between criticism of authors, genres, or works (art or literary criticism, as we now see it) and philosophical reflection on general artistic principles. In uniting literary criticism with philosophy of art, Martineau was of her time and place.

In her first essay, on Scott's 'Characteristics', Martineau explains how Scott can write great literature on account of his virtues of character—his 'characteristics'— which find expression in corresponding artistic virtues in his writing. His virtuous character is the condition of his producing great art. What are his virtues?

First, Scott treats everything purely, in contrast to Lord Byron's licentiousness (Martineau [1832] 1836a: 12). By 'purity' Martineau seems to mean that Scott treats everything in a sympathetic and far-sighted way. He does not wallow in his characters' pleasures or sufferings but feels for them while keeping an eye on the bigger picture. In contrast, genius combined with impurity produces 'the two-headed monster of the moral world, one of whose countenances may be regarding the starry heavens, while the other is gloating over the garbage of impurity beneath it' (13).

[4] Iain Crawford (2020: ch. 1) considers the Scott essays in relation to Martineau's writing career and her stadial theory; Ella Dzelzainis (2010) sees them, as I do, as spelling out the underpinning of the *Illustrations*.

[5] In 1834 *Tait's* incorporated *Johnstone's Edinburgh Magazine*, edited by John and Christian Johnstone. Christian, who was female, thereupon became *Tait's* editor until 1846. She was the first woman to edit a major British periodical (see Easley 2004: ch. 3).

[6] HM to William Tait, October 1832, in Martineau (1990: 35); HM to William Tait, November 1832, in Martineau (1990: 37).

Second, Scott has a praiseworthy reluctance to dwell on his merits as a writer. However, his modesty leads him to underestimate the moral importance of his work, and mistakenly to claim that literature is merely 'the amusement of life' and not its 'business'. He declares himself 'no great believer in the moral utility to be derived from fictitious compositions' (Scott, quoted in Martineau [1832] 1836a: 18, [1833] 1836b: 37). In fact, literature's 'first business...[is] the office of casting new lights into philosophy, and adding new exemplifications and sanctions to morals....This is the task, the real "business" of moral philosophers of all ranks and times' (Martineau ([1832] 1836a: 19–20). Literature's primary purpose is ethical: to 'exemplify' moral principles, and to do moral philosophy in a practical and illustrative mode.

Third, continuing the assessment of Scott, he combines frankness with discretion, and his cheerfulness is manifest in the 'lofty faith in humanity' that suffuses his novels. Being industrious, he has written a huge amount, but this has come to him easily and not laboriously, a sense of ease that is reflected in the broad-ranging optimism of his work. Finally, he is practical-minded, hence the 'practical character, i.e., the reality which pervades his loftiest scenes' (27).

Reading this after the death of the author, Martineau's heavy focus on Scott the person may jar, but it reflects her concern with morality. To produce art that imparts moral lessons, she takes it, the artist must be virtuous him- or herself. Realistically, only a virtuous person can possibly produce morally edifying art.

Martineau's ([1833] 1836b) second essay moves on to 'the works of Scott, in their effects as influences, rather than...an analysis of their constitution as specimens of art' (37–38). That is, she sets aside the strictly artistic features of Scott's work to focus on its moral virtues and their beneficial influence on his readers. The first essay went from Scott's virtues of character to the moral virtues of his art; now the second essay radiates out from the virtues in the art to the virtues it spreads in society.

Scott's wide reception, Martineau says, has broken down national boundaries, especially between Scotland and other nations. Rather than teaching abstract equality, he instead shows, by his sympathetic treatment of all his characters, that everyone shares common interests and feelings and merits sympathetic attention. 'He has imparted...the conviction that human nature works alike in all' (51). He exposes the evils of priestcraft and fanaticism through concrete examples (37), and he satirizes eccentricities and follies (39). Even his female characters—'a set of more passionless, frivolous, uninteresting beings was never assembled at morning auction' (48)—unintentionally illustrate the wrongs of the present system of female education, more effectively than Wollstonecraft. Despite these satirical and critical elements, kindliness pervades his work: 'he has...recommended benignity in the survey of life, and indicated the glory of a higher kind of benevolence' (51).

Overall, Scott 'has taught us the power of fiction as an agent of morals and philosophy' (52). This is despite his own mistaken denial that literature has this moral purpose. His works perform their moral service *unconsciously*, not consciously (55). 'We...learn from him how much may be impressed by exemplification which would be rejected in the form of reasoning, and how there may be more extensive *embodiments* of truth in fiction than the world was before thoroughly aware of' (52). Indeed, Scott 'has done more for the morals of society... than all the divines, and other express moral teachers, of a century past'. For 'all moral sciences are best taught by exemplification', so that novelists and dramatists 'have usually the advantage, as moralists, over those whose office it is to present morals in an abstract form' (28).

For Martineau literature is a form of practical moral philosophy, recalling Baillie's description of drama as a 'form of moral writing' (Baillie [1798] 1806: 14). For Martineau, literature *exemplifies* moral rules rather than systematizing them; it shows, or *pictures*, or *depicts*, rather than states. This makes literature a more effective vehicle of moral instruction than theoretical systems. Compared to theory, examples make a more vivid impression, and so they have more emotional impact, are better retained in memory, and enter more fully into our habits and dispositions (Martineau [1833] 1836b: 55).

These claims rest on Martineau's associationist account of the mind. Like Priestley and Barbauld, she was an enthusiast for David Hartley (Martineau 1877: vol. 1: 80). In particular, Martineau's view of literary examples rested on her empiricist distinction between sensory impressions, which are immediate, lively, and vivid ('an impression exerts its influence immediately or not at all'), and facts, which are statements of truth derived from impressions by induction and retained in memory in a more detached and impersonal way (1836c: vol. 1: 216–217).[7] In exemplification, a moral lesson (or a moral fact or principle) is conveyed through a vividly presented imaginary case (an impression). Here the aesthetic element serves the moral one, for the vividness of the example is what enforces the moral lesson effectively. The purpose of literature is not to give us enjoyment in its aesthetic qualities (the vividity of sensory impressions), but to use these qualities to impart moral lessons. And moral lessons *should* be exemplified, not merely stated theoretically, for their vivid sensory presentation imparts the lesson most effectively.

We might be puzzled by Martineau's view that literature 'depicts', for it does not obviously set out to recreate the visible look of things, as representational visual art does. We might also think that rather than giving sensory impressions, literature uses words to express and evoke *ideas*, residues of impressions that have lost their vivacity over time. However, plausibly Martineau thinks that literature is a

[7] This inevitably puts one in mind of Hume's distinction between impressions and ideas, but I have found no evidence that it influenced Martineau, who opposed Hume because she saw him as a sceptic about causal laws (see Stone 2023: 71).

hybrid of ideas and impressions, and that this is precisely what makes it morally effective. Literature expresses ideas, including moral lessons, in imaginary cases that are closely derived from sensory impressions and retain enough of their vivacity to impart the lessons powerfully.

Exemplifications are so effective, Martineau believes, that the writer of moral fictions has the greatest power to shape public morals, much more power than university professors of moral theory. Here she effectively stakes several claims at once: for the importance of her own moral fictions, the *Illustrations*; that the *Illustrations* are works of practical moral philosophy; and that she is doing moral philosophy in the most practically effective form.

In sum, using her evaluation of Scott, Martineau forwards her vision of the moral purpose of literature. The virtues she finds in Scott are the virtues that she thinks literature generally should embody, while his shortcomings show what writers ought to do differently. They should moralize consciously, not unconsciously; they should recognize literature's moral power and wield it knowingly, not merely accidentally. In addition, writers should overcome what Martineau regards as Scott's central limitation, as we will now see: his lack of sympathy for poor and working people.

4.4 Beyond Romance to Realism

Martineau sees sympathetic kindliness as the central virtue of Scott's fiction, but he fails to extend this kindliness to poor farming and working people. He knows nothing of these people, for he 'bonded himself within a small circle' and 'knew not that the strength of soul, which he represents...[in] his heroes,...is of the same kind with that which is nourished in our neighbours of the next alley, by conflicts of a less romantic, but not less heroic cast' (Martineau ([1833] 1836b: 42). Ordinary people feel the same passions and undergo the same conflicts as better-off people—and more genuinely, not hiding them under a carapace of conventional restraint. As Martineau ([1832] 1862) has one of her characters declare in a visionary statement in the *Illustration* 'For Each and For All', written in September 1832 and probably published that October:

> The true romance of human life lies among the poorer classes: the most rapid vicissitudes, the strongest passions, the most undiluted emotions,...the truest experience are there...and yet these things are almost untouched by our artists; be they dramatists, painters, or novelists...From the upper and middling classes are the fine arts mainly furnished with their subjects. This is wrong; for life in its reality cannot become known by hearsay, and by hearsay only is there any notion of it among those who feel themselves set above its struggles and its toils: the greater part of the aristocracy. (27)

In this light, we can retrospectively make sense of the seemingly oblique opening of Martineau's ([1832] 1836a) first Scott essay. The upper classes, she says there, have no knowledge of reality, only belief and imaginings. Working people *do* know reality, but they cannot stop to express their knowledge due to the very pressure of economic circumstances that they know about. We have theorizing without knowledge, and knowledge without theorizing. How then can the upper class ever learn about reality? (3). She finds the solution in those upper-class people who have suffered illness, infirmity, or bereavement. They know enough of hardship to reach out mentally to connect with working people (4). Thus, Scott's infirmity and long illness in childhood allowed him to become a great writer with wide sympathies (5). Even so, his aristocratic background and conservatism left much of reality a sealed book to him, so that 'Scott...knew about as much of the real condition and character of the humble classes...as the Japanese; perhaps less' Martineau ([1833] 1836b: 46).

Transcending Scott's limitations, literature in the 1830s must tackle the real condition of the 'humble classes', Martineau ([1833] 1836b) maintains. The novel should take modern and not feudal society as its landscape, ordinary working and poor people as its protagonists, and base its plots around the dramatic tensions and conflicts of industrial society. The dynamic prose of nineteenth-century life, not the sentimental romance of feudal life, is needed. This puts a vast new field of material at art's hand: morals, politics, economy, working life, are all 'fit for the process of exemplification' (52).

Martineau is dramatically extending the scope of literary sympathy. As we know, Barbauld denied that literature could properly elicit sympathy for the working poor:

> Poverty, if truly represented, shocks our nicer feelings; therefore whenever it is made use of to awaken our compassion, the rags and dirt, the squalid appearance and mean employments...must be kept out of sight, and the distress must arise from...the shock of falling from higher fortunes. (Aikin and Aikin 1773: 203)

Barbauld also held that 'the misfortunes which excite pity must not be too horrid and overwhelming' (196), specifying that the horrors of tragedy, like the gloomy atmosphere of the gothic, arouse amazement and terror more than sympathetic pity (197). As we saw in Chapter 3, Baillie extended literary sympathy into the gothic regions where Barbauld claimed it could not reach: 'violent and gloomy passions', 'Battles, tortures and death' (197), and 'violent expressions of passions and distress' (199). However, like Scott's novels, Baillie's tragedies were limited in that her protagonists remained high-born and upper-class. They lived in quasi-medieval societies regulated by feudal hierarchies. To this extent, Martineau went

far beyond Baillie, extending sympathy to characters who are ordinary working people in the modern industrial world.

It is worth clarifying that Martineau would have known the 'Enquiry into those Kinds of Distress which Excite agreeable Sensations' in which Barbauld set out her restrictions. It appeared in *Miscellaneous Pieces*, which Martineau had read (as we know from 'Female Writers on Practical Divinity'). And she probably knew that Barbauld was the author, since Barbauld and the Aikin family had talked to her about who wrote what.[8] Martineau knew Baillie's work too: she could hardly avoid it, given Baillie's fame, just as Baillie could hardly avoid Martineau once the *Illustrations* made her a 'literary lion'. The two became friends in the 1830s, as Martineau tells us in her *Autobiography* (Martineau 1877: vol. 1: 270–271). Before this, as I mentioned earlier, Martineau already viewed Baillie as a role model, if not quite as much so as Barbauld. Martineau praised the 'invulnerable justification which [Baillie] set up for intellectual superiority in women' (271) (Baillie had, for instance, worked her own way through Euclid; see Slagle 2002: 67–68). Reciprocating Martineau's warmth, Baillie said of her *Society in America* that 'the descriptive part of it is beautiful and I think decidedly marked with genius and often with good feeling', though she objected to Martineau's 'political discussions, always referring to abstract principles' (JB to Dr Norton, 24 October 1837, in Baillie 1999: vol. 2: 945).

As for Martineau's differences from Baillie, the clue here is that Baillie and Scott were very close, not only as friends from 1806 onwards but also in their literary practice.[9] Martineau was well aware of this proximity (see, e.g., 1877: vol. 2: 317). To this extent, her objection to Scott's feudal settings and narrow circle of high-born characters applies to Baillie too.

Crucially, though, Martineau remained faithful to one of Barbauld's restrictions on literary sympathy: 'No scenes of misery ought to be exhibited which are not connected with the display of some moral excellence or agreeable quality' (Aikin and Aikin 1773: 196). Baillie differed, many of her tragic protagonists ending up at the mercy of brutal and even murderous passions. Admittedly, she insisted that these characters remained 'noble' and essentially good. Their passions had overwhelmed them, but the passions deserved execration and not the people. Even so, Baillie extended sympathy to larger-than-life, violent, and tumultuous individuals who had committed serious crimes. For Martineau, on the contrary, it remained almost axiomatic that we can only properly sympathize with real and fictional people insofar as they are virtuous. If literature

[8] For instance, Martineau knew who contributed what to *Evenings at Home*—'Mrs B and the Aikins have always anxiously explained this' (HM to the Beauforts, 9 June 1867, in Martineau 2007: vol. 5: 180).

[9] See Slagle (2002: ch. 3). Baillie and Scott independently gravitated towards their shared aesthetic, and they met only after Baillie had published *Plays on the Passions* Volumes 1 and 2.

led us to sympathize with wrongdoers and vicious characters (whether on the page or in real life), then it was failing in its moral purpose.

In short, Baillie enlarged sympathy in the direction of romantic passion but left its class restrictions in place. Conversely, Martineau enlarged sympathy over class boundaries but had little time for passion or deviations from virtue. As we will see, this is reflected in the *Illustrations*.

4.5 *Illustrations of Political Economy*

From Sections 4.2 to 4.4 we can pull together the moral–aesthetic framework underpinning Martineau's *Illustrations*:

Art's moral purpose. Artworks have a great moral influence because they illustrate moral principles rather than state them; they show rather than tell. This makes their lessons vivid and memorable. Since artworks have this power, the artist's 'first business' is not to amuse or entertain but to impart moral lessons, ideally with self-awareness.

Moral exemplification, and general laws as moral principles. The purpose of literature is to exemplify moral principles, *and* to raise our minds to grasp the general laws that regulate the universe and perceive them at work. These two go together, for Martineau, because the morally right thing to do is follow the general laws of the universe. If we obey these laws, and make them the principles of our action, then we can obtain happiness and avoid asking more of the world that it can possibly give. As we saw earlier, Martineau took this idea from Barbauld's neo-Stoicism. To act virtuously is to obey these general principles. Literature must show that virtuous people who follow these laws prosper, and that the vicious suffer when the laws that they are flaunting act back upon them, a sort of punishment administered by the universe itself.[10]

The moral case for realism and not romance. Literature has been limited by its exclusive concentration on the privileged classes. Now it must focus on working people. This follows from literature's moral purpose. Literature is to embody virtues and spread virtues to its readers, and sympathy is one of these virtues (as Martineau said apropos of Scott). Literature's class limitations are therefore limiting its moral power, the scope of its sympathy. So, on moral grounds, the novelist must jettison feudal romance for modern realism. Only then will middle- and upper-class people develop sympathy for working people in real life.

Laws of political economy as part of moral laws. However, working-class characters in fiction will only command our sympathies if they are virtuous, and to be virtuous they must follow the general laws of the universe. Or rather, more specifically, they must follow one branch of these laws: those that govern our

[10] For more on Martineau's moral theory, see Stone (2023: ch. 2).

economic lives. These laws are theorized by the science of political economy. For Martineau, these economic laws are the 'counterparts of the natural, immutable, and inevitable laws of the physical sciences' (Freedgood 1995: 33). Like all general laws, these economic laws supply some of the moral principles that should govern our actions, in this case our actions in the economic domain. Why should it be economic laws that working-class characters are shown to act on? Precisely because these characters are *working* people, embroiled in economic struggles. If literature is to foreground working people and their virtues and vices, it must also foreground the laws of political economy, since these shape people's working lives. Accordingly, literature should show that working people's lives go well or badly depending on whether they obey these economic laws.

This is the singular framework behind Martineau's *Illustrations*. Let us now look at the framework fleshed out in *Illustration* number 7, *A Manchester Strike*, from 1832.

The central character is a working man, William Allen. He is a good man, self-disciplined and principled, well-respected by both fellow-workers and capitalists, making him an effective union representative and mediator. Unfortunately he is meek and timid and so, despite his better judgement, he is pressurized by a group of unscrupulous workers into supporting a strike. The strike is a response to falling wages—but, Martineau makes clear, artificially raising wages is not in the capitalists' power. The problem is an excess supply of workers on the market, since working people are having too many children. One of the capitalists urges this point (1832b: 35), which Martineau spells out again at the end (she closed each tale with a statement of the principles it illustrated): 'THE PROPORTION OF THIS FUND [the wages fund] RECEIVED BY INDIVIDUALS MUST MAINLY DEPEND ON THE NUMBER AMONGST WHOM THE FUND IS DIVIDED' (134). Thus, as in other *Illustrations*, Martineau (controversially) supported birth control as the only means by which workers could obtain, and realistically demand, better wages.

The strike goes ahead but inevitably fails to achieve its goal. It leaves the workers even worse off, having lost income when striking and then finding that the capitalists can only afford to rehire some of those employed before the strike. One of those laid off is Allen. The final chapter, 'Hope Extinct', ends:

> There were other circumstances which made them scarcely able to believe him the same William Allen....He no longer...appeared to see others as they passed;...He would not even represent his children, who grew up one after another to be employed in the factories, while their father toiled in the streets with his water cart in summer and his broom in winter...(133)

We feel sad for Allen—a terrible, unrelieved sadness pervades the entire tale. It is an icy sadness, for Martineau conveys that Allen does not simply deserve our sympathy. He has in a sense got his deserts, having brought his downfall on himself.

Yet Martineau does not want this critical judgement to drown out our sympathy altogether. She therefore depicts Allen as a fundamentally responsible, upstanding man who is reluctant to strike. He must be basically good for us to sympathize with him (as with Baillie's character De Monfort), though Allen makes a tragic error of judgement in acceding to the strike. As Martineau (1834) states in 'The Moral of Many Fables', the final *Illustration* which reprises all the principles exemplified in the series:

> There are many William Allens among the class of operative; but I also believe that few of these are leaders of strikes. Allen was an unwilling leader of a strike; and there are many who see even more clearly than he did the hopelessness and mischievousness of the contest, who have…more nerve to make a protest against a bad principle, and a stand against a bad practice. I believe that the most intelligent and the best men among the working-classes now decline joining a turn-out…(55)

Martineau may well seem unduly harsh towards Allen, and her judgements are coloured by her hostility to strikes. At the same time, she makes a radical innovation in treating a hard-pressed working-class man as a tragic hero. To return to her statement of the realist programme in 'For Each and For All' ([1832] 1862):

> Our painters of life do not take into account—in fact know little of—some of the most important circumstances which constitute life, in the best sense of the word. They lay hold of the great circumstances which happen to all, the landmarks of universal human existence, and overlook those which are not less interesting, though not universal. They take Love; and think it more becoming to describe a Letitia going to the altar with a lord F–, than a weaver and his thoughtful bride taking possession of their two rooms, after long waiting and anxiety. (128)

Or, we might say: they take Tragedy, and describe a De Monfort in a quasi-feudal society, overcome by hatred and driven to murder his rival Rezenvelt, rather than a factory worker ruined for lacking the courage to resist the shorter-sighted and rebellious workers around him.

If Martineau's sympathy for Allen is limited, she arouses much keener sympathy for the children in the story, above all Allen's daughter Martha. We meet her right away, seen through Allen's eyes as they walk home from work (Martineau 1832b):

> He saw her before him for some distance, and observed how she limped, and how feebly she made her way along the street (if such it might be called), which led to their abode. It was far from easy walking to the strongest. There were

heaps of rubbish, pools of muddy water, stones and brickbats lying about, and cabbage leaves on which the unwary might slip, and bones over which pigs were grunting, and curs snarling and fighting. Little Martha, a delicate child of eight years old, tried to avoid all these obstacles; but she nearly slipped down several times, and started when the dogs came near her, and shivered every time the mild spring breeze blew in her face. (2)

Martha Allen is clearly the prototype of Dickens's better-known Tiny Tim from *A Christmas Carol*. Sad, infirm, and in failing health, Martha's source of comfort is her companion animal, Billy the bird. He symbolizes her dreams of escape and flight and, since he lives in a cage, her current plight. Even this crumb of comfort is snatched from Martha when the family's economic losses during the strike force them to sell Billy to a local animal dealer. Allen promises to buy Billy back as soon as he can. But the strike drags on, and instead:

Every day for the next fortnight,... little Martha lingered about the bird-fancier's door... One day she was remarked by her parents to be very silent; and after that she went out less. She had missed Billy, though his empty cage still hung in the shop; and having made bold to ask, had found that he was sold to a country customer; really gone for ever. (118)

Our sympathy for Martha is unqualified since, unlike Allen, she is not responsible for any moral errors. Rather, she is the helpless victim of Allen's mistake. In this way, though, our compassion for Martha arraigns Allen all the more.

There have been countless criticisms of Martineau's *Illustrations* in general and *A Manchester Strike*, one of the most popular *Illustrations*, in particular.[11] Much of the story consists of arguments and counter-arguments between workers and capitalists, resulting in something of a hybrid with a philosophical dialogue. Deirdre David (1987) complains that 'the characters speak as the embodiments of the stiff principles that they are' (42) and are more abstractions than rounded individuals. They stand for general principles: excessive attachment to strikes in some workers, lack of sympathy in some capitalists. The characters cannot develop freely, as they are only there to embody economic principles and abstract arguments; they are wooden, or so many critics have complained.[12]

[11] For a sample of these criticisms, see Bulwer-Lytton (1833), David (1987), Fenwick Miller (1887: esp. 81), Freedgood (1995), and Oražem (1999: ch. 4).

[12] Eleanor Courtemanche (2006) suggests that criticism of Martineau's wooden characters is misplaced because her real protagonists are not individuals but economic laws (384). Perhaps the *Illustrations* do give a rounded portrayal of *these* protagonists—the laws—in all their developments, ramifications, consequences, and so on. I am intrigued by this suggestion but not wholly convinced. It seems to me that William Allen *is* the protagonist and that he is a working-class realist version of a tragic hero.

The woodenness charge recalls the main criticism levelled against Baillie, which was that her organizing moral concept of illustrating one passion per play, and her relegation of plot to a subordinate element, meant that her characters could not develop freely and had no life. Francis Jeffrey (1803), writing anonymously, said that to Baillie's

> peculiar plans,...we confess that we are far from being partial; they necessarily exclude many beauties, and ensure nothing but constraint; the only plan of a dramatic writer should be, to please and interest as much as possible; but when,...he resolves to write upon nothing but...the history of a passion in every one of his pieces, he...puts fetters on the freedom of his own genius. (269)

Baillie, he continued, had put moral concepts above aesthetic beauty (270). Very similarly, Edward Bulwer-Lytton (1833) (himself a novelist in the then popular 'silver-fork' genre, dealing with the lavish lives of the upper class) said of Martineau, again anonymously, that:

> it is but fair to attribute the greater part of the defects [of the *Illustrations*]...to Miss Martineau's evident desire of making everything subordinate to the illustration of certain valuable truths....We wish that...she would put her imagination under less visible and cramped restraint. (150–151)

Baillie and Martineau alike were accused of adopting concept-driven frameworks that constricted their material like a Procrustean bed. Interestingly, they were *not* accused of over-emotional feminine gushing. Quite the opposite; their work was judged to be too theory-driven.[13]

I want to suggest something different: rather than the series being flawed because it rested on a moral framework, it was flawed due to tensions *within* that framework.[14] Earlier we identified several elements of the framework: the idea of art's moral purpose; moral exemplification and general laws as moral principles;

[13] In a now-classic essay, Isobel Armstrong (1995) held that male critics censured female Romantic poets, especially Felicia Hemans, for feminine gushing (15). For Armstrong, the female poets actually used feminine-coded stylistic features self-reflexively and subversively (32). But in any case, the critics of Martineau and Baillie wanted *more* gushing, not less—Bulwer-Lytton specifically urged Martineau to explore the passions.

[14] Others have located the problems elsewhere. For instance, Catherine Gallagher (1985: 51–61) traces them to Martineau's belief in causal determinism (on which see, for example, Martineau 1877: vol. 1: 85, 110–11). Gallagher argues that this makes Martineau's tales flat, lacking in drama, and unemotional—the same fault that Baillie found in the Greek tragedies, again blaming it on their determinist premises. But if, contra Baillie, their determinism does not make the Greek tragedies flat, that suggests that it is not Martineau's problem either. Moreover, Martineau seems to assume that the characters *can* make free choices, as when Allen wrongly decides to acquiesce in the strike. In contrast, for Martineau, the right choice is to follow the general laws of the universe, including the law about the size of the wages fund. Yet this reveals another problem. The reason why Martineau thinks it is right to follow these laws is that we must obey these laws anyway: they are invariant, and it is quixotic to

the moral case for realism not romance; and political economic laws as part of morality. Having looked at *A Manchester Strike* we can now spell out two additional constituents of the framework:

Moral purpose before aesthetic detail. In exemplification, the aesthetic features of artworks—their sensory detail and emotional qualities—convey moral lessons. The artist should therefore avoid delving into sensory details for their own sake, or dwelling on vicious behaviour or suffering, or physical pleasure or sensations, in their own right. These should only be depicted to the extent necessary to exemplify a moral point.

Sympathy with the virtuous. In the service of exemplification, artists should employ sympathy. When we are led to sympathize with virtuous characters, this inclines us to support the virtuous behaviours they exemplify, and to sympathize with similarly virtuous people in real life. But concomitantly we should not be led to sympathize with vicious or misguided people in real life, so fiction should not invite boundless sympathy for all characters. Sympathy must be for the virtuous and where it is for those of limited virtue, like Allen, it must be for their virtue only, *not* their mistakes.

Martineau adheres to this framework in *A Manchester Strike*. She does not linger over the sufferings of Allen, Martha, or anyone else; they are outlined with understated brevity. Description is sparse, just sufficient to illustrate the basic points at hand. The lack of sensory warmth and detail mirrors the workers' impoverished and aesthetically depleted lives. But for Martineau it is *right* that sensory details should not be delved into, so that rather than lamenting or condemning the aesthetic deprivation of working-class people's lives, she replicates it.

This lack of aesthetic detail in turn limits how far the characters arouse our sympathies. Allen's tragic potential cannot be fully realized, as Martineau passes swiftly over his downfall and narrates it in a matter-of-fact way. She skims too quickly over the surface of the suffering to bring it home to us. Even with the sale of Martha's bird, Martineau (1832b) moves swiftly on: 'This hope destroyed, Martha tried to comfort herself, as she had proposed, with visions of a triangle' (i.e., the musical instrument that she hopes to learn to play) (118). Martineau wants to portray Martha as virtuous, sympathy-worthy, looking for a positive solution instead of giving way to self-pity. But, again, it means that the depths of her sorrow cannot be plumbed.

The tale's power to arouse our sympathy for the characters is curtailed further because Martineau wants to ensure that we judge them in light of moral principles. She does not look too deeply into Allen's tragic fate, as it would push our sympathy beyond the proper limits set by the judgement that he has made a serious mistake. Moreover, we are to judge Allen and others in light of the principles of

disobey them. But that implies that we have no choice in the matter after all. On this contradiction in Martineau's thought, see Stone (2023: ch. 2).

political economy, so that Martineau ends up, not so much criticizing the harsh economic regime under which her working-class protagonists are living, as insisting that they must learn to conform to economic requirements, difficult as this may be. This contributes, too, to the leaden sadness of *A Manchester Strike*: the sense that there is no escape anywhere from the unwavering laws of the market.

Finally, Martineau's limited aesthetic detail and restricted sympathies come into a tension with her realism. She aims to foreground ordinary working people leading their everyday lives (Martineau [1832] 1862), and she insists that they must be pictured as they are, not as aristocrats falsely imagine them (128–129). Yet she largely depicts these characters not as they are, but either as they *ought* to be (with the characters who deserve sympathy) or as they ought *not* to be (with the unsympathetic ones). As to how the characters might be beyond this rubric— how Martha may feel to relinquish Billy, aside from her virtuous search for a new source of hope—this is not the proper concern of literature.

In the end, then, Martineau's programme falls short of her inspiring mission statement that literature should advance into the modern era by expanding sympathy across class boundaries. She does not enlarge our sympathies as much as we might have hoped. They remain heavily restrained, more so than with Baillie, who for all her quasi-feudal stagings leads us to understand and engage with individuals that Martineau would think unworthy of sympathetic understanding.

Martineau's *Illustrations* are thus torn between realism and moralism, sympathy and principle, aesthetic detail and general rule. These tensions are connected, for limited aesthetic detail means limited sympathy, and lack of emotional warmth impoverishes the tales aesthetically. Both these limitations also compromise Martineau's realism.

4.6 Martineau on Bad Art

Martineau pioneered a turn to depict ordinary working people which Dickens, Eliot, Elizabeth Gaskell, and many others took forward.[15] In particular, as I will now suggest, Eliot developed her version of realism partly to surmount the problems of Martineau's approach. To be sure, Eliot's realism synthesized a vast panoply of influences: Comteian positivism, Herbert Spencer's sociology, German historicism, and Spinoza's metaphysics (see Fleishman 2010). But amongst these, her reaction to Martineau has a place.

[15] For example, *A Manchester Strike* influenced Gaskell's 1848 novel of working-class life *Mary Barton*. See Fryckstedt (1980), and on Martineau's wider relations with Gaskell, see Sanders (2002). On Martineau's influence on the 'social novel', see Cazamian ([1903] 1973) and Kovačević (1975).

In the 1840s Eliot loved and admired Martineau's fiction.[16] We can still see Martineau's influence in *The Mill on the Floss*, when Eliot ([1860] 2016) says that as well as the 'conspicuous, far-echoing tragedy' of 'very lofty personages', 'The pride and obstinacy of millers and other people you pass unnoticingly on the road every day, have their tragedy too; but it is of that unwept, hidden sort that...leaves no record' (147). But in other ways Eliot's literary programme stood in pointed contrast to Martineau. In the slightly earlier anonymous *Westminster Review* essay 'The Natural History of German Life' which set out the key ideas driving her realist fiction, Eliot (1856) insisted that: 'The thing for mankind to know is, not what are the motives and influences which the moralist thinks *ought* to act on the labourer or the artisan, but what are the motives and influences which *do* act on him' (54).[17] This idea of tracing the motives that really do act on people fed into *The Mill on the Floss*, informing its famous statement that the novelist needs to bracket moral 'maxims' and unfold characters' situations and experiences in rich detail without moral judgement (Eliot [1860] 2016: 371). Then the reader can enter imaginatively into the characters' minds, coming to see things as the characters see them and understand why these characters feel as they do. The reader is thereby led to sympathize with the characters. These sympathetic reactions, Eliot had already argued in her essay, furnish the 'raw material' of moral sentiment (Eliot 1856: 54).

For Eliot then, genuine sympathy depends on realism, which requires both a suspension of moral judgement and the provision of enough sensory detail of the world to create a fully rounded sense of reality. This belief in an intrinsic connection amongst bracketing moral maxims, providing sensory detail, realism, sympathy, and genuine moral sentiment seems calculated to improve on Martineau. Indeed, Eliot (1856) was surely alluding critically to Martineau in saying:

> The greatest benefit we owe to the artist, whether painter, poet, or novelist, is the extension of our sympathies. Appeals *founded on generalisations and statistics* require a sympathy ready-made, a moral sentiment already in activity... (54; my emphasis)

Eliot gave literature just as serious a moral mission as Martineau. For Eliot, that mission was to enlarge our sympathies, first imaginatively, then emotionally, then practically in real life. Like Martineau, Eliot thought that literature must be realistic to fulfil this mission. But for Eliot, literature could only be truly realistic and accomplish its moral mission if it gave greater rein to the aesthetic features

[16] See Eliot to Martha Jackson, 21 April 1845, in Eliot (1954–78: vol. 1: 189); Eliot to Mrs Bray, 25 May 1845, in Eliot (1954–78: vol. 1 192). Eliot and Martineau became very close in the early 1850s, but they fell out because Martineau disapproved of Eliot's relationship with George Henry Lewes.

[17] 'I undertake to exhibit nothing as it should be; I only try to exhibit some things as they have been or are', she later added (Eliot to Blackwood, 15 February 1861, in Eliot 1954–78: vol. 3: 378).

that Martineau truncated: vivid, lingering sensory description; deep probing of emotions; the slow, organic unfolding of motivations, actions, interactions, and consequences; and imaginative reach into characters' own views of the world—how they must and do react to the circumstances unfolding around them, not how they ought to react.

Martineau was not persuaded. On the contrary, she regarded most of the fiction of her younger contemporaries, including much of Eliot's work, as bad art. Martineau's critical remarks shed additional light on her account of art and morality.

One novel that Martineau was relatively positive about was Charlotte Brontë's *Villette*, but in an anonymous review Martineau (1853) still objected that the female characters were all obsessed with love, but 'reason and taste will reject the assumption that events and characters are to be regarded through the medium of one passion only' (2). Moreover, *Villette* had an atmosphere of excessive, unrelieved misery. The novel lacked 'anybody that is good—serenely and cheerfully good' along with 'the cheerfulness of health with its bracing influence' (2) (in contrast, of course, to Scott). Martineau's criticisms of Brontë deepened over time. In her *Biographical Sketches* (1869) she deplored 'the coarseness which to a certain degree pervades the works of all the [Brontë] sisters, and the repulsiveness which makes the tales by Emily and Anne really horrible to people who have not iron nerves' (48).

In the same critical vein, she said of Wilkie Collins:

I have been reading at last, from a sense of duty, what I avoided before—the 'Woman in White'. I see it constantly treated as a *model* story; so I have read it. I have found it simply a bore,...There is to me no charm of character whatever...no moral interest; and the horrors are done by a mere chafing of the reader's memory and imagination. I can't conceive how it can be so popular. (HM to Samuel Lucas, 18 December 1862, in Martineau 2007: vol. 4: 362)

This resonated with her objections to Dickens and Eliot:

We have been reading 'Clerical Scenes' [Eliot's *Scenes of Clerical Life*] and find them odious...'Janet's Repentance' leads one through moral squalor as bad as Dickens's physical squalor (in the Marshalsea & elsewhere). I am sure it is bad art in both—and in all such cases. Plenty of 'power'—of satire; but I don't like *coarse* satire. (HM to Henry Reeve, 25 December 1859, in Martineau 2007: vol. 4: 207)

For Martineau, art that waded through moral and physical squalor or was 'coarse', or dwelt on misery, was morally bad. And since its content was morally bad, it was also artistically bad—'bad art in all such cases'.

How do the moral flaws translate into artistic flaws? First, considering *The Woman in White*, the characters (allegedly) are not virtuous, so the reader cannot sympathize with them and does not care what happens to them, so that the work becomes boring. Vicious characters produce an uninteresting artwork. Second, if novelists dwell on vices, passions, distress, or strong physical sensations of any kind, this produces disgust—that is, aesthetic displeasure. For instance, Martineau said of Gaskell's 1853 novel *Ruth*, about an unmarried single mother, that it contained 'much that is disgusting and a good deal that is poor'—adding six years later 'How entirely Mrs Gaskell fails, except in single portraits.'[18] To focus on 'coarse' sensory material is to revel in the lurid and unpleasant sensations of the physical world, what Martineau in her Scott essays had called the 'garbage of impurity'.

Admittedly, if a novel includes no suffering, difficulties, or bad behaviour at all, then it will lack drama—a dramatic narrative requires antagonists as well as protagonists. And on Martineau's own terms, novels should deal with people's real-life struggles with poverty, hard work, illness, losses, and so on. Without contending valiantly with these forces, the characters cannot exhibit virtue in the first place. But such difficulties as hard work, poverty, failing harvests, and so on, should be rendered in only enough detail to give the characters adversity to overcome (as when Martha immediately moves on from losing her bird to hoping to learn to play the triangle) or fail to overcome (as when Allen mistakenly accedes to the strike).

In this light, we can understand Martineau's (1877) statement:

I object to no real subjects into which pure moral feelings of any kind can enter. Whether they are, when finished, moral or immoral, depends on the way...they are treated; whether in a spirit of purity and benignity, with foul gusto, or with a mere view to delineation. (vol. 3: 195)[19]

A pure, benign treatment of suffering and vice places them as small elements in a bigger tapestry that is morally instructive. In contrast, 'foul gusto' revels in sensory details that ought really to be passed over quickly so as not to arouse disgust.[20]

[18] HM to Mrs Ogden, 11 February 1853, in Martineau (2007: vol. 3: 265); HM to Henry Reeve, 14 March 1859, in Martineau (1990: 177).

[19] Again, this went back to her Scott essays, where she said that any subject-matter could be treated in a pure *or* an impure way, 'as the food of appetite [viz. Byron], or of the affections, chastened by philosophy [viz. Scott]' (Martineau [1832] 1836a: 12).

[20] 'Foul gusto' alludes to John Keats's now-famous remark about Shakespeare: 'The poetical character has no self...it lives in gusto, be it foul or fair, high or low—it has as much delight in conceiving an Iago as an Imogen. What shocks the virtuous philosopher delights the chameleon poet' (Keats to Woodhouse, 27 October 1818, in Monckton Milnes 1848: vol. 1: 221). Martineau read and enjoyed this 1848 edition of Keats's letters, edited by her good friend Richard Monckton Milnes (HM to Milnes, 23 October 1848, in Martineau 2007: vol. 3: 131-2). Despite the enjoyment, she clearly rejected Keats' view.

The third alternative, 'mere delineation', is also artistically flawed. Martineau took 'mere delineation' to be the nature of Eliot's realism, which led to bad art—Martineau found all Eliot's novels up until *Middlemarch* shamefully bad. Martineau explained:

> Miss Evans insists (or did formerly) that in all the arts, true delineation is good art. This was before a disagreeable picture of a stork killing a toad. Being asked whether men on a raft eating a comrade would be good in art, she was silent; but repeated her dictum afterwards. (HM to Henry Reeve, 7 May 1861, in Martineau 2007: vol. 4: 274)

To 'delineate' is to render the details of the physical and human world just as they are, abstaining from moral judgement. This produces bad art because it misunderstands the purpose of literature, which is to use sensory details to illustrate moral truths, not to linger over these details in their own right, and not to present them shorn of any moral qualifications.

Considering Martineau's disapproving remarks about her fellow novelists, Valerie Sanders (1986) reasonably asks: 'Why did Harriet Martineau apparently reject a rigorously pursued realist position, having, at the start of her career, so strongly endorsed it?' (22). Sanders finds the answer in Martineau's desire to strike a 'fine balance between too stark a realism on the one hand, and too rosy and flimsy an idealism on the other' (26). I see this somewhat differently. Martineau censured Dickens, Eliot, and others on the grounds that literature's primary purpose was moral, and that the aesthetic qualities of literature must be subordinated to its moral lessons. This moral orientation motivated Martineau's realism, as I have explained, for she saw the failure of Romantics like Scott to sympathize with working people as a major moral limitation. To fulfil its moral mission, literature must take a realist turn towards the modern, industrial, working world. But because moralism *motivated* Martineau's realism, it also *limited* her realism, which could only go as far as moral education permitted and no further. When she saw others taking realism beyond those limits, she protested.

The Woman in White, Wuthering Heights, Little Dorrit—Martineau branded as bad art some of the most powerful, exciting, and moving literary fiction ever made. Surely, we might think, this reflects a problem with her theory of art. I agree. The central problem, I have tried to show, was Martineau's subordination of the aesthetic to the moral, of sensory impressions to abstract ideas. She granted literature and art great emotional and motivational power because they illustrate moral principles vividly. That, after all, was why Martineau wrote the *Illustrations*, a series of *tales*, not a treatise on political economy. Nevertheless, she took art and literature, and their aesthetic qualities—their sensory vividity and emotional power—to be valuable not in themselves but only because they are effective for

imparting morality. This is why she truncated the sensory vividity and emotional depth of her *Illustrations* to ensure that they conformed to moral principles.

The result, it must be said, is that the *Illustrations* offer limited aesthetic pleasure. Later readers have often found them hard going: Leslie Stephen (1893) described them as 'an unreadable mixture of fiction...with raw masses of the dismal science' (310). Unlike Stephen, I think that Martineau remains worth reading. She had a singular philosophical position, and she was important both as a representative of aesthetic moralism and as a pioneer of literary realism. We may not agree with her account of art and literature, but we can still benefit from thinking through her *Illustrations* and the framework behind it. There has been nothing else quite like it.

5
Aesthetics and Ethics in Anna Jameson's *Characteristics of Women*

5.1 Introduction

In nineteenth-century Britain, America, and beyond, Anna Jameson influenced thinking about art to an extent that scholars have only recently been rediscovering. Ray Strachey (1928) observed in *The Cause* that by the 1850s Jameson was 'the idol of thousands of young ladies. Her books on pictures, on Shakespeare's heroines...were exactly what the period admired' (89). Young ladies were not the only admirers. Jameson was good friends with Charles Eastlake, the first Director of the National Gallery in London; through him, she influenced the Gallery's policies and collections (see Avery-Quash 2019). The Pre-Raphaelite artist Dante Gabriel Rossetti was impressed by her works and recommended them to the other Pre-Raphaelites (see Ludley 1991). John Ruskin too, notwithstanding some sexist remarks about Jameson, was influenced by her (see Johnston 1997: 175–176). For instance, he declared that 'Shakespeare has no heroes—he has only heroines' (Ruskin 1865: 126)—a view taken from Jameson, as we will see.

More evidence of Jameson's stature comes from the periodicals.[1] The *Monthly Review* deemed Jameson a 'remarkable writer and powerful thinker' (Anonymous 1840: 414), the *Spectator* declared: 'Among the...illustrious women who have done real work in connection with painting and sculpture, Mrs Jameson is rightly placed' (Anonymous 1878: 1470), and for the *Athenaeum*:

> She has excellently shown the want under which we have till lately been labouring of anything like sound critical taste....She writes enthusiastically—poetically; brings to her task erudition, even in philological particulars; and has exhibited her taste for Art...To the artist and the connoisseur these volumes will be...of incalculable advantage. For the interpretation of the mysteries of Sacred and Legendary Art he need henceforth look no further than to its pages. (Anonymous 1848: 1335–1336)

[1] For more on the numerous reviews of Jameson's works, almost all positive, see Robinson (2000: 167–8).

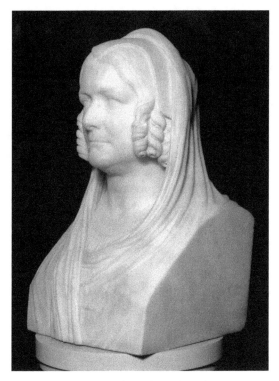

Figure 5.1 Bust of Anna Jameson by John Gibson (1862)

These are not anomalies: John Kemble (1839) noted the exceptional level of approval with which Jameson's work had met (134–135), and when the novelist William Thackeray attempted to publish a criticism of her in *The Times,* he admitted he had been 'as disgustingly offensive, vulgar and impertinent and cowardly as I ever was in my life'—and, anyway, his piece was rejected (Thomas 1967: 141).

A recurring theme was Jameson's genius. The heavyweight *Edinburgh Review* called her 'a woman of genius' who produced 'eloquent and philosophic female criticism' (Moir 1834: 181). *Blackwood's Magazine* likewise spoke of her 'fine genius' and 'luminous...philosophical criticism' (Wilson 1833: 141). The inscription on the bust of Jameson made by the neo-classical sculptor John Gibson after she died begins: 'Anna Jameson, a distinguished critic, and writer upon art. Endowed with poetic genius, and a vigorous understanding.' (The bust is now housed in the National Portrait Gallery in London; see Figure 5.1.) Jameson thus presents our most glaring case yet of a woman hailed in the nineteenth century as a philosophical critic of genius, yet roundly ignored for most of the twentieth century.

Her obituary in the *New York Times* proclaimed:

> As an art-critic Mrs Jameson was almost unrivalled. She appreciated and expounded not only technical excellence, but the inward meaning of works of art; the relations they bear to the history of art itself, and the history of nations among whom they were created. (Anonymous 1860a: 1)

The phrase 'almost unrivalled' shows that Jameson was regularly seen either as Ruskin's equal or as a close second. The *Saturday Review*, for example, remarked that: 'It is to Rio *and* Ruskin,...Mrs Jameson *and* Lady Eastlake, that we have to go for the "libri idiotarum"' ('books for the illiterate', i.e., the reading of visual artworks) (Anonymous 1864: 791; my emphasis). From twentieth- and twenty-first century histories, one would scarcely suspect that Jameson once had an authority roughly comparable to Ruskin. On the contrary, the standard view now is that 'the most significant figure in nineteenth-century British aesthetics was...John Ruskin' (Guyer 2014: 191) and that 'John Ruskin [was] the most important nineteenth-century British writer on art' (Kravetz 2017: 11). This view persists even though Jameson has undergone an amount of recovery. This began with a superb biography by Clara Thomas (1967), then an important article by Adele Holcomb (1983), and then a wave of scholarship from the 1990s onwards, including Judith Johnston's (1997) invaluable monograph.[2] However, philosophers, aestheticians included, have yet to pick up on this scholarship.

Holcomb called Jameson 'the first professional English art historian', but this needs qualification. Jameson was a scholarly and meticulous researcher, but she still wrote before professionalization and specialization proper. Accordingly she ranged over history, biography and life-writing, literary theory and criticism, religion, art history and criticism, travel writing, politics, women's studies, and philosophy. The red thread was the relation between art and ethics. The titles of some of her books show this: *Characteristics of Women: Moral, Poetical and Historical* (1832), *Memoirs and Essays Illustrative of Art, Literature and Social Morals* (1846), and *A Commonplace Book of Thoughts, Memories, and Fancies*, divided into *Part I: Ethics and Character* and *Part II: Literature and Art* (1854).

How did Jameson view the connection between art and ethics? Generally she thought that an artwork was better as art the more morally sound it was. For instance, Jameson ([1854] 1855) said in the *Commonplace Book*: 'The morals of art,...we must never lose sight of. Art is not only for pleasure and profit, but for good and for evil' (282). She drew a contrast with Goethe:

> Goethe, who...laid down the principle that works of art speak to the feelings and the conscience,...by some strange inconsistency places art and artists out of

[2] See inter alia Adams (2001), Anderson (2020), Fraser (2014), Hughes (2016), (2022a), Kanwit (2013), Palmer (2017), Robinson (2003), and Styler (2010: ch. 4).

the sphere of morals. He is wrong.... The idea that what we call *taste* in art has something quite distinctive from conscience, is one cause that the popular notions concerning the productions of art are abandoned to such confusion and uncertainty. (284)

For Jameson, the moral and aesthetic aspects of artworks were so closely connected that we can only appreciate artworks aesthetically (with taste) if we also respond to them morally (with our consciences). Similarly, in 'Some Thoughts on Art' (1849b) she maintained:

Art is for PLEASURE and for CONTEMPLATION.... But not only must we have pleasure and contemplation associated together; they must be associated in equal measure... The intense feeling of Beauty, merely as such, without a due exercise of... the intellect, or a due subjection to the moral sympathies, produces... if not a degraded and frivolous, at least a narrow and defective, taste in art. (103)

Jameson may sound like Harriet Martineau, but there were significant differences. For Jameson, contemplation (moral response) and pleasure (aesthetic response) must be associated 'in equal measure'. In contrast, for Martineau artworks' aesthetic qualities must be kept firmly in service to their moral purpose. Martineau saw the relation between aesthetic and moral qualities as hierarchical, whereas Jameson sought a perfect balance between them.

How exactly she conceived the 'equal association' of pleasure and contemplation, taste and conscience, the aesthetic and moral aspects of artworks, changed over time. Canvassing the entirety of Jameson's many works is beyond my scope, so I will focus on two of the most influential ones. In this chapter I look at her 1832 book *Characteristics of Women*, hereafter *Characteristics*. The next chapter will move on to her multivolume *Sacred and Legendary Art*, which appeared from 1845 onwards.

I begin with *Characteristics*, since it was Jameson's first fully developed work of criticism.[3] It made her name: as Martineau (1869) reported, 'Mrs Jameson's world-wide reputation dates from the publication of this book' (116). Very widely reviewed, praised, and taken up, the book was reissued twenty-eight times in Britain and America over the nineteenth century—in other words, it sold out and was reprinted every two-and-a-half years. This made it Jameson's second most popular work after *Sacred and Legendary Art* (which also went through twenty-eight editions, but came out later). Indeed, 'so widely was *Shakspeare's Heroines*

[3] Jameson's previous books were the faux-autobiographical *Diary of an Ennuyée* (1826), *Memoirs of the Loves of the Poets* (1829), and *Memoirs of Celebrated Female Sovereigns* (1831). Dabby (2017) classes the last two, along with Jameson's 1833 *Beauties of the Court of King Charles the Second*, as 'picturesque history' (ch. 1).

read that almost every subsequent nineteenth-century writer on Shakespeare's women characters mentions the book' (Russell 1991: 35; as I will explain, the book was renamed *Shakespeare's Heroines*). Joseph Candido and Ronald Tumelson document a slew of British Shakespeare critics and editors who adopted Jameson's views either in whole or in part, right across the century (Candido 2021: 11–13; Tumelson III 2006: 86). However, after the 1920s the book fell into near-oblivion. It remained there until scholars began to rediscover it from the 1990s onwards, as part of the wider reclamation of Jameson's work.[4]

I will now look at the basic project of *Characteristics* (Section 5.2) and Jameson's conception of virtuous character (Section 5.3), before considering how her view of virtue differed from those of both Martineau and Joanna Baillie (Section 5.4). Then I shall bring in Jameson's conception of aesthetic wholes (Section 5.5), which drew heavily on early German Romanticism, especially the views of August Wilhelm Schlegel. On this basis, I will explain how Jameson conceived the connection between the aesthetic and ethical elements of artworks in *Characteristics*.

5.2 *Characteristics of Women*: Moral Philosophy by Aesthetic Example

Jameson's two-volume, 500-page, signed work *Characteristics of Women: Moral, Poetical, and Historical* came out in 1832. What the title did not make clear was that the book was partly a work of Shakespeare criticism, in which Jameson offered a moral reading of twenty-three of Shakespeare's female characters. To make this more apparent, the first German translation by Adolph Wagner (uncle of Richard Wagner) bore the title *Frauenbilder, oder Charakteristik der vorzüglichsten Frauen in Shakspeare's Dramen*[5] (i.e., *Pictures of Women, or Characteristics of the Most Excellent Women in Shakespeare's Dramas*).[6] The American editions from 1846 and 1848 were called *Heroines of Shakespeare*, and posthumous British editions from 1897 onwards adopted *Shakespeare's Heroines*, retained in the 2005 Broadview Press re-edition (Jameson [1832] 2005). It is not clear that Jameson ever authorized these variant titles.

[4] See Booth (1999/2000), Dabby (2017: ch. 4), Gillett (2018), Hoeckley (2011), Johnston (1997: ch. 3), Russell (1991), and Slights (1993).

[5] The possessive apostrophe, as in 'Shakespeare's', was accepted in some contexts in nineteenth-century German (see Heyse 1849: II: 790).

[6] Wagner's translation came out in 1834, and two more German translations quickly followed in 1840. There was intense competition to translate Shakespeare into German at that time, so different factions produced their own translations of Jameson to enlist her authority in their support; see Gillett (2018) and Johns (2010). Plainly, Jameson was popular in Germany too. For example, Heinrich Heine brought out *Shakespeares Mädchen und Frauen* in 1838, attempting to emulate her success.

Jameson's reasons for the original title are illuminating about her project. 'Characteristics', for Jameson, are *moral* character-traits (as the German title captured). Jameson (1832) explores how different configurations of intellect, passion, and affection in Shakespeare's women produce varying degrees of virtue or vice. She thus reads Shakespeare's plays for examples of more and less virtuous women. Some examples, above all Portia from *The Merchant of Venice*, are uniformly positive: role models, as we now say. Other examples are more negative, like Lady Macbeth, serving as 'warnings' of what to avoid (vol. 1: xli). Most of the examples are in-between, mixtures of role model and warning. 'Characteristics' thus tells us that the book deals with women qua moral examples.

Evidently *Characteristics* is a singular work. Cheryl Hoeckley classes it as a hybrid of a conduct manual, Shakespeare criticism, and a feminist argument for the reform of women's education and social position (Hoeckley 2005). Alison Booth places it in the genre of collective biography of illustrious women (Booth 1999/2000). In addition, *Characteristics* does moral philosophy and moral psychology by aesthetic example, as Jameson explains in the light-hearted dialogue that introduces the book.

In this dialogue, written last and in a style of Shakespearean banter, Jameson's (1832) mouthpiece 'Alda', the imagined author, convinces the initially sceptical 'Medon' of the worth of her inquiry. As Alda clarifies, she seeks to teach morality not in a theoretical treatise but by examples:

> I do not choose presumptuously to fling these opinions in the face of the world, in the form of essays on morality and treatises on education. I have rather chosen to illustrate certain positions by examples, and leave my readers to deduce the moral themselves, and draw their own inferences. (vol. 1: viii)

At the end of this introductory dialogue, persuaded of the project's merits, Medon asks:

MEDON. ... But now for the moral.
ALDA. The moral!—of what?
MEDON. Of your book. It has a moral, I suppose.
ALDA. It has indeed, a very deep one, which those who seek will find. If now I have answered all your considerations and objections, and sufficiently explained my own views, may I proceed?
MEDON. If you please—I am now prepared to listen in earnest. (lx–lxi)

Like Martineau, Jameson was finding a way to do moral philosophy as a woman, outside the academy, in a form other than the systematic treatise. Again like Martineau, Jameson turned to literature as a domain where morality could be taught, and moral psychology probed, through aesthetic examples.

And Martineau likewise used the word 'characteristics' to mean 'virtues as exemplified in art' in her Scott essays, which came out in 1832 and 1833, nearly simultaneously with *Characteristics*. However, moral principles were taught for Martineau primarily by *writing* literature, for Jameson by *interpreting* literature. And whereas Martineau looked at the virtues of Scott, the author, as expressed in his art, Jameson scarcely considers Shakespeare the person at all. Instead she focuses on the virtues of his *characters* as quasi-autonomous individuals. When she does refer to Shakespeare's virtues, it is strictly as manifested in his characters. Furthermore, Jameson differs from Martineau in the playful lightness of touch that she brings to her inquiry.

One way Shakespeare's plays give moral guidance, Alda suggests, is by providing a safe space for readers to witness the damaging consequences of uncontrolled passion:

> We can do with them [these heroines] what we cannot do with real people: we can unfold the whole character before us, stripped of…all disguises of manner. We can…watch the rise and progress of various passions…And it is the safer and the better way [than in real life]…Passion, when we contemplate it through the medium of imagination, is like a ray of light transmitted through a prism; we can calmly, and with undazzled eye, study its complicate nature…(xxi–xxii)

Literature allows the reader to learn, at a safe distance, from the warning example of characters who succumb to their passions, and avoid following in their footsteps. But Shakespeare's heroines do not only exhibit dangers; between them they display the full spectrum of 'the various modifications of which the female character is susceptible, with their causes and results' (vii). Characters such as Portia show that women can be intelligent, powerful, passionate, *and* virtuous. From Portia, with whom Jameson's book proper begins, down to Lady Macbeth, with whom it ends, a continuous spectrum of possibilities unfolds. Which ones any actual woman realizes will depend on her education, opportunities, and social circumstances. Portia shows the best that is possible, but social conditions determine how far any given woman can actualize this ideal. For, Alda continues:

> The condition of women in society, as at present constituted, is false in itself, and injurious to them…the education of women, as at present conducted, is founded in mistaken principles, and tends to increase fearfully the sum of misery and error in both sexes…(viii)

Present conditions, in which women are not educated to use reason or principled judgement, bring out the worst in women, by leaving them ill-prepared to regulate their passions and affections.

Jameson's focus is *women's* virtues. As Johnston has pointed out, Jameson enlarges Shakespeare's female characters into the principal actors, looking at his male characters only in relation to the women—the reverse of the usual interpretive procedure (Johnston 1997: ch. 3). But Jameson's general view that literary characters embody varying degrees of virtue and vice can apply equally well to male characters and pertain equally well to male readers. Indeed Jameson ([1854] 1855) maintains that virtue is essentially the same for both sexes, saying that it is mistaken to believe:

> that there are essential masculine and feminine virtues and vices. It is not, in fact, the quality itself, but the modification of the quality, which is masculine or feminine; and on the manner or degree in which these are balanced and combined in the individual, depends the perfection of that individual character. (85)

She adds: '"The virtue of the man and the woman is the same"…[is] the moral truth' (86).

Jameson's radical step, however, is to reverse the historical tendency to run together accounts of virtue in general with examples of male virtue in particular. Instead, she discusses virtue through female examples. Jameson thereby emphasizes not only that women are perfectly capable of being virtuous, given the right social arrangements, but also that men can learn from the example of women—just as Medon takes instruction from Alda in the opening dialogue.

5.3 Jameson's Taxonomy of Female Characters: Moral Psychology by Aesthetic Example

Jameson (1832) divides *Characteristics* into four parts, each dealing with a particular class of Shakespearian women. Through this taxonomy she puts forward an indirect account of the best way to configure intellect, passion, and affection to achieve a virtuous character.

(1) *Characters of intellect*. Their paradigm, Portia, holds 'the first rank' among Shakespeare's women (vol. 1: 5). Portia's intellect is not separate from her moral fibre; rather, part of her intellect is her principled morality. She also has powerful passions, but her intellect steers and directs them, so that their power is harnessed into the service of the intellect. The result is 'a human being, in whom the moral, intellectual and sentient faculties [are] exquisitely blended and proportioned' (32).

(2) *Characters of passion and imagination*. The paradigm, Juliet, furnishes a warning, as Alda makes explicit. If a single passion takes a person over completely and becomes their entire character, they will find themselves

unable to continue existing in the real world. This fate has befallen Juliet, whose entire being is love, and who embodies love under all its aspects (104). Indeed, Jameson argues, 'Love, as a passion, forms the groundwork of the drama' (90), the whole action of which is to develop the passion in full. By implication, the whole play is the unfolding of Juliet.

Jameson's interpretation of *Romeo and Juliet* contrasts with that of the early German Romantics Caroline and August Schlegel, for whom the play's organizing principle is the unity of opposites: the sensual *and* the spiritual, love *and* death, bliss *and* suffering. This view is expressed in two long letters of Caroline to August (C. Schlegel 1797a, 1797b), and again in an essay published only under August's name (A. Schlegel 1797) which drew heavily on these letters, and which he later admitted Caroline had co-authored (A. Schlegel 1828: xvii–xviii). Although Jameson engages extensively with other ideas of August Schlegel's, as we will soon see, she does not address this particular interpretive point, and she seems not to have known of Caroline's work or involvement with August's Shakespeare interpretations.[7] In any case, unlike the Schlegels, Jameson maintains that love *alone* is the core of the drama and is 'the passion which has taken possession of Juliet's entire soul' (1832: vol. 1: 96). Thus, whereas the Schlegels take the play's message to be the metaphysical and bitter-sweet one that we cannot have love without pain or life without death, for Jameson the message is instead moral and optimistic. Love taken to excess, driving out all other elements of character, may end in death, but this can be avoided if one cultivates a balanced character.

This is not to say that Jameson condemns Juliet. On the contrary, Jameson admires Juliet, describing her as 'preserving that moral and feminine dignity which harmonizes with our best feelings, and commands our unreproved sympathy' (120). For the passion of love is not per se bad, and neither is Juliet. In fact, she is essentially good; yet her example shows that love, like other passions, needs to be balanced by intellectual principles if it is not to overwhelm a person and bring about their downfall.

> (3) *Characters of the affections.* Their paradigm is Imogen from *Cymbeline*. These characters: in which the affections and the moral qualities predominate over fancy and all that bears the name of passion...are all gentle, beautiful and innocent; all are models of conjugal submission, truth, and tenderness; and all are victims of the unfounded jealousy of their husbands. (vol. 2: 3–4)

(Or, of unjust suspicions from other male family members). In other words, these are just the sort of women who were extolled as role models in Jameson's day.

[7] Jameson did, however, write of his relations with Germaine de Staël (Jameson 1834: vol. 1: 35–9), on whose novel *Corinne* she modelled her *Diary of an Ennuyée*.

Yet their examples show that if one acts out of dutiful obedience to male kin—i.e., from a morality of affection for others, not self-governing rational principles—then one becomes vulnerable to whatever these men may inflict. Thus, Jameson subtly treats these characters as a warning example that indicts the idea that women's primary duty is to obey their fathers and husbands.

Jameson's distinction between *passions* and *affections* figures into this. Her treatment of Portia, Juliet, and Imogen shows that she regards passions as powerful internal forces motivating action, whereas affections are sympathetic and other-oriented. Jameson ranks women of passion (like Juliet) above women of affection (like Imogen) on the grounds that the former are more self-directed and self-willed. Although passions can lead one astray if they are not harnessed by rational principles, the passions as such are desirable. When they are properly harnessed, as in Portia, they confer energy and commanding force, which is admirable in women as in men. To be sure, other-regarding affections are desirable too, and so characters such as Imogen and Desdemona are again essentially good. Even 'Desdemona, with all her timid flexibility and soft acquiescence, is not weak' (47–48). Yet these characters exemplify the dangers of making other-regarding affections one's be-all and end-all. Desdemona is 'a victim consecrated from the first,...all harmony, all grace, all tenderness, all truth! But, alas!...to see her—O poor Desdemona!' (49) Other-regarding affections may be 'all grace, all tenderness', but they need to be regulated by rational principles and complemented by strong internal passions if they are not to lead into victimhood.

It is clear by now that most of the characters serve as *both* positive examples *and* warnings. Positively, they embody some of the necessary constituents of a virtuous character. Negatively, they show the insufficiency of each constituent on its own. Affections are insufficient without strong passion, and passion is insufficient without intellectual regulation. But since both affection and passion are desirable, intellect is insufficient too unless it has these other forces to draw on and regulate. Underneath the deceptively easy readability of Jameson's work lies a multilayered moral psychology.[8]

(4) *Historical characters*. This category may sound disjointed from the others. But the clue is in the introduction, when Alda says: 'Women are illustrious in history...generally in proportion to the mischief they have done or caused' (vol. 1: xviii). The historical women are the 'mischievous' or bad characters, paradigmatically Lady Macbeth, whose 'ruling motive' and 'intense overmastering passion' is ambition, 'which is gratified at the expense of every just and generous principle, and every feminine feeling'

[8] Dabby (2017) likewise argues that for Jameson women should cultivate both intellect and sensibility, like men (105–11). But I am suggesting that Jameson's picture is finer-grained than this, including the subdivision of sensibility into passion and affection.

(vol. 2: 303). Her ambition has gained the upper hand over her intellect, her other passions, and her feelings of spousal affection. Her powerful intellect, determination, and courage have all been placed in the service of her ambition. Her equally strong affection for Macbeth has been perverted by her ambition into the overpowering desire to place him on the throne (308–309). This is not a person completely absorbed by one passion like Juliet, but a character who retains a strong intellect and set of passions and affections but where one overgrown passion directs, disfigures, and misuses all these other forces. Lady Macbeth is not one-sided but multifaceted, yet the facets are wrongly configured.

Crucially, though, even Lady Macbeth is not entirely bad. One of Jameson's goals was to show this and to refute critics who condemned Lady Macbeth as a 'monster of depravity' (304). Jameson wrote:

> The crime of Lady Macbeth terrifies us *in proportion as we sympathize with her*... It is good to behold the possible result of the noblest faculties uncontrolled or perverted.... She is a terrible impersonation of evil passions and mighty passions, never so far removed from our own nature as to be cast *beyond the pale of our sympathies*. (304; my emphasis)

Lady Macbeth's powerful intellect, her courage and resoluteness, her love for her husband, all are good and arouse our sympathy. Even her ambition is not bad as such, only because it is 'extreme, and overleaping all restraints' (vol. 1: xxv). This single passion, ambition, has grown out of control and has taken over all of Lady Macbeth's other potentially good qualities.[9]

5.4 Jameson, Baillie, and Martineau on Virtue and the Emotions

Jameson's emphasis on the dangers of overgrown passions and the possibility of regulating these passions by reason recalls Joanna Baillie's view that tragedy occurs when characters succumb to their passions with disastrous consequences. Watching or reading about this expands our sympathetic understanding of other minds and helps us learn to regulate our own passions, according to Baillie ([1798] 1806: 29–30). By their mistakes, she says, the characters give us 'the instruction of example' (32). Did this influence Jameson's view that characters

[9] This defence of Lady Macbeth was controversial. Martineau caustically referred to Jameson's 'notorious mistake' of attributing to Lady Macbeth 'an intellect loftier than that of her husband' (Martineau 1869: 116). 'Notorious' suggests that this was a point on which many critics disagreed with Jameson.

who have let their passions grow out of control act as instructive warnings? We may suspect so, especially as Jameson, like Baillie, is clear that such characters are not beyond the pale of sympathy. We can understand them and sympathize with even the worst of them like Lady Macbeth. Moreover, Jameson's above-quoted remark about watching the 'rise and progress' of passions compares closely with Baillie, who states that tragedy's task is 'to represent men under the influence of the stronger passions; and to trace the *rise and progress* of them in the heart...' (43).

To establish Baillie's influence on Jameson we need to go into some biographical details. This may seem a digression, but it is worth making to establish Baillie's influence conclusively, and for additional reasons. With women philosophers omitted from the canon, we lack the background of biographical awareness that we have for canonical figures, like Hegel's hero-worship of Napoleon or Kant's fellow Königsbergians allegedly setting their watches by his daily walks. Such details add concrete meaning to Hegel's theory of world-historical individuals and Kant's concern to systematize (or, viewed negatively, to regiment) experienced phenomena. Filling in biographical details of women philosophers helps them to come alive in the same way. Furthermore, intellectual relations between women philosophers have been neglected even more than the women as single individuals. These relations shed light on the support networks that nourished intellectual women and helped to make their work possible.

Baillie and Jameson became friends only in the 1830s,[10] but Jameson knew Baillie's work long before that, given Baillie's fame. Later, Jameson extolled Baillie as 'one of our *greatest* women' (AJ to Ottilie von Goethe, 9 March 1851, in Needler 1934: 174). Even so, Jameson made limited reference to Baillie in her published work, but she placed a clue. Jameson dedicated *Characteristics* to her friend, the actress Fanny Kemble, whose 1829 stage performance as Juliet in *Romeo and Juliet* had electrified audiences. Kemble was the niece of the equally famous tragic actress Sarah Siddons, on whom Jameson published a biographical essay in 1831. One of Siddons' most celebrated roles was as Jane de Monfort in Baillie's *De Monfort* when it was staged in 1800. Jameson remarked, 'In playing Jane de Montfort, in Joanna Baillie's tragedy, her audience almost lost the sense of impersonation in the feeling of identity. She *was* Jane de Montfort—the actress, the woman, the character, blended into each other' (Jameson 1834: vol. 1: 282).[11]

[10] Annabella Byron introduced them (Thomas 1967: 91; see also Macpherson 1878: 95. Byron and Baillie had been friends since 1812). By 1838 Jameson and Baillie were such friends that Jameson considered moving near Baillie, though she opted to remain more independent (Macpherson 1878: 145). Some of Jameson's correspondence with Baillie from 1839 to c.1845 survives (see Baillie 1999: vol. 2: ch. 18). Frustratingly, it contains little philosophical discussion.

[11] Siddons loved playing Jane de Monfort, and implored Baillie to write more such parts (Slagle 2002: 92).

Thus, Jameson both knew Baillie's *Plays on the Passions* and presupposed her readers' knowledge of them.[12]

Jameson's correspondence with Annabella Byron provides more evidence that Jameson knew Baillie's work well. The pair discussed Baillie's work repeatedly, with Jameson praising the beauty of many scenes in her plays and especially her portrayal of Jane de Monfort. She gave her approval to a painting of Jane de Monfort which Byron commissioned from Charles Landseer (brother of the better-known animal painter Edwin Landseer). Jameson remarked of this painting: 'Will you turn to the lines uttered by Jane de Monfort...Do you remember the first scene of Act II? This is a picture ready made—and a very fine picture.'[13]

Jameson was certainly influenced by Baillie's view that tragic characters such as De Monfort have only taken further seeds of passion that are present in everyone. These characters contained much that was good, although their raging passions have prevailed over these good elements (Baillie [1798] 1806: 62). Very similarly, for Jameson, we see in 'bad' characters like Lady Macbeth good traits, such as a powerful intellect and great energy. Observing how Lady Macbeth's ambition has perverted her intellect, we appreciate the need to restrain our own passions so as to avoid ruining our own potential. Had Lady Macbeth done the same, she could have realized the good qualities with which she started out: 'What would not the firmness, the self-command, the enthusiasm, the intellect, the ardent affections of this woman have performed, if properly directed?' (Jameson 1833: vol. 2: 375). Lady Macbeth serves as a warning only because she has features in common with everyone, has many admirable traits, and is no monster of depravity. This humane and optimistic message is the 'grand moral lesson' of *Macbeth* (vol. 2: 308).

Yet Baillie and Jameson differ insofar as Baillie primarily regards the passions as dangerous, whereas Jameson's view is more positive. In her view, passions and affections are part of a good character and are good in themselves as long as they are regulated and channelled by the intellect. A rich emotional life is essential to the most complete, rounded character. As Jameson ([1854] 1855) later says in her *Commonplace Book*, 'One great fault in education is...[that] it is as if we took it...that passions could *only* be bad, and are to be ignored or repressed altogether—the old mischievous monkish doctrine' (43). For Jameson the passions should be harnessed; for Baillie they should be restrained.

Jameson's positive evaluation of the emotions also became a key point of dispute with Martineau once the pair became friends. They were certainly acquainted by 1834, since Jameson introduced Annabella Byron to Martineau

[12] Jameson (1854) discussed *De Monfort* again, analysing Baillie's use of the gothic device of a screeching owl, in her later *Commonplace Book* (vol. 1: 269).

[13] AJ to Byron [c.1834], in Jameson (1834–53: 31-3); AJ to Byron [c.1840], in Jameson (1834–53: 50-1). Baillie told one of her correspondents about the painting: 'The story is in many respects well told, although Jane is much too young, and the colouring is beautiful. It was painted for my partial friend Lady Byron, as a present to me' (JB to Lady Davy, [1841], in Baillie 1999: vol. 1: 513).

at that point. Jameson had read many of Martineau's writings including the *Illustrations of Political Economy*, sending Adele Schopenhauer (Arthur's sister) 'a complete set of Miss Martineau's tales' in 1833. Jameson idolized Martineau, saying 'how little I feel myself, compared to Harriet Martineau', and describing Martineau to Byron as 'one of the most extraordinary and gifted women I ever met with; I am almost overpowered with her'.[14]

Both in correspondence and person, Jameson and Martineau discussed religion, philosophy, art, literature, and politics. But they had a major disagreement during Jameson's stay with Martineau in 1842. Martineau castigated the '*sexual tone*' of various novels of the time, whereas Jameson insisted that 'Love, as a passion' had a vital place in human life. Jameson, while admitting that she was 'absolutely exhausted by excited attention and interest and by the rapidity and vivacity of her language and ideas', confided to Byron that Martineau's views 'are founded, I think, in ignorance of some facts of our human nature'.[15] In response Martineau shrank back, saying that 'I could never have friendship—not yet with one so epicurean'—i.e., such a pleasure-lover. For Martineau was adamant that: 'Love, like other passions, [is] guidable by duty' (HM to Richard Monckton Milnes, 21 April 1844, in Martineau 1990: 87). For Martineau, duty must regulate and curtail the passions, whereas for Jameson, the most developed character integrates the passions. On this issue Martineau and Baillie are closer together, and Jameson's difference from them reflects her desire to balance the aesthetic and the moral, pleasure and contemplation, rather curtailing aesthetic pleasure in the name of contemplation.

It is interesting to look a little further into the falling-out between Martineau and Jameson, as it illuminates both their temperaments and the fact that relations between women were not always supportive, but could become extremely hostile. After their disagreement about the passions, their relations worsened when Jameson was not happy that Martineau wanted her to destroy their correspondence (AJ to HM, 17 January 1843, in Erskine 1915: 222–224). The final straw surrounded the journal the *Athenaeum*. In late 1844 the journal published Martineau's 'Letters on Mesmerism', her account of her apparent cure from debilitating illness by mesmerism (i.e., hypnotism). The letters provoked a storm of controversy. Charles Wentworth Dilke, the editor, infuriated and humiliated Martineau by publishing accusations that she was hysterical (Brodie 1844),[16] had made the whole thing up (Forbes 1845), had been deceived by scoundrels (Brown 1845), and suchlike. Martineau seems to have wanted Jameson to intercede on

[14] AJ to Ottilie von Goethe, 30 November 1833, in Needler (1934: 18–19); AJ to Robert Noel, February 1834, in Macpherson (1878: 92); AJ to Byron, 1842, in Erskine (1915: 217). Portions of Jameson's and Martineau's correspondence are in Martineau (2007: vol. 2) and Erskine (1915: ch. 10).

[15] AJ to Byron, 1842, in Erskine (1915: 216, 218, 216).

[16] For the attribution to the physiologist Benjamin Brodie, see Winter's superb account of the Martineau/mesmerism controversy (Winter 1995).

her behalf, for Jameson by then had a good relationship with Dilke and the *Athenaeum*. But Jameson was dubious:

> All the world is talking of Harriet Martineau's cure by mesmerism. I say nothing because everyone is saying too much, and her last letter in the 'Athenaeum' is imperfect as evidence. I hardly know what to say at all, for she is my friend, and a wonderfully gifted woman. (AJ to Robert Noel, early December 1844, in Macpherson 1878: 203)[17]

Martineau felt betrayed, judging by the following letter from Elizabeth Barrett (later Browning) to Jameson:

> As must be obvious to everyone (yourself included), you did everything possible to prevent the catastrophe, and…no friend could have done better…are you not mistaken in fancying that she blames you, that she is cold with you? I really think you must be. Why, if she is displeased with you she must be unjust, *and is she ever unjust*? I ask you…it is impossible for me to believe without strong evidence that she could cease to be your friend on such grounds as are apparent. Perhaps she does not write because she cannot contain her wrath against Mr. Dilke (which, between ourselves, she cannot, very well), and respects your connection and regard for him. (Barrett to AJ, late December 1844, in Barrett Browning 1897: vol. 1: 227–228)

Martineau's letters of early 1845 indeed brimmed over with anger against Dilke. By mid-1845, she was anxious to 'avoid tête-a-tête' with Jameson: 'the fondness is all on one side, *if at all*' and 'I wish her not to take up Mesmerism'.[18] These remarks show that, contrary to Barrett's optimism, the mesmerism debacle ended the friendship between Martineau and Jameson.[19]

Martineau then wrote a rather acidic account of Jameson when she died, later included in Martineau's 1869 *Biographical Sketches*. Here she said of *Characteristics* that although on first reading 'the analysis seemed to be acute, delicate, and almost philosophical…there was no philosophy in all this, but only *fancy and feeling*' (116; my emphasis). That is, Jameson put too much weight on affection (or feeling) and passion (which she linked with the imagination, or fancy) compared to reason, regarding all three as necessary parts of a virtuous character.

[17] Baillie was guarded too, saying to Byron: 'I suppose you have heard of Miss Martineau's wonderful recovery by the power of Mesmerism, every one will be pleased with the result whatever they may think of the remedy' (JB to Annabella Byron, 11 October 1844, in Baillie 1999: vol. 2: 767).

[18] See Martineau (2007: vol. 2: 339–42); HM to Jane Carlyle, 27 June 1845, in Martineau (2007: vol. 3: 17).

[19] Before then, Martineau had already begun complaining that Jameson had thrust herself upon her (HM to Monckton Milnes, 21 April 1844, in Martineau 1990: 86–7). But their correspondence shows that they really were close, with Martineau baring her soul to Jameson about her childhood memories and early reading (HM to AJ, 15 June 1841, in Martineau 1990: 58–62).

This to Martineau was quite wrong, for duty must prevail over the passions, not be balanced with them.

Even before Martineau published that sketch, the animosity had begun to go both ways. For Jameson, Martineau's and Henry George Atkinson's 1851 *Letters on the Laws of Man's Nature and Development* 'contain nothing that is new, and much that offends...they renounce Christianity, sneer at the "Romance of the Bible", congratulate themselves on the prospect of annihilation' (AJ to Ottilie von Goethe, 19 April 1851, in Needler 1934: 175). This was the book in which Martineau publicly renounced religion, whereas Jameson's work became increasingly religious over the course of the 1840s.

This quarrel may seem trivial now, but it was of great public interest to the Victorians, since Martineau and Jameson were the two best-known intellectual women in Britain at that point.[20] Beyond mere gossip, critics tried to pin down the philosophical differences between Jameson and Martineau. Richard Henry Horne (1844) concluded:

> The one represents the intellect of the question, the other the feeling; one brings it to an acute abstract comprehension, the other all the sympathies of a woman...Harriet Martineau has generally written with some fixed aim, some doctrine to illustrate...Mrs. Jameson, on the other hand, has pursued the study of art. She is a fine critic, and possesses a subtle insight into character. (236)

Horne's remarks might sound vague, but he has put his finger on the key difference. Although both women believed that literature had to exemplify morality, this was in very different senses. For Martineau, literature illustrates *moral laws* by showing how characters' lives go better or worse if they obey or disobey them. For Jameson, on the other hand, literature illustrates *character types*. This in turn shows that they have different moral theories. For Martineau, a virtuous person follows the right rules for action ('fixed aims'). Conversely, for Jameson, the right thing to do is what a virtuous person would do (so that we need 'insight into character'). For Martineau rules precede virtue; for Jameson virtue precedes rules. Jameson is thus a virtue ethicist, although she does not use this phrase. Character, for her, is the core of morality.

5.5 The Aesthetics of *Characteristics*: Aesthetic Wholes and Moral Examples

Sections 5.2 and 5.3 of this chapter looked at Jameson's moral philosophy and psychology in *Characteristics*. What about its aesthetic side? How does Jameson integrate aesthetic and moral concerns?

[20] For example, Geraldine Macpherson published *Memoirs of the Life of Anna Jameson* to prove that the two had previously been close and to show that Martineau's negative remarks on Jameson were unfairly coloured by personal animosity (see Macpherson 1878: ix–x).

Medon asks Alda why moral lessons need to be taught via literary characters at all. Why not use real women, present-day or historical? First, Alda answers, she does not want to make criticisms of real-life people (Jameson 1832: vol. 1: ix). Second, our knowledge of both past and present women is very limited and clouded with prejudices (xvii). In contrast, we see literary characters as a whole, with all their traits, the unity these form, and the actions that follow from them. We can therefore know the moral character of literary figures *better* than that of real people and learn moral lessons better from literary than real people. This is because (to return to a statement of Jameson's which I mentioned earlier) 'we can do with them [the literary characters] what we cannot do with real people: we can unfold the *whole* character before us, stripped of...all disguises' (xxi; my emphasis). Literary figures are not merely ancillary to a moral project that could be done equally well using history or real people. The reference to literature is fundamental.

To draw out Jameson's views here, it is helpful briefly to consider how they relate to what I will call the paradox of moral fiction. It arises out of the broader paradox of fiction, namely (under countless slightly different formulations) that we do not believe that fictional characters are real; we only care about what happens to people we believe to be real; yet we care about what happens to fictional characters. The further paradox of moral fiction may be expressed: we do not believe that fictional characters are real; we can only learn moral lessons from the actions and traits of real people; yet we can learn moral lessons from the actions and traits of fictional characters. Jameson heads off this paradox but not simply, as we might suppose, by effectively denying the second premise and saying that we can learn from fictional characters. Instead, she modifies the first premise to say that fictional characters do have a level of reality, as the following remarks show:

> Alda:...the riddle which history presented I found solved in the pages of Shakespeare....All I sought, I found there; his characters combine history and real life; they are complete individuals, whose hearts and souls are laid open before us; all may behold, and all may judge for themselves. (xx)

> Of these four exquisite characters [Portia, Rosalind, Beatrice, and Isabella], considered as dramatic and poetical conceptions, it is difficult to pronounce which is...most admirably drawn...But if considered in another point of view, as women and individuals, as breathing realities, clothed in flesh and blood...[then Portia is the best]. (5)

> Many women have possessed many of those qualities which render Portia so delightful. She is in herself a piece of reality, of whose possible existence we have no doubt...(32)

> Whenever we bring her [Ophelia] to mind, it is with the same exclusive sense of her real existence, without reference to the wondrous power which called her into life. (186)

In a sense Shakespeare's female characters *are* real and we believe, indeed know, them to be so.

Jameson does not deny that these women are 'poetical conceptions'. After all, she says that drama shows us the passions through the prism of imagination, thus safely removed from real life. But though these women are imagined, they have features in common with real-life women: they embody permutations of intellect, passion, and affection, just as real-life women do. Thus what is crucial, Jameson (1833) states, is not 'the mode in which a certain character is manifested'—i.e., whether in real or fictional mode—but 'the combination of abstract qualities making up that individual human being' (vol. 2: 308). These combinations are what real and imagined women have in common. Having combinations of traits that are also found in real people, the imagined characters have a level of reality, and they are sufficiently real for us to learn from them morally. Furthermore, for Jameson, imagination, like prejudice and feeling, colours our judgements of real-life people as well (vol. 1: xvii). In respect of both shared qualities and this pervasive role of imagination in life, Jameson sees no hard-and-fast real/fictional divide.[21] This is reflected in her key descriptors for Shakespeare's heroines being *imagined* and *poetical*, not *fictitious*: the latter suggests 'made-up' and 'unreal', as the former two terms do not.

From the foregoing we can see that for Jameson the reality of Shakespeare's heroines depends on their *completeness*. That is, these women are rounded individuals with a full complement of interrelated traits, giving each of them a complete personality out of which all their words and actions flow. This completeness, or wholeness, makes each of these women real because it gives them a complex personality structure, a 'combination of abstract qualities making up [an] individual human being', something equally true of real-life people.

Jameson's understanding of completeness came out of German Romanticism, by which she was heavily influenced. This German influence on Jameson is interesting, for it used to be thought that nineteenth-century British culture was parochial, with very limited knowledge of German culture (see, e.g., Wellek 1931: esp. 3–5). Recent scholarship shows that British engagement with German culture was more substantial than previously thought (e.g., Hughes 2022a; Teukolsky 2009). Jameson's case confirms this. Indeed, through her German connections and her writing about them, Jameson acted as a major force for 'British-German cultural transfer' in this period, as Alessa Johns says (Johns 2014: ch. 4). Or, as Robert Gillett (2018) puts it, 'Jameson was a pronounced Germanophile and played a not inconsiderable role in Anglo-German cultural relations' (120).[22]

[21] Cheryl Hoeckley, Jessica Slights, and Anne Russell all question Jameson's treatment of fictional characters as real (Hoeckley 2011: 11–15, Slights 1993: 388, Russell 1991). However, they find it useful politically in expanding the range of possibilities for real women. I am arguing, though, that Jameson also had philosophical grounds for her view.

[22] Linda Hughes (2022a), too, calls her a 'crucial cultural mediator' between Germany and Britain (13). See also Dabby (2017: 115–16).

Not surprisingly, Jameson was especially influenced by German Romantic engagement with Shakespeare. One of her central reference points in *Characteristics* was August Schlegel's Shakespeare interpretations in his *Course of Lectures on Dramatic Art and Literature*, translated into English in 1815 (Schlegel 1815).[23] Jameson (1832) objected that his description of Portia as a 'rich, beautiful and clever heiress' was dismissive (vol. 1: 6), and she set out her taxonomy of female characters in defiance of his stricture 'that it is impossible to arrange Shakespeare's characters in classes' (xxxiv; cf. Schlegel 1815: vol. 2: 154–155). But though she was critical of Schlegel's treatment of the female characters, she took up his conception of translation and the aesthetic ideal of organic wholes that went along with it.

Schlegel and Ludwig Tieck were the named authors of the monumental German translation of Shakespeare's plays known as the 'Schlegel–Tieck' Shakespeare, produced in stages from 1797 to 1833.[24] In reality, a substantial amount of translating was done during the 1797–1802 phase by Caroline Schlegel,[25] and in the 1825–33 phase by Wolf Baudissin and Tieck's daughter Dorothea. The principles underpinning the translation project were set out by August Schlegel in two essays published under his name (A. Schlegel 1796, 1797), one of which was co-authored by Caroline. The principles were that the literary work to be translated is a complete whole, akin to an organism, where every detail flows out of its organizing idea (A. Schlegel 1797: 560). The translator's task was to apprehend this idea intuitively and then recreate the whole work in the new shape of the translation. The latter must be utterly faithful to the original—the Schlegels repudiated the then-standard practice of freely amending one's source text. But the translation had to be faithful to the spirit, not the letter, of the original: to its unifying idea, not its mere external details. If a translation recreated the unifying spirit of the source-work, then that translation would be a unity and a complete whole in its own right, and therefore would have aesthetic worth (see Adey 1989: 90).

Jameson knew of and fully subscribed to this view of translation. She discussed the 'Schlegel–Tieck' translation with Tieck,[26] whom she admired as much as Schlegel, even saying that she learnt German in order to read Tieck (AJ to Robert

[23] Originally *Über dramatische Kunst und Literatur*, 1809–11.

[24] Jameson met Schlegel, along with Ludwig Tieck, when visiting Germany in the 1830s (when she also became a lifelong friend and close correspondent of Ottilie von Goethe, Goethe's daughter-in-law). In 1833 she reported: 'Schlegel was introduced to me and we had a long chatter' (AJ to Ottilie von Goethe, 23 July 1833, in Needler 1934: 2–3), and she told her sister: 'Schlegel became very amiable…and they tell me it was a complete conquest. Pity I am married!' (AJ to Charlotte Murphy, 7 September 1833, in Macpherson 1878: 108).

[25] On this complex authorship, see Stott (2009–22), Larson (1987), and Tieck (1830: iii–iv).

[26] Clearly Tieck failed to enlighten her that he and Schlegel were not the sole translators, as she remarked that 'the combination of their two minds has done perhaps what no single mind could have effected in developing, elucidating, and clothing in a new language the creations of that mighty and inspired being' (Jameson 1834: vol. 1: 208).

Noel, 1833, in Macpherson 1878: 66). She put Romantic translation theory into practice herself by translating several plays by Princess Amalie of Saxony, stating: 'My translation is...*faithful* even to literalness, except where such extreme fidelity...would be false to the *meaning and spirit* of the original. I have [ensured] that my picture might be *complete* in all its details' (Jameson 1840: lxxviii; my emphases). She confessed with embarrassment to 'some of the great German critics', namely Schlegel and Tieck, that Shakespeare's plays were routinely performed in England with 'omissions' and 'with absolute alterations, affecting...the truth of character' (Jameson 1834: vol. 1: 77–78). Thus she rejected the then-common practice of excising the sexually explicit bits of Shakespeare, complaining that editors and performers were obsessed with verbal propriety instead of reality (Jameson 1832: vol. 1: xxxvii). When it came to reality, she said, Shakespeare 'never confounds that line of demarcation which eternally separates good from evil' (vol. 2: 317). Shakespeare himself, unlike the editors who have wreaked havoc with his texts, was 'true to the spirit and even to the letter of history; where he deviates from the latter, the reason may be found in some higher beauty' (vol. 1: lix).

More broadly, the German Romantic aesthetic of organic wholes influenced Jameson to locate aesthetic value in completeness, unity, and wholeness.[27] For instance, advising Elizabeth Gaskell on the rather abrupt conclusion to *North and South*, Jameson wrote: 'the end is not in proportion with the beginning. This is a fault of construction—but what is done is so *beautiful and complete* that it is only in considering the work *as a whole* that we feel that too great compression' (quoted in Johnston 1997: 4; my emphases). And in *Characteristics*, she repeatedly said that Shakespeare's portrayals of female characters were aesthetically good—'exquisite', 'admirably drawn, highly finished', 'developed with consummate skill', 'the supreme and consummate triumph of art' (Jameson 1832: vol. 1: 5, 135, 186)—*because* they rendered the characters as complete wholes—giving 'a *complete* personification of...female perfection', 'the *complete* development of the character' (5, 77; my emphasis).

This does not mean that art's value comes from aesthetic wholeness alone and has nothing to do with morality. For Jameson, we have seen, what it is for the characters to be complete wholes is for them to be psychological unities, rounded individuals all of whose acts and utterances flow out of their entire personalities. But this psychological unity also makes them characters in a moral sense, with varying compounds of virtue and vice. That is, the characters can only be aesthetically complete wholes if they are psychologically rounded individuals, who therefore necessarily also have a moral character and exemplify moral lessons.

[27] On the value placed upon organic wholes in German Romantic aesthetics and philosophy, see inter alia Beiser (2006).

The concept of 'character' distils this unity of the aesthetic and the moral, hence its centrality to Jameson's analysis.

Her view is not quite that the characters can only be aesthetically good if they are also morally good, for some characters like Lady Macbeth are superb aesthetic creations yet are on balance morally bad. Jameson's view is rather that an artistic delineation of a character can only be aesthetically good—presenting the character in their complete wholeness and reality—if that delineation is also morally good—in so presenting the character as a complete whole that they furnish a moral example (whether it be a warning, a role model, or anything in between). But how exactly does the moral badness of some Shakespearian heroines fit into this view? First, we remember, for Jameson even Shakespeare's bad characters contain much good, it being one of his signal merits to bring this out. Second, another of his merits is to portray the bad elements of these characters *as* bad. He neither passes off vice as virtue nor simply depicts it flat, devoid of moral qualification. Here she contrasts Shakespeare with Artemisia Gentileschi, who has 'painted one or two pictures, considered admirable as works of art, of which the subjects are the most vicious and barbarous conceivable...which I looked at once, but once, and wished then, as I do now, for the privilege of burning it to ashes' (2).[28] In contrast, Shakespeare's depictions remain morally good even when the characters depicted are bad, for Shakespeare presents their vices *as* vices, their virtues *as* virtues, and avoids portraying any of these individuals as being wholly without such redeeming virtues.

Jameson (1833) concedes that Shakespeare's depictions might still seem questionable precisely because he elicits our sympathy for bad characters. She replies:

> If it should be objected to this view of Lady Macbeth's character, that it engages our sympathies in behalf of a perverted being—and that to leave her so strong a power upon our feelings in the midst of such supreme wickedness, involves a moral wrong, I can only reply in the words of Dr. Channing, that 'in this and the like cases, our interest fastens on what is *not* evil in the character'...and might he not have added that many a powerful and gifted spirit has learnt humility and self-government, from beholding how far the energy which resides in mind may be degraded and perverted? (vol. 2: 318–319)[29]

Likewise, Jameson (1832) maintains, Shakespeare's Cleopatra fascinates and attracts us not for her bad qualities (temper, caprice, deceitfulness, inconstancy) but her good ones (grandeur, wit, vivacity, magnificence) (vol. 2: 123–124).

[28] Elizabeth Ellet protested: 'Mrs. Jameson remarks, "This dreadful picture is a proof of her genius, and, let me add, of its atrocious misdirection." But the artist should not be censured', and instead Ellet commended Gentileschi's brilliance (Ellet 1859: 67).

[29] Jameson refers to William Ellery Channing, the American Unitarian theologian who also influenced Baillie.

She combines 'all that we most hate, with what we most admire' (121). The latter is what we find alluring.

Jameson takes German Romantic aesthetics in a distinctive direction by making moral exemplarity a necessary concomitant of organic wholeness. As well as introducing this moral dimension, Jameson also appears to deviate from the Schlegels in that for her it is *characters* and their delineations that are organic wholes. In contrast, the Schlegels' initial idea was that *artworks* such as Shakespeare's plays are organic wholes. For instance, for the Schlegels, *Romeo and Juliet*, the play, is an organic whole (see, e.g., C. Schlegel 1797b). Jameson (1832) instead stresses that Juliet the character is an organic whole (vol. 1: 104). Jameson does consider the play to be a whole as well (90), but she derives its unity from that of its central character. We recall that for Jameson, the unifying idea of *Romeo and Juliet* is love (90). But Juliet embodies the passion of love in its complete unfolding (104), so what unifies the play is in fact the unity of Juliet.[30] Jameson takes the same approach with, for example, Imogen in *Cymbeline*: 'she is the proper subject—the heroine of the poem' (vol. 2: 60). The entirety of the action serves to draw out and illuminate Imogen's character.

Overall, for Jameson, dramatic works primarily unfold characters, not actions. This view perhaps reflects Baillie's influence again. As we saw in Chapter 3, for Baillie dramas primarily trace the psychological processes of their central characters, and plot is a subordinate element. Jameson agrees. Her views are also bound up with her expansion of the female characters into the principal characters, so that she sees *Romeo and Juliet* as unfolding the character Juliet, *Cymbeline* as unfolding Imogen, and so on. But although her examples and focus are female characters, her general view that artworks delineate characters could in principle apply equally well to male characters.

Jameson's points about aesthetic and moral wholeness apply, by extension, to artworks of other kinds, at least so long as they depict characters. If a painting delineates a character so as to convey their nature as a whole, for example, then a painting can be ethically and aesthetically good in the same way that a literary work can. This was true, for instance, of Landseer's portrait of Jane de Monfort, in Jameson's opinion (AJ to Byron [c.1840], in Jameson 1834–53: 50–51).

As a whole, Jameson unites the German Romantic aesthetic of organic wholeness with the idea that delineations of characters, and artworks as delineations of characters, can only be aesthetically good (presenting the characters as wholes) if they are also morally good (presenting the characters as moral examples). This is how Jameson tightly links the aesthetic and ethical aspects of artworks.

[30] Jameson's view here was influenced by Fanny Kemble, with whom she discussed *Characteristics* extensively during the writing. When Kemble performed Juliet, she elevated the character into the centrepiece of the play (Thomas 1967: 63). Similarly, Jameson's above-quoted remarks on *De Monfort* show that she saw Jane as its central character.

The characters only work as moral examples if they are aesthetic wholes, and they can only be delineated as aesthetic wholes if they are presented as moral examples. These views inform Jameson's later remarks on taste and conscience: to have a tasteful appreciation for artworks as organic wholes one has to be conscientiously sensitive to the morally exemplary characters that these works depict, and vice versa.

Jameson's connection between the aesthetic and ethical aspects of art is more sophisticated and subtle than Martineau's subordination of the aesthetic to the moral. Even though Jameson (1849a) speaks of the 'error' and 'evil' of the assumption that 'the individual fancy has a right of judgement unfettered by any moral responsibility' (70), she does not impose heavy-handed moral constraints on art or on our responses to it. Rather, in *Characteristics* she does moral philosophy and psychology indirectly through aesthetic examples, maintaining that aesthetic wholeness and moral exemplarity necessarily go together. Her original way of linking art and ethics deserves to be rediscovered.

6
Anna Jameson and *Sacred and Legendary Art*

6.1 Introduction

In the 1840s, Anna Jameson's thought on art entered a new phase. Previously, the art-form she had been most concerned with was literature. Now she turned to the visual arts—sculpture, painting, drawing, and engraving—and embarked on an ambitious programme to educate the public about art and culture, tying in with the rapid growth of popular interest in art at this time.[1] In this vein, Jameson published a two-volume *Handbook to the Public Galleries of Art in or near London* (1842), a *Companion to the Most Celebrated Private Galleries of Art in London* (1844), the 1843–45 series *Essays on the Lives of Remarkable Painters* in the *Penny Magazine*, which became the two-volume *Memoirs of the Early Italian Painters* (1845),[2] and her magnum opus, the multivolume signed work *Sacred and Legendary Art*. This appeared from 1845 onwards, and I will call it *Sacred Art* for short.

In *Sacred Art*, Jameson's stated purpose was to decode for people the huge body of medieval and Renaissance European art which was based on Christian narratives that had become unfamiliar in the modern world. By explaining these narratives, and showing how they were expressed in art, Jameson set out to demystify these artworks and reacquaint Europeans with their own heritage. Providing a taxonomy of and guide to a wealth of Christian art, as outlined in Table 6.1, *Sacred Art* was probably the largest-scale art-critical project undertaken by any nineteenth-century woman.

Jameson started work on the project in 1842 and continued it, interspersed with other writings, until her sudden death from pneumonia in 1860. She carried out the research on the European travels that occupied at least half of her

[1] On Jameson's educational programme, see amongst others Avery-Quash (2019), Kane Lew (1996), and Krisuk (2014). Her programme chimed with the rise of the liberal ideal of an aesthetically cultivated, many-sided, expanded self, well explored by Thomas (2004).

[2] The *Penny Magazine*, published from 1832–45, was the organ of the Society for the Diffusion of Useful Knowledge. Aimed at the working class, the *Penny Magazine* soon reached an unprecedented 200,000 readers a week, which was over 1% of the population. By 1843, readership had fallen to 50,000 and the editor, Charles Knight, commissioned Jameson's series to boost sales (Johnston 1997: 157). The series was unsigned, but Jameson's *Handbook, Companion,* and *Memoirs* were all signed.

Table 6.1 The Organizing Framework of *Sacred and Legendary Art*

Series	Volume	Date	Title	Divisions
1	1	1848	[The Poetry of] Sacred and Legendary Art[3]	Introduction The angels and archangels The four evangelists The twelve apostles The doctors of the church Mary Magdalene
1	2	1848	[The Poetry of] Sacred and Legendary Art	The patron saints of Christendom The virgin patronesses The early martyrs The Greek martyrs The Latin martyrs The early bishops The hermit saints The warrior saints
2	3	1850	Legends of the Monastic Orders	Introduction St Benedict and the early Benedictines The Reformed Benedictines Early Royal Saints The Augustines Orders Derived from the Augustine Rule The Mendicant Orders: 1. The Franciscans 2. The Dominicans 3. The Carmelites The Jesuits The Order of the Visitation of St. Mary
3	4	1852	Legends of the Madonna	Introduction I. Devotional Subjects: 1. Virgin without Child 2. Virgin and Child II. Historical Subjects: 1. Life of the Virgin from Birth to Marriage 2. Life from Annunciation 3. Life until Crucifixion 4. Life from Resurrection to Assumption

[3] The initial title was *The Poetry of Sacred and Legendary Art*; from the third (1857) edition onwards, '*The Poetry of*' was dropped.

adult life.[4] Most of Volume 1 and some of Volume 2 first appeared serially in the *Athenaeum*, from January 1845 to February 1846. The *Athenaeum* was founded in 1828 to showcase work by 'the most distinguished philosophers, historians, orators and poets of our day' (Marchand 1941: 1). It struggled financially at first, before Charles Wentworth Dilke took it over in 1829 and successfully cemented it as a 'mirror of Victorian culture', to use the subtitle phrase of Leslie Marchand's book about the journal. The fact that Jameson's *Sacred Art* first appeared in the *Athenaeum* testifies once more to her high standing, especially since the series was signed, whereas much of the journal's content was anonymous. The first two volumes then came out in book form in 1848. Buoyed by their success, Jameson completed the third volume, *Legends of the Monastic Orders*, in 1850, and the fourth, *Legends of the Madonna*, in 1852. Two final volumes, *The History of Our Lord as Exemplified in Works of Art* (Jameson and Eastlake 1864), were completed after Jameson's death in 1864 by her friend Elizabeth Eastlake. I shall not discuss these last two volumes, for the reason that Eastlake heavily revised Jameson's material, changed the organizing framework, and wrote parts of the book herself.[5] *The History of Our Lord* therefore says as much about Eastlake's views than Jameson's, and Jameson's own views are best ascertained from the first four volumes.

Sacred Art was incredibly successful, influential, and widely read. The first two volumes were reissued twenty-eight times over the nineteenth century alone (i.e., with a new edition roughly every eighteen months). Volume 3 was reissued twenty-one times and Volume 4 eighteen times. There were various alternative editions as well, like the five-volume *Writings on Art of Anna Jameson*, edited by Estelle May Hurll, published in Boston in 1896. No wonder the *New York Times* said Jameson had 'done probably more than any other writer to familiarize the public mind with the principles of art; and her perception of the inner spirit of a great work was so thorough, that its mere statement was eloquence' (Anonymous 1860b: 2).

Despite its nineteenth-century fame, *Sacred Art* fell into obscurity in the twentieth century until the recent rediscovery of Jameson's work. However, contemporary scholars looking at *Sacred Art* have concentrated mainly on one particular aspect, Jameson's account of female figures in Christian art.[6] Jameson recovered

[4] As Joanna Baillie marvelled to Annabella Byron: 'Nothing seems to impede her [Jameson's] motions; she is ready for every thing. She might be sent off on a mission at twenty hours warning to the farthest nook of the earth' (JB to Byron, 1845, in Baillie 1999: vol. 2: 775).

[5] Kimberly Adams argues that Eastlake's reorganization departed from Jameson, reflecting Eastlake's (2001) belief in 'the Protestant understanding of providential history' (61), whereas Jameson was more ecumenical. Ainslie Robinson (2003) takes a similar view (195).

[6] See Adams (2001), Alvarez (2016: ch. 3), Johnston (1997: ch. 7), and Styler (2010: ch. 4).

positive images of the Madonna and of female saints, nuns, and martyrs, presenting these women as exemplars of female virtue. This followed on from her interest in virtuous female characters in *Characteristics of Women*, and it anticipates recent feminist attempts to reclaim positive images of women within Christianity.[7] Important as this side of Jameson's project is, I shall not explore it here, both because others have already dealt with it well and because *Sacred Art* rested on a conception of the value of art as a whole, not only of artistic representations of women. Jameson's wider conception of art deserves attention in its own right.

Jameson remained preoccupied with the connection between the aesthetic and ethical aspects of artworks, but now she linked them through a third term: religion. Here she distinguished official church theology from the popular Christianity that had dominated Europe for the last millennium. In the latter, religious legends about the saints, apostles, martyrs, monastic founders, and other revered figures, male and female, embodied popular hopes for justice and virtue in an unjust social world. These moral hopes were integral to people's faith in these religious figures, whose lives held out the possibility of a better world in which faith and virtue would defeat corruption and inequity. This was how Jameson linked religion and ethics; she then linked this religion–ethics couplet with the aesthetic aspect of Christian art based on a historicist conception of art's value. Having been drawn deeper into art history, she now held that artworks were better aesthetically, the more fully and authentically they expressed the spirit of a given stage of civilization. In terms of historical European art, this meant expressing Christian beliefs, and specifically the Christian legends beloved of the people, not abstract theological concepts of God. So Christian-era art was aesthetically good insofar as it expressed popular Christian beliefs and sentiments. Since those beliefs embodied people's moral hopes, Christian-era art could only be good aesthetically if it expressed and sustained people's moral convictions. This was Jameson's new connection between art and ethics, and it depended on and was woven into the fabric of *Sacred Art*.

To draw out this account, I will start by stepping back to look at Jameson's 1849 essay 'Some Thoughts on Art' (Section 6.2). Written after *Sacred Art* Volumes 1 and 2 but before Volumes 3 and 4, this essay spelt out the historicist view of art which informed the series. With this key in hand, I explain the framework and taxonomy of *Sacred Art*, referring largely but not solely to the Introduction to Volume 1 (Section 6.3). One of Jameson's organizing distinctions was between *devotional* and *historical* modes of representation, which prompts the question of whether she was influenced by Barbauld's idea of devotional taste—more than Jameson admitted, I will suggest. From there, we can see how Jameson now connected art with religion (Section 6.4) and ethics (Section 6.5). Finally, I will raise

[7] For instance, Warner (1976) and Irigaray [1980] (1991).

some critical questions, drawing on John Ruskin's veiled criticisms of Jameson in *Modern Painters* Volume 3. To us, Ruskin and Jameson may seem quite close in linking art, ethics, and religion. But in their minds and those of their contemporaries, the differences were significant, and Ruskin pinpointed some real difficulties with Jameson's position (Section 6.6).

6.2 Greek and Gothic Art

The signed, two-part essay 'Some Thoughts on Art', hereafter 'Thoughts', came out in *The Art-Journal* in 1849. Jameson explained what aesthetic education was for and why it was especially needed for Christian art, which she characterized, following Friedrich Schlegel, as 'Gothic' art. Her account of aesthetic education led into a historicist view of art and its value.

'Thoughts' was not only a partly retrospective elaboration of the premises behind *Sacred Art*. Jameson also had an occasional motivation for writing it: to introduce a series of prints commissioned for *The Art-Journal*. This context deserves comment before we proceed to Jameson's arguments. *The Art-Journal* became the most widely read and dominant nineteenth-century British journal on art, one of the longest-running Victorian serials, and 'the very voice of the Victorian art establishment' (Haskins 2012: 12). It acquired a stature equal to *Fraser's, Cornhill,* and the *Contemporary Review*. The owner and editor from 1839 to 1880, Samuel Carter Hall, was a friend of Jameson's. In 1849 he upgraded the journal to become an illustrated monthly, showcasing the change with a series of prints based on engravings of Robert Vernon's art collection. At this key juncture, Carter pulled in Jameson to provide an authoritative statement on the need for aesthetic education to vindicate him in publishing the prints. Thus here, in 1849, a *female* art theorist was the key authority called in to give the *Art-Journal* greater prestige and popularity, and to help boost its circulation from 15,000 in 1849 to 25,000 just two years later (Teukolsky 2009: 13).

Jameson's (1849a) account of aesthetic education is as follows. Plastic art—by which she means not only sculpture but all visual art ('all imitation of form' (69))—consists of materials and form, and, if the artwork has any value, a content (70). Without content art is empty, and if we cannot appreciate the content, our *relation* to art is empty (69). But we cannot understand an artwork's content without attending to its materials, form, and the techniques of making it, for what needs understanding is the content *as* expressed in art's materials and form. So aesthetic education should guide us to grasp the content expressed in artworks, and inform us about art's forms and materials, not narrowly for their own sake, but so that we can see what content they express (69–70).

By content, Jameson clarifies, she means the 'spiritual conditions of Art' (70). What are these 'spiritual conditions'? Art, Jameson (1848) says in *Sacred Art*,

depends on 'social civilization', and above all a civilization's form of religious belief (vol. 1: xx). She objects that Richard Payne Knight's *Analytical Inquiry into the Principles of Taste* (1805), Edmund Burke's *Philosophical Enquiry into the Origin of Our Ideas of the Sublime and Beautiful* (1757), and Horace Walpole's *Anecdotes of Painting* (1762–71) all erred in being ahistorical.[8] Georgian aestheticians failed to carry out 'any inquiry into the true spirit and significance of works of Art, as connected with the history of Religion and Civilization' (Jameson 1848: vol. 1: vii). Content, then, is historically evolving religious content. Taking this as our starting-point, we find that Europe has had two great ages of art: ancient Greek art, bound up with paganism; and Gothic art, bound up with Christianity (Jameson 1849b: 104). The art of both eras was great *because* it was religious: it channelled the religious beliefs of these stages of civilization.

To understand Greek and Gothic artworks we must locate them in their historical eras, and know what religious content they express. With Greek art, we need to know about Greek myths and stories of the gods: Cupid and Psyche, Ino and Bacchus, the three Graces, Venus and Cupid. Yet we can no longer believe in these myths: 'It may well be doubted whether the impersonation of the Greek Allegories in the purest forms of Greek art will ever give intense pleasure to the people, or ever speak home to the hearts of the men and women of these times' (104). In contrast, in Gothic (or Christian) art, we find 'the expression of what is most venerable and dear to us in memory; in life, and in after-life': 'a style of Art embodying the grand and holy memories of our religion, the solemn and gracious figures of our scriptural personages:...the forms of those beings consecrated in our poetry or memorable in our annals' (104). Gothic art remains spiritually alive to us, unlike Greek art which has stopped progressing and is fixed in the past. However, our educational system is classically orientated, and so people know the stories behind Greek art better than those expressed in Gothic art. In one case we have knowledge without live belief; in the other, live belief without knowledge.

Although Jameson distinguishes Greek and Gothic art, they have overarching similarities. In both eras, art expresses religion; in both eras, artworks are aesthetically good when they express people's lived religious beliefs. Expressiveness confers aesthetic value because art that genuinely expresses religious beliefs is rich in meaning. Such art is *poetic*, a word that Jameson uses to mean 'meaningful', as we will see later. Art of this kind offers not narrow sensory pleasure, but higher spiritual significance.

In this essay Jameson invokes the names of two theorists. One is Harriet Martineau: 'The faculty of delight in beauty needs to be educated like all our faculties, and I wish Miss Martineau had said something upon the subject in her

[8] To be fair, Walpole did trace the history of painting in England, but he did not treat it as expressive of wider stages of civilization.

admirable little treatise on household education' (1849a: 70). That is, for Jameson, Martineau failed to include aesthetic education as part of education because she did not give enough weight to aesthetic pleasure and the sensory qualities that occasion it. Jameson is indicating her rejection of Martineau's moralism and her desire to balance pleasure and contemplation.

The other theorist she invokes is Friedrich Schlegel, brother of August Schlegel with whose Shakespeare interpretations Jameson had engaged. She refers to Friedrich Schlegel's claim that the poetry of art is finite, whereas that of nature is infinite (Jameson 1849b: 104).[9] From this starting-point, Jameson explains that the Greeks expressed their pagan myths in the finite forms of sculpture and architecture above all, whereas Gothic art expresses Christianity in music, painting, sculpture, and architecture. In both cases the forms and materials are 'bounded'. But there is an 'essential difference' between the two eras:

> As Greek sculpture was the apotheosis of mortal beauty and power, it found early and necessarily its limits of perfection, and the highest possible adaptation of its principles as the deification of external nature; but as Gothic Sculpture was the expression of a new life introduced into the world—of Love purified through Faith and Hope—of human affections, sorrows, aspirations—it follows, that we have not yet found or imagined any limit to its capabilities; we test its perfection by a wholly different law. (104)

In ancient Greece, physically limited materials fully expressed the pagan sense of the gods as quasi-physical beings, modelled on beautiful and powerful human beings. This is why Greek art developed fully then stopped: its sense of the divine was limited. In contrast, Gothic art rests on belief in truly spiritual qualities such as love, faith, and hope. No plastic artwork can ever completely convey the boundless aspiration involved in these spiritual feelings. After all, art is material, so its expression of genuinely spiritual content can never be perfect. But this very limitation motivates artists to keep striving to do better and better. Therefore the onward progression of Gothic art is inexhaustible, as that of Greek art was not. Greek art ended; Gothic art remains alive.

These views are very similar to Hegel's far better-known distinction between Classical and Romantic art (see Hegel 1975: vol. 1: 77–80). Well-versed as Jameson was in German culture and literature, she never referred to Hegel, strangely enough. Instead, the similarity between their views arose because both Hegel, in

[9] She refers to his 1794 essay 'On the Limits of the Beautiful', recently translated into English in the *Aesthetic and Miscellaneous Works of Friedrich Schlegel*. He says: 'while art is bounded on every side, nature...is everywhere vast, illimitable, and inexhaustible' (Schlegel 1849: 418). This essay collection also included his 'Principles of Gothic Architecture', originally from 1804–05, where he argued that Gothic art expressed Christianity (158). This was the source of Jameson's equation of the Gothic and the Christian.

the 1820s, and Jameson, in the 1840s, were expanding on ideas of the Schlegel brothers. Friedrich Schlegel distinguished Classical from Modern art (Schlegel [1797] 2002) and then reconceived the latter as Romantic (Schlegel [1798] 1991)—and subsequently also Gothic in 1804–05 (Schlegel 1849: esp. 156)—along lines that Hegel and Jameson took further.

Notably, through Schlegel, Jameson came to conceptualize and valorize the Gothic several years before Ruskin famously analysed 'The Nature of Gothic' in *The Stones of Venice* (Ruskin 1853). However, Ruskin had already touched on the Gothic in *Modern Painters* Volume 2 (Ruskin 1846), and he elaborated considerably in *The Seven Lamps of Architecture* (Ruskin 1849). By the time of the latter, and even more so in 'The Nature of Gothic', Ruskin regarded the Gothic not simply as a formal style of architecture, but as a wider style of art expressive of a certain spirit, and of a state of virtue and faith (see Ruskin [1864] 1866: 102). Clearly, this conception of the Gothic is close to Jameson's. Yet whereas Ruskin's conception of the Gothic has been continuously discussed since his own time, Jameson's view of the Gothic has been almost entirely ignored. So too, has the possibility that she may have influenced Ruskin, as well as him influencing her.[10]

In terms of her stated theoretical influences in 'Thoughts' Jameson continues to pair German Romanticism with British moralism. Previously she coupled August Schlegel and Joanna Baillie; now it is Friedrich Schlegel and Harriet Martineau.[11] Jameson no longer unites these traditions through the idea of character as in *Characteristics of Women*. Instead, she appeals to the German Romantic idea that art expresses spiritual content in bounded material shape. Because this content is spiritual, understanding art improves us morally, imparting to us a spirit of aspiration and self-improvement—hence the link to British moralism.

However, in contrast to Jameson's earlier idea of aesthetic wholes, she now thinks that artworks can never be perfect wholes. Artworks can perfectly express spiritual content, as in ancient Greece, but only when that content is itself limited and mixed with materiality. Or art can express truly spiritual content, as in the Gothic era, but now the content cannot be given perfect material expression just because it is truly spiritual. This is why the poetry of all art is finite: there are limits to its expression of spiritual meaning.

[10] Both Jameson and Ruskin wrote in the wake of the Gothic revival spearheaded by the architect Augustus Pugin. He wrote on the Gothic too, but from a more technical point of view (Pugin 1841).

[11] Hilary Fraser (2014) notes some of Jameson's other continental influences, concluding that she was located 'intellectually within Continental rather than British art-historical research at the time' (22). Jameson's German philosophical influences were extensive (see Johns 2014 and Hughes 2022a). Another major influence was Alexis-François Rio's *De la poésie chrétienne* (1836): Rio, a Schellingian, argued that art's value derived principally from its expression of spiritual truth, apprehended by the artist in unconscious intuition. Amidst these varied sources, Jameson's British female influences have been somewhat overlooked.

6.3 How Jameson Decodes Christian Art

Jameson (1848) began *Sacred Art* by deploring the fact that most people in her time were at sea in their own artistic heritage, unable to read the artworks around them or sympathize with the sentiments they expressed. For instance, diminishing numbers of people could readily decipher the stories narrated in stained-glass windows in churches, beyond obvious cases like the crucifixion and resurrection.

> This form of '*Hero-Worship*' has become, since the Reformation, strange to us—as far removed from our sympathies and associations as if it were antecedent to the fall of Babylon, and related to the religion of Zoroaster, instead of being left but two or three centuries behind us, and closely connected with the faith of our forefathers and the history of civilization and Christianity. (vol. 1: xv)

Jameson (1852) sought to combat people's religious illiteracy: 'The general plan of the work...really aims at nothing more than to render the various subjects intelligible' (v). She added:

> A picture or any other work of Art, is worth nothing except in so far as it has emanated from mind, and is addressed to mind. It should, indeed, be *read* like a book. Pictures...are the books of the unlettered, but then we must at least understand the language in which they are written. (69)

Sacred Art was thus a work of religious, moral, and aesthetic education as defined in 'Thoughts'. The aim was to inform people about the religious legends of their culture, guide people to see how artworks expressed this content, and morally improve the public by helping it to relate to art's spiritual content. This giant work of aesthetic education was needed, Jameson believed, not only due to secularization and cultural change but also due to Christian art's inescapable limits. The artistic material could never perfectly embody its spiritual content, so that Christian art was never completely transparent but stood in need of decoding.

The need of these artworks for decoding already tells us something both about art and our relations to it. Art is the outgrowth of a wider culture, an expression of its 'state of feeling, and...legends and traditions' (Jameson 1848: vol. 1: xv). Artworks embody 'in beautiful shapes...associations and feelings and memories deep rooted in [people's] very hearts, and which...[have] influenced, in no slight degree, the progress of civilization, the development of mind' (xx). Across different eras, these associations, feelings, and memories have centred on religion, and so 'the true spirit and significance of works of Art [is] connected with the history of Religion and Civilization' (xxi). So the question to ask of artworks concerns: 'The spirit of the work—whether *that* was genuine; how far it was influenced by

the faith and the condition of the age which produced it...whether the treatment corresponded to the idea within our own souls' (xxii). As Jameson's formulations convey, sensitive understanding of artworks does not require mere abstract knowledge about their cultural background. Rather, we need to be able to enter with imagination and feeling into the states of belief that found expression in the art. We need sympathetic understanding, not analytical knowledge.

Jameson's core views are, once again, close to those of Hegel and the German Romantics. Hegel, like Jameson, was systematizing German Romantic views, and for him too art is part of a wider culture and evolves historically along with civilization. Moreover, for Hegel (1875), art has specifically evolved along with religion (vol. 1: 71–73). The ancient Greeks expressed their beliefs about the gods and heroes in their art, and something similar goes for art of the Christian era. But here Jameson's distinctiveness vis-à-vis Hegel comes into view.

For Hegel, Romantic art expresses the inwardness of spirit, which becomes increasingly individual, subjective, and secular over time, so that Christian art is only the first and least developed form of Romantic art. Christian art has three proper subjects (vol. 1: 533): 'the redemptive history of Jesus Christ', love (of Mary, Jesus, or the disciples), and the community of Christians, including the martyrs. This threefold division is appropriate because it reflects the three persons of the Trinity. Accordingly, the martyrs should be shown either undergoing physical tortures or repenting—'the proper subject-matter...is endurance of cruelties, and a man's own freely willed renunciation' (544). These express the body's return back to spirit, and so God's return to himself. Hegel is dismissive of legends: 'the whole representation [is] given over to every folly and the whole caprice of chance' (230), 'legends often pass over without difficulty into what is abstruse, tasteless, senseless, and laughable,...what is absolutely irrational, false, and non-divine' (550). God's triune nature sets the proper limits of Christian art, and beyond those limits it falls into irrationality.

For Jameson (1848), in contrast, art of the Christian era does not primarily express theological doctrines or the pure faith of the Gospels. The religion expressed here is *popular* Christianity, as narrated in the 'legendary literature' that 'formed the sole mental and moral nourishment of the *people* of Europe' (vol. 1: xvi), 'the once popular legends of the Catholic Church' (xv). In fact this 'literature' was often oral, since the Bible, like theological doctrine, was out of most people's reach (xvi). Instead the people had stories of martyrs, saints, angels and archangels, penitents, apostles, and so on. These stories made up a 'polytheistic form of Christianity' (xx). It was peopled not by God and Christ alone, but by 'more material beings in closer alliance with human sympathies' (xvi). In this accessible form of Christian belief, the religious landscape was full of quasi-material individuals with whom people could identify and in whom they could lay their hopes.

This distinction between theology and religion, official doctrine and popular spirituality, pervades *Sacred Art*. For instance, Jameson (1852) complains that the sixteenth-century Council of Trent, which reasserted Church authority over numerous heresies, killed religious art: 'Spiritual art was...no more. It was dead; it could never be revived without a return to those modes of thought and belief which had at first inspired it. Instead of religious art, appeared what I must call *theological* art' (23). This was art regulated by the Church with a view to doctrinal correctness, and it was quite distinct from truly religious art. To be sure, Jameson (1848) concedes, the arts re-emerged after the Dark Ages through patronage from the Church and the monastic orders (vol. 1: xix). Yet the Church *'absorbed'* popular legends, and gave them artistic representation, in order to win support for itself. Christian art was therefore a 'compromise' between established Church and popular belief, but the latter remained at the heart of the art that resulted (xix–xx)—at least until the Council of Trent. This emphasis on popular belief is a logical consequence of Jameson's basic view that art expresses the spirit of a culture. The true spirit of a culture is necessarily that of its *entire* people, not only its elites.

Jameson's conception of popular Christianity may seem to conflict with her distinction between true Christian (Gothic) spirituality and Greek polytheism. It now appears that, *like* Greek polytheism, popular Christianity filled the religious landscape with 'more material beings', amenable to artistic representation. However, the saints, martyrs, and so on, were 'more material' only relative to God. Compared to ordinary people and the natural world, they remained spiritual. The saints, martyrs, and so on, strove to transcend the material world and succeeded:

> All traces of an individual existence seem to have been completely merged in the abstract ideas they represented...they were *powers*, differing indeed from the sensuous divinities of ancient Greece, inasmuch as the moral attributes were infinitely higher and purer... (Jameson 1848: vol. 2: 76)[12]

So these individuals were *truly* spiritual, unlike the Greek gods. But for this reason the gap between spiritual content and material expression persisted, which is why Christian art needed deciphering.

To decode this art, we need to know about popular legends and beliefs, not theological doctrine. Her concern, Jameson says, is not with 'the faith of the enlightened and reflecting Roman Catholics...but of the feelings which existed, and still exist, among the lower classes in Catholic countries,...respecting these poetical beings' (76). Accordingly, she outlines numerous legends behind specific

[12] Jameson is talking here about 'The Virgin Patronesses', but the point applies to other Christian figures too.

artworks, such as the stories of St Jerome and the lion, or St John Chrysostom leading the life of a wild beast in the desert in penance for his sins.

We also need to understand *how* these legends are communicated by artworks. Here Jameson introduces a key distinction between the *devotional* and the *historical*:

> All sacred representations, in as far as they appeal to sentiment and imagination, resolve themselves into two great classes,...the DEVOTIONAL and the HISTORICAL. Devotional pictures are those which portray the objects of our veneration with reference only to their sacred character...They place before us no action or event, real or supposed. They are neither portrait nor history.... But a sacred subject, without losing wholly its religious import, becomes historical the moment it represents any story, incident, or action, real or imagined. (vol. l: xxv–iv).

In devotional artworks, the subjects depicted are *symbolic* of spiritual qualities, for example when Mary Magdalene is a symbol of repentance. In contrast, if she is treated historically, then the artwork depicts some of the events known, believed, or imagined to have happened in her life. Or, for instance, the Last Supper may be depicted devotionally, as a symbol of the Eucharist, or historically, as an event that took place and is shown in its dramatic character. For Jameson, artworks should be either devotional or historical and not mingle the two. If the Last Supper is being treated devotionally, 'it is a fault to sacrifice the solemnity and religious import of the scene in order to render it more dramatic' (256). For some of her key claims about the devotional/historical distinction, see Table 6.2.

Using this distinction, for example, Jameson tells us which animals stand for which saints and martyrs, whether devotionally—where the animals symbolize these individuals' distinctive virtues—or historically—because of reputed episodes in which these individuals interacted with certain animals. She enumerates which spiritual qualities different colours symbolize (e.g., red is the fire of divine love; blue stands for constancy and fidelity), and which figures are depicted in which colours, whether for symbolic or historical reasons (e.g., with the colours of different monastic orders). She not infrequently criticizes artists for getting these symbolic and historical codes wrong, by depicting someone in the wrong colour, putting the wrong animal next to a particular saint, muddling symbols and attributes, and even confusing different saints and religious personages. She criticizes artists not only when they mingle devotional and historical approaches but also when they mingle Christian and classical styles. For example:

> Vasari has had the bad taste to give us a penitent St Jerome, with Venus and cupids in the background: one arch little cupid takes aim at him—an offensive instance of the extent to which, in the sixteenth century, classical ideas had mingled with and depraved Christian art. (280)

Table 6.2 Jameson's Devotional/Historical Distinction

Devotional	Historical
Symbolic—depicting an event, scene or person as the symbol of a spiritual event or quality (e.g., Lazarus as symbol of the resurrection)	*Representational*—depicting an event, scene or person that is known, imagined, or reputed to have happened or existed (e.g., the raising of Lazarus as a reputed historical event)
	The event may be narrated in scripture, or in legends; legends in turn may be partially based on scripture
Uses *emblems*—i.e., where something has a fixed symbolic meaning, as with the lamb as symbol of 'the Redeemer as the sacrifice without blemish' (1848: vol. 1: xxxvi); the dragon as symbol of sin; the cherub, lion, ox, and eagle as emblems of the four evangelists; the crown as the symbol of glorious martyrdom	Uses *attributes*—i.e., where certain objects signify that something took place historically—for example, when a martyr is shown with a sword or knife that indicates how they were killed; or when someone wears a crown to indicate that historically they were of noble birth
Allegorical—the events depicted stand for events in another spiritual realm, and have another meaning beyond their mundane one	*Literal*—the events are depicted in their historical character
Ideal, sculptural—the person or scene is not depicted in material detail because the focus is on what they stand for—for instance, wings as symbols of 'the might, the majesty, and the essential divinity of beauty' should not be portrayed like the real wings of birds (vol. 1: 14)	*Dramatic*—detailing the realistic qualities of the subjects depicted (vol. 2: 11)

For Jameson there is a code that specifies which elements have which meanings (the wheel for St Catherine, the club for St James Minor, the arrow for St Ursula, etc.), and artists ought to adhere to it. She distinguishes the meaning of an artwork from the artist's intention:

The prophets and the poets often say more than they intended…: so also the great painters.…The true artist 'feels that he is greater than he knows'.…[Such artists] speak to all times, to *all* men, with a suggestive significance, widening, deepening with every successive generation; and to measure their depth of meaning by their own *intention*…, what is it but to measure the star of heaven by its apparent magnitude?—an inch rule will do that! (132)

Artists draw on two sources of meaning that go beyond their conscious knowledge: one is the spirit of their time and its genuine faith; the other is a set of cultural codes that the artist has not originated and of which they may be

scarcely aware. These sources enable artists at best to generate an immense wealth of meaning, but at worst to get the codes wrong and produce botched artworks or ones that fail to express the genuine spirit of their time, as in the Vasari case just mentioned.

This raises a question about how Jameson sees the role of the artist. In *Memoirs of the Early Italian Painters* she looked at artists very much as individuals whose personal lives shaped their art. More virtuous painters produced better art, and conversely. For example, 'it is pleasant to be assured that the life and character of Francia were in harmony with his genius' (Jameson 1845: vol. 1: 215), whereas Fra Filippo 'desecrated' sacred topics by 'introducing the portraits of women who happened to be the objects of his preference at the moment' (114). But in *Sacred Art*, Jameson takes a different view. The role of the artist is to transmit the spirit of the age faithfully and to understand and apply symbolic codes correctly (which need not be a conscious or explicit understanding). The artist will be more successful the more they make themselves a conduit for these wider cultural meanings.

The devotional is such a central category for Jameson that we may wonder whether Barbauld's essay on devotional taste influenced her. Jameson's distinction of theology from popular, emotional, lived faith also recalls Barbauld's distinction between religion as a system of truths and an aesthetic matter of imagination and emotion. I have found no references to Barbauld in Jameson's published work but, as we saw in Chapter 1, Jameson told Annabella Byron that Barbauld's 'Evenings at Home' was one of her greatest early influences: 'I trace to this book my first wish for knowledge, my perception of the beauty of natural objects… I never tired of it.' She added 'my pious feelings I owed to my mother and to Mrs Barbauld's Hymns, which I would repeat by heart' (AJ to Byron [c.1841], in Jameson 1834–53: 36–37). In these Hymns, we saw in Chapter 2, Barbauld put her devotional aesthetic into practice. So she undeniably had some influence on Jameson.

There were also differences. For Barbauld, to acquire devotional habits is to learn to associate all natural objects, everyday scenes, and phenomena with ideas of God. The focus of her devotional aesthetic is on nature and the everyday world, so that a devotional taste is available even to young children. In contrast, for Jameson, the devotional is a property of artworks that depict particular things, people, or events as symbolic of spiritual qualities and deploy a code that specifies what symbolizes what. Jameson has moved devotion out of everyday life and into the art-world and its complex cultural codes.

Another difference concerns the sublime. For Barbauld, the upward movement from everyday things to God is sublime, while the downward movement to find God in everyday things makes them beautiful. Jameson does not define beauty, but throughout *Sacred Art* she takes artworks to be beautiful when they genuinely express spiritual content and make material shape a vessel of spiritual

expression. The sublime, on the other hand, is not a significant aesthetic category for Jameson (1848). She tends to treat it as a form of the beautiful, for example when referring to a 'beautiful, picturesque, and (to my fancy) sublime legend' (vol. 1: 181). But she uses the words *beautiful* and *picturesque* far more often than *sublime*.

However, on those occasions when Jameson *does* invoke the sublime, it is in Barbauld's sense of the upward movement from what is sensed to the spiritual. For instance, Jameson says that 'the smile in many of Correggio's angel heads has something sublime and spiritual, as well as simple and natural' (44), and that 'the head of the angel, looking up in the face of the Madonna, is in truth sublime...none could doubt that it is a *divine* being' (96). The more successful a devotional representation is, the more it is sublime, where 'sublime' means 'lifting our minds to the divine realm'. As a whole, Jameson *uses* categories like *beautiful* and *sublime* in *Sacred Art*, rather than analysing them. This is in keeping with her overall project of reflecting on and making sense of the arts, rather than mapping the forms of aesthetic experience and value.

6.4 Religion and Aesthetics in *Sacred Art*

Until now, I have avoided bringing in the single statement from Jameson's *Sacred Art* that many recent interpreters have seen as defining her approach.

> I have taken throughout the aesthetic and not the religious view of these productions of art which, in as far as they are informed with a true and earnest feeling, and steeped in that beauty which emanates from genius inspired by faith, may cease to be Religion, but cannot cease to be Poetry; and as poetry only I have considered them. (Jameson 1848: vol. 1: xi–xii)

Many readers have inferred that Jameson is looking at religious art merely aesthetically and from a position of religious neutrality. For Judith Johnston (1997), Jameson preferred 'that her work be read as secular rather than containing any form of religious bias' (36) and she was 'very determined to achieve' a shift of 'focus from the religious to the poetical' (194). Ainslie Robinson (2003) speaks of Jameson's 'secular perspective' and says that she 'suspends any personal religious views' (197). Kimberly Adams (1996) treats Jameson as a quasi-Feuerbachian for whom 'Human fears and human longings...gave rise to divine attributes and sacred legends' (66), adding that for Jameson 'the sacred becomes primarily a human category of perception' (Adams 2001: 76). For Hilary Fraser (1992), 'Jameson was...interested in representations of the Madonna for overtly secularist reasons' (81). And for Jane Styler (2010), Jameson's view is that: 'It is the associations which worshipers have invested in the saints which constitute their spiritual significance' (89)—*our* investments, humanly constructed meanings.

This line of interpretation is understandable. Most academics today are secularists, so Jameson's work will be more relatable if she is construed as a proto-secularist. Yet still I think the interpretation is wrong.[13] For Jameson, to understand art sympathetically it is not enough to analyse its techniques, forms, and materials:

> There is pleasure, intense pleasure, merely in the consideration of Art as *Art*; in the faculties of comparison and nice discrimination...in the exercise of a cultivated and refined taste...But a three-fold, or rather a thousand-fold pleasure is theirs, who to a sense of the poetical *unite a sympathy with the spiritual in Art*. (Jameson 1848: vol. 1: xlvi–xlvii; my emphasis)

We need, as Jameson had argued in 'Thoughts', to understand the artwork's content; that content is spiritual; and, if the art belongs to the Christian era, then that spiritual content is Christian, specifically, popular-Christian. It is not enough for our understanding to be neutral and analytical, we need felt sympathy with the spirit expressed in the work. Jameson therefore insists that however superstitious popular Christian legends may appear to the modern critical mind, we must look for the positive in these legends, their core of genuine faith. She tells us that she 'hates' the 'destructive' attitude that would write all this off as credulous and childish nonsense (xxi)—as Hegel did, for instance, as I mentioned above.

For Jameson, we must instead take the 'progressive' attitude that discerns the fundamental truth behind the myths (xxi). In *Legends of the Monastic Orders*, recapitulating, Jameson (1850) writes:

> In the first series, I reviewed the scriptural personages and the poetic and traditional saints of the early ages of the Church, as represented in Art. I endeavoured to show that these have, and ought to have, a deep, a lasting, a universal interest; that even where the impersonation has been, through ignorance or incapacity, most imperfect and inadequate, it is still *consecrated* through its original purpose, and through *its relation to what we hold to be most sacred*...(xvii; my emphasis)

To relate to Christian art, we must enter sympathetically into its animating faith. Even when we no longer believe in some specific legend or myth, we should still reach into it for the nucleus of shared faith that remains alive for us today. So we cannot access the art's content if we suspend or bracket our faith; we can only connect with this content by relating to art from our lived religious commitments.

[13] Adams (2001) in fact agrees, saying that scholars 'have too readily accepted her disclaimer that her approach was aesthetic rather than religious' (53).

Thus the right approach to Christian art is *religious*. Consider Jameson's (1852) remarks on Raphael's *Sistine Madonna*, her ideal artwork:

> Six times have I visited [it]…and…when again at a distance…disturbed by feeble copies and prints, I have begun to think, 'Does not rather the imagination encircle her with a halo of religion and poetry, and lend a grace which is not really there?', and as often, when returned…there is more in that form and face than I had ever yet conceived. I cannot…speak to this picture merely as a picture, for to me it was a *revelation*. (34; my emphasis)

These views tie in with Jameson's historicism. If every artwork is of its historical era, the question inevitably arises of how we can ever sympathetically understand artworks from different periods. In 'The House of Titian' Jameson (1846) gives her answer:

> The real value, the real immortality of the beautiful productions of old art lies in their truth as embodying the spirit of a particular age. We have not so much outgrown that spirit, as we have comprehended it in a still larger sphere of experience and existence. We do not repudiate it…but we carry it with us into a wider, grander horizon. It is no longer the whole, but a part, as that which is now the whole to us shall hereafter be but a part; for thus the soul of humanity spreads into a still widening circle, embracing the yet unknown, the yet unrevealed, unattained. (28–29)

Later historical stages are wider than and encompass earlier stages, so that latecomers can understand those who went before them. This set of concentric circles would fall apart if we repudiated religion altogether. We relate to past Christian art from a wider, deeper, less superstitious, more truly spiritual, form of Christianity that encompasses and keeps alive the kernel of immortal spirit in past productions (27–28).

Why then did Jameson misleadingly suggest that her approach was not religious but only aesthetic? Part of the answer, as others have shown, is that most of the art she was decoding was Catholic (Adams 2001: 26–27, Kanwit 2013: 72–74). Yet her audience was largely Anglican, so she had to make clear that her praise of Catholic art did not entail support for Catholicism as a denomination. Moreover, this reveals another reason for her distinction between Catholic church and popular religion. By siding with popular religion and its universal moral hopes—the same ones recognized in Protestantism—she sought to find a common core of Christianity that bridged sectarian divides.[14]

[14] Indeed, in her *Commonplace Book*, she envisaged an 'idea of possible harmony in the Universal Church of Christ', which she called 'Expansive Christianity' (Jameson [1854] 1855: 169).

A final piece of this jigsaw is that Jameson (1848) says her approach is poetic, rather than either religious or artistic:

> All the productions of Art, from the time it has been directed and developed by Christian influences, may be regarded under three different aspects. 1. The purely religious aspect, which belongs to one mode of faith; 2. the poetical aspect, which belongs to all; 3. the artistic, which…has reference only to…the means and material employed. (vol. 1: xlvi)

I suggest that what Jameson means by 'poetic' is that we need to look on religious art as *expressive of meaning*. Ruskin (1856a) used the word 'poetic' in the same way: 'Painting is properly…opposed to speaking and writing, but not to poetry. Both painting and speaking are *methods of expression*' (14; my emphasis). Thus, Ruskin and Jameson had a common understanding of 'poetic', on which artworks need not be works of poetry or literature to be poetic. Paintings and sculptures are poetic if they express meaning, and, for Jameson, religious art is expressive of meaning in several senses: expressing poetic legends; expressing the spirit of an age and culture; expressing true spiritual content; and operating with tacit symbolic codes. This approach is ecumenical—it finds the poetic meaning, the spiritual expressiveness, that 'belongs to *all*' forms of Christian art, unlike the (sectarian) religious approach which 'belongs to one' mode of faith only. But the poetic approach remains religious, in an open-minded and universal sense. And it remains distinct from a narrowly artistic or aesthetic approach, which neglects spiritual content and meaning and concentrates narrowly on forms, materials, and techniques.

6.5 Religious, Aesthetic, and Moral Value in *Sacred Art*

How did Jameson now connect art, religion, and morality? In her view, legends of the saints, martyrs, and other religious figures were a beacon of moral hope in a hopeless world. Let me quote her rich evocation at length:

> At a time when men were given over to the direst evils that can afflict humanity—ignorance, idleness, wickedness, misery…when slavery was recognized by law throughout Europe; when men fled to cloisters, to shut themselves from oppression, and women to shield themselves from outrage…then—wondrous reaction of the ineffaceable instincts of good implanted within us!—arose a literature which reversed the outward order of things, which asserted and kept alive in the hearts of men those pure principles of Christianity which were outraged in their daily actions; a literature in which peace was represented as better than war, and sufferance more dignified than resistance…a literature in which the tenderness,

the chastity, the heroism of woman played a conspicuous part; which distinctly protested against slavery, against violence... (Jameson 1848: vol. 1: xviii–xix)

Poetic religion upheld a protest against the injustices, inequalities, and oppressions of the medieval era. Against these forces, poetic religion celebrated heroic men and women who personified virtue; who practised abstinence, peacefulness, mercy, and charity; who would die rather than compromise their virtue; and whose spiritual triumph promised a better world in which happiness would be proportioned to virtue.

Marx ([1843–44] 1992) likewise regarded religion as 'the sigh of the oppressed creature, the heart of a heartless world, and the soul of soulless conditions' (244). But he condemned religion as an opiate, giving people the solace to endure the heartless world instead of changing it. Jameson took the contrary view that people would never change the world without virtues of courage, hope, aspiration, and trust. And, in an unjust society, people could only cultivate these virtues under the influence of religious stories and ideals. Without legends of exemplary virtuous individuals triumphing over material injustice, people would give way to the vice around them.

For Jameson, popular Christianity was moral through and through. This, again, distinguished it from ancient Greek myth:

> The mythology of the ancient Greeks was the deification of the aspects and harmonies of nature. The mythology of Christianity was shaped by the aspirations of humanity—it was the *apotheosis of the moral sentiments*, coloured by the passions and suffering of the time. (Jameson 1848: vol. 2: 3; my emphasis)

Christianity elevated spirit above nature as Greek paganism did not, and moral aspirations were crucial to this elevation, for people could only aspire to another world better than the actual one by looking to a *spiritual* world elevated above the existing material one. It was because popular Christianity centred on hope for a morally better world that it invested belief in a spiritual world raised above nature and actuality.

Having seen how Jameson linked popular religion and morality, how did she bring aesthetic value into the picture? Her discussion of monasticism (1850) sheds some light. The art that depicted the monastic founders and leaders was compromised morally *and* aesthetically (xviii). Because these sainted figures renounced the world and its pleasures altogether, they were not beautiful but were often ugly and painful to look on, with wasted features, ruined health, emaciated bodies, unkempt hair, and so on. Morally, they erred on the side of excessive renunciation, and this moral flaw generated an aesthetic flaw. Conversely, these monastic pictures retained some aesthetic value because the monks and nuns also had genuine virtues. They lived with self-restraint, so they often

presented soothing, soft, settled calm (xx), while in other cases their genius, strong will, and energetic aspirations were manifest (390).

It seems that a depiction of someone morally flawed must be aesthetically deficient: 'the effigies of the Monastic personages... *necessarily* fail in beauty' (xi; my emphasis). Conversely, a depiction of a virtuous character will be aesthetically good. But why should this be? Here we must go back to Jameson's central idea that artworks are better aesthetically the more genuinely and meaningfully they express their culture (as quoted earlier: 'The real value... of the beautiful productions of old art lies in their truth as embodying the spirit of a particular age' (1846: 28)). In the Christian era artworks must genuinely express popular Christianity to be aesthetically good (beautiful). But popular Christianity essentially registers a moral protest against an unjust society. Thus artworks cannot express the popular Christian spirit of their time unless they express its moral hopes and faith. And unless artworks depict the saints and other religious personages as virtuous, these figures cannot embody people's moral hopes. So when the figures depicted are morally flawed, as with the monastic founders, these artworks are not wholly faithful to popular aspirations. Their moral limitation is a failure of aesthetic expressiveness as well.

Evidently, Jameson equates artworks being good as art with their being good aesthetically and, in turn, with their being beautiful. For her, the aesthetic domain *is* the domain of art, first and foremost; and the central aesthetic value is beauty, as a property of certain artworks. Jameson does not deny that nature can be beautiful, but for her it is secondary (I will return to this in Chapter 10).

The upshot is that a Christian-era artwork can only be good aesthetically—expressing the true spirit of its age—if it holds up saintly and religious figures as virtuous. The saints, martyrs, and other figures should be presented as moral exemplars whose virtues shine out attractively. For instance, in a time of violent oppression, St George set wrongs to rights. When plagues and diseases ravaged the populace, St Cosmo and St Damian had healing powers. When travel was dangerous, St Christopher offered travellers protection. When women were sexually oppressed, female saints like St Catherine and St Ursula embodied 'unblemished chastity' (Jameson 1848: vol. 2: 3).

Conversely, Jameson castigates a wide range of aesthetic flaws under the heading of 'coarseness'. Artists may dwell excessively on the physical sufferings undergone by renunciants (3: xviii), or the physical tortures suffered by the martyrs: 'dolorous and sanguinary death-scenes... are no more fitted for spiritual edification, than the spectacle of public executions to teach humanity and respect for the law' (139). These artworks highlighting the martyrs' physical sufferings depart from popular moral aspirations:

> The sympathy of the lower orders was less excited by the apparatus of physical agony than the bearing of the victim. To them the indomitable courage, the

glorious triumph of the sufferer, were more than the stake, the wheel, the rack, the scourge, the knife.... The most beautiful and edifying representations of the martyrs are...those in which they look down upon us from their serene beatitude...their triumph accomplished...(139)

Only when artworks portray the saints as being spiritually victorious, despite their physical pains, do these artworks express the popular moral hopes of the period (they edify) and thereby achieve aesthetic value (beauty).

Artworks can also be coarse by dwelling excessively on physical pleasures. Jameson (1850) singles out for its 'vileness' Bernini's *The Ecstasy of St Teresa*: 'the *materialism* of the conception...the grossest example—the most offensive' (421). This is the statue, we remember, of which the psychoanalytic theorist Jacques Lacan ([1972-73] 1985) later said: 'You only have to go and look at Bernini's statue in Rome to understand immediately that she's coming' (147). But Jameson is not a stereotypical Victorian prude. She regards Teresa as having 'genius...with all its terrible and glorious privileges' (1850: 434). Bernini's statue reduces Teresa to a sexual object rather than a powerful agent. More generally, artworks that show saints revelling in physical pleasures fail to express the aspiration towards a spiritual world different from and better than the physical one. This expressive loss is religious, moral, and aesthetic at once.

Even when religious subjects are being treated historically, the material detail should not be so lavish that we lose the spiritual aspiration to a better world. Jameson's ideal is Raphael,[15] whom she regards as the Shakespeare of visual art: 'Not long ago, I heard a distinguished writer of the present day—an artist, too— express his opinion, that "Raphael had been overrated". One might as well say that Shakespeare had been overrated' (123). Raphael's first rank among visual artists was well established in Jameson's day. It had the imprimatur of Joshua Reynolds ([1769] 1891), who instructed artists: 'Consider with yourself how a...Raphael would have treated this subject, and work yourself into a belief that your picture is to be seen and criticised by [him] when completed' (71). But Jameson (1852) has particular reasons for exalting Raphael. He portrays his figures with just enough materiality to embody their symbolic qualities or historical attributes and no more: 'the object of sense remained in subjection to the moral idea' (3). Hence the grace and weightlessness of Raphael's best figures, the softness of his outlines and contours, and the translucency of his colours (Jameson 1848: vol. 1: 110, 113). In all these ways spirit elevates, softens, and shines through the bodies he depicts. Raphael gives us ideal materiality, not a coarse materiality from which spiritual hope has flown.

[15] 'I have seen my own ideal once, and only once, attained: *there*...Raphael—inspired if ever painter was inspired' (Jameson 1852: 34; see also Jameson 1846: 3). She even confesses that Raphael is 'the God of my idolatry' (1846: 7).

6.6 Jameson, Ruskin, and the Canon

Jameson's enthusiasm for Shakespeare and Raphael reflects her acceptance of the established canon of great art. This has disappointed some recent interpreters:

> Jameson accepts without question the most venerable and canonical works of legitimate culture—the paintings of Rubens and other Old Masters... Jameson writes about high art, and her canon does not extend beyond those works which were understood to exemplify the social status and meaning of what it was in her time... to be 'cultured'. (Kane Lew 1996: 832)

Antje Anderson (2020), too, speaks of Jameson's 'conventional admiration of masterpieces and the great men who created them' (194), saying that Jameson 'opted to repeat or at best amplify already-established opinions' and was 'interested in already famous, canonical art' (191).

Jameson accepted the canon partly because of her desire to educate the public about art. Exploding or querying the canon would have undermined the effort to teach the public about its artistic heritage. But more than that, Jameson simply did not share recent feminist concerns with critiquing, expanding, or rejecting the canon. This is not solely because she was of her time, for, after all, her near-contemporaries Elizabeth Ellet and Eleanor Creathorne Clayton produced canons of female artists (Clayton 1863, 1876; Ellet 1859). Indeed, Jameson herself included sections in *Visits and Sketches* (1834) on 'German Authoresses', 'Thoughts on Female Singers', 'Thoughts on Female Artists',[16] and sketches of Sarah Siddons and Fanny Kemble. A few years later Jameson hoped to collaborate with Ottilie von Goethe on a projected 'Biography of Female Artists', which she said would be 'far more important' than her catalogues of London art (AJ to Goethe, 20 April 1840, in Needler 1934: 124). However, this project never came to fruition and more generally Jameson did not bring her thoughts on female artists to bear on her engagement with canonical works. Her central interest remained with the mainstream male canon.

Yet this acceptance of the canon was in some tension with Jameson's own framework. This comes out from Ruskin's (1856a) criticisms of her in *Modern Painters* Volume 3. He writes:

> Sacred art... has yet to attain the development of its highest branches... All the histories of the Bible are, in my judgement, yet waiting to be painted... religious art, at once complete and sincere, has never yet existed. It will exist, nay I believe the era of its birth has come, and that those bright Turnerian imageries... and

[16] For an excellent discussion of this little-studied part of Jameson's book, see Holcomb (1987–88).

those calm Pre-Raphaelite studies... form the first foundation that has ever been laid for *true* sacred art. [But]... those who mingle the refinements of art with all the offices and practices of religion... mistake their enjoyments for their duties, or confound poetry with faith. (64–65; my emphasis)[17]

Although Jameson's name is not mentioned here, the phrase 'sacred art' tells us that she is the critical target. And the criticism is that much art billed 'sacred' by Jameson is not truly sacred at all. In particular, Ruskin demotes Raphael: 'The clear and tasteless poison of the art of Raphael... is the first cause of all that pre-eminent *dulness* which characterizes what Protestants call sacred art' (61). Some try to invest his art with true religious vitality, Ruskin says (viz. Jameson), but they are mistaken. Raphael in fact epitomizes the undesirable tendency to put 'pleasure as [art's] first object; religion as its second'. Raphael's art, and that of his followers, are '*impurer* for not being in the service of Christianity' (Ruskin 1855: 205). For Ruskin, these flaws reflect Raphael's adoption of classical ideals. Whereas medieval art expresses the true spirit of Christianity, the Renaissance hybridizes that spirit with classicism, adulterating religious motives with secular pleasure in the beauty of the embodied human form.[18] Consequently, for Ruskin, the Renaissance is not the pinnacle of artistic achievement but a deterioration, and a return to art's earlier, genuinely Christian spirit is needed. Ruskin believed that the Pre-Raphaelites were making this return, and so he championed their work (see, e.g., Ruskin 1851). After all, they called themselves the *Pre*-Raphaelite Brotherhood because they took as their model earlier Italian painting, prior to Raphael and the high Renaissance. In short, for Ruskin, Jameson mistakenly reads the true Christian spirit into the high Renaissance where it is not to be found.

Ruskin and Jameson were at odds not only about art history but also in their positions in social networks and artistic movements. Jameson was by then firmly ensconced in the establishment circles in British art which Ruskin and the Pre-Raphaelites rejected. For instance, she provided the introduction to Ludwig Grüner's book *The Decorations of the Garden-Pavilion in the Grounds of Buckingham Palace* (1845). This contained illustrations of a (now lost) pavilion with Renaissance-style fresco paintings in the grounds of Buckingham Palace. The work was overseen by Jameson's good friend Charles Eastlake, President of the Royal Academy from 1850 to 1865, first Director of the National Gallery, and a practising artist whom Jameson rated one of the country's best painters (AJ to Robert Noel, 20 June 1834, in Macpherson 1878: 95–96). Charles was the

[17] The fact that Ruskin is criticizing Jameson here, and in the preceding few pages, is pointed out by Wheeler (1999: 98) and, in more depth, by Haskins (2012: ch. 4).
[18] Ruskin ([1843] 1848) at times distinguishes a low kind of beauty as mere sensory pleasure (25) from a higher, genuine beauty which is moral and 'theoretical' (Ruskin 1846: 11). High Renaissance artists, he maintains, had turned aside from the latter to the former.

husband of the same Elizabeth Eastlake who completed the *Sacred Art* book series, another sign of Jameson's close ties with the art establishment. That establishment took the high Renaissance as its model. Indeed, this is another factor in why Jameson was later eclipsed and forgotten, for we now remember the Pre-Raphaelites much more than the Academicians like Charles Eastlake whom they opposed.[19] Margaret Oliphant (1892) was already noting this trend by the end of the century, defensively saying of Jameson's books that 'not even Mr Ruskin has made them out of date', although 'the Raphael worship which...existed in her day has changed with many into a condescending patronage' (vol. 2: 529). Raphael had been downgraded, and since he was Jameson's ideal artist, her art theory was on the verge of sinking with him.

To be fair, Jameson, like Ruskin, criticizes artists when they mingle classical and Christian themes, even Raphael. She complains that he gives St Paul a 'Jupiter Ammon head' in *Paul Preaching at Athens*: 'one of the instances in which Raphael, in yielding to the fashion of his time, has erred' (Jameson 1848: vol. 1: 225). And of his *Domine Quo Vadis?*, she remarks: 'Raphael has interpreted it in a style rather too classical for the spirit of the legend' (206). But for Jameson, these are Raphael's occasional misfires and not a structural flaw, for unlike Ruskin she holds that: 'The display of beautiful form was permitted and even consecrated by devotion' (vol. 2: 24). Artists may present beautiful shapes and bodies, as long as these express spiritual meaning and artists do not linger over physical details in their own right. After all, plastic art inherently uses formed materials to convey spiritual content—it is art, not religion. It *embodies* religious narratives, rather than stating them verbally.

Nevertheless, for Jameson, Christian art should express the true religious spirit of this era. So perhaps, consistently, she ought to agree with Ruskin and see the glorification of beautiful form by Raphael, Michelangelo, and others as an undesirable hybridization with classicism, wrongly delighting in physical form as it is and affirming the existing material world rather than aspiring beyond it. That is, arguably, Jameson's theory of art should have led her, like Ruskin, to criticize some of the art most exalted in her time, including that of Raphael. Yet she was not willing to question the established canon. Perhaps this was because of her gender. Ruskin, man and 'graduate of Oxford' (as he originally signed *Modern Painters*), had the confidence and credentials to be an iconoclast. Not having graduated from Oxford, Jameson could not afford to deviate from accepted opinion as Ruskin did.

[19] Incredibly, David Robertson's 1978 biography of Charles Eastlake was the first since Elizabeth Eastlake's 1870 memoir (and Robertson felt the need to preface his book by reassuring his readers that he really did like Rossetti). Many general books on Victorian art pass over Eastlake dismissively. Fortunately, this is changing; see, e.g., Avery-Quash and Sheldon (2011). On the generation of painters who, like Eastlake, emulated Raphael, see Fraser (1992: ch. 2).

Moreover, for Ruskin, art need not depict accepted religious stories to be religious in spirit. In his eyes, Turner's landscapes express a true Christian spirit, whereas countless pictures of Moses, Deborah, David, and Isaiah have never portrayed 'the faintest shadow' of these individuals as spiritual figures (Ruskin 1856a: 64). If religious *spirit* is crucial, then it should not matter what physical subject-matters are depicted. Ostensibly religious subjects can co-exist with a total lack of genuine spiritual meaning, and vice versa. Here again, then, Jameson fell short by taking for granted that the accepted canon of European Christian art was where spiritual meaning was to be found, rather than considering alternative possibilities.

A modern reader may find the differences between Jameson and Ruskin small (rather like the differences between Eastlake's and Rossetti's paintings). After all, both Jameson and Ruskin believe that European art should express the Christian spirit, and that art is aesthetically good when it does so. They both conjoin religious spirit, moral virtue, and aesthetic value. Yet, in their time, the differences loomed large. Jameson was the voice of the pro-Renaissance art establishment, Ruskin of the Pre-Raphaelite alternative. This became an important factor in their different afterlives, in which Ruskin grew bigger the more Jameson shrank, so that we now struggle to see that they once had nearly-equal stature.

Jameson's conservatism about the art canon should not overshadow her achievements. Her *Sacred Art* project was incredibly ambitious, she wrote with enthusiasm and eloquence, and she forged a unique blend of German Romanticism and Victorian religiosity. She even anticipated liberation theology with her vision of a popular Christianity that embodied the hope for justice in an unjust world. Rather than being put off by Jameson's piety, perhaps we can approach her later work with the same open-minded sympathy that she urged her readers to adopt towards Catholic art:

> If those who consider works of art... would not be afraid of attaching a meaning to them, but consider what we may be permitted, unreproved, to seek and find in them both in sense and sentiment—how many pleasures and associations would be revealed in every picture... which is now passed over either with indifference or repugnance! (Jameson 1848: vol. 2: 77)

7
Frances Power Cobbe, Female Genius, and the Hierarchy of the Arts

7.1 Introduction

Frances Power Cobbe was famous in the later nineteenth century for her many writings on philosophy and religion, published from the 1850s until 1904. In 1895, the American journal *Literary World* reported that Cobbe was 'known all over the civilized world as a writer of books on ethics and religion of the most helpful and constructive kind' (Anonymous 1895: 326). Cobbe was hailed as one of the great intellectual women of the age. Her admirer Maurice Johnson (1904) predicted soon after she died that '"there is a name that will eternally smell sweet, and blossom in the dust", and that will be the name of Frances Power Cobbe' (656). Sadly, this was no truer than Anna Barbauld's prediction that Joanna Baillie's fame would outlast British national power. Cobbe soon fell from view and was almost totally forgotten during the twentieth century.

Since the 1990s, Cobbe has undergone a welcome rediscovery as a feminist, animal welfare campaigner, moral philosopher, and prolific author and journal contributor.[1] However, there has been virtually no study of Cobbe's theory of the arts.[2] This is surprising, since Cobbe tackled female genius head-on and presented a systematic ranking of the arts in the style of canonical Germans like G. W. F. Hegel and Arthur Schopenhauer. Despite her leanings towards system-building, Cobbe was a creature of the British periodical culture in which she published so prolifically, and she eagerly embraced the identity of wide-ranging critic which this culture made possible. Moreover, her primary interest was in classifying the arts rather than the forms of aesthetic value. To that extent, she remained a philosopher of the arts in the same spirit as our other women.

Cobbe's main writings on philosophy of art were from the 1860s. She defended female genius in the 1862 essay 'What Shall We Do With Our Old Maids?' (hereafter, 'Old Maids'). This appeared, signed, in *Fraser's Magazine*, before being incorporated in Cobbe's 1863 essay collection *The Pursuits of Women*.

[1] See, amongst others, Caine (1993), Peacock (2002), Mitchell (2004), Williamson (2005), Hamilton (2006), and Stone (2022).
[2] Even Hilary Fraser passes over Cobbe swiftly in a valuable account of Victorian women's interventions on sculpture (Fraser 2017). However, on Cobbe's engagement with Harriet Hosmer's sculpture, see Cherry (2000: 113–16).

Fraser's, which serialized Mill's *Utilitarianism* in 1861, was a key site for philosophical discussion at the time. So *Fraser's*, again, was where Cobbe placed her two-part 1865 signed essay 'The Hierarchy of Art' (hereafter, 'Hierarchy'). Shortly afterwards, 'Hierarchy' reappeared in Cobbe's 1865 collection *Studies New and Old of Ethical and Social Subjects*—a book, one reviewer commented, that should have been called *Ethical*, Aesthetic *and Social Subjects*, so much of it was on art and literature (Anonymous 1865: 701).

I will look first at Cobbe's account of female genius (Section 7.2), from there branching into a broader discussion of ideas of genius at the time, and their ambiguities as to both gender and race (Section 7.3). Then I look at Cobbe's hierarchy of creative, reproductive, and receptive art (Section 7.4), her taxonomy of the art-forms (Section 7.5), and finally her attempted middle ground between moralism and aestheticism (Section 7.6).

7.2 Cobbe and Female Genius

Cobbe ([1862] 1863) began her defence of female genius in 'Old Maids' by declaring that until recently people had doubted 'the possibility of women possessing any creative artistic power' (80). These were the doubts she set out to challenge. But *did* her contemporaries have these doubts?

We have seen Barbauld, Baillie, and Anna Jameson all described as geniuses. As for Harriet Martineau, *Tait's Edinburgh Magazine* found her 'Possessed in the highest degree of…female genius' (Johnstone 1833: 92), and Maria Weston Chapman commented that:

> All the reviews of this period, hostile as well as friendly, took for granted the fact of her great genius. Unquestioned as it was by the world, by herself it was always steadily denied…Her friendly critic of the 'Edinburgh Review' was so impressed by her as a woman of genius, that he vigorously contested the point with her…And surely if genius be the faculty called divine, of creating in literature, from what life actually is, the vision of what it may be, then surely Harriet Martineau was in truth the genius that popular enthusiasm declared her to be. (Chapman 1877: 75)

Admittedly, as Chapman says, Martineau asserted that she had 'not an atom of genius' (Martineau 1877: vol. 3: 166). Caroline Roberts and Linda Peterson argue that this was because Martineau's view of authorship departed from the Romantic model of genius (Peterson 2009: 62; Roberts 2002: 10-13). For Peterson (2009), Martineau *had* to depart from the Romantic model since it inherently excluded women (44). In support of the claim that the model was gender-exclusive, Peterson refers to Christine Battersby's influential feminist critique of the ideology of

genius (see Battersby 1990). However, in her *Autobiography*, Martineau liberally attributes genius to other people—both women, such as Barbauld and Baillie, and men, such as Edward Bulwer-Lytton, allegedly 'a woman of genius enclosed by misadventure in a man's form' (Martineau 1877: vol. 1: 266). This does not obviously suggest that Martineau either rejected talk of genius or saw it as excluding women.

More broadly, evidence from nineteenth-century periodical culture suggests that the discourse of genius was mixed. Barbauld, Baillie, Jameson, and Martineau were not the only women credited with genius. The *Edinburgh Review* stated: 'In poetry, what corner is not at the present day illustrated by female genius—from stately tragedy or not less stately lyric, to the most simple strain of domestic tenderness, or artless expression of feeling…?' (Moir 1834: 181) Not everyone agreed. William Maginn scoffed: 'What stuff in Mrs Hemans…&c. &c. to be writing plays and epics! There is no such thing as female genius' (Maginn and Lockhart 1824: 603). But he was combatting numerous descriptions of Felicia Hemans *as* a genius (see, e.g., Sigourney 1840; Tuckerman 1852), and as David Higgins remarks, 'few critics would have concurred with Maginn's deliberately provocative claim that there is "no such thing" [as female genius]. A liberal like Bulwer, for example, reviewing [Letitia] Landon's novel *Romance and Reality* in 1831, describes her as "a lady of remarkable genius"' (Higgins 2007: 8). Bulwer (that is, Bulwer-Lytton) and Maginn were at two ends of a spectrum between which a profusion of opinions could be found.[3]

Female genius, then, was contested. One might perhaps wish it had been uncontested. But still, nineteenth-century British attitudes to women and genius were more diverse than recent feminist aesthetics suggests. In this body of thought, it has become almost axiomatic that the Romantic ideology of the solitary genius inherently excluded women.[4] This is partly because feminist theorists have tended to take Kant's idea of genius, and the German Romantic tradition that came out of it, to be definitive. For Kant, 'Genius is a *talent* for producing something for which no determinate rule can be given…hence the foremost property of genius must be *originality*' (Kant [1790] 1987: 175, Ak 307–308). Genius does not follow rules, it originates them, and rather than imitating existing artworks, the genius must be inspired and impelled to create by the force of

[3] On the treatment of such women as Martineau and Landon by Maginn and others in *Fraser's Magazine* in the 1830s, see Sanders (2001).
[4] For just a few examples: Parker and Pollock (1981: 114), Nunn (1987: 12–13), Pollock (1988: 1–2, 11), Battersby (1990: 3–5), Wilson and Haefner (1994: 5), Korsmeyer (2004: 29–31), and Korsmeyer and Weiser (2021). To be fair to Battersby, she criticizes the way genius has been interpreted as male, but she wants to salvage a concept of female genius—*female* not feminine genius, because femininity stands for the gendered constraints that women need to transcend to create great art (Battersby 1990: ch. 15). This is similar to Cobbe's position, as we will see. There are also exceptions to the feminist scepticism about genius, such as Julia Kristeva's celebration of genius in Hannah Arendt, Melanie Klein, and Colette (see Jefferson 2014).

their own nature (176, Ak 308–309). This conception could exclude women, especially when it meshed with Burke's division of the masculine sublime from the feminine beautiful. For Burke (1757), the sublime was masculine in its great power, magnitude, and potential to inspire awe and fear, whereas the beautiful was feminine because it was small, smooth, delicate, and pleasing. 'Fragility is almost essential to it', he added; 'The beauty of women is considerably owing to their weakness, or delicacy' (101). These views readily flowed together with Kant's idea of genius, such that to be a true originator and bypass the rules one must have great power, perhaps an awe-inspiring and even terrifying level of power—i.e., one must be masculine and cannot be feminine. After all, Kant said that 'the imagination is very mighty [*mächtig*] when it creates' (Kant [1790] 1987: 182, Ak 314).

These connotations were certainly in circulation, but they were only one strand in British discourses of genius, which long predated Kant. For example, in 1711 Eustace Budgell remarked that 'There is no Character more frequently given to a Writer, than that of being a Genius' (Oxford English Dictionary, 'genius', n. & adj., Sept 2023). Genius was discussed by many eighteenth-century writers (see Costelloe 2013: 113), including Alexander Gerard, whose *Essay on Genius* (1774) influenced Kant. In any case, conceptually, did one have to be a force of nature to be a genius? Not necessarily. Both Martineau and Baillie were classed as geniuses because they could imagine possibilities that went beyond existing reality (see Chapman's remark above, and, on Baillie, see Milman 1836: 490). This was seen more as imaginative breadth than titanic power. Both women, along with Jameson, were described as having feminine or female genius—Martineau, because she combined imaginative vision with discrimination, tact, and refinement (Johnstone 1833: 92); Baillie, because of her grace and tenderness (Milman 1836: 488); Jameson, because of her 'tact and knowledge of...character' and her 'graces of language and illustration' (Moir 1834: 185). Grace and tact, delicacy and lightness of touch, mixed with imaginative vision to produce a specially feminine kind of genius.

This means that when Cobbe championed female genius, she was not the lone challenger of an anti-woman consensus. Rather, she was taking one side in a long-running debate. Yet, to complicate matters further, she made a big concession to her opponents:

> Till of very late years it was, we think, *perfectly justifiable* to doubt the possibility of women possessing any creative artistic power... to originate any work of even second-rate merit was what no woman had done.... Such works as women did accomplish were all stamped with the same... feebleness and prettiness. Mrs. Hemans and Joanna Baillie ... wrote poetry,... [but] it was all 'Angelical'... super-refined sentiments and super-elongated limbs. (Cobbe [1862] 1863: 80–81; my emphasis)

Here Cobbe held the ideals of originality and power against women. It may seem surprising that this came from an avowed feminist. However, for Cobbe, the point was that until recently women had been producing sub-standard artworks not because angelical refinement was all they were capable of, but because the prevailing *denial* that women had true creative powers had led women to hold themselves back (87). Believing people who told them they could not be geniuses, women never developed and exercised their powers of genius, and the denial of female genius became a self-fulfilling prophecy.[5]

It is apparent, too, that Cobbe worked with a Romantic view of genius. This may have come from Kant, who was Cobbe's biggest philosophical influence, though I have found no positive evidence that she had read his Third Critique (she had read translations of his *Metaphysics of Morals, Groundwork*, and the First and Second Critiques; see Stone 2023: 83). But she was well acquainted with Samuel Taylor Coleridge's transposition of Kant's idea of genius into that of the primary imagination, the 'repetition in the finite mind of the eternal act of creation in the infinite I AM' (Coleridge [1817] 1907: 202). Cobbe's view of genius reflected Coleridge's influence, as we will see presently.

Cobbe's claim that women had long been prevented from achieving genius sheds light on a more general difficulty with the feminist critique of ideas of genius. The more we recognize women's artistic achievements, the more these achievements seem to suggest that patriarchal ideas about genius have *not* held women back. To criticize these ideas and claim that they had been harmful Cobbe had to portray them as having been potent enough to cramp women's art-making powers. In turn, she had to claim that women *had* been cramped and prevented from making good art.[6] This left Cobbe rather awkwardly defending female genius from the starting-point that no woman had displayed it until the 1860s, not even front-runners like Hemans and Baillie. Incidentally, we have to wonder whether Cobbe had actually read Baillie. Her bold vision for the *Plays on the Passions* was not 'feeble', and her gothic passions were not 'super-refined' (they were the opposite, as we saw in Chapter 3). Nor is Hemans' famous 1826 poem *Casabianca* angelical and refined. It starts 'The boy stood on the

[5] Cobbe exactly anticipates Linda Nochlin's thesis that there were no great women artists because social conditions precluded it (Nochlin 1971). But Cobbe, as we will see presently, at least granted genius to women of her own time such as Rosa Bonheur, whereas Nochlin, after a detailed account of Bonheur's clothing choices, projects onto her 'the feminine mystique with its internalized ambivalent narcissism and guilt, [which] subtly dilutes and subverts that total inner confidence, that absolute certitude and moral and aesthetic self-determination demanded by the highest and most innovative work in art' (507–8). In fairness, Nochlin subsequently did much to recover women artists, for instance convening the landmark *Women Artists 1550–1950* exhibition; but, in hindsight, her 1971 essay is very mixed.

[6] Or, as Alison Booth (2004) remarks, 'feminist projects of recovery depend on enhancing the sense of women's suppression in the past' (5). As Booth notes, Cobbe 'obliterates' many female artists to make her critical point (85).

burning deck' and ends with an explosion and the boy's dismembered body scattered over the sea.

In any case, Cobbe ([1862] 1863) continued, times were changing and for the first time women *were* making art of power and strength:

> The same age has given us in the three greatest departments of art—poetry, painting, and sculpture—women who...are pre-eminently distinguished by one quality over all others, namely, strength... POWER itself, deified and made real before our eyes. (81–83)

Cobbe referred to three artists: the poet Elizabeth Barrett Browning, praising her epic poem *Aurora Leigh* for its hard rhythms, searing insights into character, storms of passion, and real-life problems (81); the painter Rosa Bonheur (82), whose giant painting *The Horse Fair*, completed in 1855, showed a seething mass of life-size, powerful, muscular horses; and, above all, the neoclassical sculptor Harriet Hosmer (87). Cobbe singled out Hosmer's 1859 *Zenobia in Chains* (see Figure 7.1). This was a monumental eight-foot statue of an ancient Palmyrian queen, captured by the Romans but standing dignified, her power and majesty intact. Hosmer's *Zenobia*, like Bonheur's *Horse Fair*, was a sensation in Britain, prominently exhibited at London's International Exhibition in 1862 and viewed by over half a million people.[7]

One reason Cobbe picked out these three artists was that she had befriended all of them in Italy, where she stayed regularly in the late 1850s and 1860s. At the time Italy, Rome in particular, was a magnet for female artists from around the world. Women found there 'a social and cultural space that...affirmed feminine participation in creative endeavours' (Dabakis 2020: 27), and a thriving community of other open-minded and supportive artistic women.[8]

In more theoretical terms, Cobbe picked out these three women on the grounds that their art embodied strength and power. This mattered because

[7] Harriet Goodhue Hosmer (1830–1908), *Zenobia in Chains*, 1859, marble, height: 208.3 × 68.6 × 83.8 cm., mount: 148 × 163.2 cm., The Huntington Library, Art Museum, and Botanical Gardens. Photography by Fredrik Nilsen, courtesy of The Huntington.

[8] Hosmer, originally American, moved to Italy to pursue her artistic career, studying under John Gibson (the same Gibson who produced the bust of Jameson). On the community of women artists in Italy, see Vicinus (2003), Merrill (2003), and Dabakis (2020). As Dabakis (2020) shows, the Arcadian Academy, which was open to women and of which Angelica Kauffmann and Germaine de Staël had been members, was crucial in making Rome 'an enlightened center of female creative activity' (28). As is noted in these studies, both Cobbe and Jameson participated in these Italian networks. Cobbe's partner, Mary Lloyd, was another female sculptor who studied with Gibson, while Jameson, who had been close friends with Hosmer since 1856, advised her extensively on *Zenobia*, about whom Jameson had written in her *Memoirs of Celebrated Female Sovereigns* (see Carr 1913; Waller 1983). Having shown Jameson a photograph of the work-in-progress, Hosmer happily reported in 1858 that *Zenobia* 'has just passed muster with Mrs Jameson' (Hosmer to Wayman Crow, 11 March 1858, in Carr 1913: 123). For Jameson's enthusiasm, see Carr (1913: 151), although Jameson wanted Zenobia to look more intellectual.

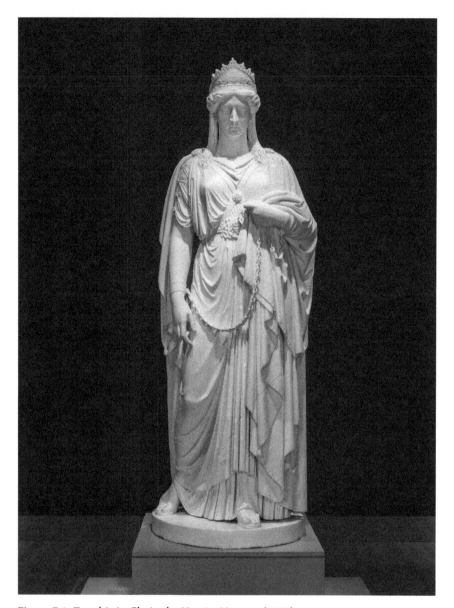

Figure 7.1 Zenobia in Chains by Harriet Hosmer (1859)

although not everyone denied female genius (contra Cobbe), those who *did* deny it typically traded on the connection of genius with power. For instance, for 'Omega' (John Neal), 'all the training in the world will never make the female part of the human family *equal* in bodily or intellectual power—by power, I mean downright and absolute strength—to the male part' (Neal 1824: 389). Or, for the *Illustrated London News*, 'Strength of will and power of creation belonging rather

to the other sex, we do not...look for the more daring efforts in an exhibition of female artists' (Anonymous 1857: 545). If genius required power, and power required physical strength, then genius seemed out of women's reach—unless women *could* make art with power after all, as Cobbe contended.

An important piece of background to Cobbe's argument is the heated controversy about whether Hosmer even qualified as *Zenobia*'s author. This controversy erupted in the British press in 1863, with statements in *The Queen* and the *Art-Journal* that Zenobia was 'said to be by Miss Hosmer, but really executed by an Italian workman at Rome', namely one of Hosmer's studio assistants (Anonymous 1863: 181).[9] These accusations went back to the late 1850s, and Cobbe found them infuriating. Hosmer did employ studio assistants, as many artists have done then and since. But Cobbe argued that Hosmer remained the true author, for the real work of sculptural creating was to conceive a design and impose it on material to produce a small-scale model or 'clay sketch' (Cobbe 1862: 5).[10] This was indeed Hosmer's practice (see Hosmer 1864). Scaling the model up to full size could be delegated to assistants, or 'subordinates', Cobbe argued, since this was mere implementation. It was mere handling of material, not true creativity: 'Great artists [are] not stone-cutters, and [do] not spend the months and years in which their beautiful works are designed in the mere manual labour of filing and chiselling' (Cobbe 1862: 5).[11]

The truly creative part of sculpture, Cobbe ([1862] 1863) claimed, recapitulated God's creation of the world:

> Not untruly has sculpture been named the *Ars Divinior*. A deep and strange analogy exists between it and the highest we know of the Supreme Artist's works. Out of the clay, cold and formless, the sculptor slowly, patiently, with infinite care and love, moulds an image of beauty. (83–84)

Cobbe was taking up the Romantic idea of genius as original creation, drawing on the religious language under which Coleridge had redescribed it. On this basis she ranked sculpture the highest, most divine and creative art. And, she maintained, women could excel at it.

In locating the real work of sculptural creation in small-scale design, in order to defend Hosmer, had Cobbe conceded that women lacked physical strength after all? She argued that women had the imaginative and creative power to

[9] The issue was resolved when Hosmer threatened a libel suit against *The Queen*, which backed down and published an apology. See Cherry (2000: 107–8), Cronin (2013), and Dabakis (2020: 81–6).

[10] Cobbe published this short piece in the newspaper Charles Dickens founded, the *Daily News*. Though unsigned, her piece was 'from our Italian correspondent', i.e., Cobbe.

[11] Jameson took the same view of Hosmer's originality, writing to her: 'The originality of a conception remains your own, with the stamp of your mind upon it, to give it oneness of effect as a whole' (AJ to Hosmer, 10 October 1858, in Carr 1913: 149–51).

impress original ideas on matter, to envision bold and grand designs and set their realization underway. This effectively distinguished imaginative and creative power from physical strength. Men might have more of the latter, but women had an equal share of the former, and a lack of physical strength had nothing to do with one's level of imaginative power. Cobbe was on strong ground here, as denials of female genius traded on the conflation of these two quite separate senses of strength and power. Once we disambiguate them, Cobbe showed, the grounds for excluding women from the Romantic idea of genius fall away.

7.3 Power, Genius, Gender, and Race

Cobbe argued for female genius under a conception of genius in terms of power, rather than arguing for a distinctly female form of genius that combined power with grace and delicacy. That was the more cautious line of defence of female genius which we find in, amongst other texts, Jameson's reflections on female artists in her *Visits and Sketches* (1834). I am not sure whether Cobbe had read these reflections of Jameson's, but the resonance and friction between their views suggests that she may well have done so. She had certainly read Jameson's 1854 *Commonplace Book* carefully, copying out several passages from it (Mitchell 2004: 77). One was the remark: 'I have a great admiration for power, a great terror of weakness—especially in my own sex' (Jameson [1854] 1855: 52). So Jameson inspired Cobbe's account of female artistic power; yet their understandings of that power diverged.

For Jameson (1834), women could achieve genius, but only when they made feminine art: 'the presence of a power...kept subordinate to the sentiment of grace, should mark the female mind and hand' (vol. 1: 220–221). If instead, like Artemisia Gentileschi, women tried to make masculine art in which power was untempered by grace, the result could only ever be second-rate: 'You must change the physical organization of the race of women before we produce a Rubens or a Michael Angelo' (220). She clarified:

> All those whom I have mentioned were women of undoubted genius; but they all, except Gentileschi, were *feminine* painters...there is a walk of art in which women may attain perfection, and excel the other sex; as there is a department from which they are excluded....If women would admit this truth, they would not presume out of their sphere...(220)

Jameson shared in the consensus view of Hemans as a poet of genius—*feminine* genius. Her art was every bit as powerful as masculine art: 'no feebleness, no littleness of design or manner' (220). But this was because Hemans embraced a distinctive, feminine, kind of power with grace. Conversely, when women

emulated the masculine, the end result could only ever be '*fade*, insipid, or exaggerated' (220).

What Jameson saw as feminine power, Cobbe dismissed as mere sweetness and light, again with reference to Hemans. Cobbe ([1862] 1863) was equally scornful of 'the washed-out saints, and pensive ladies, and graceful bouquets of...Rosalba [Carriera]...and Kauffman' (82). Jameson (1834), in contrast, praised Rosalba's 'exceeding elegance' and Kauffman's 'exceeding grace' (219). Thus Jameson did better than Cobbe at valuing women artists such as Hemans and Carriera, claiming that their art displayed a power of its own feminine sort. But the downside was that Jameson was unsympathetic to artists like Gentileschi who overstepped their proper limits. Moreover, being more positive about women's existing achievements, Jameson saw less need to criticize patriarchy, closing her reflections: 'But to return from this tirade. I wish my vagrant pen were less discursive' (220).

Cobbe ([1862] 1863), in contrast, never hesitated to unleash a powerful tirade, one of her targets being the view that powerful works by women artists were deficient because they were not feminine (88). Powerful art by women, for Cobbe, was necessarily *female,* since 'every faculty He has given her is a woman's faculty, and the more each of them can be drawn out, trained, and perfected, the more *womanly* she will become. She will be a larger, richer, nobler woman for art' (89). That is, everything women did would inescapably express their female nature, as long as they were acting authentically from their own inner dispositions—namely showing genius, allowing their nature to give the rule to art. But women could not possibly make art that was both powerful and feminine, as Jameson (1834) thought. For femininity was nothing but an imposed and artificial construction, the outcome of a system of 'clipping and fettering every faculty of body and mind' (Cobbe [1862] 1863: 88–89). This clipping system produced 'Dolls, not Women' (414). To create powerful art, women must escape from femininity, and this was not a deficiency but a condition of artistic excellence.

Between them, Cobbe's and Jameson's different views expose a dilemma. One could accept the equation of genius with power, as Cobbe did, but then one would devalue art by women when it watered down power with grace, tact, and so on. Conversely, like Jameson, one could valorize power-with-grace as a distinct feminine form of genius. But then one would devalue art by women that embodied pure power and rejected feminine graces. One thing is clear: ways of combining genius and femininity were varied and not a monolith.

As we have seen, Cobbe distinguished female genius from mere physical strength and handiwork. In making this distinction, one of her aims was to vindicate Hosmer's sculptural practice. Yet the distinction did not entirely gel with the *content* of *Zenobia*. By portraying the ancient queen in chains, Hosmer was making a statement about women's plight under patriarchy. But Zenobia's size and classical grandeur conveyed that her power, dignity, and freedom remained

essentially intact. Zenobia's larger-than-life size stood for her power to command and direct—that is, her *physical* power and strength stood for her mental and regal power. Moreover, by implication patriarchal chains could not deprive women of their physical or mental power, whereas Cobbe thought these chains had cramped women's abilities.

To tease out these issues further, and expand the discussion, it is useful to look at the work of another artist who was close to Hosmer's network: Edmonia Lewis, an American-born woman of mixed Black and Ojibwe descent.[12] Cobbe never referred to Lewis' work, and so looking at Lewis may seem a digression, but it is one worth making. It sheds light on how connections between genius and power were ambiguous with respect to race as well as gender, and it shows a woman of colour taking part in art practice and thinking at the time.

On her own account, Lewis moved to Italy in 1865 to pursue her career as a sculptor in a 'social atmosphere where [she] was not constantly reminded of [her] color' (Anonymous 1878b: 5). Lewis was successful: she sold numerous works to US buyers and won great acclaim for her *Death of Cleopatra* (c.1875) in the 1876 Philadelphia Centennial Exhibition. Sadly, in the by-now familiar pattern, Lewis fell into oblivion for much of the twentieth century. Incredibly, *The Death of Cleopatra* ended up in a salvage yard, where it was finally recognized and recovered in the late 1980s.[13]

In an earlier work, *Forever Free* (1867), Lewis hailed the abolition of slavery. A standing man triumphantly lifted up his broken chain, posing as if he had just won an Olympic tournament, with his female companion kneeling in reverent gratitude at his side. Lewis' work was unusual because generally imagery of this kind showed liberated Black men not standing but sitting or kneeling, as in, say, Thomas Ball's 1866 *Freedmen's Memorial to Lincoln*. As Hosmer implied with *Zenobia*, Lewis conveyed that those enslaved remained powerful and inherently free, with the strength to break their chains and stand tall, reflected in the man's honed muscles and sturdy physique. Hence the sculpture's inscription '*forever free*'. The neoclassical style, representing an idealized human body that was free and powerful, facilitated these connotations.

I speculate that this classical association of freedom with physical vigour and strength may have particularly appealed to Lewis because Black women were liable to be seen *not* as weak and delicate, but as the 'mules of the world', in the phrase Zora Neale Hurston later made famous (Hurston [1937] 2009: 37). As Alice Walker clarified, 'Black women are called, in the folklore that so aptly identifies one's status in society, "the *mule* of the world", because we have been handed the burdens that everyone else...refused to carry' (Walker [1983] 2004: 237).

[12] Hosmer and Lewis' relationship unfortunately never developed beyond their initial acquaintance, according to Buick (2010: 64–5). But for a more positive assessment, see Dabakis (2020: 167).
[13] See Journal of Blacks in Higher Education (1996: 33).

Black women were assigned hard physical labour, and Burke's idea of women being beautiful, small, and frail was not applied to them.

For some, Lewis' equation of power, freedom, and physical strength went in too physical a direction. 'The limbs were like sausages', complained the American philosopher Lydia Maria Child in an 1870 letter, likewise objecting that Lewis' *Hagar* looked 'like a stout German woman' (quoted in Buick 2010: 16). Child was taking it that genius was an imaginative power and not a matter of physical strength. Yet, as we have seen, the power of genius was regularly conflated with physical strength when it came to white men. Lewis was only turning this conflation to the advantage of Black people.

From another direction, people of African descent were sometimes portrayed as lacking the creative imagination to do anything other than physical labour. Take Letitia Landon's (anonymous) account of the progress of poetry. 'The imagination...is the source of poetry...It civilizes because it refines', said Landon (1832: 466). But, she continued:

> Africa is the least civilized quarter of the globe...the distinguishing mark of its deficiency...is the total want of imagination....No august belief fills with beauty or terror the depths of her forests, and...her creeds have neither beauty nor grandeur....Slaves from the earliest period...all about them is earthly...'A slave cannot be eloquent'...nor poetical either...(466–467)

For Landon, Africans were inherently slaves even before colonial slavery for they lacked imagination, the freedom to imagine alternative possibilities.[14]

Lewis challenged such ideas both in *Forever Free* and *The Death of Cleopatra*. Most images of Cleopatra at the time showed her ruminating, on the point of committing suicide. Lewis' graphically dead Cleopatra had already killed herself, to avoid being taken captive by the Romans. She had preserved her freedom, even at the cost of her life (Buick 2010: 207). Again, she remained forever free and did so—contrary to Landon—as an *African* woman and ruler.

That said, Lewis' Cleopatra had classical rather than African facial features, a much-debated choice. Perhaps Lewis' choice was strategic, intended to make her *Cleopatra* more acceptable to white viewers (Gold 2012), or to 'thwart...attempts by her white audience to *read her into the work*' (Nelson 2007: 178). I would add another possibility: that Lewis' use of classical facial features reinforced the idea that Cleopatra was free, given the idea of classical Greece as the birthplace of freedom. This would tie in with the fact that Lewis depicted Cleopatra alone, whereas most images showed her accompanied by her slaves. Lewis thereby

[14] *Landon's* genius, on the other hand, was widely celebrated; see, e.g., Sheppard (1841).

rejected Africa's association with slavery and unfreedom, instead putting Africa and freedom together.

The wider ideology that Lewis was challenging deemed women of colour capable of physical handiwork but not free creative imagination. Conversely, white women were liable to be seen as capable of imagination but physically weak. Cobbe's strategy in privileging imaginative genius over physical handiwork thus spoke well to the challenges faced by white women artists, suggesting that physical strength was not needed for imaginative power. Her strategy spoke less well to the challenges faced by women artists of colour. From this perspective we can see, again, why Lewis may have found neoclassicism a useful idiom. As an art of idealized, glorified bodies, it took physical strength and prowess to embody freedom and power, effectively rejecting the division between bodily strength and mental imagination.

Whereas Hosmer was a sensation in mid-century Britain, Lewis attracted little attention from the British periodicals (although she eventually moved to London, where she died; see Beard 2021). As Deborah Cherry (2000) observes: 'Lewis does not seem to have come to the attention of British feminists', whose sightlines were 'fissured by perceptions of racial difference...after abolition, an earlier philanthropic interest did not convert into support for an independent woman artist of colour' (118).[15] One outlier who did discuss Lewis was Henry Wreford, an Italian correspondent for several British papers. Writing as 'H. W.', he reported on Lewis' work in both the *Athenaeum* and *Art-Journal* (Wreford 1866a, 1866b, 1870).

Wreford (1866a) deplored the fact that Lewis, a 'member of a much-injured race', was left 'struggling with ignorant prejudice' (302). Yet he went on to describe her, in a rather prejudiced way, as '*Naïve* in manner...she prattles like a child, and with much simplicity and spirit she pours forth all her aspirations'. This seemed to imply that Lewis lacked the self-command necessary for genius. However, Wreford quickly added that Lewis 'has genius enough to prove that she bears the image of Him who made all nations under the sun' (302). Still, Wreford's phrase 'genius enough' remains guarded. Some other white British thinkers, such as Martineau, were more forthright in affirming Black genius. She wrote a fictionalized biography of the Haitian revolutionary leader Toussaint Louverture to bring 'into full notice the intellectual and moral genius of as black a negro as was ever seen' (1877: vol. 1: 449). Cobbe, too, said that her friend Keshub Chunder Sen, a leader of the Hindu reform movement the Brahmo Samaj, 'at any other age of the world, would have taken his place with such prophets as Nanuk...and Gautama; or with the...saints like St Augustine' (Cobbe 1894: vol. 2: 130). This seems tantamount to calling him a religious genius. Cobbe was also hinting that his genius was unrecognized due to racist attitudes.

[15] This chimes with the wider pattern identified by bell hooks: the opposition of some white feminists to slavery did not automatically translate into an opposition to racism (hooks 1981).

There was a spectrum of opinion on Black and African genius, then, as on female genius. 'What emerges', as Rachel Teukolsky (2009) has said of Victorian art theorizing more broadly, 'is the sheer plasticity of aesthetic ideologies, their capability to be adapted to the interests of many different groups and politics' (8). This certainly applies to ideas of genius, of which there was no one overriding view. The nature of genius, who could have it, and how it related to power, strength, femininity, and race—all were contested matters.

7.4 Cobbe's Three Orders of Art

In 'The Hierarchy of Art', Cobbe set out her system of the arts. She reworked her distinction between true creation and mere material implementation into a distinction between primary creative art and secondary reproductive art, adding a third category, tertiary receptive art. This threefold distinction was one axis of her taxonomy; along the other, she categorized the primary, secondary, and tertiary versions of the five art-forms of poetry, music, architecture, sculpture, and painting. I'll start with her three 'orders' of art before proceeding to the art-forms in Section 7.5.

We may wonder what inspired Cobbe to produce a systematic ranking of the arts. Kant (1987) had offered a taxonomy (189–207, Ak 320–336), and Hegel, F. W. J. Schelling, and Schopenhauer had elaborated their systematic hierarchies at length. But Cobbe (1855) was not keen on Hegel and Schelling, preferring Kant's 'true transcendentalism' to their 'mere dialectic subtilties' (48). She was also highly critical of Schopenhauer (Cobbe 1877). The most likely influence was Coleridge, who had put forward a set of *Principles of Genial Criticism Concerning the Fine Arts* in 1814 (included in Coleridge [1817] 1907: vol. 2). Cobbe referred to Coleridge regularly (e.g., Cobbe 1872: 25, 354–355); his conception of genius influenced her, as we have already seen; and he had a great influence on nineteenth-century British philosophy generally.

Primary art. For Cobbe: 'Primary art is creative, and is directly derived from God's revelation of the Beautiful through his works. We call the works of God...Nature. We call man's copy of them at first hand, Art. The man has created Art out of what before was Nature' (Cobbe 1865: 289). First the artist apprehends God's creativity in beautiful nature, then the artist re-expresses in artistic form the beauty so apprehended.

What makes nature beautiful? Cobbe does not say that nature is beautiful when it has a harmonious or pleasing or unified form. Indeed, she is frustratingly brief on what beauty consists in, only stressing that God reveals it to us in nature. 'God—the source of all goodness, truth, and beauty—reveals Goodness to the conscience, Truth to the intellect, and Beauty to the aesthetic nature of his creatures' (295). However, she seems to identify God's revelation of beauty in nature

with his creation of nature (his 'works')—he reveals beauty to us in nature *by* creating nature. This suggests that nature is beautiful just because it embodies and expresses God's creativity. Natural beauty is the reflex of divine creativity, as art beauty is the reflex of human creativity. This ties in with Cobbe's view in 'Old Maids' that the artist shows genius when they create an original artwork and recapitulate God's original creation of nature.

This throws up an ambiguity. In making primary creative art, does the artist recapitulate God's work by creating something out of nothing? It sounds like it when Cobbe says that all art-making is *poiesis*, creative making. But on the whole her view is now different. The artist first apprehends God's creativity manifest in nature and then recapitulates God's creation by *copying* part of that creation in art, say by painting some region of beautiful nature. Art is 'man's copy' of God's works, that is, of nature (289).

On this view, we create the form of artworks, the ways that they express their content, but we do not create that content out of nowhere. Instead, we apprehend the content that God has created and then reproduce it in art. Cobbe approvingly quotes Barrett Browning: 'God Himself is the best Poet, and the Real is His song' (Barrett Browning [1844] 1901: vol. 3, 157, lines 248–249). As Cobbe glosses this idea, in all *poiesis*, creative art-making, the ultimate artist is always God, whose creation of beautiful nature inspires the artist. 'In so far as the artist has done that which makes him a creator, i.e.,...*received* God's revelation of the beautiful through Nature, and has *faithfully* transferred it to Art, in so far he is a poet' (Cobbe 1865: 295; my emphases).

For Cobbe, then, all beauty really comes from God, and the artist only transfers it into a new form. A comparison with Hegel may help. For Hegel, artworks are beautiful when their form expresses their content so well that the content 'shines' through the form. This fit between form and content produces beauty (Hegel 1975: vol. 1: 70–71). For Cobbe, conversely, artworks are beautiful when they successfully express a content that is *already* beautiful. That content is the artist's already-received impression of beautiful—i.e., divinely created—nature. Art's content should be beautiful, and then the form will be beautiful if it successfully embodies that content, with beauty flowing down from content to form. Beauty comes not from form–content fit as such, as for Hegel, but from form expressing a content that is antecedently beautiful.

Clearly, Cobbe's account of art is religious through and through:

> All true Art is *religious* art; it is religious in proportion as it...more perfectly reproduces the beauty revealed by God through Nature. To ask that it shall specially occupy itself by direct reproduction of subjects suggested by the historical forms of religion, and to count it merely secular and profane when it passes such subjects by, and only reveals Nature in man, or Nature in a tree or a mountain, is to mistake entirely the high office of Art...to Art alone it pertains to bring to

human hearts the sense of that Beauty which is also divine. If it succeed in this aim it is religious in a higher sense than if it presented to us the loftiest subjects in the range of theology. (Cobbe 1865: 350)

This seems to be a critical allusion to Jameson, for whom art was sacred when it depicted subjects 'suggested by the historical forms of religion'. Cobbe's criticism of Jameson is the same as Ruskin's:[16] some art that tackles explicitly religious subject-matters may be irreligious in spirit, while some art that is not about religious subject-matters may be deeply religious. In particular, it is by depicting beautiful *nature*, not topics from scripture, that art becomes most genuinely religious in the 'higher sense'.

Notably, Cobbe takes nature to include human nature, as we see when she says that art may reveal 'Nature *in man*'. As such, her definitions leave many human subjects available to artists: all those that flow out of human nature, which is part of nature, and so part of God's creation. A novel can deal entirely with inter-human relations yet still count as revealing beautiful nature. Just as art can be religious without having to tackle overtly religious topics, art can reveal beautiful nature without having to depict the non-human world.

This account of the relations among God, nature, beauty, and art supplies Cobbe's standards for evaluating primary artworks. 'Their value, if good, is determined, first, by the beauty of the thing they express, second, by the perfection of the expression' (293). The most perfect art expresses beautiful content well; the next best art has beautiful content but fails to express it well; the next best art again has unbeautiful content expressed well; and an artwork deficient in both content and expression loses its 'pretensions to the title' of art altogether. Artworks also fall short if they take other artworks as their subject or inspiration, rather than natural beauty. Such works fall into the lower order of secondary reproductive art.

Secondary art. Reproductive artworks are inspired not directly by divine nature but by primary artworks, which the secondary artist sets out to recreate in some form, for example in a translation, a recitation, or a musical performance. Such art, however good, 'must remain in a different order from primary Art' (291). A secondary work is judged by the excellence of the primary artwork that it reproduces and by how successfully it recreates that source to yield a new work that is complete in its own right, 'judged independently of the original' (292). For example, a translator must reproduce the spirit of the original, not its letter, and the result must be a complete artwork that stands on its two feet (304).

[16] Cobbe does not refer to Ruskin, though, and I have found no evidence that Cobbe was influenced by him, although her view that beauty is essentially divine is very similar to his position in *Modern Painters* Volume 2 (see Ruskin ([1846] 1851). For his part, sadly, Ruskin said that his problem was not with what Cobbe said but the fact that she, a woman, was saying it at all. He complained that she sounded like an ever-tinkling saucepan (see Mitchell 2004: 239–40).

If the original is beautiful, and the secondary artwork genuinely recreates it, then the beauty of the original transfers to the reproduction.

Tertiary art. This peculiar category does not encompass artworks of any kind. Rather, tertiary art is the reception of either beautiful nature or primary or secondary artworks. Cobbe does not speak of 'aesthetic experience' but evidently this is what 'tertiary art' refers to. Thus, she treats aesthetic experience as an integral order of art, although she ranks it beneath primary and secondary art, as it is even less creative than secondary art.

The category of 'tertiary art' may seem infelicitous, but it reflects a period when the *aesthetic* was very largely equated with the *artistic*. We have seen this equation become consolidated over the period covered in this book. Whereas Barbauld paid attention to aesthetic experience of nature as well as the arts, Baillie, Martineau, and Jameson were concerned with art almost exclusively. Cobbe sought a wider notion of aesthetic experience that included our responses to beautiful nature, which inspire primary art. But because the inherited vocabulary assimilated aesthetics to art, Cobbe reintroduced aesthetic experience only by conceiving it as a third form of *art*.

Tertiary 'artworks'—that is, aesthetic experiences—are ranked by the beauty of the artwork or part of nature that the subject is receiving, and the level of the subject's comprehension and appreciation of that beauty. This does not mean mere technical comprehension, like the ability to identify a column as Doric or Corinthian. What is crucial is a person's sensitivity to the sentiments animating the artwork, or the qualities of some part of beautiful nature.

Cobbe's three orders of art, then, are meant to form a hierarchy from most to least creative:

Divine beauty in nature > Primary creative art (*poiesis*) > Secondary reproductive art > Tertiary receptive art

This kind of hierarchy is arguably gendered, as Cobbe (1864) more-or-less admits in her book *Italics*:

> *Secondary* creation—the reproduction of poetry and music and painting, as actresses, singers, pianists, copyists—*this*, women have constantly accomplished well. But to write great poems, to compose music, to paint new pictures, or model new statues, these are things they have most rarely achieved. (413)

However, she adds, Harriet Hosmer cannot be denied 'that *creative* power which has been certainly far more rarely bestowed on women than on men'.

Cobbe's (1865) hierarchy is unstable, however, for primary art depends on tertiary art. This is because 'receptive Art is not limited to the appreciation of human works but extends much further…to the appreciation of the beauty from which

they are one and all derived, found in Nature itself' (354). The appreciation of nature's beauty is the wellspring of all art. As we have seen, primary creation transfers into artistic form the artist's apprehension of natural beauty, which manifests God's creativity. God is always the true artist in the end, so we must receive beauty from God before we can recreate it in art. Tertiary art is therefore the precondition of primary art. In addition, since the artist can only make primary art by *reproducing* divine beauty in artistic form, even the most creative art 'copies' God's work. One must reproduce to produce, so that secondary copying and imitating are built into the primary order all along. Consequently, things end up like this:

Divine beauty in nature > Response to divine beauty (tertiary reception) > Copying of divine beauty in artistic form (secondary reproduction) > *Poiesis* (creative making)

7.5 Cobbe on the Forms of Art

Turning to the art-forms, Cobbe again aims to present a hierarchy. She starts with the highest-ranked art-form, poetry, intending to proceed through the forms in descending order of merit. But ultimately, we will see, the relative merits of the art-forms are unclear.

Cobbe does not rank the forms on the grounds that some are more creative and others more reproductive. Instead she distinguishes more creative and more reproductive variants within each art-form. For example, within music, composition is creative whereas performance is reproductive. The resulting taxonomy is shown in Table 7.1.

Poetry. Cobbe's (1865) first art is poetry 'expressed through the medium of language' (299), as distinct from poetry in the broader sense of *poiesis*. The latter is the same as primary creative art, whereas poetry in language is the first particular art-form. Moreover, poetry in language actually includes prose: the particular art-form of poetry is defined by the use of the linguistic medium, whether or not in verse.

Cobbe's definitions may seem odd, but in her time it was common to equate 'poetry' with both literature as a whole and the still wider realm of expressive meaning. For instance, Ruskin equated 'poetry' with 'expression', which could be found in both painting and language (Ruskin 1856a: 14). We have seen that Jameson took the same view and hence regarded expressively meaningful paintings and sculptures as 'poetic'. One source of these views was Coleridge, who claimed that all art is poetry (one of his essays was even called *Poesy or Art*). 'All the fine arts are different species of poetry. The same spirit speaks to the mind

Table 7.1 Cobbe on the Art-Forms

Art-form	Primary creative art (*poiesis*)	Secondary reproductive art	Tertiary receptive art
Poetic literature	Composition of poetic and prose literature	Dramatic performance, recitation, operatic singing, translation	Reading literature/watching drama
Music	Musical composition	Musical performance	Listening to music
Architecture	Designing buildings to embody feelings	Designing buildings modelled on other buildings	Responding to buildings
Sculpture	Sculptural design	Implementation	Viewing sculptures
Painting	Composition	Engraving, lithography, copying	Viewing paintings

through different senses' (Coleridge [1817] 1907: vol. 2: 220). He then subdivided art into poetry of language (i.e., poetic literature as ordinarily understood), poetry of the ear (music), and poetry of the eye, this last divided into plastic poetry (sculpture) and graphic poetry (painting) (221). This may well have influenced Cobbe when she identifies all creative art-making with *poeisis* and defines literary art as poetry expressed in language.

Cobbe (1865) judges poetry in language the best art-form on the grounds that its material, language, admits of infinitely varied use, can cover infinitely many subjects (298), and is semi-immaterial (296). She continues, 'if poetry be the greatest of the original arts...its various reproductions...hold similar rank among the secondary arts' (298). These secondary poetic arts are drama, dancing and operatic singing, recitation, and translation. A dramatic actor, Cobbe says, makes the written word more fully real, not merely intoning the poet's words but giving them new embodied and enacted significance. Similarly with dancing and, at their best, with singing, recitation, and translation. Finally, the tertiary form of poetry is the reception of beauty from not only poetic writing but also its performance (310–311).

Music. Music's medium is tones and their combinations, a medium that again is semi-immaterial: 'tenuous and ethereal...transitory and evanescent, dying away with the undulations of air which are its media' (314). Music is intrinsically transient, and unlike words its meaning is always uncertain and inconclusive. On both counts, tones are inferior to words. Yet the transience and inconclusiveness of tones perfectly suit them to express human feelings in their indefinite and volatile flow—'joy, pain, love or fury' (313). So whereas poetry can take any subject-matter, music's subject-matter is limited to the play of human emotions.

If music expresses human emotions, how does this fit with Cobbe's claim that art expresses the beauty of nature? She clarifies that the emotions are part of human nature and human nature is part of nature, all created by God. So our emotions, too, are beautiful inasmuch as they embody God's creativity:

> How does the fact that music is only the expression of a human...feeling... correspond with the assertion with which we began, namely, that all true primary art is derived directly from 'God's revelation of the Beautiful through His works?' It corresponds perfectly, inasmuch as the thoughts and feelings of man, which form the proper themes of music, are all beautiful, divine revelations. (314)

The primary musical art is composition, secondary musical art is performance, and tertiary musical art is the informed and sensitive response to music read or performed. However, here another limitation of music compared to poetry emerges. The primary musical artwork cannot fully exist at all without being performed. As a score, the work is only half-complete: 'The performer is indispensable to the composer, while the vocal reader is not so to the poet' (317). Music does not observe the primary/secondary divide as well as poetry.

Architecture. Poetry, music, sculpture, and painting follow the rule of *l'art pour l'art*, that is, they pursue the beautiful 'as an end in itself, the real and only end of art' (318). Architecture, however, usually has a utilitarian purpose. When the useful purposes of architectural works predominate over their artistic aspects, as with ordinary dwellings and buildings, such works are not pure art. Conversely, if the works have a purpose that leaves room for beauty to come first and for utility to be secondary, then these works can be pure art. This applies to religious buildings and monuments, since their purpose is to enable worship and reverence. In pursuit of this goal, practical utility—e.g., having pews shaped for comfortable seating—is properly secondary to the purely artistic purpose of expressing feelings of reverence, awe, worshipfulness, solemnity, and so on.

Interestingly, for Cobbe architecture is like music in that architecture's proper subject-matter, if it is pure art, is human feelings. However, compared with music, architecture can express only a limited range of feelings:

> Architecture is similarly [to music] derived from the Beautiful in *human nature only*...It represents a certain number of the sentiments natural to man, which are beautiful in themselves...Religious Awe, Solemnity, Praise...Joy, Triumph, Mourning...nearly exhaust the list of the sentiments reproducible by architecture. (333)

Music is more limited in scope than poetry, and architecture is more limited still.

Again like musical works, architectural works are beautiful if they express human feelings that are beautiful in virtue of being part of human nature,

which in turn is beautiful in virtue of being God's creation, like the whole of nature. Architectural works should be ranked by the beauty of the feelings they express, how well they embody these feelings, and how well they use proportion, balance, and gravity to this end. As for secondary architectural works, Cobbe admits that the primary/secondary line is hard to draw because all architectural works are modelled on one another 'in unbroken series' (335). However, secondary architectural works are inspired *primarily* by other architectural works, as with French buildings that emulate ancient Roman ones, rather than aiming to express feelings directly. As for tertiary architectural art, this consists of sensitive responses to the feelings expressed by buildings combined with technical knowledge of principles, structures, and styles (337–338). People tend to assume that only the latter is needed to appreciate architecture, but Cobbe insists that feeling is needed too, for what matters is how certain physical arrangements express particular emotions.

Sculpture. Whereas music and architecture express interior human feelings, sculpture expresses the beautiful outward human form (338). The sculpted body conveys human passions to a degree, as manifested in bodily features—say, with a flared nostril conveying anger. But compared to architecture, the expression of direct feeling is far more limited, for the sculpted body must be harmonious and serene in order to be beautiful. This leaves room only for 'the very calmest and most chastened indication' of emotion (340). The scope of sculpture is therefore more limited than that of poetry (all subject-matters), music (all emotions), and architecture (specific emotions). Sculpture only deals with subdued emotions, wielding an even more limited affective palette.

In this connection, Cobbe repeats her earlier view that the true sculptural work is the small-scale model. This is the primary work, and the full-scale version is only secondary. The sculptures we view in galleries are thus, strictly, reproductions. The sculptor may produce these him- or herself, or delegate their production to assistants. Even in the former case, the artist is in the odd position of being 'the reproducer and copyist of his own work' (341).

The tertiary art of receiving sculpture, again, must combine sensitivity to the emotions embodied with technical appreciation of how the work expresses these feelings (346). Cobbe complains that public sensitivity to sculpture is at a low level, perhaps alluding to the controversy about Hosmer's authorship of *Zenobia*. However, arguably the problem arises from the merely 'chastened' expression of feeling in sculpture. If feelings can be only hinted at from behind a veil of serenity, inevitably it will be hard for the audience to discern them.

Painting. Finally, painting embodies natural beauty in shape and color. Its scope is wider than architecture, music, or sculpture, for an artist can paint 'every conceivable thing which man may either see or imagine he sees, and of which Beauty may be predicated' (347). Painting's secondary forms are engraving, lithography, and copying. Here the primary/secondary divide is much firmer

than with music, architecture, or sculpture. Engravings, copies, and so on, are both derivative of and separate from primary works of painting, which can exist perfectly well without ever being reproduced at all. Finally, tertiary reception of paintings must again combine sensitive feelings with technical judgement; mere technical know-how on its own is insufficient (353).

Cobbe's hierarchy of art-forms, like her hierarchy of art's orders, is unstable. The order in which she treats the various art-forms presumably reflects their relative ranking. Yet, apart from identifying poetry as the best art and music as the second-best, she does not explain the comparative merits of architecture, sculpture, and painting. Poetry, music, architecture, and sculpture seem to be ranked in descending order by their increasingly limited subject-matters—but then we come to painting, whose range is as big as poetry. Perhaps painting ranks lowest because it depicts what is visible. In that case, the arts would be ranked from most spiritual (poetry) down through all the emotions (music) to some emotions (architecture) to their bodily expression (in sculpture) to visible bodies (painting). The order would descend from most immaterial to most material. But then the further complication is that it is only in painting that the primary/secondary division fully applies. In different ways, works of poetry, music, and sculpture cannot fully exist without being reproduced, while architectural works feed off one another in unbroken series. The primary/secondary divide applies to painting *because* it is the most material art, which means that a painting can exist as a material item independent of any reproductions. This same materiality is why Cobbe ranks painting as the lowest art. In her own terms, the better and more spiritual an art-form is, the less well it observes her primary/secondary division.

7.6 Cobbe on Art, Religion, and Morality

In 'The Hierarchy of Art', Cobbe attempts to steer a middle course between aestheticism and moralism, between 'art for art's sake' and 'art for morality's sake'. Cobbe endorses the idea of *l'art pour l'art*, which she knew from the French cultural scene, where this slogan was by then widespread (Murphy 2008; Wilcox 1953). Cobbe knew it from the work of Victor Cousin in particular (see Cousin 1853). Cousin divided values into the true, good, and beautiful, and Cobbe followed him. In her version of *l'art pour l'art*, art should be made for its own sake, specifically to express beauty, not to serve utilitarian purposes or impart moral precepts or religious doctrines didactically. When objecting to the (Jamesonian) view that religious art tackles overtly religious subject-matters, Cobbe stated: 'It is by revealing Beauty that Art fulfils its purpose. Nothing more and nothing less is to be desired of it' (Cobbe 1865: 355). Art must aim at beauty and beauty alone.

Nonetheless, for Cobbe this pursuit of beauty does not rule religion out of art. On the contrary, the artist can only create genuinely religious art by pursuing

beauty alone, for beauty always derives from God. Cobbe argues similarly concerning morality: it is just when the artist pursues beauty alone that she can create genuinely morally edifying art.

> The Good, indeed, and the True are so inseparably linked with the Beautiful that *every work really attaining the Beautiful must partake of Truth and Goodness*. But it is not for the sake of instilling Truth or preaching Goodness that the Beautiful should be produced. When any artist attempts to do so, and makes a poem or picture whose main purpose is to...enforce moral lessons, the result is an inferior and imperfect work of art. (321; my emphasis)

So the artist should not enforce morality. They have no need to do so: beauty already contains goodness, as its source is in God, who is supremely good. What God creates is beautiful, and he creates in accordance with his goodness and wisdom, so that truth, goodness, and beauty converge. If any natural object or artwork is genuinely beautiful, it must be imbued with and convey God's goodness.

We might object that surely not everything in nature or human nature is good. For example, regarding music, Cobbe admits that we have base, spiteful, and mean feelings, but she states that these are inappropriate musical subject-matter:

> Music cannot deal with ignoble, mean, or ugly thoughts and sentiments, with petty cares, or base, rancorous or envious feelings.... Music paints the flowers in these gardens...But the weeds...she will not paint. They are no subject for her art. (314–315)

But why shouldn't ignoble and mean feelings be given musical expression, if these feelings are natural? And if they are natural but ignoble, how does that square with God's beneficent creation of nature?

Cobbe does not directly answer these questions in 'Hierarchy', but her other writings spell out her twofold answer. First, human evil does not directly come from God but arises from our misuse of the freedom God has given us. The fault lies with us, not God (Cobbe 1855: vi–vii). Human evil is therefore not part of nature, the realm that God has directly created. Consequently, human evil is neither beautiful nor fit subject-matter for art. Second, natural evils like earthquakes and diseases do not directly come from God either. Cobbe quotes the Old Testament: 'After the wind there was an earthquake, but the lord was not in the earthquake' (1 Kings 19: 11–13). She takes this remark to show that natural evils are mere byproducts of the operation of natural laws and forces that are generally benign and life-sustaining (Cobbe 1888: 74). So natural evils are again not directly created by God, therefore not beautiful, therefore not appropriately treated in art.

This shows that despite her professed commitment to art for art's sake, Cobbe *does* impose moral limits on the subject-matters with which art can properly deal. We see this clearly in her 1864 essay 'The Morals of Literature':

> 'Is it not then competent to art to seize on every subject, every phase of existence, and bring it out into the light under its magic glasses?' 'No', we answer fearlessly, it is *not* competent to art to choose subjects base or gross. The office of art is to express thought; but it must be good and noble thought, or the art is prostituted. (Cobbe 1865: 279)

However, she immediately adds:

> Of course, so long as nature is in question—inanimate nature, or human nature which is really nature at all—there can be nothing unfit or beneath art. It is the distortion of the natural into the artificial which makes a thing or person an unfit subject for art. (279)

In other words, if a novelist depicts human beings as cruel, selfish, or mean, then they are giving a distorted picture of human nature that fails to copy God's work. If a musician gives vent to scorn, despair, or cynicism, then they are letting their own nature become artificially distorted and disfigured, and so again they are failing to copy God's work. These are moral failures *because* they are aesthetic failures—failures to give the artwork a truly beautiful content.

Cobbe believes that art can be made for its own sake without this threatening morality, since goodness is intrinsic to nature's divine beauty in the first place. We can have what the moralist wants—edifying, noble artworks—without having to subordinate artistic goals to moral ones didactically. Just as art need not illustrate overt religious subjects to be religious (contra Jameson), art need not exemplify overt moral principles to be morally good. The artist must simply ensure that they copy God's work and take inspiration from the beauty of nature.

Unfortunately, even as Cobbe wrote, this optimistic view of nature was collapsing in the face of Darwin's theory of evolution. As Cobbe (1888) later admitted, if life evolves through a process of struggle and conflict in which many individuals and species are eliminated, then nature cannot easily be seen as God's beneficent creation. If one views life as evolving through natural selection *and* being created by God, then:

> The Supreme Power who had seemed to stand on high directing each shaft of light with the godlike ease and certainty of...Apollo...appears now rather as an Engineer discharging a huge catapult or *mitrailleuse*, whereof one bullet in fifty strikes the mark and the rest fall to the ground. (75)

As she also put it, on the evolutionary view nature is a battleground, not a garden. A God who expresses himself in nature so understood is at worst demonic, at best a warrior-god like Odin (72). We can only conclude that God is not directly manifest in nature at all: his domain is instead the interior world of spirit (66).

Cobbe thus abandoned the view of nature with which she had tried to reconcile aestheticism and moralism. Nonetheless, her attempt to reconcile them remains interesting, both for the distinctive nature of Cobbe's position and in historical terms, as showing the cultural pendulum swinging away from moralism. Jameson had sought to balance aesthetics and morality more evenly than Martineau, and Cobbe sought a still more even balance than she found in Jameson. As I mentioned earlier, Cobbe was familiar with Jameson's *Commonplace Book*, in which Jameson denounced as erroneous and damaging 'the idea that what we call *taste* in art has something quite distinctive from conscience' (Jameson [1854] 1855: 284). To a point, Cobbe agreed: mere technical connoisseurship (or taste) without sensitive feeling (or conscience) was empty, and sensitive feeling for the beautiful coincided with conscience, because what was properly beautiful was morally good. But Cobbe went beyond Jameson in endorsing *l'art pour l'art*, and in holding that art only needed to copy beautiful nature in order to be religious and moral.

The historical dynamic was as follows: Jameson moved away from Martineau's programme of illustrating overt moral principles in art; instead, she came to approach art's moral content indirectly, by way of a third term, religion. In Jameson's wake, Cobbe too linked art and morality indirectly by way of religion. But Cobbe understood art to be religious just when it copied the divine beauty of nature, not when it expressed overtly religious content, as Jameson thought. For Jameson, art beauty differed in kind from natural beauty: the latter was infinite, the former an inevitably finite expression of the religious beliefs of a particular civilization. Cobbe, instead, thought that at its best art could directly reproduce the beauty of nature. By connecting art to divine nature, rather than cultural and religious history, she steered art's moral content even further away from any didactic imparting of messages. But the drawback was that her theory depended on a conception of nature which evolutionary theory made untenable. The problem of how to balance the aesthetic and moral aspects of artworks remained.

8
Emilia Dilke's Journey from Art Philosophy to Art History

8.1 Introduction

By the time of her death in 1904, Emilia Dilke had risen to be Britain's pre-eminent authority on French art. She built up her reputation with *The Renaissance of Art in France* (1879b), *Claude Lorrain* (1884), *Art in the Modern State* (1888), and a four-volume book series on eighteenth-century French art (Dilke 1899, 1900, 1901, 1902). Yet despite her once-high standing, Dilke was forgotten for nearly all of the twentieth century, in a pattern dismally familiar by now. She was misleadingly left out of histories of thinking about art in Britain, until recent scholars restored her to the historical record.[1]

Although Dilke's work in art history has been rediscovered, another part of her oeuvre still awaits re-examination. Before she turned to art history, Dilke produced a substantial body of writing on philosophy of art. Spanning the mid-1860s to the early 1870s, it includes numerous short essays and reviews plus two major theoretical statements, 'Art and Morality' (1869) and 'The Use of Looking at Pictures' (1873b).[2] This chapter examines Dilke's account of art in these writings.

I will show that Dilke began in the 1860s as a historicist, believing that artworks were inescapably the products and expressions of their social and historical circumstances (Section 8.2). This historicist view led her to think that art had separated from morality and religion over time, making aesthetic moralism inappropriate in the modern world. She therefore came to defend aestheticism, above all in the long 1869 essay 'Art and Morality' (Section 8.3). Notably, this essay preceded the book normally taken as the founding statement of aestheticism, Walter Pater's 1873 *Studies in the History of the Renaissance*. The standard view is that Pater was the 'foremost exponent of aestheticism' in nineteenth-century Britain (see, e.g., Johnson 1969: 3). But as we will see, Dilke had already argued for aestheticism more rigorously than Pater. This raises a question as to whether Pater was influenced by Dilke (which I consider in Section 8.3).

[1] See Askwith (1969), Clarke (2005), Eisler (1981), Mansfield (1996, 1997, 1998, 2000), Israel (1999), Demoor (2000), Fraser ([2004] 2008, 2014, 2019), and Kanwit (2013).

[2] Mansfield (1998) gives an excellent account of these articles, but she foregrounds Dilke's authoritative persona within them more than their philosophical arguments.

Even though historicism had led Dilke to aestheticism, once fully developed her aestheticist position turned out to conflict with aspects of her historicism (Section 8.4). She wavered between her aestheticist and historicist commitments in the early 1870s. Then she resolved the tension in 'The Use of Looking at Pictures' by distinguishing between the best artworks, which have aesthetic value and transcend history, and the majority of lesser artworks, which have only historical value as expressions of their periods (Section 8.5). Concluding that the right approach to most art was therefore historical and explanatory, Dilke now abandoned philosophy of art and turned instead to art history (Section 8.6).

What were Dilke's relations to the other women philosophers of art we have looked at? This is something of an enigma. Of all these women, Dilke referred least often to any of the others. Her reticence concerning Anna Jameson, her central precursor as a woman doing large-scale art theory, stands out. The reticence probably reflected Dilke's desire to carve out a niche independent of Jameson, as well as her substantial disagreement with Jameson about art (explored in Section 8.7). As regards Dilke's broader reluctance to reference other women, it is worth noting that she only began to use a female signature herself once she was well established. Before this, she favoured anonymity or gender-neutrality, and so she minimized references to other women which might have exposed her gender.

Dilke used a changing array of names and signatures, as a brief review of her life and career can bring out. Born Emily Francis Strong, she was always called Francis, and grew up in Oxford in an artistically well-connected family, knowing John Ruskin and the Pre-Raphaelites (she rejected Holman Hunt's marriage offer). With Ruskin's encouragement she studied art from 1859–61 at the National Art Training School in London, before returning to Oxford to marry the much older humanist rector of Lincoln College, Mark Pattison. She thereby became Emily Francis Strong Pattison. The couple's marriage was unhappy. It was widely seen as the model for Dorothea and Casaubon in Eliot's *Middlemarch* (Mark Pattison wrote about the historical Casaubon and was notorious for struggling to complete his scholarly projects).[3]

Francis Pattison (as Dilke then was called) began publishing in the periodicals in the 1860s. According to her second husband, Charles Dilke: 'The subjects upon which she wrote largely in her early days were in the main philosophical.... The dominant interest [in aesthetics] soon came to the front...in a series of reviews of German books developing theories of aesthetics' (Dilke 1905: 28), and English and French books as well. These 1860s pieces appeared anonymously in the *Saturday Review*, from which she progressed to publish in the prestigious *Westminster Review* from 1869–73, again anonymously, and then from 1870 in *The Academy*, for which she became the art editor in 1873. In *The Academy*, she

[3] Eliot knew about Dilke's marital woes as they were good friends and corresponded regularly (see Israel 1999: 299, n. 41).

published as 'E. F. S. Pattison', retaining the 'S' for 'Strong' in opposition to coverture. By then she was also reviewing numerous art exhibitions, making the turn to art history that culminated in her 1879 book *The Renaissance of Art in France*, signed 'Mrs Mark Pattison'. Meanwhile, she had privately changed her first name to the more cosmopolitan and literary 'Emilia'. After Mark Pattison died in 1884, she married Sir Charles Dilke in 1885, becoming Emilia Dilke—'Dilke', as I call her for simplicity. She then published her books on French art signed 'Lady Dilke'.

By that point, Dilke had come to see artworks not merely as aesthetic creations but as material products, contributing to the economy, and shaped by political arrangements. This materialist standpoint convinced her of the importance of production and the political necessity for improved working conditions for all producers, particularly women (see Fraser 2014: ch. 4 and 2019). She became immersed in the movement to unionize women workers, assuming the Presidency of the Women's Trade Union League from 1886–1904. We can now follow the journey that led Dilke to this materialist outlook.

8.2 Dilke's Historicism

Dilke began writing for the *Saturday Review* in 1863. Although it was a conservative and acerbic journal—Frances Power Cobbe said that it 'squirted its venom each week like a toad by the roadside' (Mitchell 2004: 153)—its strict policy of anonymity offered Dilke a safe space to develop her ideas and criticize other art theorists.[4] She used these critical reviews to work out her own approach to art which, at first, was positivist and historicist.

In 'The Art-Idea', Dilke reviewed James Jackson Jarves's book *The Art-Idea: Sculpture, Painting, and Architecture in America*. Jarves, she complained, offered 'fine speculations' and a 'philosophy that wants but one thing—bottom' (Dilke 1864: 219). His theory had not faced 'the test of facts'. Against speculation, she recommended the 'far more reasoned system of Comte', which derives theory from facts. As well as supporting empiricism and positivism Dilke was somewhat sceptical about theory and metaphysics. This would be a leading refrain in her work. It chimed with what Charles Dilke called 'her invariable straightforwardness, often "brutality", of intellect' (C. Dilke 1905: 12)

Given her positivist sympathies, in 1865 she favourably reviewed the *Philosophy of Art* by the French theorist Hippolyte Taine, whose blend of positivism and historicism influenced her considerably. For Taine, one understands an artwork by explaining it with reference to the artist's whole oeuvre, in turn explained by his school, in turn explained by the 'moral, social and...political condition of the

[4] The *Saturday Review* had an exceptionally strong corporate voice, which left its authors free to be quite vitriolic (see Craig and Antonia 2015: 67–86).

world around', a world in constant historical evolution (Dilke 1865: 520). Thus for Taine, artworks were ultimately products of the artist's historical environment. To understand artworks, we must explain how external factors have produced and shaped them.

Dilke agreed that we have to explain artworks by tracing the causes acting on them and working out the natural laws of art's evolution. 'No work of art, then, is...isolated. The starting-point of a true philosophy must necessarily be that of the *ensemble* which surrounds the work, and of which it forms a part' (520). She also enthused over Taine's practical recommendations:

> We find, in the principles here laid down, the clue to all true and healthy progress. Taking nature as the standard...in the depth and breadth of organic life—we shall no longer be subject to the complaint that art is dead, or remain enslaved to the...conventions of the past. (520)

More specifically, good art must draw inspiration from the present day, for 'the art of an age is the presentation...of its reality' (520). Art invariably reflects its age anyway, so artists should recognize and embrace this reality; rather than hearkening back to earlier eras, they should aim to channel and mirror the dynamics of the social world around them. Then the artist could depict individuals who embodied the vital tendencies of the time, raising these characters into representative archetypes.

In short, Dilke took from Taine the following views. Artworks must be explained by the causal factors shaping them. These causal factors come from the historically evolving social environment, which must be analysed empirically. Good art distils the trends of its time in exemplary types and, by pursuing this path, nineteenth-century art can become both modern and vital.

This belief in the importance of history led Dilke to distinguish moral from aesthetic value in her 1868 review of John Tyrwhitt's *Handbook of Pictorial Art*. He proposed that modern art should be didactic and educate people by depicting real historical events. Dilke (1868a) objected that it only made sense for art to be instructive in past eras when most people were illiterate. Nowadays, art should be free to pursue properly aesthetic ends. Tyrwhitt's strictures would impose:

> an unnecessary and unreasonable tyranny. In the kingdom of art, imagination is not the handmaid, but the mistress, of the understanding; and work which is not done for its own sake, in which the chief place is claimed for the historical or the moral...in which the contents form the weightiest part, loses its aesthetic character, and cannot possess those poetic elements which fire the fancy and rouse the emotions. (262)

Didactic works might have been good art in the Middle Ages, but they could be so no longer, because didacticism was out of place in the modern world.

These points led into Dilke's 1868 piece 'Religious Art in the Nineteenth Century', which was not a review but an independent essay. Formerly, art and religion were 'knit compactly in unity of organic life' (1868b: 361). That unity was now lost: 'Religious art is now severed from the world's art'. Yet there was no way back: 'One reason why most religious art in the nineteenth century has been a failure is that it does not belong to the century'.

Dilke proposed an alternative way for modern art to regain a serious and meaningful purpose. 'Painters wrongly suppose that religious art means a perpetual reproduction of Saints and Holy Families'—presumably a jibe at Jameson—whereas 'the subjects arising out of daily experience' would be more suitable (361). Artists should take everyday modern individuals and raise them into types exemplifying the age. This would yield a new 'ideal realism': not mere naturalism, and not finding the supernatural in the natural, but finding the typical in the individual, and so giving daily realities profound meaning.

Dilke seemed to allude to Jameson, again, when she said: 'There was a breadth, simplicity, picturesqueness...emotion, in early popular belief...When teachers spoke in parables, church walls were covered in ancient panoramas, for an artist can paint a parable, but not a creed' (361). Yet Dilke was tacitly criticizing Jameson, first, for wrongly restricting religious art to art that depicted explicitly religious themes; second, because in any case art and religion had now parted ways irrevocably. We should *not* go back to religious art. A new, secular way forward was needed, which Dilke found in her Tainian conception of ideal types.

In sum, Dilke opposed any subordination of art to education, religion, or morality, on the grounds that art had necessarily separated from these other variables over the course of history. Instead of looking backwards, artists should make art that was of its time and so pursued independent aesthetic goals. The motivation for Dilke's aestheticism thus came from her historicist view that art had become independent from other aspects of social life in the modern era, and that art should reflect this fact and disclose the direction of secular modernity.

8.3 Dilke's Aestheticism

Dilke's next major piece was the anonymous 1869 article 'Art and Morality' in the *Westminster Review*. Ostensibly a review of two books by the French spiritualist-cum-eclectic Victor Laprade, this 16,000-word piece made a sustained argument for aestheticism. Unfortunately, this important argument seems to have been universally missed, possibly because Dilke buried it under the guise of a review.

The argument is complex, and we may divide it into the following stages:

Critique of Laprade, moralism, and idealism (Dilke 1869: 149–160). Overtly situating herself in the British empiricist tradition, Dilke objects to Laprade's demand that art should provide 'moral instruction and moral advancement' (184). Indeed, she remarks that there is too much art theorizing altogether, to the

detriment of our immediate sensory responses to art. Yet despite her 'preference for artistic produce over artistic theory', she has been forced to theorize in order to combat the undesirable moralist theories of Laprade and other idealists (149). These idealists distinguish ideal beauty from mere sensory reality by combining Plato, Descartes, and Thomas Reid (as the French eclectics did) to postulate an idea of moral beauty, perceived by God, of which physical beauty is merely the symbol. Dilke replies that if real beauty is ideal and grasped by reason and not the senses, then it is so far removed from ordinary sensory beauty that it is not properly called 'beauty' at all. These theorists have simply replaced (sensory) beauty with (ideal) morality.[5]

Sensualist account of beauty (160–168). Rejecting defective theories is easy, but it behoves us to put a better account in place. 'If we have satisfied ourselves that it is idle to identify that which we call beauty with a real transcendental perfection cognizable by reason, this is the place to indicate…what we in fact mean by the word' (160). She proposes 'to explain the nature and growth of the sentiment of beauty on a basis of sensation' (161). She subdivides sensations as follows:

(1) *Simple sensations* are produced in the body by single colours, sounds, shapes, and so on. Some of these give us pleasure: certain colours, curved lines, musical notes. 'That certain simple sensations…are attended by an organic pleasure, must be accepted as a primitive part of our nature' (162). These *simple pleasures* are independent of any further associations and meanings we may attach to the qualities being sensed.

(2) *Compound or cognitive sense-impressions* occur when one sensed quality recalls others we associate with it, as when a sound suggests a waterfall or a smell suggests a rose. This is 'the stage when sensation acquires an intellectual character' (164). Some of these associations also produce pleasure, as when a smell evokes the idea of an attractive rose. These *associative pleasures* are distinct from simple pleasures (162).

The nucleus of beauty is in simple and compound sensations agreeable to sight and hearing. Sight and hearing are fundamental here, not the other senses, for several reasons. Sight and hearing are unexclusive: sounds and sights are available to many people at the same time, whereas tastes and smells are more private. Sight and hearing are more intellectual: they are the most cognitive senses, the richest in associations. And they are sources of disinterested pleasure: we find certain sounds and sights pleasing irrespective of how useful they are to us. One

[5] Dilke does not say so explicitly, but this is clearly also a critique of Ruskin, because in *Modern Painters* Volume 2 he held that beauty, truth, and goodness were one, and that one was grasped theoretically, not with mere 'animal' sense-perception (see Ruskin 1846: 11).

can find the sight and sound of a raging torrent pleasing, despite knowing it is dangerous (165).

The pleasures produced by the other senses only become 'artistic' when they are joined to pleasurable sights and sounds. For example, viewing a painting of a country scene may produce simple visual pleasures (from its colours and shapes), associative visual pleasures (in the scene depicted), and by extension associative olfactory or gustatory pleasures (if one associates the scene depicted with pleasing smells of fresh grass and tasty picnics). The pleasures of smell and taste can thus be made unexclusive, intellectual, and disinterested by being attached to pleasures of sight and sound. In that case, the former pleasures become artistic (166).

Further qualities can become 'ingredients of the Beautiful' as well: harmony, utility, fitness (suitability of means to ends), power, and completeness (167). These qualities become beautiful when we contemplate them in real-life events in a disinterested way or when they are present in fictional events within literary works; or, again, when they are associatively suggested to us by the look of real-life visible things or when they are present in depicted objects in pictures. So these qualities become aesthetic by being attached to other more basic sensory qualities and associations that are already aesthetic. Finally, novelty, variety, unity, and successful imitation are further components of beauty, and become so on the same, ultimately sensory, basis.

Dilke therefore traces the various ingredients of beauty back to a basis in the senses, along the following route:

1. We naturally feel simple and associative pleasures in some qualities presented to our sight and hearing—these qualities are beautiful;
2. When other pleasurable qualities (for example, smells) become attached to these pleasurable sensory and auditory qualities, they become 'artistic' or beautiful too;
3. The above visual and auditory qualities are public, intellectual (rich in associations), and give disinterested pleasure;
4. When real or artistically depicted events or objects share in those three qualities, they become beautiful as well.

Dilke is building on a long-standing British tradition in approaching beauty in associationist terms, but she claims to put a distinctive weight on simple, organic pleasures. Although associative pleasures become joined to simple pleasures, the latter are fundamental and comprise the nucleus of beauty, out of which its other constituents radiate. For Dilke it is *by* being joined to simple pleasures that associative pleasures become beautiful (and the other qualities in turn). She differentiates herself from Archibald Alison, for whom simple and pleasurable ideas only become beautiful when further associations are joined to them; this, Dilke says,

'begins at the wrong end' (162).[6] More positively, Dilke acknowledges her proximity to Alexander Bain. Like Dilke, he stresses that we take organic pleasure in certain simple qualities, to which further associations are superadded (Bain 1865 211–112).

Dilke criticizes Thomas Reid on similar grounds to Alison. For Reid, material things are beautiful when they express admirable mental and intellectual qualities of the artist (Dilke 1869: 162–164). He too 'begins at the wrong end'; to start at the right end is to treat sensory qualities as the basis of beauty, and build its other components up from there. Simple sense-impressions—of colours, tones, shapes—produce 'a particular and homogeneous kind of pleasure in virtue of which, and not in virtue, as Reid would have it, of intellectual approval consciously bestowed, the object causing it is called beautiful' (164; and see Reid 1973: 41–42).

We may wonder whether Dilke sees beauty as an objective property of certain phenomena (where our feelings of pleasure register the beauty in the object) or a relational property (where the object is beautiful in virtue of inducing certain pleasurable feelings in us). This is not entirely clear, since her concern is not with these clarifications but with the anti-moralist implications of her theory, to which she moves on immediately:

> From an account of beauty such as the foregoing it is easy to deduce consequences subversive of…all theories that would make moral improvement the end of fine art. If the differential character of fine art is its power to produce a certain kind of pleasure, it will be guilty of foregoing this character if it aims at producing something else. On the great principle of the separation of functions, let moral and intellectual agencies be applied to further the ends of virtue, artistic agencies to further the ends of beauty. The relations of beauty to virtue are these: virtue is beautiful because it pleases; not, beauty pleases because it is virtuous. (Dilke 1869: 167)

Art's progressive historical separation from religion and morality (168–175). The anti-moralist conclusion needs to be 'fortified by a reference to the history of the fine arts, and to the part which the ethical or didactic element has actually played in them' (168). Dilke concentrates on two eras: classical Greece and medieval Italy. Initially Greek crafts entirely served religion, both with temples and statues of the gods. But to make worship appealing, craftspeople began to follow artistic motives: exploring combinations of colours, adding decoration, deploying contrasts of light and shade. This properly artistic element was explored more and

[6] See Alison (1790: 413); Dilke partially quotes his emphatic statement 'THE BEAUTY AND SUBLIMITY OF THE QUALITIES OF MATTER, ARISE FROM THEIR BEING THE SIGNS OR EXPRESSIONS OF SUCH QUALITIES AS ARE FITTED BY THE CONSTITUTION OF OUR NATURE, TO PRODUCE EMOTION.'

more: 'the artistic motive, the love of beauty for beauty's sake' (172). Art thereby became art properly speaking, as distinct from handicraft (168–169). For a time now art and religion cooperated. But eventually religion became subordinate, with artists only using religious subjects as pretexts.

Italian Christian art followed the same course. At first, painters and sculptors exalted the saints, angels, Christ, and Mary. But in time 'the pleasure which such things are found to give becomes a motive of itself, and supplants the glory of God' (174). Artists became interested in colour itself, in sensory details; religious and artistic motives now coexisted. But in time the artistic motives prevailed, and so, in the Renaissance, artists turned to secular subjects as well as religious ones, increasingly reducing the religious subjects to mere pretexts for exploring sensory beauty.

Crucially, art's separation from religion has been not mere change but *progress*:

> We can trace a progressive evolution [in Italian art] entirely analogous to that traceable in the case of Greek art.... That which is depicted by mature art is not 'man as a moral being...' so much as man as a physical being—man in possession of bodily perfection.... The progress of art, in short, consists in its passage from the representation of spirit to the representation of body. (175–177)

For its time, this statement is astonishing. The best art does *not* realize spirit or the ideal but allows the body and its sensory pleasures to escape the dominance of moral ideas.

This sensualist conclusion is informed by Dilke's positivism. Herbert Spencer ([1862] 1937), to whom she refers, maintained that everything undergoes evolution, defined as the 'change from an incoherent homogeneity to coherent heterogeneity' (325). For Dilke, as applied to art this means that over time art becomes heterogeneous from the religious and moral motives with which it used to be incoherently mixed. At first, we had only an incoherent mélange of religion and handicraft. Then, in the service of religion, artistic motives (sensory beauty) emerged. Then these motives become a force in their own right, then artistic motives reduced religion to a mere pretext, and, finally, art and religion separated—coherent heterogeneity.

Three aspects of Dilke's argument are worth pointing out. First, she treats the artistic, the aesthetic, and the beautiful as coextensive. People begin to make art *qua* art when they begin to pursue the motive of beauty, and what is beautiful is what gives 'artistic' pleasure (Dilke 1869: 167) or 'aesthetic pleasure' (181). 'Aesthetic' *means* 'artistic' *means* 'beautiful'.

Second, despite her stress on historical progress, Dilke's accounts of both beauty and art have an ahistorical aspect. What we find beautiful depends purely on the senses and is specifiable independently of history. Art's historical separation from religion is progressive, because previously art was mixed with religious motives that are intrinsically different from properly artistic ones (the production of sensory

beauty). The separation from religion has allowed art to become itself, to realize what was always its essential nature as art.

Third, although Dilke sets out to trace what part the 'ethical or didactic element' played in art's history, she actually focuses on religion. This is because the Victorians often assumed that religion and morality were coextensive. Consequently, Dilke takes it that in extricating itself from religion, art shakes off moral restrictions at the same time: 'the moment of art's culmination was precisely also the moment of its divorce from morality' (178).

The anti-moralist case concluded (176–178). Dilke now ties in some further claims. Good artists are not necessarily good people, and great artistic epochs are not necessarily epochs of great public virtue. Ruskin says they are, 'but inexorable history says No' (177). Classical Greece and Renaissance Italy produced great art, but endless wars amongst the city-states and independent cities. Putting all this together, art and morals are 'mutually independent' (179):

> We do not believe that art is in any way able, directly, either to make or to mar in the momentous work of moral instruction and moral advancement. Indirectly, she may perhaps contribute something, by filling men's lives with innocent and refined enjoyment... Even thus much she cannot do until she is allowed to go her natural way in the unswerving search for beauty. (184)

Against decadence (179–184). Dilke preemptively defends herself against the charge of immoralism by stressing that she does not support decadence, which she associates with George Sand, Honoré de Balzac, and Gustave Flaubert and defines as the view that modern art should delve into selfishness, cruelty, lust, and vice. She concedes that some immoral subjects can be suitable for art if they are depicted in aesthetically pleasing ways (167–168). But there are limits to this. Crucially, these are *aesthetic* and not moral limits. 'Extreme and exclusive bodily pains and pleasures' naturally arouse our aversion and disgust (182). What is disgusting always arouses displeasure, like clashing colours or dissonant chords, and as such it is *ugly*, the opposite of beauty (182–183). Indecency is therefore inadmissible in art, on grounds of its necessary ugliness. We might see these restrictions on art's proper scope as disappointing backpedalling from a consistently aestheticist position. Yet Dilke is attempting to condemn immoral art from a consistently aestheticist standpoint, rather than condemning it morally.

Sadly, Dilke's powerful defence of aestheticism has been utterly ignored in the extensive literature on the Aesthetic Movement, which makes at most passing reference to Dilke.[7] Instead, scholars locate aestheticism's central statement in Pater's

[7] Livesey (2007: 54–5), for instance, refers only very briefly to Dilke's political activism; while Bristow (2018), Johnson (1969), Maltz (2006), Schaffer (2000), and Schaffer and Psomiades (1999) don't mention Dilke at all. A rare acknowledgement that Dilke's writings were 'formative of aestheticism in the 1860s and 1870s' comes from Cherry (1993: 72).

Conclusion to *Studies in the History of the Renaissance*, published in 1873. Yet 'Art and Morality' came out in 1869, preceding *Studies* by four years. Having said that, Pater's Conclusion to *Studies* drew on his 1868 review-essay of William Morris's poetry. Here Pater (1868) extolled 'art for art's sake' under that description (312). However, the phrase was already in use well before Pater: the *Oxford English Dictionary* dates its first usage to 1824. Its French forerunner, *l'art pour l'art*, was in use too, as we saw with Cobbe (1865: 320, 322).[8]

So who influenced whom? I suspect that Dilke and Pater influenced one another: they knew each other well in 1860s Oxford. Dilke, then married to Mark Pattison whilst he was rector of Lincoln College, hosted a 'salon at the Rector's lodgings, to which gravitated most of the liberal and rationalist element of the University. Pater was often a guest' (Evans 1970: xxxiv). Charles Dilke also noted her longstanding friendly relations with Pater (C. Dilke 1905: 29–31). They remained friends even after Dilke unfavourably reviewed Pater's *Studies*, making criticisms that led him to rename the book *The Renaissance: Studies in Art and Poetry*.[9]

Even though Dilke and Pater influenced one another, their statements of aestheticism were very different. His was intentionally impressionistic and subjective, unlike Dilke's step-by-step case that art must pursue 'the unswerving search for beauty'. This makes the different afterlives of Pater's and Dilke's statements especially revealing. Men can write subjectively, poetically, and allusively, but will still be heard as making theoretical claims. In contrast, however rigorously women make philosophical arguments, if they are heard at all it will probably only be once they are relocated in a literary register.

Across their stylistic differences, Pater and Dilke agreed that the Renaissance brought in a healthful liberation of the body and the senses from religious strictures, a point of departure from another unmentioned interlocutor of Dilke's: Jameson. Dilke described a key moment in the Italian Renaissance when pleasure in artistic creation became independent of religious motives:

> The transition, the advance in the direction of naturalism…is…the consequence of such a change of motives. The names of Masaccio and Fra Filippo Lippi are two of the most prominent at this turning-point in artistic history…[but] the departure of such men as these from the antiquated types was at first distasteful to the Italian priests…(Dilke 1869: 174)

[8] See 'art, n.1.' *OED* Online.
[9] On the name-change, see Evans (1970: 27); and on Dilke and Pater, see Fraser (2016) and Østermark-Johansen (2015). The name-change shows that Pater took Dilke's views seriously; he kept up with them, for example commenting that she was 'writing well' in her latest work (Pater to Edmund Gosse, 10 September 1877, in Evans 1970: 38–9).

Compare Jameson (1845):

> We now find, on the one side, a race of painters...without any other aspiration than the representation of beauty for its own sake. On the other hand...painters to whom the cultivation of art was a sacred vocation—the representation of beauty a means, not an end....The two classes of painters [were]...the *Naturalists* and the *Idealists*...(vol. 1: 110–111)

Taking Fra Filippo to represent the naturalist current, Jameson continues:

> In the representation of sacred incidents he was sometimes fantastic and sometimes vulgar; and he was the first who desecrated such subjects by introducing the portraits of women who happened to be the objects of his preference at the moment. (114)

For Jameson, Fra Filippo took a wrong turn, away from the truly religious approach which balances material details with spiritual meaning (111). He strayed towards undue attachment to sensory beauty in its own right. For Dilke, it was in this very turn to naturalism that Fra Filippo made a key *advance*.

Dilke reinterpreted the Renaissance in opposition to Jameson—and, for that matter, to Ruskin. As we saw in Chapter 6, for Jameson the Renaissance at its peak reconciled aesthetic and religious motives. For Ruskin, on the contrary, the high Renaissance deteriorated away from religion, and Jameson had misinterpreted Raphael and others as balancing the aesthetic and the religious when they actually privileged the aesthetic and reduced religion to a mere pretext, and undesirably so. Dilke's (and Pater's) third alternative was that the Renaissance *did* indeed pursue sensory beauty in its own right (with Ruskin, *pace* Jameson), but that this was positive and progressive (*pace* Ruskin). The Renaissance became this battleground as it served as a barometer of attitudes to art and religion. The Renaissance either consummately balanced art and religion (Jameson), or fell away from religiosity (Ruskin), or set art healthfully free from religious fetters (Dilke, Pater).[10]

[10] This is not the only reason why the Italian Renaissance was important to the Victorians. Earlier in the nineteenth century the Renaissance had been eulogized as the model for good art; consequently, any changes in art theory and practice had to reappraise it. In addition, Hilary Fraser (1992) argues, the Renaissance stood as a part of the past that could be appropriated in the present (42), and it seemed to model the same sort of cultural rebirth through which the Victorians felt they were living (257). Thus, the Victorians felt they were the natural heirs of the Renaissance (a view explicitly taken by Elizabeth Eastlake; see Lochhead 1961: 115–16). Finally, women like Dilke and Vernon Lee were drawn to the Renaissance, Fraser (2014) argues, because this 'foreign' context allowed them to imagine alternative ways of living, beyond gendered restrictions (104, 135; see also Zorn's discussion with regard to Lee, in Zorn 2003: 29–38).

8.4 Aestheticism and Historicism in Tension

Initially, Dilke's historicism motivated her to adopt aestheticism. But by the time of 'Art and Morality', her earlier historicist views were left largely behind. She no longer maintained that the best art distils its age and embodies the era's historical tendencies in ideal types. She now rejected all appeal to ideal types and held that the best art simply pursues beauty, which depends on the artwork's sensory qualities.

Dilke still endeavoured to combine aestheticism and historicism by claiming that art had undergone a progressive historical separation from other factors such as religion and morality. But this constituted *progress* because art was always intrinsically separate from such factors. Art's purpose qua art is just to be beautiful, so that art improved the more that intrinsic separateness was realized historically. In contrast, Dilke's earlier historicist view had been that art was never intrinsically separate from society or history but was only ever an expression of historical forces, where art was better the more overtly it channelled these forces. On that view, medieval religious art was good because it channelled the dominant religious ethos, and modern secular art was good because it expressed art's modern separation from religion—because it *reflected* modern causal forces, not because it had *escaped* all extraneous influences. In 'Art and Morality', instead, Dilke maintained that art was better the more it extricated itself from all external factors to pursue beauty alone.

Yet Dilke was not yet ready to abandon historicism entirely. Its tension with her aestheticism broke out in a set of essays she now published on Ruskin, Pater, and Hermann Grimm. This began in September 1870 with a harsh review of Ruskin's recent *Lectures on Art* (Ruskin 1870). Dilke's review was in the newly established liberal periodical *The Academy*, which had a policy of signature, so that she published here as 'E. F. S. Pattison'. She held that although Ruskin was a perceptive observer of colour and line, his 'moralizing zeal' had led him into the 'unsafe and dangerous ground' of claiming that great art must either enforce religion, perfect our ethical state, or do us material service (Dilke 1870b: 305). She protested:

> Art itself is neither religious, nor irreligious; moral, nor immoral; useful, nor useless; if she is interpreted in any one of these senses by the beholder, is she to bear the blame? Not one of these qualities are essential to fine art, and as to perfecting the ethical state, that by means of art comes to pass, not by 'direction of purpose', but by her constant presence indirectly refining our perceptions. (305)

Reiterating her arguments in 'Art and Morality', she insisted that there was no fixed correlation between good art and a just society. Refined art and social corruption could go together, as in sixteenth-century Paris. Nor did an artist have to be a morally sound character to have genius.

In fairness, Ruskin was more equivocal about art and morality than Dilke makes out. Not only did his views change over time, but more generally he sought to unite and balance beauty and goodness (see Guyer 2014: esp. 195–214; Landow 1971). For Dilke any such balancing act necessarily subordinated beauty to extraneous goals. Art beauty was intrinsically separate from morality and had to go its own way, otherwise it would necessarily be curtailed.

Dilke swiftly followed this criticism of Ruskin with another highly critical (and anonymous) review of Pater's *Studies* in the *Westminster Review*.

> The historical element is...wanting, and its absence makes the weak place of the whole book...Instead of approaching his subject, whether in Art or Literature, by the true scientific method, through the life of the time of which it was an outcome, Mr Pater prefers in each instance to detach it wholly from its surroundings, to suspend it isolated before him, as if it were indeed a kind of air-plant independent of the ordinary sources of nourishment. (Dilke 1873a: 639–640)

Consequently, Pater missed the meaning of the art-objects he studies. Dilke conceded that he was sensitive to aesthetic qualities and nuances (like Ruskin), yet Pater's studies were 'not history, nor are they...to be relied on for accurate statement of...matters of fact' (640). Her objection to Pater thus came from a historicist standpoint, on which we must study art by starting with observed facts regarding the artwork's context and connecting these facts into the *ensemble* of conditions shaping the work. By treating artworks as causal outcomes of these wholes, we explain the works and thereby access their meanings. Causal explanation is needed for successful interpretation.

This was a sudden revival of Dilke's earlier historicism and positivism. It conflicted with her view that the aesthetic qualities of artworks have a sensory basis and so can be appreciated independently of any historical explanations. It also conflicted with her critique of Ruskin, in which she insisted that art's aesthetic qualities did *not* correlate with its social conditions. By implication, those qualities were independent of social conditions, precisely what Dilke now denied apropos of Pater. After all, if an artwork is the product of its time, then one would expect social and ethical conditions to correlate with the qualities of artworks.[11] Dilke later admitted as much: 'All fertile movements...bear in their breasts the seed of renewed ethical impulse. The Renaissance is no exception; it had not only its artists,...it showed, like all great moments, the signs of spiritual life' (Dilke 1879b: 29). Her criticism of Pater was thus symptomatic of the underlying tension between her historicism and aestheticism.

[11] As Kali Israel (1999) points out too (254).

However, between her critiques of Ruskin and Pater, Dilke had developed the seeds of a resolution in an 1872 *Academy* review of an essay collection by the late German Romantic art historian Hermann Grimm (specifically his *Zehn ausgewählte Essays zur Einführung in das Studium der modernen Kunst*). As ever, Dilke (1872) used the review to present her own latest thinking. The aesthetic relation to an artwork, she stated, is to its form; the poetic or literary relation is to its content. Only the best artworks have a universal content: they 'develop some simple strain of passion, eternal in human nature, which, as such, speaks straight to the heart of all time in spite of unaccustomed mode of manifestation' (124). We can all relate to such works directly and immediately, responding to their universal human interest across differences of time and place. However, most works have only time-bound interest and appeal. A work of the latter kind

> cannot have the full significance which attached to it in its own place and day.... It is impossible for us to thrill with the emotions which quickened the pulse of past life.... The crowning beauty of that which is handed down to us from the Past is fled. The surroundings are gone, the people are no more who girt about the master and his work—that work in which he shadowed forth his secret, which was one and the same as the secret of his people and his day. (124)

We must therefore mentally reconstruct the conditions surrounding these works to appreciate their significance. The meaning is not immediately accessible; disinterring it requires explanatory and historical work.

So where there is temporal or contextual distance between artwork and observer, and where the work is one of the large majority of lesser-quality artworks, historical reconstruction is needed to fill in its content and understand it. This is not the case with the best works, which transcend their circumstances and embody content that has a universal appeal. Moreover, historical explanation is only ever needed to reconstruct content, not form. The properly aesthetic qualities of artworks are formal and can be directly apprehended with the senses, independently of history.

Here Dilke began to demarcate the historical and the aesthetic. Beauty, perceived with our senses and bodies, stands essentially apart from the workings of history. Conversely, historical explanation is needed for the meaningful elements in artworks that are not aesthetic and are harder to get at.

8.5 The Uses of Pictures

Dilke (1873b) refines these distinctions in her last major philosophical essay on art, 'The Use of Looking at Pictures', another anonymous *Westminster Review* piece. 'Matter-of-fact people sometimes ask what good is to be got by looking at

pictures', she begins, assuming a similarly matter-of-fact tone herself (415). Looking at pictures has many uses, she replies, including moral, scientific, and practical ones. But the principal uses are aesthetic. Looking at pictures is good aesthetically, as it gratifies and educates our sensitivity to aesthetic qualities, principally beauty. 'The first thing, then, that a picture does for us is that it makes us see a certain good thing [beauty], which without it we should see either not at all, or less wisely and less well' (415). Beauty—subdivided into that of human beings, landscapes, and animals—is more readily seen in stationary pictures than real life, where it may be hard to access, fleeting, defective or mixed up with other features. By helping us to see beauty, pictures train our senses and capacity to see beauty outside the gallery.

> It is the beauty which a seeing eye can trace in beast, bird, flower, and thing, that a picture shows us, and shows us better than anything else can show us. To interpret therefore this beauty is the main end of the art of painting, and the right enjoyment of this beauty is the main end of the act of picture-seeing. Such enjoyment is not the main good of life, but it is the good which we go to a picture to get. We call it the *aesthetic* good as contrasted with the moral or scientific or utilitarian good to be got from things. (416)

'Now, what do we mean when we talk of beauty?' Dilke asks (416). It is a composite quality, and its components are:

(1) visible qualities of brightness and harmony of colour;
(2) gracefulness of form (constituted by economy of means to end);
(3) symmetry of parts;
(4) marks of health, goodness, and intelligence.

'It will be clear from this that the conception of beauty is...of singular complexity, and that in the use of the term there is great danger of equivocation.' To disambiguate it, Dilke claims that landscapes can only ever be beautiful in respect (1); animals in (1), (2), and (3); and human beings in all four respects. A human form that has all four components is perfectly beautiful, crossing over the 'line of ideal beauty' (417). A human form that satisfies only most of (1) to (4) merely passes the 'mean line of beauty'. People whose beauty crosses at least the mean line will look pleasing to everyone: not only to some people, depending on contingent associations and personal feelings, but universally. They 'satisfy the aesthetic sense of mankind'.

As before, then, Dilke thinks that humanity has a natural propensity to take pleasure in certain qualities, those enumerated under (1) to (4). Her account of beauty is more clearly objectivist than before. When objects exhibit enough of qualities (1) to (4), they have the property of beauty, and they please us because

we have an 'aesthetic sense', a natural responsiveness to the qualities that make for beauty.

Pictures' primary use is to present us with beauty, but things depicted can only pass the mean line of beauty if they are in repose, exhibiting 'a certain statuesque immobility' (417). This is because pictures should present beauty more clearly than in real life, isolated from contingent fluctuations. Thus, to be beautiful, pictures must also be *picturesque*, defined by statuesque immobility. The picturesque is aesthetically pleasing in itself (417–418). So a second aesthetic purpose of pictures is to present us with, and gratify our sense for, the picturesque.

However, Dilke admits, many modern painters, especially the Dutch, depict people who fall short of the mean line of beauty or, as in Michelangelo's *Last Judgment*, portray dramatic, agitated scenes that fall short of being picturesque. 'We thus arrive at the large class of pictures which violate one or both of the aesthetic canons proposed, and we ask what good can be got by looking at them?' (418). They may instead present us with *interesting* scenes and people, characters influenced by strong and conflicting motives. Such pictures have 'poetical value': they reveal the human interest in subjects who are not beautiful and may even be ugly, arousing our sympathy for these individuals. The poetic, for Dilke, is only partly aesthetic. On the one hand, pictures that are merely poetic and not also beautiful or picturesque 'violate the aesthetic canons'. On the other hand, they show us 'the soul of beauty that may exist in things ugly'. All told, a work that has (only) poetic value has a degree of aesthetic value but less than one that is beautiful and/or picturesque (419).

Yet most poetically interesting pictures have interest only for people who belong the same time-period as the pictures. For example, devotional pictures of saints held great poetic (sympathetic) interest for people in a religious age but hold little live interest today. This leads Dilke to draw a further distinction. The greatest poetic pictures have universal interest, depicting individuals who appeal to everyone's sympathies at all times. But most poetic pictures fall short of this and so lose their poetic interest over time. They retain a different use: the psychological and historical value of showing us how people in other times and places thought and felt. This is '*indirect*' rather than direct poetic value. In short, as times change, most poetic artworks migrate from having direct poetic use to having merely historical use. 'Hence the historical value of a work of art is in some sort a value for all time and almost all minds, while its poetical value varies directly with its absolute or relative distance from the age which contemplates it' (419).

Is historical value a grade of aesthetic value? On the one hand, Dilke equates it with indirect poetic value, where poetic value is a (diminished) grade of aesthetic value, which suggests that historical value is a still more diminished grade of aesthetic value. On the other hand, Dilke says, over time the poetic value of most works becomes increasingly indirect until it evaporates altogether. Historical

value, then, is such a low grade of aesthetic value that it marks the line where the value ceases to be aesthetic at all.

Having outlined these central 'uses' of pictures—(1) to be beautiful, (2) to be picturesque, (3) to hold (universal or direct) poetic interest, and (4) to have historical interest—Dilke canvasses some subordinate uses: (5) illustrative, (6) comic, (7) didactic or utilitarian (for example, scientific or commercial illustrations), and finally (8) mere displays of technical skill, which are worthless. Aside from (8), then, every picture 'ought to offer us one of these things' (419).

Dilke has thus categorized the different 'uses'—valuable qualities and effects— of pictures and by extension artworks generally. Her argument has several interesting and important features.

She remains an aestheticist: didactic works come low in her scale of value and the best works are those whose value is most aesthetic. She also remains an empiricist: beauty is a compound quality, composed from several sensory sources. But is Dilke still a historicist? In the 1860s she thought that the ideal artwork channels its time. Now, she thinks that the ideal artwork transcends its time, by possessing either aesthetic qualities that please universally or universal human interest. The more an artwork's value is aesthetic, the more it stands apart from history. Conversely, the more historically bound it is, the more its value falls short of being aesthetic.

Yet Dilke remains a historicist in other respects. She believes that all artworks are products of their historical locations, so that even works that fall short aesthetically retain historical interest. Historicity is, she says, a constant (419). Moreover, most artworks have merely historical value, and these works must be located and explained historically so that we can sympathetically understand the thoughts and feelings they express. Historical explanation is the right approach for most artworks, and explaining artworks historically means looking empirically at their social, political, cultural, and geographical surroundings and tracing how these causal factors shaped the artworks.

Thus, Dilke has found a way to combine aestheticism and historicism—by bifurcating them. The artworks with most aesthetic value transcend history and do so just in respect of their aesthetic value: beauty, picturesqueness, universal poetic interest, or all of these. Conversely, the artworks that require historical explanation have lesser or no aesthetic value. Their value instead resides in their historical interest, which is why they must be explained and understood historically.

This makes sense of Dilke's (1883) later statement when reviewing the Royal Academy exhibition of 1883:

> The march of science and democracy will force us to see things other than we did, as surely as the Christian ethos transmuted pagan art.... The social changes

which are the effect of moral change are only effected by a lengthy process; and the full expression of these changes in...art is necessarily preceded by...a struggle, out of which must eventually issue, *not* new canons of art—for the canons of art...are immutable...but new modes in their application. (373–374)

Thus: our whole mode of understanding and making art must necessarily change along with social changes (historicism), yet the canons of good art are immutable (because beauty is based in the senses). Again, what is properly aesthetic transcends history, although historical change completely explains the vast majority of artworks in any period.

In disentangling the aesthetic and historical 'uses' or values of artworks, Dilke has gone some way to distinguishing the *artistic* from the *aesthetic*. In her new scheme, art has several kinds of value, only some of them aesthetic.[12] Moral value is one of the other kinds of value that artworks can have, although Dilke deems moral value a low grade of artistic value. This low ranking shows that she has not entirely separated the artistic from the aesthetic. For she ranks the aesthetic values of art most highly: the most valuable quality an artwork can have is beauty, followed by picturesqueness, then poetic interest, historical interest, and so on. These higher-value qualities are aesthetic to diminishing degrees, with historical value marking the point where the value passes out of being aesthetic. Dilke thinks that an artwork is better the more its value is aesthetic because she continues to connect the concepts *artistic* and *aesthetic*, such that an artwork is better *as art* the greater its aesthetic value.

Something similar goes for the concepts of the aesthetic and the beautiful. Dilke has begun to pull them apart, insofar as she now recognizes that there are several kinds of artistic and aesthetic value, of which beauty is only one. Yet she still ranks the beautiful as the highest grade of aesthetic value, since it is the value that is most properly aesthetic.

Still, in starting to distinguish art, the aesthetic, and the beautiful, Dilke's essay marks a major step forward in conceptual clarification. The earlier assimilation of these three concepts had led to difficulties, as we saw regarding Cobbe in Chapter 7. Cobbe equated art, the aesthetic, and the beautiful, which forced her to classify even aesthetic experience of nature as 'tertiary art'. By distinguishing art value from aesthetic value and aesthetic value from beauty, Dilke starts to prise open the space for nature to be recognized as having aesthetic value, for art to be recognized as having other values besides aesthetic ones, and for other aesthetic qualities to be recognized besides beauty.

[12] For a similar contemporary view that artworks have several kinds of value, of which the aesthetic is only one, see Stecker (2019: ch. 3).

8.6 History and Aesthetics Part Company

Having divided aesthetic value from history, Dilke gravitated to the historical side and concentrated on art-historical studies. According to Charles Dilke, she was following Mark Pattison's advice to become a historical specialist, against her own aspirations to do large-scale philosophy of art (C. Dilke 1905 41). In a letter to her niece, Emilia portrayed matters differently: 'What I did was to *stick* to the Renaissance/France/and *art* generally, but I made myself acquainted with philosophy as far as *bearing* on my "subject".' 'Some day I will show you my list of articles and work and explain how it all developed', she added (ED to Gertrude Tuckwell, n.d., in Dilke 1868–92: 87). She thus conveyed that her art-historical turn was driven not by her former husband's dictates but her own theoretical commitments. She first clarified how philosophy bore on art, and so what her philosophy of art was. Her conclusions led her to move sideways to concentrate on the art of Renaissance France.

Indeed, in part, this move was driven by her *anti*-theoretical commitments. Scepticism about theory was an abiding refrain in Dilke's thought. She repeatedly complained that speculation and excessive systematization compromised our ability to observe facts and to appreciate artworks' sensory qualities (see, e.g., Dilke 1869: 149). She spelt out her hostility to metaphysics most fully in another letter to her niece:

> I know infinitesimally little of metaphysics and am quite sure I'll not correctly give a definition of the 'absolute' (could you?) and even then it might take some months to arrive at a definition of 'existence'.... [Of] metaphysical truths... I only know enough to know that they cannot be laid hold of as you lay hold of a walnut and cracked by mere native force. (ED to Tuckwell, 27 February 1882, in Dilke 1868–92: 61)

For Dilke, even trying to define 'the absolute', so that we all know what we are talking about, is hopeless and the whole enterprise is beyond our powers. But fortunately, we do not need metaphysical theory to appreciate the beautiful, since it is built from sensory qualities to which we are organically responsive. Our powers of response are best cultivated by looking at pictures, not reading treatises. Nor do we need theory to appreciate the timeless human interest in great works, for this speaks universally to our human sympathies. The more aesthetic value an artwork has, the less we need theory to appreciate it.

Accordingly, Dilke saw no need to write books on artworks qua aesthetic objects. On the other hand, with the majority of artworks which possess only historical interest, research and explanation *were* needed. In their case, theory

was useful, for these works lack beauty or universal poetic appeal, and we could miss their significance without knowledge of their historical context. Dilke said as much to open and motivate her *Renaissance of Art in France*, the book that crystallized her abandonment of aesthetics for art history:

> The art of the French Renaissance depends for its charm on...the...motive by which it is animated. It is...the expression...of a period when the life of the few had become exceedingly rich and complex. It cannot, therefore, be appreciated by a wide public, and requires perhaps more than the art of any other time a knowledge of the conditions under which it was produced in order to arrive at an appreciation of its excellence. Art is the speech of the people only in its most abstract forms. When it presents, for example, a type of physical beauty unaffected by any moral agent—as in the Antinous—or when it renders a physical ideal in which is embodied a conception of moral beauty—as in the Niobe, or the Sistine Madonna...art is universally intelligible. It is a tongue which knows no accent....The work of the French Renaissance scarcely, however, affords any instance of this...but it is, on the other hand, rich in local colour, and contains...an abundant source of interest for those who read it in the signs of the time at which it was produced. (Dilke 1879b: 1–2)

Where art realizes sensory qualities of beauty or presents universal human interest, it transcends history, and everyone can relate to this kind of art immediately. But most art does not achieve this and remains historically bound, as with French Renaissance art. To appreciate such art, we need historical knowledge.

To shed genuine light, this historical knowledge must be of a certain kind. It must be empirical knowledge about the 'conditions under which it [i.e., an artwork] was produced'. The correct explanatory route is from facts to meanings. The reason why this is the right approach flows out of Dilke's distinction between poetic and historical value. Artworks have poetic value either when they come from the same era as the viewer or interpreter and so elicit their immediate sympathies, or when the artworks have universal, timeless interest. Poetic value calls for poetic interpretation, a sympathetic reading of the spirit of a work, which is possible because the reader shares that spirit. This cannot apply to artworks that have only historical value, for the reader no longer shares their spirit. The form of life that shaped these artworks has disappeared, and so poetic interpretation cannot work here. In its place we need objective explanation: a detailed, patient, documentary accounting of causal forces and sources.

This turn away from 'poetic' interpretation was, I believe, another of Dilke's departures from Jameson, so let me reflect on Dilke's differences from Jameson as a whole.

8.7 Dilke versus Jameson

Dilke complained that Pater's interpretations hung free of nourishment like an air-plant, but when it comes to female interlocutors one might turn the same charge against Dilke. References to women's writings on art were sparse in Dilke's publications and even her private correspondence.[13] The only reference I have found her make to Jameson is in Dilke's critical review of a three-volume book by François-Anatole Gruyer on the iconography of the Virgin Mary. Compared to Gruyer's previous work, Dilke (1870a) says, 'This is a more important and ambitious work, that may in some sense rank... (since its character is sentimental and not scientific) beside Mrs Jameson's "History of Our Lord"' (636). Though brief, the comment is telling. Dilke knew Jameson's *Sacred Art* book series—it would have been a rather glaring gap in knowledge if she had not. Dilke respected Jameson's importance and ambition, *but* she found Jameson's approach sentimental and not scientific.

Given that Dilke inevitably knew Jameson's later work, we may justifiably read Dilke's silence about Jameson as reflecting her rejection of Jameson's theory of art. Dilke probably avoided stating this explicitly because she respected Jameson and, knowing Jameson's authority in many quarters, judged it wisest not to challenge her directly. We can see that her rejection of Jameson had the following strands.

Explanation versus *interpretation*. Dilke and Jameson shared a commitment to meticulous research. But for Jameson facts should always facilitate sympathetic interpretation, whereas for Dilke facts enabled us to explain the artworks that our sympathies could *not* reach. For such works science, not sympathy or 'sentiment', was needed.

The Renaissance. Dilke and Jameson agreed that it was a great period for art, but for Jameson it excelled by combining art and religion, for Dilke by separating them.

Art and religion. For Dilke, art's separation from religion was historically inevitable, positive, and progressive. The religious art of the past could not remain spiritually alive for people today. Jameson instead interpreted that art poetically, and she believed that a poetic interpretation was possible because our spirit today remained connected to that of the Christian past. The wider circle of modern spirit encompassed the narrower spirit of earlier times. Dilke considered this mistaken. The past artworks that survived and appealed, like the *Niobe* and the *Sistine Madonna*, lived on due to their universal human content and not their religiosity, whereas the truly religious artworks of the past were dead to us.

[13] For instance, she never referred to Cobbe, although Charles Dilke knew and admired Cobbe's work and corresponded with her in 1874 (see Mitchell 2004: 226–7), so that Emilia would have known of Cobbe.

Anyone who knows Jameson's (1846) essay 'The House of Titian' may wonder here about her claim:

> Those who would resuscitate the forms of art of the past ages, might as well think to make Attic Greek once more the language of our herb-women...and as it has been with the classical languages, so it is with the arts of the middle ages; they live and are immortal—but for all present purposes they are *dead*. (29–30)

Jameson added the cryptic observation: 'Piety in art—poetry in art—Puseyism in art—let us be careful how we confound them.' Doesn't this mean that Jameson agrees with Dilke?

I think not, because I understand Jameson's claims as follows. Protestants could not go back to Catholic belief and should not try to; the belief is dead (contrary to Puseyism, i.e., the Catholic revival). But Protestants could still relate to the *poetry* (meaning) of Catholic art and do so with *piety*, i.e., sympathy with the common core of Christianity that remained alive and immortal. Thus, Jameson's claims tied in with her belief in the viability of a poetic interpretation of earlier religious art. Dilke, in contrast, denied that this was viable.

French versus *Italian Renaissance*. From the 1870s onwards Dilke increasingly focused on French art, especially that of the Renaissance. Jameson had focused on the Italian Renaissance. By turning to France, Dilke claimed a field free from Jameson's shadow and one that had suitably different connotations. Jameson had affiliated herself with the heartland of the Catholic church, whereas Dilke aligned herself with the land of the Enlightenment and French Revolution.

Different historicisms. Both Dilke and Jameson were historicists, but Dilke was a materialist historicist whereas Jameson was an idealist. For Jameson, art expressed the ideas of an epoch of civilization. For Dilke, art was the product of material developments, political institutions and policies, and social changes.

In sum, Dilke's approach to art history, unlike Jameson's, centred on France, eschewed moral judgements on art, and was causal-explanatory, materialist, and secular.[14]

Once she had fully worked out this approach, Dilke's transition from philosophy to art history was complete. She made that transition on philosophical grounds, so that ironically her philosophical standpoint led her to abandon philosophy in favour of art history. Her journey away from philosophy towards empirical science is interesting both in respect of her reasoning for it, and as part of a wider later nineteenth-century intellectual movement away from idealism towards materialism and empiricism. In Germany, there was a widespread migration of later-century philosophers away from idealism towards scientific

[14] As Kali Israel has pointed out, this secular orientation is reflected in Dilke's attention to 'minor' arts: furniture, coins, tapestries, miniatures, porcelain, etc. (personal communication).

naturalism and materialism, which was paralleled within Britain in the growing popularity of evolutionary accounts of all kinds of phenomena.[15] The migration took place, most famously, in the thought of Karl Marx, when he claimed to abandon philosophy in favour of a materialist, empiricist, and causal-explanatory approach to history. Elizabeth Mansfield (2000) has therefore stated that Dilke was influenced by Marx: 'Dilke's familiarity with Marx's writings is certain' (139). I am not so sure. As Mansfield admits, 'None of her papers or correspondence include direct references to his work', and his most relevant work, *The German Ideology*, where he and Engels announced that they were renouncing philosophy for historical materialism, was not published until 1932. Moreover, Dilke had her own reasons for side-stepping from philosophy to art history. We need not see her development as having been powered by a male influence. Rather, Dilke was an independent contributor to the broader later-nineteenth-century theoretical migration towards scientific materialism.

Dilke may have left the philosophy of art behind, but we need not follow her. I hope I have shown that her account of art is still of interest in its own right. Like the other women discussed in this book, Dilke deserves a place in our narrative about the history of philosophical thinking on art.

Women on Philosophy of Art: Britain 1770–1900. Alison Stone, Oxford University Press. © Alison Stone 2024.
DOI: 10.1093/9780198918004.003.0008

[15] In later-nineteenth-century Britain, Kantian and Hegelian idealism also gained in popularity, in the British idealism of Thomas Hill Green and others. But this was against a background where the evolutionary naturalism of figures like Thomas Henry Huxley and Herbert Spencer was becoming ever more mainstream and dominant.

9
Vernon Lee, Art-Philosophy, and True Aestheticism

9.1 Introduction

Vernon Lee authored fifty books, and many more journal articles, over a long career that lasted from the 1870s right into the 1930s.[1] Her vast, experimental body of work ranged from fiction to non-fiction, from abstract theory to more personal life and travel writing, from art criticism to cultural studies, from the playful and exploratory to the earnest and apocalyptic.[2] She wrote on many topics besides art: ethics, animal welfare, social and political philosophy, intelligence, war and international affairs, religion and secularism, amongst others. But art was her central interest and the subject of at least fourteen of her non-fiction books.

Lee's work quickly met with a wide and largely favourable reception, so that by 1891 the *Athenaeum* judged that Oscar Wilde had just become the third most significant writer on art after John Ruskin and Vernon Lee:

> In speaking of writers about art Mr. Ruskin must, of course, be left in the place which he incontestably occupies by himself. But speaking of lesser people, after 'Vernon Lee' hardly anyone has a better claim than Mr. Wilde to be named as a contributor of something fresh... (Anonymous 1891: 731)

Thus the reviewer ranked Lee beneath Ruskin, but above everyone else including Wilde—and, presumably, Walter Pater.

Twentieth-century philosophers, in contrast, have almost wholly ignored Lee's work. Her name is barely even known to contemporary aestheticians.[3] Her literary writings, particularly her supernatural fiction, *have* received analysis and interpretation. But fiction and theory were not watertight categories for Lee, whose writing often interwove the literary and the philosophical. She claimed to be doing 'a sort of art-philosophy' (1881: 9)—at once a philosophy of art and an artistic kind of philosophy. Lee's somewhat disingenuous label conveys that she

[1] Simply cataloguing Lee's work is a challenge, but see Mannocchi (1983) and https://thesibylblog.com/bibliography.
[2] The last is a feature of her anti-war writings. Lee bravely and publicly opposed the First World War (see Gagel 2019 and Kandola 2010: 69–79).
[3] Exceptions are Blackburn-Daniels (2023), Garza (2009), Guyer (2014: 426–37), and Small (1977).

wrote in the same spirit as the other women we've looked at. She produced philosophical criticism of the arts, informed by extensive engagement with specific art-works, and blending into her own artistic production.

A glance at Lee's journal publications just from the mid-1870s to mid-1880s clarifies this: see Table 9.1.

Table 9.1 Lee's British periodical contributions, 1775–85 (includes essays, review-essays, dialogues, travel writing, semi-fictions)

Year	Titles and journals
1877	'Contemporary Italian Poets', *Quarterly Review*
	'Musical Expression and the Composers of the Eighteenth Century', *New Quarterly*
	'Tuscan Peasant Plays', *Fraser's Magazine*
1878	'Orpheus and Eurydice', *Cornhill*
	'Taine's Philosophy of Art', *British Quarterly Review*
	'The Academy of the Arcadi' parts 1–3, 'Studies of Italian Musical Life in the Eighteenth Century', parts 1–3, 'Hoffmann's Kreisler: The First of Musical Romanticists', *Fraser's Magazine*
1879	'Metastasio and the Opera of the Eighteenth Century', parts 1–3, *Fraser's Magazine*
	'The Anomaly of the Renaissance', 'Artistic Dualism of the Renaissance', *Contemporary Review*
1880	'Comparative Aesthetics', *Contemporary Review*
	'Faustus and Helena', *Cornhill*
	'The Art of Singing, Past and Present', *British Quarterly Review*
1881	'A Dialogue on Poetic Morality', *Contemporary Review*
	'Cherubino: A Psychological Art Fantasy', *Cornhill*
	'Culture-Ghost', 'In Umbria: A Study of Artistic Personality', *Fraser's Magazine*
1882	'Apollo the Fiddler', *Fraser's Magazine*
	'Art Notes from Italy', 'A History of the Papacy during the Period of the Reformation', *Athenaeum*
	'Botticelli at the Villa Lemmi', *Cornhill*
	'Mozart: A Study of Artistic Nationality', *Blackwood's Magazine*
	'The Influence of the Italian Renaissance on the Elizabethan Stage', *British Quarterly Review*
	'Vivisection', 'Impersonality and Evolution in Music', *Contemporary Review*
1883	'Metastasio's Letters', 'The Little Schoolmaster Mark', 'Italian Fiction', *Academy*
	'Niccolo Machiavelli e i suoi tempi', *Athenaeum*
	'Portrait Art of the Renaissance', *Cornhill*
	'The Responsibilities of Unbelief', *Contemporary Review*
	'The Transformations of Chivalric Poetry', *National Review*
	'Youth of Raphael', *Art-Journal*

1884	'Lombard Colour Studies', *Art-Journal*
	'North Tuscan Notes', *Magazine of Art*
	'Shakespeare's Predecessors in the English Drama', 'Human Intercourse', *Academy*
	'The Outdoor Poetry of the Middle Ages and the Renaissance', *Contemporary Review*
1885	'A Dialogue on Novels', *Contemporary Review*
	'The Value of the Ideal', *National Review*
	'The Wish to Believe', *Academy*

Note: This list is not necessarily exhaustive; it is informed by Mannocchi (1983), supplemented by Demoor (2000). Linda Hughes (2022b) helpfully explains which books these periodical essays subsequently went into (Appendix).

Aside from revealing Lee's tremendous productivity, Table 9.1 illuminates the character of her art-philosophy. She was not building up a comprehensive aesthetic system. Instead, she wrote essays on the arts in the full sense of 'essays': attempts, forays, explorations, provocations. As she explained herself (1881): 'While dreading beyond all things to cramp my still growing, and therefore altering, ideas in the limits of a system, I...have evolved for myself...an art-philosophy entirely unabstract, unsystematic, essentially personal' (9). She would broach a theme in one essay, then explore it again under a slight variation in another essay, and so on repeatedly, until successive variations added up to substantive changes of position over time. British periodical culture was ideal for such writing and made it possible.[4] Lee's titles show her moving freely between criticism of specific artists (Mozart, Shakespeare, Hoffmann) and general philosophical reflection (on comparative aesthetics, art and morality, the novel, the ideal). She moved with equal fluidity between reflection on the arts and writing that was artistic, partially so in the case of her many dialogues, or more completely in fictional writings like 'Culture-Ghost'. Reflecting the specificities of Victorian periodical culture, Lee signed almost all these essays, like her subsequent work, with her pseudonym, with a very few exceptions that were either anonymous or signed 'V. Paget'.

Table 9.1 also makes apparent the challenge of making sense of Lee's vast oeuvre. Its scale means that no single chapter can possibly offer a synoptic view. Instead, I will model a possible way of approaching Lee philosophically, by concentrating on her thought about aestheticism. This is one of the areas of her thought that has already received most attention. However, interpreters have mainly looked either at her engagement with aestheticism as an artistic and

[4] On how deeply Lee belonged to Victorian periodical culture, despite living in Italy, see Hughes (2022b).

cultural movement, or at her fictional treatments of aestheticism, such as her critique of decadence in the 1884 novel *Miss Brown* (Lee 1884). There has been less scrutiny of her *philosophical* engagement with the idea of art for art's sake.[5]

Some might interject here that aestheticism should not be reduced to art's for art's sake. Diana Maltz (2006) argues that aestheticism always contained competing 'missionary' and 'decadent' strands, with the missionary strand being more socially engaged (20–25). Ruth Livesey (2007), though, argues that 'art for art's sake' remained the core of aestheticism, even though it was contested and taken in more socialist directions (14). Livesey's view helps us to keep a clear handle on what counts as aestheticism. One can transform and qualify and socialize aestheticism, but the further one goes in these directions, the more questions will arise about whether one remains an aestheticist at all.

Such questions arise with respect to Lee, as we will see when we trace her engagement with aestheticism over fifteen years from 1881 to 1896. This carries us from her strongest statement of 'art for beauty's sake' (Lee 1881: 250), through successive qualifications over the 1880s, up to her advocacy of 'art for life's sake' in 'Art and Life' of 1896. She continued to explore 'art for life's sake' in, amongst others, 'Art and Usefulness' (Lee 1901a, 1901b) and *Laurus Nobilis: Chapters on Art and Life* (1909), but I stop the clock in 1896. This makes the discussion manageable and makes intellectual sense because 1897 signalled a transition in Lee's work, when she published the major essay 'Beauty and Ugliness' with Clementina Anstruther-Thomson. That essay distilled a new direction towards which Lee's thought had been building ever since she met Anstruther-Thomson in 1887 and they began studying our physiological and psychological responses to artworks. In 'Beauty and Ugliness', they drew on William James' view that bodily changes, in which we react to stimuli by (for instance) crying, trembling, or lashing out at someone, are felt as emotions of sadness, fear, and anger. '*The bodily changes follow directly the* PERCEPTION *of the exciting fact, and…our feeling of the same changes as they occur* IS *the emotion*', James contended (1884: 189–190). Applied to our aesthetic enjoyment of 'certain arrangements of sounds, of lines, of colours', James' thesis entailed that the basis of that enjoyment was particular bodily sensations, but he did not elaborate in detail (189). Lee and Anstruther-Thomson (1897a, 1897b) did: they traced aesthetic pleasure back to certain bodily reactions to art-works, such as alterations in breathing, balance, and levels of muscular

[5] To date, most Lee scholarship is on (i) empathy—see, inter alia, Burdett (2011), Lanzoni (2009), Mahoney (2016), Martin (2013), and Morgan (2017: ch. 5)—or (ii) aestheticism—see Agnew (1999), Burdett (2016), Colby (1970), Evangelista (2009: ch. 2), Horrocks (2013), Kandola (2010: ch. 1), Mahoney (2016), Maxwell and Pulham (2006), Schaffer (2000), Schaffer and Psomiades (1999: chs. 11 and 13), Townley (2011), and Zorn (2003: esp. ch. 5)—or, heavily overlapping with the latter, (iii) Lee's relations with Pater—Burdett (2016), Evangelista (2009: ch. 2), Maxwell and Pulham (2006), Valentine (2023), Zorn (2003: ch. 2). Other areas that would repay examination are Lee on beauty (e.g., Lee 1913), on music (e.g., Lee 1932), and on literature (e.g., Lee 1923, 1926).

tension. As Lee pursued this line of thought, developing the related concepts of empathy and psychological aesthetics, she moved into a twentieth-century register. Indeed, some of her post-1900 works like *The Beautiful* (1913) adopted a precision and step-by-step argumentation which placed Lee in the neighbourhood of analytic philosophy. As Kristin Mahoney (2016) observes, Lee was 'a transitional figure between the moral criticism of the Victorians and the formalist criticism of early twentieth-century practitioners' (551). Her pre-1896 period shows her continuity with the nineteenth-century debates about art and morality that have occupied this book.

To bring this continuity into view, I will begin with Lee's separation of art from religion in the 1880 essay 'Faustus and Helena: Notes on the Supernatural in Art'. Here she argued that art could not possibly be both beautiful *and* religious, in implicit opposition to Jameson, amongst others (Section 9.2). Next, in 'Ruskinism' of 1881, Lee separated beauty from morality, explicitly arguing against Ruskin that beauty and goodness were essentially different (Section 9.3). However, doubling back on herself, she began to reconnect beauty and goodness on the grounds that pleasure is good and the goal of moral action is to increase overall pleasure, while beautiful art gives pleasure and therefore has moral value. This was the first of a series of qualifications to her aestheticism; more qualifications followed in the 'Dialogue on Poetic Morality' (1881), 'On Novels' (1885), and 'Orpheus in Rome: Irrelevant Talks on the Uses of the Beautiful' (1889) (Section 9.4). The combined force of these qualifications led Lee (1896b) to reconceive her position as 'true aestheticism' (Section 9.5). This was not art for art's sake, nor art for beauty's sake, but art for life's sake—art for the sake of bettering and enriching everyone's lives (815). How far this remains aestheticism at all, and what kind of aestheticism it may be, I will consider at the end.

9.2 Art Beauty versus Religion and the Supernatural

'Faustus and Helena' first appeared in the journal *Cornhill* in 1880 and was then included in Lee's 1881 collection *Belcaro: Being Essays on Sundry Aesthetical Questions*. Its central thesis is that figurative art and the supernatural are at odds. This is because we find something supernatural just when we only vaguely, fleetingly, imagine it. Something given to our senses—a churchyard, a shadow, the sound of a footstep—arouses our imagination, which reaches beyond the given to grasp at its possible meanings (Lee 1881: 76–77). If we pin down these 'vague, fluctuating impressions', the sense of the supernatural is lost (80). For us to retain a sense of the supernatural, what we imagine must remain indefinite. The supernatural, therefore, always hovers on the edge of our awareness, but as soon as it is fully, directly presented, it becomes natural, an ordinary phenomenon subject

to the laws of nature. Yet what art *does* is present things to the senses in a harmonious, pleasing, complete form. So 'the hostility between the supernatural and the artistic is well-nigh as great as the hostility between the supernatural and the logical' (74).

Lee's thesis bears on religion, because she argues that religion and the supernatural are intrinsically connected, although in two different senses (75). In the first sense, religion used to serve as a primitive form of science, explaining natural events by appeal to supernatural agencies such as divine powers (75–76). Christian theology continued this enterprise, building up a systematic explanation of the world with God at its centre (78). Yet these were only defective modes of explanation—naturalism that had not yet found its way—rather than the supernatural proper.[6] Second, and quite different, is 'the genuine supernatural' (78). Here people have a vital sense of mysterious and ineffable powers that they cannot quite fathom, hovering on the fringes of everyday life (78–80). This sense of the supernatural was part of Christianity too. It was present, for instance, in people's beliefs in the powers of saintly relics, in the abilities of angels or the Madonna to intercede into daily affairs, and in the ever-threatening presence of the devil. Lee thus distinguishes popular Christianity, with its heartfelt belief in supernatural forces, from theological doctrines. The former was what Christian-era artists sought to depict, trying to make perceptible this mysterious and enticing aspect of the world. 'Gods and demons, saints and spectres, have afforded at least one-half of the subjects for art' (74).

So far, Lee may seem surprisingly close to her *bête noire* Jameson—as we know, Lee adopted her pseudonym to be *un*like 'miserable Mrs Jameson' (see Chapter 1, Section 1.6). Jameson likewise held that Christian art dealt with these figures of popular legend. For Lee, however, artists could not render the liminal supernatural powers visible. They tried to portray mythic and religious figures in their mysterious and other-worldly characters. But, just by *presenting* these figures, artists inevitably reduced them to being merely human (82–83). Christian art was 'reverent in intention, but…desecrating in practice; even the Giottesques turned…the Virgin, and the Saints, into mere Florentine men and women' (85). This seems to be a critical allusion to Jameson, for whom, we remember, Raphael's *Sistine Madonna* was no mere work of imagination, it was *revelation*. For Jameson, Raphael had elevated an ordinary woman into a sacred figure. For Lee, the reverse is true: he reduced the Madonna to a merely human woman just by presenting her. The only time when art expresses a genuine sense of the religious supernatural is when it contains undeveloped elements that are not fully

[6] Seeing religion and myth as primitive forms of science was popular in Lee's time, a view expressed, for example, in Edward Burnett Tylor's 1871 work *Primitive Culture* and J. G. Frazer's 1890 work *The Golden Bough*.

presented. This is true, Lee suggests, with the confused shapes in the reeds in Raphael's *Il Stregozzo* (*The Witches' Procession*) (90). Thus whereas Jameson thought that Christian art had perfectly balanced the aesthetic and the religious, for Lee these aspects have been in constant tension, each tending to repel the other.

For Lee, just as religious significance and artistic presentation oppose one another, so do religious meaning and beauty. Lee speaks of our 'clear and calm enjoyment of the beautiful' (96). Art is beautiful when it presents our senses with something that pleases us by its clarity, calmness, and harmonious form (a very Raphaelite view of beauty). To be beautiful, art *must* drive out the vagueness, suggestiveness, and confusion of religious meaning. Or, if art does have a truly religious meaning, it must be aesthetically deficient. Lee refers, for example, to a 'very ugly, stupid, and unattractive', clumsily drawn sixteenth-century landscape over which a demon hovers, with 'frightful suggestiveness'. 'This nameless smearer succeeded where Raphael has failed...because he is not an artist, and because Raphael is' (91–92). So, as art matures and becomes more beautiful, in the Renaissance, its religious content necessarily drops away and becomes a mere 'pretext' (87). Art's inherent purpose of being beautiful requires it to separate from religion, as it has over the course of history.

Lee's views overlap considerably with those of Emilia Dilke. For both women, art's intrinsic purpose is to be beautiful, art must break from religion to fulfil this purpose, and this break happened in the Renaissance. But Lee's account of why art must break from religion is even stronger than Dilke's. For Lee, to be beautiful is to present a harmonious form to the senses, which precludes any sense of the liminal, wavering, not-fully-present supernatural. The supernatural pulls artists to try to present it, but they cannot. They can have either presentation or the supernatural, art or religion, beauty or the indefinite, but not both. 'The more complete the artistic work, the less remains of the ghost' (94).

How persuasive is Lee's argument? It seems to overreach itself, entailing that good art cannot possibly be horrifying or frightening and that if art *is* frightening then it cannot be good art. This jars with the fact that Lee wrote some compelling supernatural fiction, presumably without intending to make bad art. Indeed, she was partly interested in the supernatural because she wrote ghost stories and wanted to think about the genre and the principles underpinning her practice.

We might think the solution must be that 'Faustus and Helena' concerns 'art' only in the sense of visual or plastic art, not literature. In that case, ghost stories could be genuinely frightening and still be good art, although paintings and sculptures could not. But this solution cannot be right, because Lee opens 'Faustus and Helena' with an example from Goethe's *Faust*, in which Faust brings back the form of Helen of Troy, the personification of beauty. This appearance of

the ghostly Helen is not frightening, Lee argues, precisely because *Faust* is good art and Helen is beautiful (72). This shows that her thesis covers *all* art, including literature.

Perhaps a more constructive reading is that given the tension between beauty (presentation) and mystery (imagination), the challenge for the would-be supernatural artist is to provide enough of both to satisfy their competing demands.[7] The artist should be sparing enough with presentation for their work to be frightening, yet supply enough presentation to achieve beauty. For example, M. R. James' terrifying 1904 story 'Oh, Whistle, and I'll Come to You, My Lad' climaxes with the momentary revelation of the ghost—its 'horrible…intensely horrible face of *crumpled linen*'—but even this description is brief and thin enough to leave the imagination running over plenty of horrifying possibilities (James 1986: 105). Since the story reaches its high point with this revelation, there is enough presentation for the story to count as good art.

Even read this way Lee's argument still overreaches. The problem is that she takes it that art must be beautiful to be good art, but beauty entails presentation. If Lee instead were to recognize that beauty is only one of the values artworks can have, then she could acknowledge that some art is good qua beautiful and other art is good in other respects—by being frightening, terrifying, horrifying, and so on. Some artworks can be good by presenting (and being beautiful), others by suggesting. But if artworks can have other values besides beauty, then some artworks could have value by sincerely expressing religious faith, even if this stops them being beautiful. That is, if art can be good in multiple ways, then this would undermine the sharp demarcation of art from religion that Lee wants (and which was meant to set her writing apart from that of 'Mrs Jameson', the standard-bearer for sacred and legendary art).

However, something that remains interesting about Lee's division of art from religion is that she makes it on grounds that her religious contemporaries would have had to accept. Most of them, like Lee, equated artistic and aesthetic value with beauty, while they also equated beauty with religious value. We saw this with Cobbe; the same applies to Ruskin ([1846] 1851), for whom 'beauty…is in all cases something Divine' (130); and the same applies for the later Jameson, for whom art is beautiful just when it authentically expresses spiritual content. Lee throws down a challenge. Beauty (presentation) opposes religious meaning (beyond presentation). So, if art is good art just when it is beautiful, then good art *cannot* be religious. Lee's contemporaries thought that art could unite beauty and religion, when really—according to Lee—they could have beauty *or* religion, but not both.

[7] On how Lee attempted this in her supernatural tales, see inter alia Maxwell (2009: 142–9).

9.3 Lee's Anti-Ruskinism

Lee continued to assault the assumptions of her contemporaries in 'Ruskinism', another essay in *Belcaro*. Lee wrote it in November 1880, drawing upon an earlier plan (VL to Mary Robinson, 20 November 1880, in Lee 2017: 275). Her critical target was both Ruskin and the broader view, Ruskinism, for which he stood, on which art must be morally good to be beautiful. In opposition to this view, Lee sought to drive a wedge between beauty and morality.

This essay is the place where Lee most fully embraces the idea of art for beauty's sake. This reflects Pater's influence, for, as we saw in Chapter 8, Pater was a key exponent of art for art's sake. Moreover, Pater pitched his aesthetic against Ruskin, so that Pater is a background presence behind Lee's anti-Ruskinism.[8] I don't want to discuss Lee's relations with Pater at any great length, for they have been extensively analysed elsewhere (see footnote 5), to a degree that sometimes obscures Lee's independent arguments and ideas. Nevertheless, Pater influenced Lee so heavily that it would be misleading not to bring him in at all.[9]

Lee and Pater met in 1881 and remained in dialogue until his death in 1894. But she knew his work well before 1881, and at first was hugely enthusiastic about it, calling Pater 'the subtlest thinker and most artistic writer in present-day England' (Lee [1885] 2023: 296). She found Pater's work enabling and empowering. For one, Pater's approach was deliberately impressionistic and subjective, and Lee drew from this, for example, when beginning her 1885 (Italian-language) review of Pater's novel *Marius the Epicurean*: 'It was one of the first days of spring when I read the book's first chapters. On the farms, fennel, mint, and the yellow daisies we call "Maria's gold" were starting to emerge...' (296).

Over time, Lee became critical of Pater's perceived hedonism and amoralism, but certain of his ideas never ceased to influence her. In particular, in *Studies in the History of the Renaissance* Pater (1873) valorized classical Greek culture as 'the ideal' (e.g., 146, 154, 170), far superior to the Gothic art that Ruskin favoured. For Pater, the classical ideal was one of 'earthly passion, in its intimacy, its freedom, its variety—the liberty of the heart' (4). The antithesis of high Victorian moral sternness and repression, he links this ideal with 'the free play of human intelligence' (4),

[8] As Timothy Costelloe (2013) remarks, 'Pater read Ruskin's writings as a young man and, in almost every way possible, appears to contradict and reject everything he found there' (242).

[9] Maxwell and Pulham (2006) describe Pater as 'the dominant influence on Lee' (6) while Stefano Evangelista (2009) says that 'Vernon Lee's debut into aestheticism takes place in the shadow of Pater's discipleship' (55). To be sure, as I argued in Chapter 8, Emilia Dilke had theorized aestheticism more rigorously than Pater and had done so prior to *Studies in the History of the Renaissance*. But Lee seems not to have known of Dilke's work. In 1881 Lee told her mother that she had just met Mark Pattison, 'a sort of eminent Oxford humanist' (VL to Matilda Paget, 7–10 July 1881, in Lee 2017: 308). If that was all she knew of Pattison, Dilke's husband at the time, then Lee very probably did not know of Dilke, or E. F. S. Pattison as she then was. Alternatively, Lee may have known of Dilke but disliked Dilke's severe critique of Pater. Either way, the result was that Pater's version of aestheticism, not Dilke's, was important for Lee.

'health or animation, with its gratitude, its effusion, and eloquence' (64). On the one hand, Pater operated with a classicist conception of beauty: 'There is...a standard of taste...This standard takes its rise in Greece at a definite historical period. A tradition of all succeeding generations, it originates in a spontaneous growth out of the influences of Greek society' (170). On the other hand, Pater was reluctant to define beauty in the abstract (vii–viii), preferring to say only that it is the power of objects to produce pleasurable sensations in us (ix). They are sensations of a special kind, but he did not wish to define this kind further, seeing the effort to define beauty as an instance of the serious spirit weighing down our sensitivities with constricting stipulations. Instead, for Pater, the critic should have the sensitive temperament to receive impressions of beauty and be 'deeply moved by the presence of beautiful objects' (x). All these ideas would have a long afterlife in Lee's thought. Indeed, the contrast between the Gothic (supernatural, religious, Ruskinian) and the classical (beauty, secular, Paterian) already tacitly organized 'Faustus and Helena'.

Despite her debts to Pater, Lee rather surprisingly begins 'Ruskinism' by granting *Ruskin* unparalleled importance among art theorists. This is on the grounds that he considers not merely the value of art or of different kinds of art, but art's value compared to the value of *non*-artistic aspects of life, especially morality. He investigates 'the legitimacy not of one kind of artistic enjoyment more than another, but of the enjoyment of art at all' (Lee 1881: 199). How can anyone rightly spend time on art when the world is full of poverty and misery? For instance, Ruskin (1856b) tells of one occasion when he was enjoying a country walk only to be jolted into realizing how much poverty and misery underpinned the picturesque scenes. 'I could not help feeling how many suffering persons must pay for my picturesque subject and happy walk', he comments (11). Lee does not mention this particular anecdote, but it epitomizes the side of Ruskin she has in mind.

Ruskin's moral worries lead him to see art as a dangerous distraction from duty. Yet he cannot bring himself to abandon art, and remains torn between 'the creation of beauty and the destruction of evil' (Lee 1881: 201). Where he goes wrong is in determining to resolve the conflict and force beauty and goodness into an artificial unity, under which:

> the basis of art is moral...art cannot be merely pleasant or unpleasant, but must be lawful or unlawful...every legitimate artistic enjoyment is due to the perception of moral propriety...every artistic excellence is a moral virtue, every artistic fault is a moral vice...the whole system of the beautiful is a system of moral emotions, moral selections, and moral appreciation...(205)

On the resulting view—Ruskinism—only artworks that embody moral virtues are artistically excellent, and art may only legitimately be enjoyed when it is morally good.

This systematic equation of beauty with virtue rests on a false premise, according to Lee, for beauty and goodness are fundamentally different and can always conflict. 'The world of the physically beautiful is isolated from the world of the morally excellent' (Lee 1881: 207). The two may coincide at times, but this is only ever accidental, not necessary. As Lee puts it in one of her best-known statements: 'Beauty, in itself, is neither morally good nor morally bad; it is aesthetically good, even as virtue is neither aesthetically good nor aesthetically bad, but morally good' (1881: 210).

She explains the difference as follows: right and wrong differ from beauty and ugliness, and we perceive these two sets of qualities with different parts of our natures (208). Our moral instincts are products of evolution, following Darwin. These instincts lead us to judge as right or wrong things that have no direct physical or sensory existence: actions, feelings, and characters. Conversely, we find certain artworks beautiful in virtue of their physical qualities, such as colours and sounds, which have pleasing effects on our senses, again because of how we have evolved. Pater's influence is at work here: beauty is a matter of certain sensory impressions and the pleasures they arouse. Admittedly, there are non-physical elements in our ideas of beauty—Lee refers to the 'idea of inherited habits and love of proportion' (209). But even so, proportion depends on the object's lower-level material and perceptible qualities, and habits are formed on a bodily basis. So 'beauty is a physical quality, as goodness is a moral quality' (210).

Aren't judgements about someone's actions or character likewise based on the sense-perception of the physical actions that the person has performed? Lee would reply, I think, that the basic entity to which a moral judgement refers is the spiritual quality of certain physical actions. In contrast, judgements of beauty basically refer to the sensory properties of certain objects and their effects on our bodies. In the former case, the physical is only a vehicle for the spiritual. In the latter case, the spiritual (e.g., proportion) is secondary to what is physical and perceptible with the senses.

For Lee, these sensory qualities make certain objects beautiful because these qualities please us. This suggests that beauty is a relational property of certain objects, a property they have in virtue of their relation to us. But elsewhere, as in the *Belcaro* essay 'The Child in the Vatican', Lee suggests that beauty is an objective property of certain objects, specifically artworks. We can learn:

> To see clearly a form isolated from any extraneous interest of expressiveness, resemblance or utility...That highest intrinsic quality of form is beauty, and the highest merit of the artist...is to make form which is beautiful. (41)

On this view, certain forms or shapes are beautiful independently of any 'extraneous' relations these forms may bear to us. Lee's formulations on beauty are thus ambiguous between objective and relational conceptions. On the objective view,

certain artworks please us when we appreciate the beauty that they have, independently of us; on the relational view, it is only because these artworks have qualities that tend to give us pleasure that they count as beautiful.

For Lee, beauty is primarily a property, whether relational or objective, of some *art*. Pater (1873) had spoken of the beauty of 'works of art *and* the fairer forms of nature and human life' (ix; my emphasis), and in 'Ruskinism' Lee acknowledges that Ruskin reveals 'the beauty of physical nature' (1881: 200), but it is a passing acknowledgement, disconnected from her theorizing. Without explicitly denying that nature can be beautiful, Lee is always focused on art. Considerably later, in her book *The Beautiful* (Lee 1913), she would change her mind and claim that 'the distinction between Beautiful and Ugly does not belong either solely or necessarily to what we call Art' (98). In that work Lee would argue that beauty is a property of certain shapes that give us contemplative, i.e., disinterested, pleasure. These shapes can be found anywhere, not only in art. But that would be thirty years after *Belcaro*, which remained art-oriented.

For Lee (1881) in 'Ruskinism', beauty differs from morality:

That beauty is in itself physical, is a point which few have denied: that beautiful curves and harmonies are moral qualities very few have asserted. But few have as yet been willing to admit that beauty is a quality independent of goodness, independent sometimes to the extent of hostility: that it is as independent of moral excellence as is logical correctness. Yet thus it is…(210)

Because beauty and goodness are mutually independent, they can diverge, and sometimes we may have to give moral values precedence. But we should not deceive ourselves that the two sets of values are united, as Ruskin does. Instead, we should admit that the disunity is real. This shows that Lee's anti-Ruskinism rests ultimately on value pluralism. There is more than one kind of good, different kinds of good can conflict, and they are not reducible to any higher-level unity. Consequently conflict is inescapable, and the world can never be made entirely good (206).

Having identified the false premise on which Ruskinism rests, Lee now argues that Ruskin's entire aesthetic system is a tissue of lies. Under the guise of doing justice to art *and* morality, he privileges morality everywhere. For instance, he claims that every period of artistic decline must reflect moral decay (218). He takes what is ugly but morally edifying, like pictures of emaciated hermits and saints, to be artistically better than what is beautiful but nonmoral, such as classical sculptures of athletic bodies (222). A system intended to vindicate art has ended up subordinating and destroying it. This is inevitable, for Lee, because beauty and goodness differ, and forcing beauty into alignment

with goodness must lead to the loss of the large part of beauty that is not so aligned.

Is Lee fair to Ruskin? I think she overstates her criticisms, but she does so deliberately, using Ruskin as a shorthand for aesthetic moralism generally. Moreover, if we compare Lee with Dilke, who also criticized Ruskin sharply and treated him as a pure and simple moralist, Lee does more to acknowledge both Ruskin's importance and his complexities and changes of mind. Lee recognizes that he is drawn to beauty as well as the good and that he does try to reconcile the two, misguided as this is.

But to muddy the waters further, Lee does not completely decouple art and morality herself either. Her argument veers in a different direction at the end of her essay. She says that Ruskin cannot allow any innocent pleasures of artistic creation and enjoyment. For him, innocence is not enough: art must be positively *for* morality, otherwise art is against it. Ruskin loses sight of the fact that just in affording innocent (harmless) pleasure, beauty *is* moral. There is a morality of beauty independent of the morality of spirit.

> All that which is innocent is moral...the morality of art is an independent quality equivalent to, but separate from, the morality of action...beauty is the morality of the physical, as morality is the morality of the spiritual. (227)

Immediately afterwards Lee reverts to her main thesis that beauty and morality are categorically different. 'Only morality is *really* moral, and only virtue *really* virtuous...physical beauty intrinsically possesses but an aesthetic value quite separate from all moral value' (228; my emphasis). But having started down the line of thought that beauty has its own morality, she cannot shake it off.

Lee states that having differentiated morality and aesthetics, we now see that beauty and its enjoyment have a moral value of their own (229). This value comes about because beauty gives people pleasure or, more precisely, certain artworks have perceptible qualities that affect our senses in ways that give us pleasure. But the goal of moral action, for Lee, is to increase the overall amount of pleasure or happiness in the world. So she says in her ethical essays of the 1880s; Lee is, at this point, a utilitarian, for whom the good is human welfare or the general happiness, and moral rules tell us how best to increase that happiness. As Lee's (1886) spokesman Baldwin declares, in a dialogue originally from 1883:

> The school of philosophy to which I adhere has traced all the distinctions of right and wrong to the perceptions, enforced upon man by mankind...of the difference between such courses as are conducive to the higher development and greater happiness of men. (78)

Beautiful artworks give pleasure, and the goal of moral action is to increase the overall amount of pleasure in the world, so beautiful artworks and their creation have moral value:

> Physical beauty and its egotistic enjoyment have yet a moral value of their own: the value of being, in the lives of others, absolute pleasure, the giving of which is positive good.... For, though art has no moral meaning, it has a moral value; art is happiness, and to bestow happiness is to create good. (Lee 1881: 229)

By making beautiful art, artists increase the overall happiness.[10] Making art is therefore not only morally permissible, it is morally desirable and obligatory, at least for those gifted with the power of creating beautiful art. Far from being a frivolous distraction from social duties, art-making *is* a social duty.[11]

Realizing that she has undercut her own sharp distinction between the aesthetic and the moral, Lee (1881) finally tries to salvage it by claiming that moral action aims merely to *reduce* evils (or to reduce unhappiness) whereas the 'morality of beauty' *creates* positive goods (pleasure) (228–229). She stresses this point in a long letter too (VL to Mary Robinson, 20 November 1880, in Lee 2017: 273). But this distinction does not help. It contradicts Lee's claim, quoted above, that actions are morally right when they bring about greater happiness (not only when they diminish unhappiness). And anyway it is hard to see how art can increase our happiness without reducing unhappiness, by distracting us from real-life troubles or soothing feelings of distress.

In short, by the end of 'Ruskinism', Lee's views have undergone a reversal. Initially, she insists that beauty and goodness are categorically distinct and so can and often do conflict. By the end, she maintains instead that in creating beautiful art one does something morally right, because beautiful art gives pleasure, and this is what moral action aims to increase.

We may wonder whether Lee's final position remains a form of aestheticism. In some respects it is. For her, art is morally valuable just when it is beautiful, i.e., gives sensory pleasure. The artist should aim strictly for beauty if they are to increase happiness and therefore make a moral contribution. In principle, this might seem compatible with the artist attempting to impart moral content, as long as they also produce beauty. However, as we've seen, Lee thinks that beauty is a physical quality whereas moral content is a spiritual quality. From her perspective, pursuing spiritual qualities inevitably distracts and detracts from the pursuit of beauty. Only by refraining from any attempt to impart moral *content* can the artist achieve a morally desirable *effect*. So Lee is, at least, an aestheticist

[10] I am running together 'pleasure' and 'happiness' because Lee does the same, as we see from the above quotation: she says that art bestows pleasure *and* happiness, treating them as synonyms.

[11] Lee (1886) says that art gives us 'unutilitarian pleasure', which may confuse us (202). But she means that the pleasure that art gives us is valuable in itself, not merely as a means to some other non-aesthetic kind of pleasure. Aesthetic pleasures contribute directly to overall pleasure.

in affirming that artworks should not be vehicles of moral instruction, and that works made for moral instruction will be bad (unbeautiful) art.

In other respects, Lee seems to end up no aestheticist at all. Early on in 'Ruskinism', she declared that beauty was independent of goodness—her strongest statement of aestheticism, made in Pater's wake. Yet it turns out that beauty and goodness are *not* independent. The good is happiness, and beauty contributes to it; the enjoyment of beauty is a part of the good life, probably a necessary part. In saying this, however, Lee has drawn out what was already part of Pater's position—that beauty is connected with the values of health, playfulness, liberty, and life. His celebration of classical culture and its renewal in the Renaissance was, after all, 'expressed...in a language of life and flourishing' (Costelloe 2013: 244). Perhaps art was always for the sake of a flourishing life. That was the conclusion Lee would ultimately reach, but she did so in stages over the 1880s and 1890s, as I will now trace.

9.4 Lee's Qualified Aestheticism

Lee qualified her aestheticism further in two dialogues on poetic literature. She often used the dialogue form because, as she explained, 'everyone tells me that it makes those somewhat dry subjects more readable, and...it enables myself to take a much fairer view of my subject' by accommodating objections (VL to Thomas Escott, 27 August 1883, in Lee 2017: 450). Besides, the dialogue had a pedigree going back to Plato's *Phaedrus* and *Symposium* for discussions of art and beauty. Like Plato, Lee set her dialogues in imaginary scenarios, regularly interspersing the characters' conversations with breaks or pauses in which they responded to their surroundings or to artworks, or digested one another's claims. Thus her dialogues hybridized fiction and philosophy. These fictional stagings allowed Lee to depict her characters as being, like herself, not mere abstract theorizers but people whose aesthetic activities and experiences shaped their reflections (Maxwell 2018: 286).

At least, that was Lee's dialogues at their best. In practice, just as Plato's dialogues often deteriorated into near-monologues on the part of Socrates, Lee's early dialogues frequently descended into monologues delivered by her mouthpiece, Baldwin. This is true of the 'Dialogue on Poetic Morality', published in the *Contemporary Review* in 1881 and then included in *Belcaro*. The conversation, which takes place between Baldwin and his interlocutor Cyril, falls into two halves. The first half reprises ground from 'Ruskinism'; the second moves on to literature.[12]

[12] Lee said that this dialogue, written in March 1881, was 'the first time I write on poetry in general' (VL to Mary Robinson 21-3 March, in Lee 2017: 285)—a remark that also illustrates the ongoing tendency to use 'poetry' to mean the whole of literature.

The endearing character Cyril, modelled on Lee's partner of the time A. Mary F. Robinson, is tempted to give up writing poetry. Drawn towards the Ruskinist position, Cyril feels that writing poetry is futile and selfish in a social world full of evil.[13] He has tried to 'believe in Art for Art's sake—Goetheianism', but he feels it is the creed of 'intellectual Sybarites, shutting themselves out, with their abominable artistic religion, from all crude real life' (Lee 1881: 233–234). He accuses Baldwin of having pressed on him a self-contradictory doctrine—that he must increase the amount of good in the world, *and* that 'the sole duty of the artist is to produce good art, and that good art is art which has no aim beyond its own perfection' (239).

This is, evidently, an objection to Lee's aestheticism in 'Ruskinism'. Baldwin/Lee defend themselves by restating the argument that removing evil is different from creating positive good, and that only the artist can do the latter (241–243). Cyril protests that while the artist's work may give people pleasure, this is mere selfish gratification and there is no moral value in conferring it. Baldwin replies that there is, because the morally right thing to do is just to increase pleasure (244–245). So far we are still on the same ground as 'Ruskinism', but things take a new turn when Cyril replies that Baldwin's theory may apply to music, which works with notes and sounds, and painting, which uses forms and colours. But the theory does not apply to poetic literature, which addresses many issues of moral significance and has to deal with evil and injustice (248–249).

Baldwin agrees that literature differs from the other arts in one key respect. At least half of the writer's material is ideas, including moral ideas. A novelist cannot depict human interactions over time without having 'a correct sense of what, in such feelings and doings, is right and wrong' (250). Literature therefore cannot simply give sensory pleasure or displeasure, as painting and music can. Dissonant sounds and jagged lines harm our sensory nerves, but wrongdoing and injustice in novels offend our moral sense (251). This does not mean that the novelist or poet cannot depict any bad actions or people—they are needed for dynamic tension. But what matters is 'not only the actors and the actions, but the manner in which they are regarded by the author' (252). Bad actions and people must be shown to *be* bad (265). In addition, Baldwin claims, certain unspecified offences against decency may not be represented at all, even if they are portrayed as offensive and degrading (262–263). The writer needs a keen moral sense to steer through these treacherous waters (274).

Lee's manoeuvres recall the pains Dilke took to distance herself from decadence and put forward an aestheticism that did not offend against morality. Dilke opposed decadent art on the aesthetic grounds that it was necessarily ugly. In

[13] In real life, Robinson was tempted to abandon writing poetry in order to do something morally useful. Lee urged her to stick to poetry, insisting that by making art Robinson would be creating positive good, as only the artist can (VL to Mary Robinson 20 November 1880, in Lee 2017: 273).

contrast, Lee opposes literary decadence on the grounds that literature should not be judged by the same purely aesthetic and sensory standards as painting and music. Literature is an art of ideas that speaks to our higher, evolved moral nature, so it must be judged primarily by directly ethical standards and only secondarily by aesthetic ones.

Lee's commitment to 'art for beauty's sake' is now doubly qualified. First, the pursuit of sensory beauty in painting and music makes a moral contribution by increasing overall happiness. Second, poetic literature makes a moral contribution in a different and more direct way, as an art of ideas which educates our moral sense. That sense motivates us to increase the general happiness, so the several arts all contribute to the good but in different ways. Painting and music contribute purely by their pleasurable effects, literature largely by its edifying content.

It is very clear here how Lee came out of nineteenth-century debates about art and morality, and how she was drawn to moralism *and* aestheticism, pulled in both directions.[14] She was closer to Ruskin than she maintained. Perhaps she would reply that Ruskin resolved the aesthetic/moral tension with an artificial unity, while she accommodates the difference by apportioning moralism to literature and aestheticism to the non-literary arts. However, since both kinds of art contribute to the good, the difference appears ultimately to be a unity, and aesthetic value (the pleasure of certain sensory qualities) to be a part of moral value (the overall happiness, which morality aims to increase).

This is confirmed by Lee's dialogue 'On Novels', published in the *Contemporary Review* in 1885, and then in her 1886 dialogue collection *Baldwin*. 'On Novels' was the 'companion piece' of the 'Dialogue on Poetic Morality' (VL to Percy Bunting, 30 December 1884, in Lee 2017: 615). In 'On Novels', different characters voice their opinions on the novel, but the core is an extended statement from Baldwin.

Painting, sculpture, music, and architecture each give a particular species of pleasure, Baldwin says. All these are modes of aesthetic pleasure, which is (as Pater had maintained) a unique kind of pleasure overall:

> The aim of art is the production of something which shall give us the particular kind of pleasure associated with the word *beautiful*, pleasure given to our aesthetic faculties, which have a mode of action and necessities as special and as impossible to translate into the mode of action and necessities of our logical and

[14] Vineta Colby understandably called Lee 'the puritan aesthete' (Colby 1970)—the suggestion that Lee was puritanical having first been tentatively mooted by Pater (1887). But 'puritan aestheticism' sounds pejorative. Perhaps a better description is that Lee was an 'engaged', as distinct from a 'decadent', aesthete, following Christa Zorn (2003: 79), who takes this engaged/decadent distinction from Regenia Gagnier (1994). Still, the problem remains of how Lee can consistently be morally engaged *and* an aestheticist.

animal faculties as it is impossible to translate the impressions of sight into the impressions of hearing. (Lee 1886: 200)

Artworks of all four forms give pleasure by being beautiful: 'all real art addresses itself mainly, however unconsciously, to a desire for beauty' (202).

The novel, on the other hand, deals principally with human emotions and actions and its aim is to portray virtue. Unlike other kinds of art, the novel may contain some beautiful elements, but beauty 'has a far smaller share in the poem, novel, or the drama than in painting, sculpture, or music' (204). We might describe certain characters or their actions as 'beautiful', but really we mean 'virtuous', which is beautiful only by analogy (a residue of the idea that moral goodness and aesthetic beauty are categorically distinct). However, morally vicious actions and characters are needed for dramatic tension, which again differentiates the novel from the other arts. Artworks of other kinds must aim to be entirely beautiful and contain nothing ugly, whereas the novel has to contain vice, i.e., the moral equivalent of ugliness. None of this makes literature an inferior art-form. What literature lacks in beauty it makes up for ethically—by expanding our sympathies, reinforcing our sense of right and wrong, and providing moral education (207–209). Novels are less beautiful than artworks of other kinds, but they make up for it in direct moral value.

Lee is no aestheticist at all when it comes to literature. As she says: 'My thesis is that the novel is only partially liable to artistic laws, being mainly a factor of moral improvement or the reverse' (VL to Percy Bunting, 30 December 1884, in Lee 2017: 615). Ironically, '*mainly* a factor' makes Lee a stronger moralist about literature than Jameson, who sought an equal balance between the aesthetic and the moral, in literature as in other arts. For Lee, in contrast, the novel is primarily a vehicle of moral reflection and education.

Lee's aestheticism was leaning so heavily in a moral direction that it threatened not to remain aestheticism at all. As a result, Lee rethought her views in an effort to make them coherent. Her new position emerged in 'Orpheus in Rome', another *Contemporary Review* dialogue from 1889, later included in her 1893 collection *Althea*.

'Orpheus' departs formally from the two dialogues just considered. It is a multi-way conversation between three characters, rather than Baldwin instructing the others. His interlocutors are Maria, who finds modern art decadent and pessimistic, and her opposite pole Carlo, who only likes modern art and cannot relate to the art of the ancients. Baldwin, we learn, has been ill, taken up with social problems and disengaged from art, with which he is now reconnecting in Rome. Perhaps this illness is a metaphor for the collapse of Lee's initial aestheticism, and Baldwin's reunion with art stands for her effort to reconceive her position.

Maria extols the healthiness, symmetry, and balance of classical sculpture, against our present diseased era—a version of Pater's classicist ideal of health and

vitality. Coming around to this view, Carlo agrees that 'the classic is...hygienic beauty. It's things as they should be, bodies as they should be' (Lee 1889: 839). Yet modern art shows us the people we are, not those we ought to be, and so Maria in turn admits that modern art can appeal to us. But, she maintains, it does so only by drawing on our savage instincts, which is bad for our moral health. Baldwin agrees: some art appeals to our older, brutal instincts rather than our more recently acquired, softer, more refined and civilized feelings. Only art that touches the latter 'has a morally sane effect', whereas art that conjures up brute passions is 'morally detrimental' (841). Maria expands further on this theme: some music expresses our deep-seated, savage, powerful passions; other music is beautiful, classical, suggesting bodily calmness and moderation. Baldwin calls this latter type: 'The ideal, the desired, the desirable of our less selfish instincts' (843). Such art, he admits, offers the ideal rather than unalloyed reality. Although this involves a deception, its moral effect is beneficial:

> We are so made that nobility drags out nobility. We feel good in the presence of great bodily perfection. Beauty, as it seems to me, is not merely, as Rossetti has it somewhere, genius; beauty is goodness. We are the nobler for the delusion, nay, rather the great reality of association we feel. (843)

We are deluded when we perceive an artwork as a unity embodying ideal perfection, because reality is not like that. Yet such artworks concentrate our senses and vitality, so that we come to perceive life everywhere as more of a whole—'the single work, the single art...intermeshing...with all life's nerves and arteries' (849). Great art makes us feel the world to be better, more whole and complete, alive and healthy than it is. Since these feelings are part of reality, art thereby actually *makes* reality more complete and whole than it would otherwise be. The ideal becomes reality, and reality is better for it.

We note Baldwin's crucial statement along the way—*beauty is goodness*, and not merely by analogy. Rather, perceiving beauty has direct moral effects. It fortifies our health and vitality and draws out our softer, sympathetic feelings, calming our savage passions. It leads us to experience life as more of an interconnected whole, which makes life become more unified.

Earlier, Lee thought that literature acted on our moral judgements and motivations directly, steering us as moral agents, whereas the other arts gave sensory pleasure, affecting us as the moral patients whose happiness ought to be increased. Now, instead, Lee thinks that all beautiful art affects us in a way that is at once bodily, vital, emotional, *and* moral, feeding off one another. The difference between literature and other arts becomes less significant, because all the arts operate on us as beings who are both moral and physical. Literature may affect us more spiritually, through ideas, and painting and music may affect us more physically, through beauty, but these are only differences within the same overarching

way that art improves our lives—as whole beings. Insofar as art of all forms improves our lives, by modelling wholeness and calm rather than decadent savagery, that art makes a moral contribution, increasing the good. The nature of that good has subtly changed. Lee now understands happiness in an expanded sense, in terms of vitality, health, and organic unity rather than simple pleasure. Moreover, our happiness in this sense is only part of the vitality, health, and organic unity of the world. By increasing our unity, good art increases the world's unity. It literally makes the world a better place.

9.5 Lee's True Aestheticism in 'Art and Life'

What kind of aestheticism Lee now believes in, if it remains aestheticism at all, we can investigate by looking at her elaboration in the long three-part essay 'Art and Life', published in the *Contemporary Review* in 1896.

At first sight, Lee (1896a) goes back to demarcating beauty and goodness. She says near the start that beauty, goodness, and truth are distinct, and that we perceive, respond to, and desire each of them with different instincts.

> Beauty, save by a metaphorical application of the word, is not in the least the same thing as goodness, any more than beauty…is the same thing as truth. These three objects of the soul's eternal pursuit have different objects, different laws, and fundamentally different origins. (659)

But though they are different they are necessarily interrelated, because we are living beings, organic wholes, all of whose instincts interconnect and act upon one another. Lee therefore repudiates the 'spurious aestheticism and…shortsighted utilitarianism which have cast doubts upon the intimate and vital connection between beauty and every other noble object of our living' (659–660). She proposes to show how the instinct for beauty acts on our other instincts so that experiences of beauty (or aesthetic experiences) increase our sense of harmony, strengthen our altruism, and foster our individual spiritual development.

She tackles each in turn, starting with individual spiritual development in the first part of 'Art and Life'. We find certain artworks beautiful, she argues, because of how their visible and audible forms affect our nervous and vital functions. Our propensity to be so affected has been established by evolution.[15] The artworks that affect us in this way are organic, harmonious wholes. They promote our organic vigour and harmony, because the artwork's organic form resonates with and reinforces the organic wholeness of our bodies. This 'aesthetic heightening of

[15] Lee was picking up on discussions of the 1870s and 1880s about how evolution has selected for the sense of beauty (see, e.g., Allen 1877, Anonymous 1878a, Naden [1884] 1891).

our vitality' is not narrowly physical (661). It is also an expansion and enlivening of our consciousness, for, after all, as living bodies we are sensing, experiencing, and conscious. So 'all Beauty, and particularly Beauty in art, tends to fortify and refine the spiritual life of the individual' (662).

In part, all of this constitutes a continued engagement with Pater. For him, art was beautiful when it conferred pleasurable sensations *and* he understood beauty in the classicist terms of harmonious perceptible form. Lee has now found a way to integrate these ideas with one another and with Pater's wider classical ideal of health and vitality. In addition, she now integrates all these ideas with the Paterian ideal of the critic as someone with a developed sensitivity to aesthetic qualities.

To get art's full spiritual benefit, Lee maintains, we need to train and cultivate our powers to respond to it with attention, patience, reverence, intelligence, and sympathy. Without this 'special training', we will likely only have lower-grade immediate reactions to the poorest, most ephemeral and sensual art, Lee continues (662–663). Cultivating our aesthetic powers thus makes us more spiritual, and it makes all of our experience more spiritual, because our accumulated store of aesthetic experiences subtly infuses and enriches our entire everyday life. Consequently: 'The habit of aesthetic enjoyment makes this epicurean into an ascetic' (668). Because the aesthete enjoys things of the spirit, she can endure hardships, illness, and setbacks, and can exercise self-restraint when tempted by mere immediate physical pleasures.

> The intimate and continuous intercourse with the Beautiful teaches us, therefore, the renunciation of the unnecessary for the sake of the possible; it teaches asceticism leading not to indifference and Nirvana, but to higher complexities of vitalisation, to a more complete and harmonious rhythm of individual existence. (669)

In short, the aesthete is 'active, self-restrained, and indifferent to lower pleasures and interests' (Lee 1896b: 813).

This leads to the second part of the essay, on how aesthetic experiences and pleasures foster altruism:

(i) Ordinarily, people waste a lot of time on merely physical, destructive pleasures. Their attractions can be much reduced by cultivating one's aesthetic responsiveness.
(ii) Aesthetic pleasures are heightened by being shared, due to the contagion of emotion. Therefore we necessarily want to share these pleasures. They are intrinsically unselfish and social (815).
(iii) Aesthetic pleasures do not depend on possession of the art object being enjoyed. Spiritual communion, not legal or physical ownership, is what

matters: 'the deeper our enjoyment of beauty, the freer shall we become of the dreadful delusion of exclusive appropriation' (818).

(iv) Aesthetic pleasure expands the soul, so the more we cultivate our aesthetic powers the greater will be our 'spiritual activity...readiness to perceive small hints, to connect different items, to reject the lesser good for the greater' (819). The aesthete perceives more harmonies and connections, takes a broader view of things.

(v) The more aesthetically cultivated we are, the more we must want everyone to share in aesthetic pleasures and not be dragged down by want, boredom, drudgery, dirt, and ugliness. This is, again, because aesthetic pleasure is unexclusive—if this pleasure is good for me, then I must see it as good for everyone else too, and want them to share in it. Consequently, 'aestheticism can help to bring about a better distribution of the world's riches' (822)—contrary to the *pensée* of Pascal's to the effect that a fop carries on his person the evidence of...many people devoted to his service' (820). Lee is combating the stereotype of the decadent aesthete, luxuriating in a private mansion of sensual delights while the world around them burns. The *true* aesthete, Lee replies, is unselfish, egalitarian, and virtually a socialist. She is active, not indolent; attuned to things of the spirit, not a selfish voluptuary.

The third part is on how aesthetic experience increases one's sense of harmony.[16] There is mere art, and there is great art, not made merely for fame, money, or to comply with a formula (Lee 1896c: 63). To be great, art must be made for its own sake, and it must have a certain quality: *style*, defined as 'organic correspondence between the various parts' (62). The work's style makes it beautiful, so that it pleases us. For we are organic wholes too, and so great art expresses the wholeness of our living bodies, and we find it suited to our organic nature. 'The great work of art is vitally connected with the habits and wants, the whole causality and rhythm of mankind; it has been adapted thereto as the boat to the sea, as the sea itself to its rocky bed' (64). Art that embodies wholeness confirms and fortifies our own life. In contrast, fragmented, dissonant, disjointed art strikes us as threatening, disturbing, and damaging. Great art counters the lack of harmony elsewhere in our lives, so that such art is 'ideal'. It conforms 'to Man's inborn and peremptory demand for greater harmony, for more perfect co-ordination and congruity in his feelings' (63).

Lee continues: 'In this manner can we learn from art the chief secret of life...of action and reaction, of causal connection, of suitability of part to part, of organism, interchange, and growth' (64). Art teaches us this not merely intellectually

[16] On the importance of the concept of harmony for Lee, see also Garza (2009: ch. 2).

but as we feel it in our bodies, in the expansion of our vitality and spirit as we respond to an artwork that has style. In this organic sense, art educates us to apprehend and enjoy wholeness, and to select for it in our experience by removing dissonant elements and making things around us more whole (66).

The true aesthete thus pursues congruence, and not merely in trivial matters like the arrangement of their furniture. Necessarily, the aesthete seeks congruence in ever wider circles of life; otherwise, there remains an incongruity between things that are closer and further away from her (68–69). The aesthete pursues ever greater harmony in the universe—and this includes her seeking ever greater happiness for other people (70). This is because the aesthete must seek congruence between their happiness and the experiences of others, and so they must want to raise the happiness of others. In this way, aesthetic experience is 'morally elevating' and motivates us to pursue an equal distribution of happiness.

Lee's position now depends on her conception of life. Human beings are organic wholes, and it is as living beings that we respond to the unified forms of certain artworks and find them beautiful. For Lee, this appeal to physiology is the hallmark of modern aesthetics. She comments that aesthetic theories today, in which 'beauty is a complex physical, or mainly physical, quality' may seem far removed from Plato (59). But Plato's character Diotima was essentially right: by contemplating beauty we purify ourselves and become more spiritual and more moral. Diotima, though, understood this in a merely vague, intuitive, mystical way. The true explanation must be physiological and scientific: artworks with style reinforce and speak to the harmony of our living bodies.[17]

In connecting art and life, Lee has moved into the same territory as Kant ([1790] 1987) in the *Critique of Judgement*. For Kant, there is an inherent link between the unity we find in living organisms and the harmonious play of our faculties that underwrites our judgements of beauty. How exactly Kant understands the nature of this link remains debated. But in any case, Lee seems to have had no great interest in Kant (though she could read German and had read his First Critique, *Prolegomena*, and *Metaphysical Foundations of Natural Science* in translation).[18] Lee and Kant differ fundamentally, for Lee's understanding of reality and its organic wholeness is realist. To be sure, she thinks the more we are organically unified in our bodies and spirit, the more we will experience the world as being organic. To that extent, our form of experience affects how the world presents itself to us. But still, this is a matter of our being more or less

[17] The theoretical influences on Lee's conception of life can be discerned from the list of books donated from her library to the British Institute in Florence. By 1896, her reading on biology and life included Darwin's *Origin of Species* and *Descent of Man*, August Weismann on heredity, Jean de Lanessan on the evolutionary transformation of matter, and Grant Allen's physiological aesthetics. Lee read Bergson, but only after 1898. For Lee's donation, see: www.britishinstitute.it/en/library/the-archive/vernon-lee-collection.

[18] Judging, again, by her book donation to the British Institute in Florence.

sensitive to organic harmonies that really exist in the world, and of our acting to draw out more of these harmonies. Moreover, the organic unity of our bodies, in which these sensitivities and actions are grounded, is a reality, for Lee—a reality identified and understood by the natural sciences, which describe and explain the world as it is mind-independently.

Lee's is not a crude, reductive scientism, however. Properly understood, life contains room for spirit, and the soul is part of the natural universe (Lee 1896c: 71). Life as a unity of parts—as 'interchange…diastole–systole…rhythm and harmony' (62)—is not simply physical but a higher-order spiritual *relation* amongst lower-level physical parts. This is why the expansion and heightening of our organic life in response to art is a spiritual expansion as well, a broadening-out of consciousness.

Because we are these organic wholes, our instincts to find harmonious forms beautiful and to find an equal distribution of happiness good are integrally connected. They are different forms of the urge towards harmony which stems from the organic oneness of our bodies. What we find morally good is harmony in people's quality of life; what we find aesthetically good is harmony in the form or style of artworks. Both the good and the beautiful are forms of harmony, and so each one stimulates the other. They are connected organically, as are all the parts of life.

Finally, is Lee's position still a form of aestheticism? It is certainly a kind of organicism. Both equal happiness (the moral good) and our enjoyment of artworks with style (the aesthetic good) are forms of organic harmony, and organic harmony is the ultimate good. It is not a unity beyond the world but a living unity that runs through the world, and more so if the world can be improved morally and enriched aesthetically in ways that enhance its unity. Although Lee still says that morality and beauty are distinct but connected, really their relations are even closer than that, for they are two versions of the same good: harmony. Moreover, Lee has moved further away from her earlier moralist leanings, because she no longer primarily understands the good as the happiness that is the object and aim of morality. The good has moved out of a primarily moral register, and she now thinks of it more expansively. Organic harmony is at once aesthetic *and* moral *and* the ultimate nature of life and reality. The good is aesthetic, moral, and ontological at once.

With respect to aestheticism, I am torn between two answers. On the first, Lee's position is no longer a version of art for art's sake, or rather of art for beauty's sake—after all, she now speaks of art for *life's* sake. Art should be made for its effects in fostering a life that is morally good, aesthetically beautiful, and vitally real. The only sense in which this is aestheticism is residual: Lee has reached this organicist position through the gradual transformation of her earlier aestheticism, and her organicism still owes things to that earlier aestheticism and incorporates elements of it. One element that she retains is that artworks must have style

and be beautiful to have positive vitalizing effects on us, and artworks cannot have style if they are made to fit formulae, including moral formulae. Artworks must be made to be beautiful wholes, not to impart moral content.

But I prefer a second answer, although it involves slightly more stretching of Lee's claims. On this reading, the organic harmony of the world is ultimately aesthetic. After all, harmony is an aesthetic value—and Lee thought so, having always equated harmony, beauty, and aesthetic value. Admittedly, I have just described harmony as the organic unity of the moral, aesthetic, *and* ontological forms of harmony, so it may seem one-sided to construe that highest-order harmony solely as aesthetic. Yet, equally, we can say that the organic unity of all these dimensions remains an organic unity, and that organic unity or harmony *is* beauty, for Lee. Beauty goes all the way up the universe, so to speak.

Interpreted this way, Lee's position remains a form of aestheticism, on which art must be made for beauty's sake. But unlike in standard aestheticism, the beauty for which art is to be made is not that of the artwork alone, but rather the beautiful harmony of the world and all its contents. Read this way, Lee offers a novel and expanded metaphysical aestheticism: beautiful art should be made because it makes the world more of a beautiful, organic whole.

Women on Philosophy of Art: Britain 1770–1900. Alison Stone, Oxford University Press. © Alison Stone 2024.
DOI: 10.1093/9780198918004.003.0009

10
The Fate of Nineteenth-Century Women Philosophers of Art

10.1 Introduction

I have argued that women made crucial contributions to shaping nineteenth-century British philosophy of art. This area was not the all-male domain we have assumed it was. Recognizing women's interventions broadens our sense not only of who wrote and thought about art but also of what was thought and how this thinking was done. The standard story of aesthetics in this period begins with such Romantics as William Wordsworth, Samuel Taylor Coleridge, and Percy Shelley. By including Anna Barbauld and Joanna Baillie, we see how British Romanticism encompassed a rethinking of tragic drama and the new aesthetic category of devotion. The usual story then proceeds to John Ruskin and his efforts to negotiate between the aesthetic and the ethical. We can enrich this story by feeding in Harriet Martineau's moralism and Anna Jameson's endeavours to balance artworks' aesthetic and moral sides, by way first of her concept of character and then of religion. In scale and ambition, Jameson produced a body of work parallel to that of Ruskin. Frances Power Cobbe's attempt to balance beauty and goodness deserves inclusion in this story as well. Finally, when the standard narrative proceeds to the aestheticist turn taken by Walter Pater and Oscar Wilde, we can profitably add Emilia Dilke and Vernon Lee into the picture, both for their strong statements of art for beauty's sake and for their subsequent moves in different directions.

When we include women, we find that concepts and movements traditionally linked to men alone were actually co-created by their female contemporaries. This comes out very clearly from the fact that Jameson discussed the Gothic almost simultaneously with Ruskin, and that Dilke's defence of aestheticism preceded Pater's. Who got there first does not matter in itself; such questions are bound to be murky. But these cases are important because they show how women's writings, alongside men's, defined the central issues and debates around art in this period.

Looking at the internal movement of women's thinking on art over time, we have seen that their shared central concerns were the relations between art, morality, and religion. Their views on these relations followed two largely overlapping arcs.

Along the art–morality arc, Barbauld initially held the two in balance. Novels had to entertain and give aesthetic pleasure, but their entertainment value depended on inbuilt moral features, such as narrative closure in which the virtuous were rewarded. Again, to give aesthetic pleasure, fiction had to refine and cultivate our sympathies, but it also had to be realistic enough for these sympathies to transfer into real-life morality. Barbauld also balanced art and religion; she argued that religion had an aesthetic aspect—that of feeling and imagination—but reciprocally that every exercise of imagination was inherently religious, raising our minds beyond the sensory world.

After Barbauld, the balance tilted towards morality. Baillie ([1798] 1806) characterized the theatre as 'a school in which much good or evil can be learned' (57). Martineau took the even stronger view that art's purpose was to impart moral lessons, instilling these lessons effectively by making use of the aesthetic vividity of sensory impressions. Art's link to religion tightened simultaneously, since Baillie's religious convictions underpinned her belief in our free will to act well or badly, and Martineau's early religious convictions (later abandoned) informed her conception of moral principles.

The art–morality arc then began to tip back towards greater balance with Jameson, yet in her later work she balanced art and morality by further tightening art's link with religion. In *Sacred Art*, she proposed that art was good as art when it was poetically meaningful and expressive of the religious beliefs of a given stage of civilization. Since those beliefs enshrined the moral hope for a better world, art had to be morally good to be good as art. Reciprocally, artworks could not be morally good (enshrining people's moral hopes) without being aesthetically good (truly poetically expressive of people's lived beliefs).

In other words, the art–morality link peaked before the art–religion link, and the latter peaked as a way of tilting art-and-morality back towards greater balance. This applies to Cobbe's work also, for she appealed to the divine origin of beauty to argue that all true beauty was necessarily good as it came from God. Consequently, artists could freely pursue art for art's sake anyway; as long as they pursued true beauty, no immoral consequences would follow.

The next step was that both Dilke and the earlier Lee severed the art–religion *and* art–morality links. They both saw beauty as a property of certain sensory qualities which give us pleasure, or perhaps as the power of these qualities to give us pleasure. To produce art for beauty's sake, the artist must focus solely on producing artworks embodying these sensory qualities, setting aside any concerns with morality or religion. Lee even argued that religious significance transcends the sensory world, whereas beauty is sensory and physical, so that art cannot be both genuinely religiously expressive *and* beautiful, a reversal of Jameson's earlier position.

The final move was for the arc to begin curving back towards a more moderate art–morality link. Dilke acknowledged that moral value was one kind of value

artworks could have, and Lee espoused art for life's sake, art for the sake of the greater harmony of the universe—a move back into more spiritual terrain. The net result was not simply a return to Barbauld's balance, but a push towards greater conceptual clarification on Dilke's part and towards a new metaphysical form of aestheticism on Lee's part.

Having explored what these seven women wrote about, I now want to consider two sets of issues that these women did *not* significantly discuss. First, Barbauld excepted, they tended to run together the categories of the artistic, the aesthetic, and the beautiful, consequently giving little attention either to the aesthetic qualities of nature or to the sublime. Second, and again with the partial exception of Barbauld, these women did not subject the canon or the hierarchy of the arts to much critical scrutiny. I will suggest, however, that these omissions do not give us reason to dismiss or devalue these women's ideas. On the contrary, their different interests and priorities raise critical questions about our preferences today.

10.2 The Aesthetic, the Beautiful, and Art Hierarchies

Collectively, these women spent relatively little time asking, 'what is art?' and 'is there anything that all art has in common?' Two of the most explicit answers came from Cobbe and Lee. For Cobbe, art results from creative making (*poiesis*) in which we recapitulate God's creation of nature; for Lee in 'Art and Life', great art results from the infusion of style into materials which binds them into organic wholes. Other women's answers were more implicit: for the earlier Jameson, artworks are imaginative creations that have a wholeness akin to organic nature; for the later Jameson, artworks are poetic expressions of a civilization's core beliefs. But on the whole, defining art was not a pressing concern for these women. This is probably because they lived (or, in Lee's case, formed many of her ideas) before modernist experimentation gave us works like Duchamp's *Fountain* which destabilized the concept of art.

Moreover, as we have repeatedly seen, most of these women associated the aesthetic domain with that of the arts. Barbauld was the exception, for she believed that aesthetic experiences of God in nature and the everyday world occurred independently of art. Nevertheless, she gave literature and art central roles in cultivating our aesthetic sensitivities. Subsequently, from Baillie through Martineau and Jameson, art's educative powers took more and more priority, and the arts moved into centre stage. The resulting elision of *aesthetic* and *artistic* even led Cobbe to classify our aesthetic experience of nature as 'tertiary *art*'. Tellingly, Dilke (1869) soon afterwards defined aesthetics as 'a general theory explaining the place in human nature of the emotions of *art*, and in the objects of *art* their character and causes' (148; my emphasis).

Even so, it was Dilke who subsequently began to disentangle artistic from aesthetic value, arguing that aesthetic value was only one of the kinds of value found in pictures and other artworks. Lee ultimately developed a similar line of thought after 1900. She argued in *The Beautiful* (1913) that beauty is a quality of certain harmonious forms, whether these forms are of natural objects, human beings, artefacts, or artworks. Similarly, in *The Handling of Words* (Lee 1923), she clarified: 'By *aesthetic* I do not mean *artistic*. I mean...that which relates to the contemplation of such aspects as we call "beautiful", whether in art or nature' (79). We find no such *aesthetic/artistic* demarcation in Lee's pre-1900 work, although she did foreshadow the distinction in 'Beauty and Ugliness' (Lee 1897a) when rejecting 'the usual confusion between the aesthetic phenomenon and that special ramification and complication thereof which should properly be called the phenomenon of art' (555). Yet her examples of non-art aesthetic phenomena were jars, mats, vessels, tables, garments, ceremonies, and the metrical properties of words—all craft artefacts. Lee described them as rude and elementary anticipations of art (556). That is, artefacts counted as being aesthetic because they foreshadowed art, so that Lee continued, despite herself, to run together the aesthetic and the artistic.

The *aesthetic/artistic* elision meant that these women did not really theorize natural beauty, sensitive though they were to nature's aesthetic qualities. For instance, Jameson (1826) evoked natural beauty in her *Diary of an Ennuyée*:

> Are there not times when we turn with indifference from the finest picture or statue—the most improving book—the most amusing poem; and when the very commonest, and every-day beauties of nature, a soft evening, a lovely landscape, the moon riding in her glory through a clouded sky, without forcing or asking attention, sink into our hearts? (29)

But for Jameson art remained the paradigmatic aesthetic phenomenon, and her diarist continued that she only found these aesthetic qualities in nature because she was viewing it with an artistic spirit, as if it was art. 'I look', admitted the diarist, 'upon the glorious scenes with which I am surrounded...with the eye of the painter, and the feeling of the poet' (310). Accordingly, the diarist described much that she was seeing on her travels as picturesque: wild landscapes and ruined castles (136), massed armies on a mountainside (243), 'fervid skies...sunsets... pine-clad mountains...azure seas' (361). All these scenes were observed as if in a picture, and this rendered them aesthetic.

Like Jameson, Lee regularly evoked natural beauty: 'the particular curve of the hill here, the particular effect of a clump of trees there; the trunk of an olive; the stones in the water; the tips of the cypresses and their beautiful compactly fibrous greyish boles' (Lee 1886: 10). But natural beauty was not integrated into her

pre-1900 *theorizing*. Dilke acknowledged that 'The distinction...between beauty in nature and beauty in art...is a most important distinction, and of which both the educated and the ignorant are generally unaware' (Dilke 1879a: 236). But she did not enlarge on the distinction either. Overall, nature's aesthetic qualities hovered, untheorized, on the fringes of these women's frameworks. Cobbe this time was the partial exception, since she regarded natural beauty as the proper source of all artistic beauty. However, even for Cobbe, nature was beautiful as the expression and manifestation of God's creativity—as God's creative product, the original *artwork*.

As Lee's (1923) above-quoted remark makes explicit, 'By *aesthetic*...I mean...that which relates to the contemplation of such aspects as we call "beautiful"' (79), the aesthetic and the beautiful tended to be amalgamated too. These women did reflect on other aesthetic categories—the devotional (Barbauld), the tragic (Baillie), the picturesque (Jameson, Dilke), the horrific (Lee)—but they were secondary to beauty, which remained central and paradigmatic. We see this most clearly in the aestheticism of Dilke and Lee, for whom art's purpose was to be beautiful, beauty gave us aesthetic pleasure, and the pursuit of beauty defined art as art. If anything, then, beauty's pre-eminence only grew over the period from 1773 to 1896. After all, for Barbauld devotional taste united the sublime and the beautiful, while Baillie's primary categories were the tragic and the comic; but as the century went on, beauty became ever more predominant.

Barbauld aside, the sublime was conspicuously absent from these women's theories. For Jameson (1826), the beautiful was much more salient, and her second-place aesthetic category was not the sublime but the picturesque. She often invoked the picturesque where we might have expected to find the sublime, as when she wrote: 'Let us recall that it is not alone the *visible* picturesque...which thus intoxicates...but it is something more than these, something beyond, and over all' (361).[1] She occasionally described the immense Canadian landscapes that she visited in the 1830s as 'sublime', but her much-preferred term was 'picturesque'. As Lorraine York (1986) and Wendy Roy (2003) both observe, in *Winter Studies and Summer Rambles* Jameson repeatedly described Canadian scenery as picturesque, applying 'artistic criteria of form and symmetry to a wild, recalcitrant landscape' (Roy 2003: 51). Jameson's guide Henry Schoolcraft commented that she 'appeared to regard our vast woods, and wilds, and lakes, as a magnificent panorama, a painting in oil' (quoted in Thomas 1967: 135). Elsewhere Jameson (1826) even used the language of the picturesque to describe her climb of Vesuvius while it hissed and spat out fiery stones (236–249).[2] Where she could

[1] This shading of the picturesque into the sublime (and the beautiful) was widespread in writing on the topic; see Costelloe (2013: ch. 4).

[2] Alessa Johns has identified a gendered pattern for men to find Vesuvius sublime, women to find it picturesque; see Johns (2014: ch. 3).

not render landscapes picturesque, she found them merely desolate and not awe-inspiringly vast—not sublime, but devoid of aesthetic qualities altogether.

We see a similar preference for the picturesque over the sublime in Baillie ([1798] 1806), who sought to bring the minds of troubled heroes and heroines close to us. She said that this was like homing in on the 'roughened sides shaded with heath and brushwood' of a mountain, that seen from a distance had been a mere outline (28). As Jane Stabler remarks, 'Here, Baillie uses a picturesque analogy...whereas [Ann] Radcliffe always accords more value to the sublime, the indefinite...Baillie [prefers] detail and nuance' (Stabler 2002: 53). After all, Baillie wanted to bring the passions of heroes within our sympathetic understanding. Hers was an art of psychological intimacy, not distant grandeur.

Cobbe ([1862] 1863) saw sculpture as an art of power, which meant that out of all the arts sculpture was 'when perfected...the most sublime' (82). Here Cobbe followed the entrenched connection of the sublime with power and grandeur, which came down especially from Edmund Burke. Yet she placed sculpture *within* the overarching heading of 'woman's pursuit of the Beautiful' (89): one way women could pursue the beautiful was to make sublime art. Cobbe thus treated the sublime as a form of beautiful art. So did Jameson, who described artworks as sublime when they most powerfully raised our minds to God. For example, she said that Titian's angel heads had 'something sublime and spiritual, as well as simple and natural' (Jameson 1848: vol. 1: 44).[3] Such cases of sublime art, for Jameson, fell within the overarching category of beautiful art: art that was poetically meaningful and expressive.

Cobbe often used 'sublime' in a similar way to Jameson, to mean 'raising our minds to God' (Cobbe 1865: 132, 134, 300, 438). This had a precursor in Barbauld's sublime side of devotion, the mind's upward movement from finite things towards God. Thus, one line of thought running through these women's writings connected the sublime with religion. The mind's ascending movement towards God and things of the spirit was sublime; so were the elements of artworks that prompted this movement; and one way that artworks could be beautiful was by being sublime, that is, evoking religious awareness.

The link with religion partly explains why Dilke and Lee privileged beauty more strongly than ever as the central aesthetic category. They separated art from religion, and so they set aside the sublime too, presuming it to have religious connotations. Dilke (1873b) warned of the 'danger' of confusing the beautiful with 'the really distinct terms, grandeur and sublimity' (416), and gave the latter no place in her account of the values of artworks. However, we might wonder whether the sublime survives into Lee's thought in the guise of the supernatural, which hovers beyond presentation. For instance, Catherine Maxwell (2009) not

[3] For similar uses, see Jameson (1848: vol. 1: 17, 27, 96, 107).

unreasonably describes Lee's supernatural as sublime (145–149). But it is revealing that Lee herself did *not* use the word 'sublime' in connection with the supernatural. The sublime was not a significant concept for her, and even when it would have made sense for her to refer to it, she did not.

In some recent art theory, the sublime is seen as a transgressive, radical force, expressing a world that exceeds our understanding and mastery.[4] From this perspective, beauty corresponds to the world tamed, domesticated to suit our faculties and please us. Thus whereas the sublime is exciting and destabilizing, the beautiful is rather staid and uninteresting. One might then see these women's inclination towards the beautiful as a sign of their aesthetic conservatism. But there are other possibilities. Plausibly, these women steered away from the sublime, and reduced it to a subordinate form of the beautiful, due to the gendered connotations of these aesthetic values. For the equations masculine–sublime and feminine–beautiful were well established by their time. In siding with the beautiful, perhaps these women were indirectly speaking for and from feminine values, and raising a subtle protest against masculine power. By emphasizing the feminine value of beauty, they implicitly underscored their suitability to write about art as women. In this light, we might wonder whether the current interest in the sublime accidentally imparts a bias against nineteenth-century women philosophers of art, who had understandable reasons to downplay the sublime in favour of beauty.[5]

The issue of aesthetic conservatism surfaces again insofar as these women essentially accepted the hierarchy of the arts. Between them, they reflected on all the five 'major' arts, poetry, music, painting, sculpture, and architecture. Literature received the most attention in the earlier half of the century and painting the most in the later half, reflecting the wider visual turn in later-century British culture. But these women accepted that these five arts *were* the major arts and were the proper focus of reflection on art. They worked with a system of the arts that had become fixed in the eighteenth century, along with the divide between fine art and mere craft (Kristeller 1951).

[4] For example: the sublime 'has successfully resisted being theorized, or comprehended...It is precisely as space outside theoretical or discursive mastery' (Guerlac 1991: 895); 'Under the aegis of the sublime...[are] moments of mute encounter with all that exceeds our comprehension...being taken to the limits. The sublime experience is fundamentally transformative, about...the disruption of the stable coordinates of time and space' (Morley 2010: 12). A key influence on such views is Lyotard (1982).

[5] For instance, in the 'Late Modern' section of Robert Clewis's *Sublime Reader*, the only woman included is Mary Shelley, with an excerpt from *Frankenstein* (Clewis 2019). Clewis includes many women from earlier and later periods. Of course, the criticism that the sublime is a masculine value has been made by feminist aestheticians before (e.g., Freeman 1987), but my point is slightly different: nineteenth-century women philosophers of art *themselves* seem to have seen the sublime as masculine and steered towards beauty instead. Hence the lack of sources on the sublime by nineteenth-century women, reflected in Clewis's anthology despite his inclusive intentions.

Cobbe, for instance, emphatically privileged these five arts and scorned popular arts like street music:

> Music is peculiarly an art which cannot thus bear to be vulgarized... [and] an air of music... is forever desecrated once it has become the spoil of every strumming piano-player in our drawing-rooms, and organ-grinder in the streets.... No other bad art is half so obnoxious and intrusive, nor half so injurious, as bad music... (Cobbe 1865: 318)

Dilke did take note of female craftspeople, both practically in her union work and theoretically in her French art books, where she looked at minor and major arts, treating both alike as expressions of their historical eras. Yet this rested on her premise that all these arts were merely historical and not properly aesthetic, while her canon of truly beautiful artworks remained familiar: the *Sistine Madonna*, the *Niobe*, and so on. Lee, too, focused overwhelmingly on canonical or high art, as we can see by turning back to the titles of her early writings in Table 9.1. She extolled 'great' art that had style, setting it apart from popular ephemera like music hall and mimeographs. The latter, for Lee, offered merely immediate, transient, physical pleasures to people too exhausted and depleted by work to engage with beautiful art (Lee 1896a: 663).[6]

These women's acceptance of the system of the arts thus went along with their acceptance of the canon. Barbauld's case was the most ambiguous. On the one hand she helped to establish the canon of the novel, but on the other hand she included many women novelists, and she suggested a picture of canons as temporary and provisional constructions from which I have taken inspiration. But after Barbauld, views on the canon seem to have hardened. In particular, Jameson was a gifted interpreter and consolidator of the existing literary and visual canon. Although she was a feminist and highlighted positive representations of women, these were almost entirely ones made by canonical male artists, and Jameson did not fully develop her thoughts on female artists or see their work as posing questions to the canon. Instead, she primarily aimed to make the male-centred canon accessible and intelligible to the public. As we saw in Chapter 6, her acceptance of the canon set her apart from Ruskin, who was prepared to be more iconoclastic and who pointed out that Jameson's own criteria of aesthetic value should have prompted her to raise critical questions about some of the artworks and art traditions that she praised.

[6] Lee (1901a, 1901b) revised her views, maintaining in 'Art and Usefulness' that great art necessarily grows from craft. Craft objects have both practical and aesthetic qualities, and the latter are the source of the beautiful forms that art draws out: without craft, no art. Nonetheless, Lee (1901b) continued to believe in 'artistic genius' and 'great art' (517, 518). She valued craft on the grounds that its aesthetic elements paved the way for great art.

These features of nineteenth-century women's art writing can be frustrating to feminists today. For example, Deborah Cherry (1993) has argued that nineteenth-century women's inattention to female artists 'contributed to the structural exclusion of women artists in the history and the public collections of the early twentieth century' (72). This inattention to female artists arguably flowed out of these women's acceptance of the canon of male artists and of a system of the arts under which such arts as decoration, flower painting, and embroidery were consigned to craft status. These were all arts in which women had long been expected to engage and which had feminine connotations. Recent feminist art theorists have instead taken women's exclusion from the canon as a starting-point for thinking both about the social conditions of artistic production (e.g., Wolff 1993) and about what counts as fine art at all (Parker and Pollock 1981: ch. 2). Why not treat decoration, flower painting, and embroidery as major arts?

These were not questions that our seven women pursued. Two other women, Mary Merrifield and Elizabeth Eastlake, came closer to doing so, but they still stopped short. Merrifield (1854) argued that dress could be elevated into a fine art by the application of principles of harmonious form which were known from painting and sculpture. But Merrifield did not so much question fashion's exclusion from the fine arts as *extend* the category of fine art to encompass dress. And while Eastlake defended photography, she did so on the grounds that photography was not a fine art, but that it could relieve art of the mechanical side of reproduction, liberating art proper to become more truly creative and imaginative (Eastlake 1857). Eastlake vindicated photography within the terms of the accepted art/craft hierarchy (see Chapter 11).

The irony is that these women were active participants in and beneficiaries of mass circulation culture. Martineau's *Illustrations* were a publishing sensation. Jameson introduced a pioneering series of prints in the *Art-Journal* and enthused that people could now have reproductions of artworks in their homes and local towns, with 'every beautiful work of art…multiplied and diffused by hundreds and thousands of copies' (1845: vol. 1: 168). Martineau, Jameson, Cobbe, Dilke, and Lee were adept at turning out essays and reviews to the fast rhythms of periodical culture. Yet this did not prompt them to revalue mass culture compared to fine art.

It might be objected that I am overstating these women's conservatism. Hilary Fraser (2014) argues that they *did* challenge conventions, methods, and received assumptions in particular ways. I agree: witness Baillie's grand plan for a concept-driven drama, Martineau's visionary programme of literary realism, Jameson's ambitious *Sacred Art* project, Cobbe's hierarchy of the arts, Dilke's bold defence of aestheticism, and Lee's strong argument that beauty and religion cannot mix. But one thing these women did not greatly challenge was art's canon and hierarchy or their gender implications. Rather than criticizing them on this score (with Cherry) or reading them for places where they do anticipate modern critical theories (with Fraser), perhaps we can simply accept that their concerns were

not always the same as ours. These women came to art from a different place from modern feminists, and their work is no worse, and is in many ways more interesting, for this difference.

Indeed, there is a risk that if we insist that past theorists must be iconoclasts and radical critics of artistic hierarchies, we will devalue women philosophers of art. We see this, for example, when Linda Nochlin commends the bold feminist critique of John Stuart Mill, while condemning the political and aesthetic caution and conservatism of Sarah Stickney Ellis (Nochlin 1971: 487, 498–499). The pattern that Elise Garritzen (2020) has analysed in nineteenth-century women historians is relevant here. Having less authority than men, women 'borrowed authority from renowned male historians to sanction their scholarly competence' (650). Similarly, Jameson established her credentials by engaging with canonical artists like Shakespeare and Raphael, as Martineau did with Scott, Dilke with Poussin, Lee with Goethe, and so on. These engagements had their subversive elements. Jameson foregrounded Shakespeare's female characters, and Lee used her reading of Goethe to show that good art had no room for the supernatural or religious. But still, these remained subversive readings of canonical men. Garritzen shows that women *had* to focus on canonical men to amplify their authority, whereas men such as Ruskin or Mill could afford to be more adversarial towards received opinion. Contemporary preferences for radical critique, like the contemporary orientation towards the sublime, may inadvertently create a bias against nineteenth-century women philosophers of art.

10.3 How These Women Disappeared

The women discussed in this book were not marginal or minor figures. In their time they were respected, renowned, and in some cases famous. Only later were they forgotten and left out of historical narratives, so that our accumulated scholarship says little or nothing about them. This makes these women appear marginal and minor, but this appearance is only a distorting effect of our one-sided historical accounts.

The fact that these women were once well known shows that patriarchy hasn't worked in the way we have often believed. Patriarchal constraints did not prevent nineteenth-century women from writing philosophy of art. Rather, these constraints have impeded women's philosophical writings from being heard, received, and taken up into historiography. The problem has been with *reception*, not production. As Roszika Parker and Griselda Pollock (1981) wrote forty years ago of women artists, the right question is not 'why have there been no great women artists?':

> There have always been women artists. The issues thus have to be reformulated…feminist art history…[needs] to analyse *why* modern art history ignores

the existence of women artists, why it has become silent about them, why it has consistently dismissed as insignificant those it did acknowledge. (49)

Similarly, there have always been women philosophers of art. The question is, how have they become left out of the history of aesthetics so comprehensively that it is difficult for contemporary historians to appreciate their role in shaping British philosophy of art? A complex of factors has brought this situation about.

Citations, followers, and authority. Nineteenth-century citation practice was to reference women sparingly or not at all. Unfortunately, when authors are not referenced, they quickly become forgotten. This is especially so when these authors published anonymously or under hard-to-decipher initials, pseudonyms, and changing surnames. Moreover, women writing on art, as on other areas of philosophy, did not acquire male disciples and followers who carried their work forward. Men might praise women's writing, but it would have been a rare man who placed his published work under a woman's tutelary authority. Men might admit their indebtedness to women in correspondence,[7] but published work was another matter.

Professional specialization. As I have explained elsewhere (see Stone 2023: ch. 1), late in the British nineteenth century a wave of academic specialization and professionalization took place. The earlier, deliberately amateur and generalist culture was transformed into one of specialist expertise. To make credible intellectual contributions one now had to belong to the right networks and forums and, in the end, to work as a university academic. Women could study at some universities by then, but the legacy of their exclusion from higher education meant that at first very few women could become professional academics. Thus, the credentials that were now required for credibility were largely out of women's reach. In contrast, the earlier generalist culture had not required these credentials and had been more open to female participation.

The same cultural shift negatively affected the reception and reputation of earlier thinkers, most of whom were in hindsight classed as mere amateurs. Admittedly, art history was somewhat exceptional, only becoming a specialized discipline well into the twentieth century (see Pollock 2012). But this meant that art history as a whole tended to be derided as amateur. This applied to past practitioners like Jameson and Dilke, even though they had tried to 'professionalize' art history (relatively speaking) by carefully researching art-historical facts and avoiding sweeping pronouncements à la Carlyle or Ruskin (Holcomb 1983; Kanwit 2013). In any case, being pre-professional, these women were not simply art historians. Their work also ranged over art criticism and evaluation,

[7] As the religious philosopher James Martineau did with Cobbe, for instance; see Mitchell (2004: 151).

philosophy of art, literary criticism, and other genres. This range set these women apart from twentieth-century academia with its sharpened disciplinary boundaries.

Literature. Literature was the one area in which women's historical contributions were valued and retained in collective memory. As I have pointed out before (Stone 2023: 45–46), a telling indicator is the selection of books from Mark Pattison's library which was donated to Somerville College in Oxford in 1884. These were the books deemed useful models for students of 'the best that has been thought and said', in Matthew Arnold's phrase. The few items by women were almost all literary: travel writing (Sarah Austin), novels (Jane Austen), poetry (the anthology 'The Female Poets'), and correspondence (the letters of Madeleine de Sablé and Marie de Sévigné). The sole exception is Dilke's *Renaissance of Art in France*, which was only included because she had been Pattison's wife. As Judith Johnston (1997) has observed, although nineteenth-century women 'were enormously productive and successful, as translators, biographers, historians, philosophers, critics and editors', 'women's fiction writing has been…privileged over non-fiction' (17).

In part, fiction was privileged in a defensive reaction to the rise of specialization. Take the words of Richard Garnett (writer, encyclopaedist, and Keeper of Books at the British Museum), prefacing Mathilde Blind's *Poetical Works*. Blind, he says, was 'attracted by those female writers who have shown that *in certain fields* women can rival men. George Eliot…George Sand…Mrs Browning's "Aurora Leigh"' (Garnett 1900: 19; my emphasis). That is, women could equal men in *literature*, an increasingly plausible claim in a context where women generally lacked the academic credentials that were now required for non-fiction intellectual work but not for being novelists or poets.

For the same reason, first-wave feminists selectively highlighted women's literary contributions, it being much easier to make the case for women's achievements in this domain. A revealing example is the *Eminent Women* book series of the 1880s–90s which, under the general editorship of John Ingram, was heavily slanted to writing and the arts. Its twenty-two titles covered eight writers: Eliot, Austen, Barrett Browning, Emily Brontë, Sand, Mary Lamb, Maria Edgeworth, Mary Shelley; two actresses: Rachel Félix, Sarah Siddons; three members of royalty: the Countess of Albany, Margaret Queen of Navarre, Queen Victoria; one reformer: Elizabeth Fry; and two religious figures: Teresa of Avila, Susanna Wesley. Of the other six—Margaret Fuller, Harriet Martineau, Mary Wollstonecraft, Marie-Jeanne Roland, Germaine de Staël, and Hannah More—Roland was approached as a political actor, and More, Wollstonecraft, Fuller, Martineau, and Staël in terms of their lives and literary work. Thus, at least 60% of the featured women were presented as writers.

Exceptionality. Garnett's prefatory remarks about Blind illustrate another recurring trope for intellectual women to be badged as 'exceptional'. An

anonymous retrospective essay on Dilke's work published in the *Quarterly Review* exemplifies the use of this trope:

> The small band of Englishwomen who, by their writings, have proved that the feminine intellect, in its highest development, is on a par with that of man, have had one feature in common. By the bounds which they have imposed on their talent…they have shown, the less extended the area in which they have worked, the greater…their achievement. The work of Jane Austen is the produce of a very limited horizon.… The small production of Charlotte Brontë…was likewise drawn from a circumscribed area.… [Emilia Dilke] was probably the equal in intellect of any of these…The other women whom we have quoted as displaying mental powers equal to those of men won their fame in the realm of the imagination. That of Lady Dilke will rest on…'the philosophy of aesthetics, the history of art'…Very rare are the names either of women or of men who could have accomplished her work. (Anonymous 1904: 439–443)

In short: it is exceptional for women to excel, but they can if they narrow down and specialize; they have excelled most often in literature; but Dilke excelled in non-fiction, so she was doubly exceptional. The silence about Jameson speaks loudly here: presumably she failed to impose suitable limits on her talents. Yet Jameson in turn had been described as being 'among the small list of illustrious women who have done real work in connection with painting and sculpture' (Anonymous 1878: 1470) and as 'almost unrivalled' (Anonymous 1860a: 1). When woman after woman is described as exceptional and singular, it becomes apparent that these are not statements of fact but repetitions of a trope. That trope, as Anne Pollok has acutely shown, implies that since a thinking woman is the exception, an unthinking woman is the norm (Pollok 2022).[8] That is, the trope obscures the reality that it was *not* exceptional for women to think and write, whether on art or anything else. The apparent praise of individuals like Dilke and Jameson submerges women's broader intellectual participation and presence.

Modernism. Another crucial factor in the forgetting of these women philosophers of art was the rise of modernism. Modernism broke with the past, with tradition, and with the perceived failings of the inherited social world. That inherited world was Victorian. Lytton Strachey's irreverent demolition of the moral pretensions of the *Eminent Victorians* was emblematic (Strachey [1918] 2009). Of course, modernism was born from the womb of Victorian culture, but it rejected its parent all the more strongly for that, in order to cut the apron strings tying it to the past.

[8] See also Israel's (1999) insightful exploration of the trope of Dilke's exceptionality.

Part of what the modernists rejected was Victorian periodicals culture, in which literature appeared serialized, not as self-contained great works, and where serial instalments rubbed shoulders with essays, reviews, and other miscellanea. This context was commercial: journals competed for markets and audiences in a fast-paced marketplace, in which critical or positive reviews performed commercial roles.[9] Reviews, as Laurel Brake et al. (2022) point out, blended into advertisements or 'puffing' (164–165). The same social world had made visual art much more accessible than before, with guidebooks, galleries, print reproductions, photography, exhibitions, reviews of exhibitions, illustrated magazines, all busily circulating (Cherry 2000: 33–34). The outcome was a 'picture world', as Rachel Teukolsky (2020) calls it. This realm of commercial exchange amongst pictures, words, periodicals, and money was part of what modernism turned against.[10] Championing artistic purity and autonomy, many modernists celebrated the great artwork conceived as a self-contained item, held above commercial society and its supposed flood of low-quality trash and hack writing (for a critical account, see Carroll 1998).[11]

The modernists did not only repudiate the periodical milieu in which our women published because it was contaminated by commerce. In addition, much periodical output had been anonymous and part of a collaborative conversation, but this made no sense in an outlook on which great artworks resulted from great artists viewing the world from their singular perspectives. Furthermore, the modernists sought to separate art from other extraneous influences such as religion and morality. By the same token, modernism rejected *theories* of art which foregrounded religion and morality. This rejection affected men like Ruskin as well as women, but it particularly bore on women, who had so often approached art in moral terms.

The figure of the prudish, moralistic Victorian woman personified all that the modernists sought to leave behind. As William McCarthy (2008) has explained, this accounts for Barbauld's twentieth-century disappearance. Her

> oblivion resulted from a literary revolution as thoroughgoing as any political revolution. With almost all the literary women of her time, Barbauld was dropped from literary history when twentieth-century literary modernism repudiated everything that seemed to it 'Victorian'. The spirit of that repudiation, and its association of 'Victorian' with women who are presumed elderly,

[9] On these features of nineteenth-century print culture, see Rubery (2010), and on the commercial role of art criticism, Flint (2000: 173–6).
[10] On the modernist dichotomy between literature and journalism, see Strychacz (1993).
[11] For a key statement of the modernist programme for the arts to achieve purity and raise themselves above entertainment and commerce, see Greenberg ([1965] 1982: 5–6).

repressed, and foolishly high minded, is on display in *The Importance of Being Earnest*. (xiii)[12]

McCarthy refers to Wilde's ([1895] 1920) character Miss Prism, 'a female of repellent aspect' who enforces the virtuous study of political economy and sums up: 'The good ended happily and the bad unhappily. That is what fiction means' (46). This surely sounds like Martineau.

The example of Wilde reminds us that the aestheticists prefigured the modernist turn against Victorianism. Consider Mr Babcock in Henry James' ([1877] 1879) novel *The American*. Babcock is a representative Victorian moralist, a Unitarian minister who carries Jameson's works everywhere. 'Poor Mr. Babcock was extremely fond of pictures and churches, and carried Mrs. Jameson's works about in his trunk' (64). Babcock shows his prudishness when he refuses to believe a story that a young woman had a love affair with a man without wanting him to marry her. 'Babcock had related this incident to Newman, and our hero [i.e., Newman] had applied an epithet of an unflattering sort to the young girl' (James [1877] 1879: 65). Babcock, shocked, defends the woman. His supposedly 'exquisite' sense of beauty is misguided: he cannot accept that beauty and morality are separate, so that beauty and immorality may go together without this vitiating the beauty. He refuses to believe that a beautiful exterior may conceal immoral behaviour, with women as with art.[13] Here James makes a set of symbolic equations: Victorian culture–aesthetic moralism–sexual repression–religious piety, all condensed in Babcock's idol, 'Mrs Jameson'.

This sheds light on why Barbauld, Baillie, Jameson, and Cobbe were not covered in the *Eminent Women* series. The contributing authors were in an aestheticist social network that centred on the Rossettis (see Macleod 2016), whereas Jameson and the others embodied the older moral and religious outlook that was being rejected. Lee, on the other hand, *was* part of the *Eminent Women* network, authoring its volume on the historical figure the Countess of Albany. Lee's membership in these aestheticist circles is probably another factor in her determination to separate herself from 'Mrs Jameson'. After all, she admired Henry James greatly, dedicating her novel *Miss Brown* to him.[14] Yet Lee went on to fall foul of anti-Victorianism herself. By the 1920s, as Vineta Colby (2003) writes: 'Reviewers

[12] Christa Zorn (2003) concurs: 'When modernism...became the dominant literary trend, women writers of the previous era were snubbed for their moral tone...or their lack of disinterestedness' (xv).

[13] Of course, this imaginary woman's behaviour is not really immoral, but James assumes it is.

[14] I suspect that the above passages from James's *American*, together with Lee's admiration for James, explain her remark that women's art-writing was held in contempt (mentioned in Chapter 1, note 34). As I observed earlier, this remark is prima facie puzzling because Jameson's work was widely respected. But it was *not* respected by James or the other aestheticists, hence Lee's remark. Not surprisingly, James was not keen on Lee's *Miss Brown* either, for though she dedicated the book to him, it criticized the men of the Aesthetic movement. James and Lee became friends anyway, only to fall out again over Lee's portrayal of James in her 1892 story 'Lady Tal' (see Colby 2003: 190–9).

and the reading public alike had relegated her to the Victorian age, which... carried the stigma of obsolescence and irrelevance' (310). Lee internalized this stigma, fearing that her work on art-philosophy had been 'utterly wasted' and that her books were merely 'those of an amateur and jack of all trades', the joint forces of specialization and modernism having left her behind (VL to Roger Fry, 31 January 1933, in Lee n.d.).

Compounding and augmenting one another, these factors meant that by the 1920s people barely knew of such women writers on art as Baillie, Jameson, Cobbe, and Dilke. This laid the ground for critical analyses like Virginia Woolf's. Writing when women's earlier intellectual work had been eclipsed, she mistakenly argued that women had been prevented from speaking in the first place, and that genius in women had 'certainly never got itself onto paper' (Woolf [1929] 2014: 40). Some of Woolf's claims belied her analysis. She spoke of 'Buckles, Taines, Paynes, Tuppers, Jamesons—all vocal, clamorous, prominent, and requiring as much attention as anybody else' (Woolf [1928] 1995: 143). Jameson *had* been vocal, clamorous, and prominent, as Woolf almost recognized—but not quite.[15]

The situation deteriorated further by the later twentieth century. By that time, on the rare occasions when these women were mentioned at all, the mentions tended to be disparaging and patronizing: e.g., 'Anna Jameson...offered a fairly orthodox, if inaccurate reading of Raphael's cartoon' (Wheeler 1999: 98); Charles Dilke 'carried on a very strange correspondence about the...soul...with a Miss Cobbe, the author of a little book entitled *Hopes of the Human Heart*', actually *Race* (Jenkins 1958: 91); 'Unlike Ruskin, who possessed wide knowledge...Lee had no single area of expertise...Her knowledge and her style...were emotional, intuitive, and impressionistic' (Feldman 2002: 198).

Or consider Phyllis Grosskurth on Clara Thomas's important biography of Jameson. Having dispatched Thomas's book—'not a work of art'—Grosskurth (1967) offers her own résumé of the salient facts about Jameson:

> A suitable suitor did not come along....While still a young woman she created quite a flurry of welcome attention with *Diary of an Ennuyée* and *Characteristics of Women*. These books opened up...fascinating connections for her...a suitor did eventually turn up...She probably could not have made a worse choice...she left her husband forever...scraped along...She also enjoyed a degree of increasing fame for a series of art books....The person who emerges from this biography is a self-willed, impulsive, chubby little woman, not entirely likable. But that was the sort of person an emancipated Victorian female had to be. (279)

[15] Nor did Woolf acknowledge any women of letters in the eighty years before her. This accentuated her own originality, as Schaffer (2000: 194–6) and Zorn (2003: xiii–xv) suggest.

Grosskurth judged this major female intellectual on her life, marriage, physique, famous connections—anything but her theories, dismissively passed over as 'a series of art books'. This contrasts sharply with the respectful tone of earlier work on Jameson (e.g., Erskine 1915; Needler 1934). In a slightly different vein, again in the 1960s, the critic Eli Siegel highlighted Jameson's alleged lifelong bitterness, pain, and loneliness due to her failed marriage. It failed, Siegel says, for 'it was very hard for the men of 1800 to 1900 to think that a person whose body they went after could have any mind' (Siegel 1969). This rather anachronistically makes Robert Jameson sound like a man of the sexual revolution, though he actually supported Anna's intellectual interests and arranged for the publication of her first book (Thomas 1967: 27–28). Siegel has more sympathy for Jameson than Grosskurth, but again he privileges Jameson's life and feelings over her ideas.

One might object that I am cherry-picking the worst of the twentieth century and the best of the nineteenth, but if I am, it is in the service of a broader thesis. The nineteenth century was not always as bad as we like to think it was, and we are not always as good as we like to think we are. After all, the twentieth century, not the nineteenth, is when these women philosophers of art were consigned to oblivion, a thesis that I hope this book has substantiated.[16]

This is not to deny that in their own time, nineteenth-century women faced serious obstacles and encountered a good deal of sexism. One case that is often mentioned is Ruskin's remark in a letter to his father that Jameson 'knows as much of art as the cat'. I have deliberately postponed discussing this remark, which cultural historians frequently quote.[17] In my view, it is *over*-amplified. Though merely a private remark, it is constantly referenced, whereas the dozens of laudatory and often lengthy *published* reviews of Jameson's work are rarely mentioned or examined. After all, we see the Victorians as peculiarly sexist, so statements like Ruskin's, which confirm our expectations, stand out to us as salient.

Ruskin's remark is amplified with good intentions, namely to highlight and criticize his sexism. But we should be cautious about assuming that Ruskin typifies prevailing views of Jameson. His remark is perhaps better seen in the way that McCarthy views Coleridge's snipes at Barbauld. He used these snipes to get ahead of a key female competitor and assert his greater authority (McCarthy 2008: 145–150). Similarly, when Ruskin made his remark in 1845, he must have viewed Jameson, who had been internationally renowned since the early 1830s, as a rival.

[16] My thesis chimes with Paula Feldman's (2002) argument that the obscurity of women Romantic poets 'has been due not to silencing in their own time but largely to their erasure by literary historians...from the early part of the twentieth century' (284). Scholars persist in thinking that the erasure must have happened in the Romantic era, but Feldman insists it did not, and 'says more about the twentieth century than the nineteenth'.

[17] See, e.g., Anderson (2020: 40), Clarke (2019), Ludley (1991: 33), Wheeler (1999: 71), Fraser (2014: 2), Johnston (1997: 175). It can be quite hard to find work on Jameson that does *not* mention Ruskin's remark.

In the same letter to his father that disparaged Jameson's knowledge of art, Ruskin went on to describe overhearing a woman who was sitting near him and Jameson say—about Jameson—'Look at that woman my dear. She's an authoress. I'm certain of it' (Ruskin to his father, 28 September 1845, in Ruskin 1972: 215–216). Jameson was more recognizable than Ruskin, and suffering from status anxiety he reasserted his superior knowledge. Or so I would suggest; even if my interpretation of Ruskin seems unpersuasive, his letter inadvertently shows that Jameson was once so famous that a random stranger in a hotel could recognize her as a renowned author on sight.

Jameson fell from international fame into twentieth-century invisibility due to the historical dynamics I have traced in this section. These dynamics had a similarly negative effect on the posthumous reputations of the other six women philosophers of art discussed in this book. Telling the story of these dynamics has been rather depressing, but I hope that the overall message of this book is a positive one. There were many women philosophers of art in nineteenth-century Britain, and they had interesting and original things to say. They pursued ambitious projects and advanced some compelling arguments. We can still enjoy reading their work and thinking with them about art. I hope that we are ready to rewrite our narratives about the history of aesthetics, and take these significant women thinkers into account.

Women on Philosophy of Art: Britain 1770–1900. Alison Stone, Oxford University Press. © Alison Stone 2024.
DOI: 10.1093/9780198918004.003.0010

11
Additional Women Philosophers of Art
Beyond the Frame

11.1 Introduction

This book has not covered all the women who wrote philosophically about art in nineteenth-century Britain, for there were many more such women than I could fit into a manageable narrative. I faced difficult choices about whom to include and omit. Barbauld (1810) admitted, regarding her canon of British novelists, that 'No two people probably would make the same choice, nor indeed the same person at any distance of time...the list was not completed without frequent hesitation' (61). This suggests a view of canons as partial, provisional, contingent constructions, guided by particular interests and agendas. Canons do not simply track the objective truth of what is best. They reflect judgements and choices that others may always challenge, and Barbauld suggests that we should openly acknowledge as much.

In this Barbauldian spirit, I have focused on a line of seven interconnected women philosophers of art in this book, conscious that we could instead bring forward different women, and our narrative would change. To use my metaphor from an earlier chapter, we could twist the cell of our kaleidoscope and a fresh configuration would come into view. I cannot here provide that alternative configuration, but I do want to point to a handful of the women whom I left out, as a gesture towards the rich wider world of women's art-thought beyond the frame imposed by this book. After all, I have taken issue with scholars who have omitted women from the canon of aesthetics and philosophy of art, so it would be inconsistent to present my seven women as a new canon without acknowledging that this presentation inevitably creates omissions and silences of its own.

11.2 Callcott and Merrifield

I begin with two women who perhaps qualify more as art critics than art philosophers, fuzzy though this divide is: Maria Callcott, née Dundas (1785–1842), and Mary Merrifield (1804–89). Widely travelled, Callcott produced travel

writings, contributions in geology, and—in terms of art—a guide to Giotto's chapel in Padua,[1] and the signed *Essays Towards the History of Painting* of 1836.[2]

These *Essays* were part-historical, part-systematic. On the systematic side, Callcott put forward a taxonomy of types of paintings: ethical or didactic; epic; historical; and dramatic (Callcott 1836: 175). Roughly speaking, these types exhibit a progression from more allegorical and indirect to more realistic. Presumably Callcott intended this to map onto her historical progression, though she did not make the links explicit. On this historical side, she traced art from the indigenous peoples of North and South America through China, India, Chaldea, and Egypt into ancient Italy and Greece. As each civilization rose and fell, so did its art (9–10). The overall movement was progressive, for Native American and Māori painting were merely 'savage' (9), Chinese painting was 'insensible to that standard of taste which all the rest of the world acknowledges' (17), and Hindu painting was 'florid' and 'exaggerated' (21). Callcott's account, in short, was Eurocentric, leading up to ancient Greek art. But her history stopped, rather abruptly, with the decline of ancient Greece. After then, she claimed, European painting had languished until its 'first faint revival' in the Renaissance (168–169). She intended to write a *Continuation of the Essays on the History of Painting* tracing art's development in Europe, but this was never finished due to ill-health. (Callcott shared a draft with Joanna Baillie, who sadly remarked: 'She gave me a copy of her last Essay on the history of Painting which she expects to be the last thing she shall ever write'; JB to Miss Montgomery, 1836, in Baillie 1999: vol. 2: 872).

Callcott's taxonomy of kinds of painting drew on her considerable knowledge of the technical side of painting, and this last forms a point of commonality with Merrifield, who wrote primarily on the technical and practical side of art, having undertaken scientific research into topics such as the chemical composition of paint.[3] But Merrifield also wrote some more philosophical essays, including 'The Harmony of Colours' (1851) and *Dress as a Fine Art* (1854), both signed. In the latter she argued that dress need not be merely frivolous and trivial but could, by

[1] Jameson knew and was influenced by Callcott's book on Giotto's chapel. In *Memoirs of the Early Italian Painters*, Jameson admired and copied one of the illustrations that Callcott's husband had contributed to the book. Compare his sketch of one of Giotto's women (in Callcott 1835: 6) with Jameson's (1845: vol. 1: 37).

[2] On Callcott's art writing, see Collier (2012), Lloyd (2001), and Palmer (2019). Her second husband, Augustus Callcott, was a painter whose reputation rivalled Turner's at the time. Unfortunately, Ruskin ([1843] 1848) savaged him in *Modern Painters*: 'On the works of Callcott, high as his reputation stands, I should look with far less respect...He painted everything tolerably, and nothing excellently: he has given us no gift, struck for us no light, and though he has produced one or two valuable works...they will, I believe, in future have no place' (93). Ruskin's authority meant that his attack became a self-fulfilling prophecy.

[3] On Merrifield's writings on art, see Bomford (2017, 2019), Loske (2017), and Palmer (2013).

the application of principles of proportion and harmony of colour, become an art-form in its own right.

Merrifield criticized the fashions of her day:

> What pains we take to distort and disfigure the beautiful form that nature has bestowed upon the human race!...confining the body in a case of whalebone, and compressing it at the waist like an hour glass...till the outline of the figure is so altered, that a person can scarcely recognize her own shadow as that of a human being. (82–83)

Merrifield was objecting not only that prevailing fashions harmed women but also that they disfigured the body's naturally harmonious form. Instead, dress should improve and build on nature, based on a sound grasp of the principles that make it beautiful (106–108). If dress was put on a sound basis in that way, it could provide a useful everyday source of education in beauty (82). Merrifield thus neatly tied her feminist concerns into her philosophical view that art could achieve beauty by drawing on the same principles that give rise to natural beauty.

11.3 Ellis

The idea that art beauty must draw out natural beauty was developed more systematically by Sarah Stickney Ellis (1799–1872) in *The Beautiful in Nature and Art* (1866). This was not her only text on philosophy of art; others were 'An Apology for Fiction', the preface to her *Pictures of Private Life* (1833), and *The Poetry of Life* (1835), in which she classified different kinds of poetry. *The Beautiful, Pictures, and Poetry* were all signed and, moreover, formed just one branch of Ellis's large oeuvre. But *The Beautiful* was her most substantial work on aesthetics, so I shall focus on it here.[4]

Ellis (1866) defines aesthetics as 'the science which treats of the perception of the beautiful in nature, in art, and in literature' (76). The beautiful in nature is fundamental and underpins the beauty of art and literature. There are five fixed principles, Ellis argues, that make certain natural objects beautiful (173, 205). These are: (1) Symmetry and proportion of form; and (2) Harmony and balance of colours. (3) An object's form gives it a *character*, certain essential qualities or defining characteristics that mark it as the individual object it is (157). (4) An object's character has an 'ideal' or 'spiritual' dimension, the meaning or significance it embodies (9)—such as the nobility of a horse, the gracefulness of a face, or the brooding quality of a mountain range. (5) Through all these features,

[4] There is remarkably little interpretive work on Ellis's aesthetics; I have only found Carlson (2011).

certain objects please us by affording 'refreshment'—relief from care and pressures, invigoration, expanded horizons—and by elevating us to perceive spiritual significance in material things (11–12). The more of features 1 to 5 a natural object has, the more beautiful it will be.

To achieve beauty, art must be based on observation of natural beauty and its component qualities. By observing nature closely enough, the artist can make a beautiful artwork.[5] In particular, the artist must draw out the spiritual meanings of natural things by carefully observing the physical features (characters) that embody them. 'The higher the reach of art, the more it is dependent upon character, and the more it embodies and develops character in its operations', where 'character is the *ideal*—the spiritual essence of art' (256). Ellis means the character of the natural objects depicted, but she also believes that viewing and making art develops *our* virtues of character, particularly truthfulness (5, 21, 190). The attempt to capture the character and spiritual meaning of natural objects fosters virtues of character in the artist.

Art draws out the meaning of objects, and so art relates closely to symbolism, and objects depicted in art tend inevitably to acquire symbolic significance (61–63). However, a danger arises for art here: once established, symbolic meanings can harden over time and become merely conventional. Then artists may begin to depict objects that are not in themselves beautiful—they may have disproportionate shapes or clashing colours—but which artists portray anyway on account of their symbolic connotations (67). But from Ellis' perspective the resulting artworks cannot be genuinely beautiful, and really their value is only to reveal the ideas, values, and associations of their historical periods (79).

To avoid art veering in this overly symbolic direction, artists need to strike a balance between nature and ideal. Art should delineate natural objects as they are, with their inherent characters and meanings, drawing out their ideal element, perhaps through symbolism. Yet this meaningful and symbolic element should not come to outweigh what nature supplies. This can be avoided if the artist takes care to be truthful to nature and starts with close observation. Hence the importance of artists developing the virtue of truthfulness, which enables them to keep their art properly anchored in nature.

Ellis discusses other issues, for instance providing a narrative of art's history over the different world civilizations (akin to Callcott). One interesting feature of Ellis' history is her appreciation for ancient Egyptian art. For her, the Egyptians initiated art properly speaking, as we see from the pervasively symbolic nature of their art (ch. 6). Ellis treats ancient Greek art and culture as deriving completely from Egypt, and she acknowledges that Egyptian art derived from earlier art

[5] Ellis admits that her theory really only applies to visual art—drawing, painting, sculpture, and architecture. She brackets music, saying that music neither leads us to observe nature nor derives from observation of nature. Music is instead a self-contained sphere (13–18).

traditions in sub-Saharan Africa (61). This was a departure from the view that classical Greece originated Western art and culture in a radical break from the civilizations before it, a view that was becoming increasingly standard in Ellis' time. Ellis instead placed Africa at the origin.

Ellis' book has very few references: only around six citations altogether, largely to John Ruskin and, likewise approvingly, to Anna Jameson. In some ways, Ellis' foregrounding of natural beauty sets her apart from the seven women philosophers studied in this book, who were overwhelmingly concerned with the arts. When nature and its aesthetic qualities came into these women's thinking it usually crept in around the margins. Cobbe gave the greatest role to nature, and Ellis' position is closest to Cobbe's (their accounts came out near-simultaneously). For Cobbe, art was beautiful when it copied natural beauty, God's self-revelation in created nature. Yet, as we saw, Cobbe regarded nature as the primary artwork, the product of God's artistic creativity, in line with the tendency to assimilate the aesthetic domain to that of art. Ellis reverses things, making art beauty dependent on the beauty that nature has independently.

However, in two important ways Ellis' work remains continuous with our other seven women. First, her central category is the beautiful, and she includes the sublime only as a form of the beautiful, not a category in its own right (259). For Ellis, many natural objects are beautiful—they are harmoniously formed, meaningful, and pleasing—and we get no sense from *The Beautiful* of a nature that is chaotic, disturbing, and exceeds our capacities to make sense of it. Second, even though Ellis grounds art beauty in natural beauty, her principal concern is with how the artist can produce beautiful works by starting from close observation of nature. Her focus is quite practical, perhaps because she wrote primarily for young women, intending to guide them in their artistic practice. Given this focus, Ellis is still ultimately interested in nature as it bears on the making and appreciation of art, rather than in theorizing natural beauty in its own right.

11.4 Eastlake

Elizabeth Eastlake, née Rigby (1809–1893), is the woman I have had most qualms about omitting. She was very renowned, a close second to Jameson, for her extensive body of writing on art. She produced literary criticism and travel writing, translated German works on art, ventured searing critical evaluations of Ruskin and Charlotte Brontë, completed the final two volumes of Jameson's *Sacred and Legendary Art* series as *The History of Our Lord as Exemplified in Works of Art* (Jameson and Eastlake 1864), and authored a stream of journal articles spanning several decades on topics such as 'Music' (1848), 'Madame de Staël' (1881), and *Five Great Painters* (1883). Many of these articles appeared anonymously in the conservative *Quarterly Review*, one of the most prestigious Victorian periodicals. Her

husband Charles Eastlake was President of the Royal Academy and the first Director of the National Gallery, so that the two formed a powerhouse couple at the heart of the British art establishment. Eastlake's interests, like Jameson's, ranged widely, but art was her abiding concern, and one often finds Eastlake described as an art historian. This should not obscure the philosophical relevance of some of her work. Two cases in point are long essays on Ruskin and photography, from 1856 and 1857, respectively, and both anonymous *Quarterly Review* pieces.[6]

Ostensibly reviewing the first three volumes of Ruskin's *Modern Painters*, Eastlake makes some harsh criticisms of Ruskin through which she also advances her own conception of painting. She rejects his 'first fundamental false principle' that 'the language of painting is...invaluable as the vehicle of thought, but by itself nothing' (quoting Ruskin [1843] 1848: 8). Eastlake counters: 'The only way to arrive at the true end for which an art is valuable...is by determining those qualities which no other art but itself can express' (Eastlake 1856: 388). Painting's purpose is to do what *only* painting can do.

> This being accepted as a law, we suspect that wherever an art admits of marriage with another art, or another faculty, the union can only be effected by diverting the field between them; or in other words, that the more of art the less of superadded thought will a picture be found capable of containing, and vice versa. (392)

In treating painting as a vehicle of thought, Ruskin has confused painting and poetry, but they are fundamentally different arts. Poetry's medium is words, which are arbitrary signs invested with thought. In contrast the medium of painting is *'things'*—'form, colour, and shadow and expression...the great and sole constituents of *every* natural object' (394–395). Painting is pictorial; it depicts—a key distinction between linguistic description and depiction that would only be thematized by analytic philosophers a hundred years later (see Hyman and Bantinaki 2021).

Eastlake understands depiction in terms of resemblance. She maintains that by copying the forms, colours, shadows, and expressive qualities of natural objects, the painter produces a depiction that resembles these objects. But crucially, for her, this is *all* the painter should be doing, because depicting the sensory world is proper to painting. Painting should be representational, and *only* representational. If the painter instead tries to 'teach...religion and morality' (Eastlake 1856: 404), investing her work with 'superadded thought', then the art will suffer for it. By imbuing 'superadded' meanings into her depictions, the artist will distort her work and incorrectly hybridize it with poetry.

[6] The most comprehensive bibliography of Eastlake's writings is Sheldon (2009). On Eastlake, see inter alia Anderson (2020), Ernstrom (2012), Lochhead (1961), Kanwit (2013), Miles (2008), Mitchell (2008), Palmer (2017), and Robinson (2003). Eastlake's memoirs (1895) are informative too.

On this last point, it may seem that Eastlake differed from many of the women on whom this book has focused. Baillie saw drama and the theatre as vehicles of moral instruction, and Harriet Martineau took a similar view of literature, in even stronger terms. To be sure, they were concerned with writing, not painting. But Jameson, after her pictorial turn, thought that the majority of European art instilled morality through its religious iconography. Eastlake, in contrast, singled out some of the same art—especially the *Sistine Madonna*—as being supremely good *because* it dispensed with superadded thought and only depicted the sensory world (396). Evidently Jameson's and Eastlake's close friendship, and Eastlake's deep admiration for Jameson, coexisted with serious differences of opinion. In her Ruskin essay at least, Eastlake drew near to the aestheticism overtly defended a decade later by Emilia Dilke and Walter Pater.

Eastlake's Ruskin essay, it must be said, does not entirely fit together with her argument regarding photography. To complicate things further, this argument itself has been widely misunderstood, or so I believe. Eastlake (1857) argues that photography is deficient as art because it reproduces the minute details of everything, placing them all on a par without discrimination or selection. Photography conveys these details simply as they present themselves, with no exercise of judgement. It performs 'all that requires mere manual correctness, manual slavery, without any employment of the artistic feeling' (465). These critical remarks have led to the widespread view that Eastlake is a conservative critic of photography who denies it the status of an art.[7]

However, we should note that Eastlake says positive things about photography too. It captures ephemera that might have escaped human notice, and it brings a precision and exactitude far beyond the powers of the human eye. 'Here, therefore, the much-lauded and much-abused agent called Photography takes her legitimate stand. Her business is to give evidence of facts, as minutely and as impartially as, to our shame, only an unreasoning machine can give' (466).

Still, putting these points together, Eastlake does deny that photography is an art, on the grounds that it involves no creative freedom or judgement.

> The power of selection and rejection, the living application of that language which lies dead in his paint-box, the marriage of his own mind with the object before him, and the offspring, half stamped with his own features, half with those of Nature, which is born of the union—whatever appertains to the free-will of the intelligent being, as opposed to the obedience of the machine—this...constitutes that mystery called Art. (466)

[7] Rachel Teukolsky (2020), for instance, treats Eastlake as a critic of photography (278). She also criticizes Eastlake for employing a gendered divide between feminine devalued photography and masculine valued art—but Eastlake (1857) uses 'she' of *both* art and photography as abstract concepts (e.g., 464).

Importantly however, Eastlake does *not* think that photography is worthless. On the contrary, the very same features that prevent photography from being an art give it legitimacy, including the legitimate value of service to art. Responding to those who proclaim that photography is destined to supersede art, she replies that photography cannot and will not supersede art proper. But it *will* supersede the nine-tenths of artistic effort currently expended on making bad art that merely reproduces material reality in slavish manner. 'For everything for which Art…has hitherto been the means, but not the end, photography is the allotted agent' (465). By taking this menial work off our hands—which 'relieves the artist of a burden'—photography will liberate artists to make genuine art. Thus, in the post-photographic era much less art will be made, and photographs will become numerically more prevalent than artworks. Yet the art remaining will be far more genuinely artistic. It will be better art, properly concentrated on creativity. As such, we should welcome the advent of photography. By taking over the mechanical part of art, photography will liberate art's full creativity at last (466–467).

We now see the tension with Eastlake's critique of Ruskin. Previously, she argued that depiction was particular to painting. Now, only a year later, she suggests that accurate depiction can be parcelled out to photography, freeing art up to express the artist's creative vision in which their mind and the object fuse together. Perhaps Eastlake has revised her understanding of pictorial depiction. 'Correctness of drawing, truth of detail…literal, unreasoning imitation'—none of these truly belong to painting, she now claims (466). Rather, painting employs form, colour, shadow, and expression to depict objects as they appear *to us*— hence the marriage of the artist's mind with the object. Painting's task is to depict objects in the way they visibly look to the human eye and mind, not in their exact mind-independent detail. Yet if this is now Eastlake's understanding of painting, it pushes her back significantly closer to Ruskin and to the view that painting is always about things invested with thought and infused with meaning.

One thing we can certainly say is that Eastlake was prescient about how painting would reinvent itself in photography's wake. Effectively relinquishing realistic reproduction to photography, the Impressionists and subsequent generations of modernists adopted new techniques that moved painting further and further away from straightforward representation. This chimes with Eastlake's prediction that photography would release art from the essentially extraneous task of accurately representing the objective details of the world.

11.5 Anstruther-Thomson and Naden

My final two figures, Clementina Anstruther-Thomson (1857–1921) and Constance Naden (1858–89) are later-century writers united in approaching art in relation to our bodies as living organisms.

Anstruther-Thomson's work has tended to be incorporated under that of Vernon Lee, her partner and intellectual collaborator for ten years after they met in 1888. Lee may not have had the interpretive attention she deserves, but she has at least had more attention than Anstruther-Thomson. Indeed, disentangling Anstruther-Thomson's thought from Lee's is difficult because Lee's editorial hand weighs so heavily upon their joint productions.[8] The two co-wrote the signed, multipart, *Contemporary Review* essay 'Beauty and Ugliness' (1897a, 1897b), with Anstruther-Thomson providing the parts describing the first-person bodily impact of certain encounters with art-works, and Lee supplying the philosophical theory. Considerably later, Lee edited a posthumous collection of Anstruther-Thomson's writings, *Art and Man* (Anstruther-Thomson 1924).

Even viewed through Lee's editorial prism, these writings make clear that Anstruther-Thomson was independently interested in the physicality of our aesthetic responses—nerve-stimulations, respiratory changes, muscular reactions. As Lee narrates matters, on their gallery visits Anstruther-Thomson would 'compare how the various works of art *made her feel*', transforming the question 'What is a work of art?' to 'What does it do for us, *or rather with us?*' (Lee 1924: 28). She reconceived artworks not so much as objects but more as powers to affect us in variable ways, depending on what our bodies bring to the encounter. Reciprocally, Anstruther-Thomson saw our judgements about and emotional responses to artworks as being rooted in and constituted of bodily reactions, most of which occur below the threshold of awareness, although we can train ourselves to notice them. Artworks are bundles of powers rather than objects, and our responses to these works are bundles of physical reactions rather than anything spiritually exalted. Stimulation and respiration replaced detached contemplation.

Lee became Anstruther-Thomson's pupil, she reports, venturing out of the rarefied atmosphere of literature and theory to feel her own corporeal aesthetic responses and pay attention to her physical sensations (28–29). She tried out an empirical method of asking individuals to observe and record their aesthetic feelings as registered in their bodies.[9] Lee eventually came to think that Anstruther-Thomson had over-emphasized the strictly physical side of our aesthetic responses (34). Yet Lee remained convinced that Anstruther-Thomson had recognized something important that much art criticism missed out.

Rather like the way that Anstruther-Thomson shifted focus from the artwork to the embodied experiencing subject, Naden argued that beauty was nothing objective but rather that we have naturally evolved to sense certain phenomena to be beautiful. Naden ([1884] 1991) accordingly turned to evolution to explain why we find certain phenomena beautiful (78). This was in her main paper on

[8] However, Maltz (1999) has done fine disentangling work.

[9] On Anstruther-Thomson and Lee's relationship and its bearing on their aesthetics, see Psomiades (1999); and on their theory of empathy, see Morgan (2012).

aesthetics, 'The Evolution of the Sense of Beauty', given as a talk in 1884 and published in her posthumous collection *Further Reliques* in 1891.[10]

Focusing first on the sense of visual beauty, Naden argues that certain colours and forms give us sensory pleasure. The exercise of any bodily function is pleasurable, so long as it is not over-exercised—any animal that did not enjoy the normal exercise of its functions would soon perish (82). 'The greatest pleasure is…derived from the maximum of activity with the minimum of fatigue' (83). This requires varied stimuli (to avoid both over-exertion and inertia), and smooth transitions between stimulation and rest. On this basis we can explain pleasure in strong colours, and especially, complementary contrasts, in which each set of optic nerves—e.g., those sensitive, respectively, to red and bluish-green waves—is alternately rested and stimulated, in easy transition (86). Pleasure in certain forms can be explained along similar lines, Naden proposes. Curved lines 'afford an exercise more varied than that given by straight lines, and less fatiguing than that given by angles' (91); likewise for symmetrical arrangements. And so, like birds, we enjoy 'contrasts of bright colour and…varieties of curved form' (94). We feel these phenomena to be beautiful just because we take this organic sense of pleasure in them.

As Dilke had done, and as Lee too had done in places, Naden grounds the sense of beauty in certain organic, bodily, sensory pleasures. But unlike Dilke and Lee, Naden is an avowed subjectivist, for whom the sense of beauty derives from our pleasure in exercising our sensory powers, not directly from any properties of objects, even though these properties occasion the exercise of our powers. Moreover, Naden adds a further strand of argument that moves things away from the body. Given our evolutionary history, she says, we can understand why 'savages' enjoy brilliant colours and sharp contrasts. But as civilization progresses, people tire of the obvious and seek out more subtle and subdued contrasts and balances, causing the senses to become more sensitive (95). People come to prefer human forms that express not physical strength but intelligence, and that embody abstract ideals, so that we prefer faces and figures that appear ideal and generic (96–99). Christianity has then influenced people to prefer forms expressive of tender emotions (100). Civilization thus completely reshapes what people find beautiful, even altering the workings of the senses.

So when Naden says that our sense of beauty 'is a growing organism, sprung from simple germs, always evolving into more complex forms' (100), it is organic in two senses. It is rooted in our natural evolution, but this has been overwritten by a civilizational history that is 'organic' in having progressed from simple to complex. In the end, Naden's 'evolution' of the sense of beauty is social as much as natural.

[10] Naden engaged heavily with Grant Allen's (1877) physiological aesthetics, though noting that she had already formed her views before encountering his book. She was also heavily influenced by Herbert Spencer's conception of evolution as a progression from simple to complex.

11.6 Final Remarks

To think art through fully with these six women would yield a new configuration and a new narrative. But on certain points, even this brief review of additional women thinkers confirms my overarching perspective. Once again, we see that women found ample opportunities to publish their views on art in books and journals, and that Victorian print culture was the material background making possible women's philosophical interventions in this period. Certain women, such as Eastlake, acquired considerable authority and intellectual power within this milieu. And these women, even Ellis in the end, were not engaged so much in systematic aesthetic theorizing as in a kind of philosophical reflection on the arts which blended into art and literary criticism and, at times, art history.

Taking note of Callcott, Merrifield, Ellis, Eastlake, Anstruther-Thomson, and Naden confirms, once more, the huge scale of women's neglected philosophical writing about art. Women have been omitted from our narratives not because they didn't write much on philosophy of art, but *despite* writing a great deal on philosophy of art. Omitting their writings has left us with diminished narratives about philosophy of art and has fostered a mistaken sense that women were totally excluded from nineteenth-century intellectual life. As I have stressed, the exclusion is from twentieth-century narratives, not nineteenth-century culture. In the nineteenth century, women made key interventions that helped to shape both debates about art and the whole character of British philosophy of the arts in this period.

Women on Philosophy of Art: Britain 1770–1900. Alison Stone, Oxford University Press. © Alison Stone 2024.
DOI: 10.1093/9780198918004.003.0011

Bibliography

Originally anonymous publications are de-anonymized wherever possible.

Abrams, Meyer (1971) *Natural Supernaturalism: Tradition and Revolution in Romantic Literature.* New York: Norton.
Adams, Kimberly VanEsveld (1996) Feminine Godhead, Feminist Symbol: The Madonna in George Eliot, Ludwig Feuerbach, Anna Jameson, and Margaret Fuller. *Journal of Feminist Studies in Religion* 12 (1): 41–70.
Adams, Kimberly VanEsveld (2001) *Our Lady of Victorian Feminism: The Madonna in the Work of Anna Jameson, Margaret Fuller, and George Eliot.* Columbus, OH: Ohio University Press.
Addison, Joseph, Richard Steele, and others (1945) *The Spectator*, ed. Gregory Smith. 4 vols. London: Dent.
Adey, Louise (1989) Reading Between the Lines: Tieck's Prolegomena to the Schlegel-Tieck Edition of Shakespeare. *Bulletin of the John Rylands University Library of Manchester* 71 (3): 89–104.
Agnew, Lois (1999) Vernon Lee and the Victorian Aesthetic Movement: 'Feminine Souls' and Shifting Sites of Contest. *Nineteenth Century Prose* 26 (2): 127–41.
Aikin, John, and Anna Letitia Aikin (1773) *Miscellaneous Pieces, in Prose.* London: J. Johnson.
Albrecht, Thomas (2009) *The Medusa Effect: Representation and Epistemology in Victorian Aesthetics.* Albany, NY: SUNY.
Alison, Archibald (1790) *Essays on the Nature and Principles of Taste.* Edinburgh: J. J. G. and G. Robinson.
Allen, Grant (1877) *Physiological Aesthetics.* New York: Appleton.
Allen, Walter (1954) *The English Novel.* Harmondsworth: Penguin.
Alvarez, Elizabeth Hayes (2016) *The Valiant Woman: The Virgin Mary in Nineteenth-Century American Culture.* Chapel Hill, NC: University of North Carolina Press.
Álvarez, María Begoña Lasa (2020) Women Artists and Activism in Ellen Clayton's 'English Female Artists' (1876). *Oceánida* 12: 37–44.
Anderson, Antje (2020) *Gendering Art History in the Victorian Age: Anna Jameson, Elizabeth Eastlake, and George Eliot in Florence.* PhD diss, University of Nebraska Lincoln.
Anonymous (1832) Cousin Marshall [by Harriet Martineau. Review]. *Spectator*, 8 September: 853–5.
Anonymous (1840) *Social Life in Germany*, by Mrs Jameson [review]. *Monthly Review* 151: 413–21.
Anonymous (1848) *The Poetry of Sacred and Legendary Art* by Mrs Jameson [review]. *Athenaeum*, 30 December: 1335–6.
Anonymous (1851a) *The Dramatic and Poetical Works of Joanna Baillie* [review]. *Athenaeum*, 11 January: 41.
Anonymous (1851b) Joanna Baillie. *Athenaeum*, 1 March: 246.
Anonymous (1857) Society of Female Artists, Oxford Street. *Illustrated London News*, 6 June: 545.
Anonymous (1860a) The Death of Mrs Jameson, the Writer. *New York Times* suppl., 7 April: 1.
Anonymous (1860b) The Writings of Mrs. Anna Jameson. *New York Times*, 12 April: 2.
Anonymous (1863) Mr. Alfred Gatley. *The Art-Journal*, 1 September: 181.
Anonymous (1864) The History of Our Lord in Art. *Saturday Review*, 25 June: 791–2.
Anonymous (1865) Miss Cobbe's Ethical and Social Studies. *Saturday Review*, 10 June: 701–2.
Anonymous (1878) *Memoirs of Mrs Jameson* [review]. *Spectator*, 23 November: 1470–2.

Anonymous (1878a) The Gardener Bird. *Spectator*, 23 March: 372–3.
Anonymous (1878b) Seeking Equality Abroad: Why Miss Edmonia Lewis, the Colored Sculptor, Returns to Rome. *New York Times*, 29 December: 5.
Anonymous (1891) Our Library Table. *Athenaeum*, 6 June: 731.
Anonymous (1895) Frances Power Cobbe. *Literary World*, 6 October: 326–7.
Anonymous (1904) The Art-Work of Lady Dilke. *Quarterly Review* 205: 439–67.
Anstruther-Thomson, Clementina (1924) *Art and Man: Essays and Fragments*, ed. Vernon Lee. London: John Lane.
Aquinas, Thomas (2006) *Summa Theologica*, Part I–II, trans. Fathers of the English Dominican Province. New York: Benziger Brothers.
Armstrong, Isobel (1993) *Victorian Poetry: Poetry, Poetics, and Politics*. London: Routledge.
Armstrong, Isobel (1995) The Gush of the Feminine. In Theresa M. Kelley and Paula R. Feldman, eds., *Romantic Women Writers: Voices and Countervoices*. Chicago: University Press of New England.
Armstrong, Isobel (2014) Anna Letitia Barbauld: A Unitarian Poetics? In William McCarthy and Olivia Murphy, eds., *Anna Letitia Barbauld: New Perspectives*. Lanham, MD: Rowman & Littlefield.
Arnold, Matthew (1889) *Culture and Anarchy*. London: Smith, Elder, & Co.
Askwith, Betty (1969) *Lady Dilke: A Biography*. London: Chatto & Windus.
Avery-Quash, Susanna (2019) Illuminating the Old Masters and Enlightening the British Public: Anna Jameson and the Contribution of British Women to Empirical Art History in the 1840s. *19: Interdisciplinary Studies in the Long Nineteenth Century* 28: doi: https://doi.org/10.16995/ntn.873.
Avery-Quash, Susanna, and Julie Sheldon (2011) *Art for the Nation: The Eastlakes and the Victorian Art World*. London: National Gallery.
Baillie, Joanna [1798] (1806) Introductory Discourse. In *A Series of Plays*, vol. 1. 5th edn, London: Longmans, Hurst, Rees, and Orme.
Baillie, Joanna (1836) On the Character of Romiero. *Fraser's Magazine* 14: 748–9.
Baillie, Joanna [1831] (1838) *A View of the General Tenour of the New Testament Regarding the Nature and Dignity of Jesus Christ*. 2nd edn. London: Smallfield and Son.
Baillie, Joanna [1851] (1976) *The Dramatic and Poetical Works*. Reprint edn. New York: Olms.
Baillie, Joanna (1999) *Collected Letters*, ed. Judith Bailey Slagle. 2 vols. Madison, WI: Fairleigh Dickinson University Press.
Baillie, Joanna (2001) *Plays on the Passions*, ed. Peter Duthie. Peterborough, Ontario; Broadview Press.
Baillie, Joanna (2007) *Six Gothic Dramas*, ed. Christine A. Colón. Richmond, VA: Valancourt.
Baillie, Joanna (2010) *Further Letters of Joanna Baillie*, ed. Thomas Maclean. Madison, WI: Fairleigh Dickinson University Press.
Bain, Alexander (1865) The Aesthetic Emotions. In *The Emotions and the Will*. 2nd edn. London: Longmans, Green and Co.
Barbauld, Anna Letitia (1775) *Devotional Pieces*. London: J. Johnson.
Barbauld, Anna Letitia (1795) Essay on Akenside's Poem. In Mark Akenside, *The Pleasures of Imagination*. London: T. Cadell, Junior, and W. Davies.
Barbauld, Anna Letitia (1797a) Consolation for Ideal Calamities. *Monthly Magazine* 3 (February): 96–7.
Barbauld, Anna Letitia (1797b) Prefatory Essay. In *The Poetical Works of Mr. William Collins*. London: T. Cadell and W. Davies.
Barbauld, Anna Letitia (1802) *A Series of Plays*. By Joanna Baillie. Vol. II [Review]. *Annual Review* 1: 680–5.
Barbauld, Anna Letitia (1810) On the Origins and Progress of Novel-Writing. In Anna Barbauld, ed., *The British Novelists*, vol. 1, 1–62. London: F. C. and J. Rivington.
Barbauld, Anna Letitia (1825) *Works*, ed. Lucy Aikin. London: Longman, Hurst, Rees, Orme, Brown and Green.
Barbauld, Anna Letitia, ed. [1811] (1824) *The Female Speaker*. Boston: Wells and Lilly.

Barrett Browning, Elizabeth [1844] (1901) The Dead Pan. In Charlotte Potter and Helen A. Clarke, eds., Complete *Works*, vol. 3. New York: Sproul.
Barrett Browning, Elizabeth (1897) *Letters*, ed. Frederic G. Kenyon. 2 vols. London: Macmillan.
Battersby, Christine (1990) *Gender and Genius*. London: The Women's Press.
Beard, Mary (2021) Judgements in Stone: The Two Contrasting Styles of Edmonia Lewis, the First African American Woman Sculptor. *Times Literary Supplement* 6181 (17 September): 5.
Beiser, Frederick (2006) *The Romantic Imperative*. Harvard: Harvard University Press.
Bensick, Carol (2023) American Women in the Transcendental and Pragmatist Movements. *Journal of the History of Women Philosophers and Scientists* 1 (2): 158–78.
Bergen, Daniel (2014) Reimagining the Romantic Imagination: Embodied, Proto-Cognitive Psychologies in Baillie's Introductory Discourse and *Orra*. *Literature Compass* 11 (3): 190–205.
Blackburn-Daniels, Sally (2023) Vernon Lee: Influenced and Influencer: Lee's Aesthetic Philosophy, 1880–1914. In Lydia Moland and Alison Stone, eds., *The Oxford Handbook of American and British Women Philosophers in the Nineteenth Century*. Oxford: Oxford University Press.
Bluett, Amy (2021) Victorian Women and the Fight for Arts Training. www.royalacademy.org.uk/article/striving-after-excellence-victorian.
Bomford, Zahira Véliz (2017) Mary Merrifield's Quest: A New Methodology for Technical Art History. *Burlington Magazine* 159: 465–75.
Bomford, Zahira Véliz (2019) Navigating Networks in the Victorian Age: Mary Philadelphia Merrifield's Writing on the Arts. *19: Interdisciplinary Studies in the Long Nineteenth Century* 28. https://19.bbk.ac.uk/article/id/1756.
Booth, Alison (1999/2000) The Lessons of the Medusa: Anna Jameson and Collective Biographies of Women. *Victorian Studies* 42 (2): 257–88.
Booth, Alison (2004) *How to Make It as a Woman: Collective Biographical History from Victoria to the Present*. Chicago: University of Chicago Press.
Braddon, Mary Elizabeth [1862] (1998) *Lady Audley's Secret*. Harmondsworth: Penguin.
Brake, Laurel, and Marysa Demoor (2009) *Dictionary of Nineteenth-Century Journalism in Britain and Ireland*. London: Academia Press.
Brake, Laurel, Fionnuala Dillane, and Mark W. Turner (2022) Nineteenth-Century Reviews and Reviewing: Communication, Compression, and Commerce. *Victorian Periodicals Review* 55 (2): 155–75.
Brand, Peggy Zeglin, and Mary Devereaux (2003) Introduction: Feminism and Aesthetics. *Hypatia* 18 (4): viii–xx.
Brand, Peggy Zeglin, and Carolyn Korsmeyer, eds. (1995) *Feminism and Tradition in Aesthetics*. University Park, PA: Pennsylvania State University Press.
Brassfield, Shoshana (2012) Never Let the Passions Be Your Guide: Descartes and the Role of the Passions. *British Journal for the History of Philosophy* 20 (3): 459–77.
Bressey, Caroline (2010) Victorian 'Anti-Racism' and Feminism in Britain. *Women: A Cultural Review* 21 (3): 279–91.
Breton, Philip Hemery le, ed. (1864) *Memoirs, Miscellanies and Letters of the Late Lucy Aikin*. London: Longman, Green, Longman, Roberts, and Green.
Brigham, Linda (2004) Joanna Baillie's Reflections on the Passions. *Studies in Romanticism* 43 (3): 417–37.
Bristow, Joseph (2018) Aestheticism. *Victorian Literature and Culture* 46 (3–4): 554–8.
Brodie, Benjamin (1844) A Few Words by way of Comment on Miss Martineau's Statement. *Athenaeum*, 7 December: 1198–1200.
Brown, Joseph (1845) Miss Martineau and Mesmerism. *Athenaeum*, 5 April: 333–5.
Buchanan, Robert (1862) Society's Looking Glass. *Temple Bar* 6: 129–37.
Bugajski, Ken A. (1998) Joanna Baillie: An Annotated Bibliography. *Romanticism on the Net* 12. www.erudit.org/en/journals/ron/1900-v1-n1-ron424/005817ar.
Buick, Kirsten Pai (2010) *Mary Edmonia Lewis and the Problem of Art History's Black and Indian Subject*. Durham, NC: Duke University Press.

Bulwer-Lytton, Edward (1833) On Moral Fictions. Miss Martineau's *Illustrations of Political Economy*. New Monthly Magazine and Literary Journal 37: 146–51.
Burdett, Carolyn (2011) 'The Subjective Inside Us Can Turn into the Objective Outside': Vernon Lee's Psychological Aesthetics. *19: Interdisciplinary Studies in the Long Nineteenth Century* 12. doi: https://doi.org/10.16995/ntn.610.
Burdett, Carolyn (2016) Walter Pater and Vernon Lee. *Studies in Walter Pater and* Aestheticism 2: 31–42.
Burke, Edmund (1757) *A Philosophical Enquiry into the Origin of our Ideas of the Sublime and the Beautiful*. London: Dodsley.
Burroughs, Catherine (1997) *Closet Stages: Joanna Baillie and the Theater Theory of British Romantic Women Writers*. Philadelphia: University of Pennsylvania Press.
Burwick, Frederick (2004) Joanna Baillie, Matthew Baillie, and the Pathology of the Passions. In Thomas Crochunis, ed., *Joanna Baillie: Romantic Dramatist*. London: Routledge.
Caine, Barbara (1993) *Victorian Feminists*. Oxford: Oxford University Press.
Callcott, Maria (1835) *Description of the Chapel of the Annunziata dell' Arena, or Giotto's Chapel, in Padua*. London: Brettell.
Callcott, Maria (1836) *Essays Towards the History of Painting*. London: Moxon.
Campbell, Thomas (1834) *Life of Mrs Siddons*. New York: Harper and Brothers.
Candido, Joseph, ed. (2021) *King John: Shakespeare: The Critical Tradition*. London: Bloomsbury.
Carhart, Margaret (1923) *The Life and Work of Joanna Baillie*. New Haven, CT: Yale University Press.
Carlson, Ashley (2011) *Influence, Agency, and the Women of England: Victorian Ideology and the Works of Sarah Stickney Ellis*. PhD diss., University of New Mexico.
Carlson, Ashley (2014) Gratifying a Divine Instinct: Sarah Stickney Ellis on Pleasure-Seeking and Feminine Morals. In Paul Fox, ed., *Decadences: Morality and Aesthetics in British Literature*. 2nd revised edn. Stuttgart: Ibidem.
Carr, Cornelia, ed. (1913) *Harriet Hosmer: Letters and Memories*. London: Bodley Head.
Carroll, Noël (1998) *A Philosophy of Mass Art*. Oxford: Oxford University Press.
Cazamian, Louis François [1903] (1973) *The Social Novel in England, 1830–1850*, trans. Martin Fido. London: Routledge.
Chalmers, F. Graeme (1995) Fanny McIan and London's Female School of Design, 1842–57. *Woman's Art Journal* 16 (2): 3–9.
Chapman, Alison, and Jane Stabler, eds. (2003) *Unfolding the South: Nineteenth-Century British Women Writers and Artists in Italy*. Manchester: Manchester University Press.
Chapman, Maria Weston (1877) Fame. In Harriet Martineau, *Autobiography*, vol. 3, ed. Maria Weston Chapman. London: Smith, Elder.
Cherry, Deborah (1993) *Painting Women: Victorian Women Artists*. London: Routledge.
Cherry, Deborah (2000) *Beyond the Frame: Feminism and Visual Culture, Britain 1850–1900*. London: Routledge.
Christ, Carol T. (1990) The Hero as Man of Letters. In Thaïs E. Morgan, ed., *Victorian Sages and Cultural Discourse*. New Brunswick: Rutgers University Press.
Clarke, Meaghan (2005) *Critical Voices: Women and Art Criticism in Britain 1880–1905*. London: Routledge.
Clarke, Meaghan (2019) Women in the Galleries: New Angles on Old Masters in the Late Nineteenth Century. *19: Interdisciplinary Studies in the Long Nineteenth Century* 28. https://19.bbk.ac.uk/article/id/1761.
Clarke, Meaghan, and Francesco Ventrella (2017) Women's Expertise and the Culture of Connoisseurship. *Visual Resources* 33 (1–2): 1–10.
Clayton, Eleanor Creathorne (1863) *Queens of Song: Being Memoirs of Some of the Most Celebrated Female Vocalists*. 2 vols. London: Smith, Elder and Co.
Clayton, Eleanor Creathorne (1876) *English Female Artists*. London: Tinsley Brothers.
Clery, E. J. (2000) *Women's Gothic: From Clara Reeve to Mary Shelley*. London: Northcote House.

Clery, E. J. (2017) *Eighteen Hundred and Eleven: Poetry, Protest and Economic Crisis.* Cambridge: Cambridge University Press.
Clewis, Robert, ed. (2019) *The Sublime Reader.* London: Bloomsbury.
Clifton, W. Scott (2017) Schopenhauer and Murdoch on the Ethical Value of the Loss of Self in Aesthetic Experience. *Journal of Aesthetic Education* 51 (4): 5–25.
Cobbe, Frances Power (1855) *An Essay on Intuitive Morals, Volume One: Theory of Morals.* London: Longmans.
Cobbe, Frances Power (1862) The Fine Arts. *Daily News*, 21 April: 5.
Cobbe, Frances Power [1862] (1863) What Shall We Do with Our Old Maids? In *Essays on the Pursuits of Women.* London: Emily Faithfull.
Cobbe, Frances Power (1863) *Essays on the Pursuits of Women.* London: Emily Faithfull.
Cobbe, Frances Power (1864) *Italics: Brief Notes on Politics, People, and Places in Italy.* London: Trübner.
Cobbe, Frances Power (1865) *Studies New and Old of Ethical and Social Subjects.* London: Trübner.
Cobbe, Frances Power (1872) *Darwinism in Morals, and Other Essays.* London: Williams & Norgate.
Cobbe, Frances Power (1877) Pessimism, and One of its Professors. *New Quarterly Magazine* 8: 283–301.
Cobbe, Frances Power (1888) 'The Lord was Not in the Earthquake.' *Contemporary Review* 53: 70–83.
Cobbe, Frances Power (1894) *Life of Frances Power Cobbe.* 2 vols. London: Bentley and Son.
Cohen, Paula Marantz (2007) The Elusive Aesthetics of Vernon Lee. *The Yale Review* 95 (1): 21–30.
Colby, Vineta (1970) The Puritan Aesthete: Vernon Lee. In Vineta Colby, *The Singular Anomaly: Women Novelists of the Nineteenth Century.* New York: New York University Press.
Colby, Vineta (2003) *Vernon Lee: A Literary Biography.* Charlottesville, VA: University of Virginia Press.
Coleridge, Samuel Taylor [1817] (1907) *Biographia Literaria, with his Aesthetical Essays*, ed. John Shawcross. 2 vols. Oxford: Clarendon Press.
Coleridge, Samuel Taylor (1956) *Collected Letters, Volume I: 1785–1800*, ed. Earl Leslie Griggs. Oxford: Clarendon Press.
Collier, Carly (2012) Augustus Wall Callcott and Maria, Lady Callcott. *Warwick EMECC: Early Modern Forum 1450–1850.* https://warwick.ac.uk/fac/arts/history/ecc/archive/emforum/projects/arc/calcotts.
Collins, Wilkie (1858) The Unknown Public. *Household Words* 17 (21 August): 217–22.
Colón, Christine A. (2009) *Joanna Baillie and the Art of Moral Influence.* Berlin: Peter Lang.
Connell, Sophia, and Frederique Janssen-Lauret (2022) Lost Voices: On Counteracting Exclusion of Women from Histories of Contemporary Philosophy. *British Journal for the History of Philosophy* 30 (2): 199–210.
Corman, Brian (2008) *Women Novelists Before Jane Austen: The Critics and Their Canons.* Toronto: University of Toronto Press.
Costelloe, Timothy M. (2013) *The British Aesthetic Tradition: From Shaftesbury to Wittgenstein.* Cambridge: Cambridge University Press.
Courtemanche, Eleanor (2006) 'Naked Truth is the Best Eloquence': Martineau, Dickens, and the Moral Science of Realism. *ELH* 73 (2): 383–407.
Cousin, Victor (1853) *Du vrai, du beau et du bien.* Paris: Didier.
Cox, Jeffrey N. (1992) Introduction to Jeffrey Cox, ed., *Seven Gothic Dramas, 1789–1825.* Athens, OH: Ohio University Press.
Craig, Hugh, and Alexis Antonia (2015) Six Authors and the Saturday Review: A Quantitative Approach to Style. *Victorian Periodicals Review* 48: 67–86.
Crawford, Iain (2020) *Contested Liberalisms: Martineau, Dickens and the Victorian Press.* Edinburgh: Edinburgh University Press.

Crisafulli, Lilla Maria, and Cecilia Pietropoli (2007) Introduction to Lilla Maria Crisafulli and Cecilia Pietropoli, eds., *Women Romantic Poets*. Leiden: Brill.
Crochunis, Thomas C., ed. (2004) *Joanna Baillie, Romantic Dramatist*. London: Routledge.
Crockett, Alasdair (2000) Variations in Churchgoing Rates in England in 1851. *University of Oxford Discussion Papers in Economic and Social History* 36: 1–38. www.nuffield.ox.ac.uk/Economics/History/Paper36/36Crockett.pdf.
Cronin, Patricia (2013) *The Zenobia Scandal: A Meditation on Male Jealousy*. New York: Zingmagazine Books.
Dabakis, Melissa (2020) *A Sisterhood of Sculptors: American Artists in Nineteenth-Century Rome*. University Park, PA: Penn State University Press.
Dabby, Benjamin (2017) *Women as Public Moralists in Britain*. London: Boydell & Brewer.
Dalley, Lana L. (2010) Domesticating Political Economy: Language, Gender and Economics in the *Illustrations of Political Economy*. In Ella Dzelzainis and Cora Kaplan, eds., *Harriet Martineau: Authorship, Society and Empire*. Manchester: Manchester University Press.
Dalley, Lana L. (2012) On Martineau's Illustrations of Political Economy, 1832–34. *BRANCH: Britain, Representation and Nineteenth-Century History*. https://branchcollective.org/?ps_articles=lana-l-dalley-on-martineaus-illustrations-of-political-economy-1832-34.
David, Deirdre (1987) *Intellectual Women and Victorian Patriarchy*. Basingstoke: Macmillan.
Demoor, Marysa (2000) *Their Fair Share: Women, Power and Criticism in the* Athenaeum. Aldershot: Ashgate.
Descartes, René, and Princess Elisabeth of Bohemia (1643–49) *Correspondence*, ed. Jonathan Bennett. www.earlymoderntexts.com.
Dilke, Charles (1875) Memoir. In Charles Wentworth Dilke, *The Papers of a Critic*, ed. Charles Dilke. London: Murray.
Dilke, Charles (1905) Memoir. In Emilia Dilke, *The Book of the Spiritual Life*, 1–128. London: Murray.
Dilke, Emilia (1864) The Art-Idea. *Saturday Review*, 13 August: 218–19.
Dilke, Emilia (1865) Taine's Philosophy of Art. *Saturday Review*, 21 October: 519–20.
Dilke, Emilia (1868a) A Handbook of Pictorial Art. *Saturday Review*, 22 August: 261–2.
Dilke, Emilia (1868b) Religious Art in the Nineteenth Century. *Saturday Review*, 12 September: 361–2.
Dilke, Emilia (1868–92) Correspondence with Gertrude Tuckwell, 1868–1888, MS Pattison 140. Bodleian Libraries, Archive of Mark Pattison, MS Pattison 140. Cited by folio number.
Dilke, Emilia (1869) Art and Morality. *Westminster Review* 35: 149–84.
Dilke, Emilia (1870a) Art. *Westminster Review* 37: 636–44.
Dilke, Emilia (1870b) General Literature and Art. *Academy*, 10 September: 305–6.
Dilke, Emilia (1872) Grimm's Select Essays. *Academy*, 1 April: 124–5.
Dilke, Emilia (1873a) Art. *Westminster Review* 43: 638–45.
Dilke, Emilia (1873b) The Use of Looking at Pictures. *Westminster Review* 44: 415–23.
Dilke, Emilia (1879a) Fine Art. *Academy*, 27 September: 235–6.
Dilke, Emilia (1879b) *The Renaissance of Art in France*. London: Kegan Paul.
Dilke, Emilia (1883) The Royal Academy. III. *Academy*, 26 May: 372–4.
Dilke, Emilia (1884) *Claude Lorrain*. Paris: Rouam.
Dilke, Emilia (1888) *Art in the Modern State*. London: Chapman and Hall.
Dilke, Emilia (1899) *French Painters of the XVIIIth Century*. London: Bell.
Dilke, Emilia (1900) *French Architects and Sculptors of the XVIIIth Century*. London: Bell.
Dilke, Emilia (1901) *French Furniture and Decoration in the XVIIIth Century*. London: Bell.
Dilke, Emilia (1902) *French Engravers and Draughtsmen of the XVIIIth Century*. London: Bell.
Dixon, Daisy (2022) Artistic (Counter)Speech. *Journal of Aesthetics and Art Criticism* 80 (4): 409–19.
Dowd, Maureen (1998) 'By the Delicate Hand of a Female': Melodramatic Mania and Joanna Baillie's Spectacular Tragedies. *European Romantic Review* 9 (4): 469–500.

Dumbill, Eleanor (2020) Why It's Not Empowering to Abandon the Male Pseudonyms Used by Female Writers. *The Conversation*, 18 August. https://theconversation.com/why-its-not-empowering-to-abandon-the-male-pseudonyms-used-by-female-writers-144607

Duthie, Peter (2001) Introduction to Baillie, *Plays on the Passions*, ed. Peter Duthie. Peterborough, Ontario: Broadview Press.

Dzelzainis, Ella (2010) Feminism, Speculation and Agency in Harriet Martineau's *Illustrations of Political Economy*. In Ella Dzelzainis and Cora Kaplan, eds., *Harriet Martineau: Authorship, Society and Empire*. Manchester: Manchester University Press.

Easley, Alexis (2004) *First Person Anonymous: Women Writers and Victorian Print Media, 1830–70*. Farnham: Ashgate.

Easley, Alexis, Clare Gill, and Beth Rodgers (2019) Introduction: Women, Periodicals and Print Culture in the Victorian Period. In Alexis Easley, Clare Gill, and Beth Rodgers, eds., *Women, Periodicals and Print Culture in Britain, 1830s–1900s*. Edinburgh: Edinburgh University Press.

Eastern Hermit (William Allingham) (1878) Ivy-Leaves. *Fraser's Magazine* 17: 259–68.

Eastlake, Elizabeth (1856) Modern Painters. *Quarterly Review* 98: 384–433.

Eastlake, Elizabeth (1857) Photography. *Quarterly Review* 101: 442–68.

Eastlake, Elizabeth (1895) *Journals and Correspondence*, ed. Charles Eastlake Smith. 2 vols. London: Murray.

Eisler, Colin (1981) Lady Dilke (1840–1904): The Six Lives of an Art Historian. In Claire Richter Sherman and Adele Holcomb, eds., *Women as Interpreters of the Visual Arts, 1820–1979*. Westport: Greenwood Press.

Eliot, George (1856) The Natural History of German Life. *Westminster Review* 66: 51–79.

Eliot, George (1954–78) *The George Eliot Letters*, ed. Gordon Haight. 9 vols. New Haven CT: Yale University Press.

Eliot, George [1860] (2016) *The Mill on the Floss*. New York: Open Road Integrated Media.

Ellet, Elizabeth (1859) *Women Artists in All Ages and Countries*. New York: Harper and Brothers.

Ellis, Grace A., ed. (1874) *A Memoir of Mrs Anna Laetitia Barbauld; with Many of her Letters*. Boston: Osgood.

Ellis, Sarah Stickney (1833) *Pictures of Private Life*. London: Smith, Elder.

Ellis, Sarah Stickney (1835) *The Poetry of Life*. 2 vols. London: Saunders and Otley.

Ellis, Sarah Stickney (1839) *The Women of England*. London: Fisher, Son, & Co.

Ellis, Sarah Stickney (1866) *The Beautiful in Nature and Art*. London: Hurst and Blackett.

Ernstrom, Adele M. (2012) Elizabeth Eastlake v. John Ruskin: The Content of Idea and the Claims of Art. *Canadian Art Review* 37 (2): 37–46.

Erskine, Mrs Steuart, ed. (1915) *Anna Jameson: Letters and Friendships*. London: T. Fisher Unwin.

Evangelista, Stefano (2009) *British Aestheticism and Ancient Greece: Hellenism, Reception, Gods in Exile*. London: Palgrave Macmillan.

Evans, Lawrence, ed. (1970) *Letters of Walter Pater*. Oxford: Clarendon.

Ezekiel, Anna C. (2020) Why We Should Read Günderrode as a Philosopher. ACEzekiel blog. https://acezekiel.com/2020/12/29/why-we-should-read-gunderrode-as-a-philosopher.

Feldman, Jessica R. (2004) Biography: Vernon Lee. *English Literature in Transition 1880–1920* 47 (2): 197–200.

Feldman, Paula (2002) Women Poets and Anonymity in the Romantic Era. *New Literary History* 33 (2): 279–89.

Fenwick Miller, Florence (1887) *Famous Women: Harriet Martineau*. Boston: Roberts Brothers.

Ferguson, Barbara D. (2020) A Haunting in Time and Space: Vernon Lee's 'Oke of Okehurst'. *Victorian Popular Fictions Journal* 2 (1): 43–55.

Fleishman, Avrom (2010) *George Eliot's Intellectual Life*. Cambridge: Cambridge University Press.

Flint, Kate (2000) *The Victorians and the Visual Imagination*. Cambridge: Cambridge University Press.

Flood, Alison (2018) Women Better Represented in Victorian Novels than Modern, Finds Study. *Guardian*, 19 February. www.theguardian.com/books/2018/feb/19/women-better-represented-in-victorian-novels-than-modern-finds-study.
Forbes, John (1845) Miss Martineau and Mesmerism. *Athenaeum*, 15 March: 268–9.
Fraser, Hilary (1992) *The Victorians and Renaissance Italy*. Cambridge: Cambridge University Press.
Fraser, Hilary [2004] (2008) Dilke [née Strong; other married name Pattison], Emilia Francis, Lady Dilke. *Oxford Dictionary of National Biography*. https://doi.org/10.1093/ref:odnb/32825.
Fraser, Hilary (2014) *Women Writing Art History in the Nineteenth Century*. Cambridge: Cambridge University Press.
Fraser, Hilary (2016) Walter Pater and Emilia Dilke. *Studies in Walter Pater and Aestheticism* 2: 21–30.
Fraser, Hilary (2017) Women and the Modelling of Victorian Sculptural Discourse. *Visual Resources* 33 (1–2): 74–93.
Fraser, Hilary (2019) Writing Cosmopolis: The Cosmopolitan Aesthetics of Emilia Dilke and Vernon Lee. *19: Interdisciplinary Studies in the Long Nineteenth Century* (28): doi: https://doi.org/10.16995/ntn.844.
Frazer, J. G. (1890) *The Golden Bough*. 2 vols. London: Macmillan.
Freadman, Richard (1985) *George Eliot's Theory of the Novel*. PhD diss., University of Nebraska Lincoln.
Freedgood, Elaine (1995) Banishing Panic: Harriet Martineau and the Popularization of Political Economy. *Victorian Studies* 39 (1): 33–53.
Freeman, Barbara Claire (1987) *The Feminine Sublime: Gender and Excess in Women's Fiction*. Berkeley, CA: University of California Press.
Friend, Stacie (2023) Founding Women in 20th-Century Aesthetics. Presentation at the conference *Early Women Philosophers in London*, Institute of Philosophy, 27 January.
Fryckstedt, Monica (1980) The Early Industrial Novel: Mary Barton and its Predecessors. *Bulletin of the John Rylands Library* 63 (1): 1–20.
Fryckstedt, Monica (1990) Geraldine Jewsbury's 'Athenaeum' Reviews: A Mirror of Mid-Victorian Attitudes to Fiction. *Victorian Periodicals Review* 23 (1): 13–25.
Frye, Northrop (1947) *Fearful Symmetry: A Study of William Blake*. Princeton, NJ: Princeton University Press.
Fulmer, Constance (2019) *George Eliot's Moral Aesthetic: Compelling Contradictions*. London: Routledge.
Gagel, Amanda (2019) Vernon Lee's *Satan the Waster*: Pacifism and the Avant-Garde. *Public Domain Review*, 20 March. https://publicdomainreview.org/essay/vernon-lees-satan-the-waster-pacifism-and-the-avant-garde.
Gagnier, Regenia (1994) A Critique of Practical Aesthetics. In George Levine, ed., *Aesthetics and Ideology*. New Brunswick: Rutgers University Press.
Gallagher, Catherine (1985) *The Industrial Reformation of English Fiction: Social Discourse and Narrative Form, 1832–1867*. Chicago: University of Chicago Press.
Gardner, Catherine Villanueva (2012) *Empowerment and Interconnectivity: Towards a Feminist History of Utilitarian Philosophy*. University Park, PA: Penn State Press.
Garnett, Richard (1900) Preface to Mathilde Blind, *Poetical Works*. London: T. F. Unwin.
Garritzen, Elise (2020) Women Historians, Gender, and Fashioning the Authoritative Self in Late-Victorian Britain. *Women's History Review* 30 (4): 650–68.
Garside, Peter (2000) The English Novel in the Romantic Era: Consolidation and Dispersal. In Peter Garside and Rainer Schöwerling, *The English Novel, 1770–1829*, vol. 2: *1800–1829*. Oxford: Oxford University Press.
Garza, Ana Alicia (2009) 'Art for the Sake of Life': The Critical Aesthetics of Vernon Lee. PhD diss., Queen Mary College, University of London.
Gaull, Marilyn (1988) *English Romanticism*. New York: Norton.
Gaut, Berys (2007) *Art, Emotion and Ethics*. Oxford: Oxford University Press.
Gerard, Alexander (1774) *An Essay on Genius*. London: W. Strahan and T. Cadell.

Gillett, Robert (2018) *Characteristics of Women* and their Reception in Germany. *Angermion* 11 (1): 119–32.
Gjesdal, Kristin, and Dalia Nassar, eds. (2021) *Women Philosophers in the Long Nineteenth Century: The German Tradition*. Oxford: Oxford University Press.
Gold, Susanna W. (2012) The Death of Cleopatra/The Birth of Freedom: Edmonia Lewis at the New World's Fair. *Biography* 35 (2): 318–41.
Gomes, Anil (2013) Iris Murdoch on Art, Ethics, and Attention. *British Journal of Aesthetics* 53 (3): 321–37.
Greenberg, Clement [1965] (1982) Modernist Painting. Revised edn. In Francis Frascina and Charles Harrison, eds., *Modern Art and Modernism: A Critical Anthology*. New York: Harper & Row.
Gregory, John [1765] (1772) *A Comparative View of the State and Faculties of Man*. 5th edn. London: J. Dodsley.
Gregory, Jessica (2020) What's In a Name? The Archival Legacy of Emilia Francis Strong/Pattison/Dilke. *British Library, English and Drama Blog*, 16 December. https://blogs.bl.uk/english-and-drama/2020/12/whats-in-a-name-the-archival-legacy-of-emilia-francis-strong pattersondilke.html
Grosskurth, Phyllis (1967) Review of Clara Thomas, *Love and Work Enough: The Life of Anna Jameson*. *Canadian Historical Review* 48 (3): 278–9.
Grüner, Ludwig (1845) *The Decorations of the Garden-Pavilion in the Grounds of Buckingham Palace*, introduced by Anna Jameson. London: Murray.
Guentchev, Daniel (2018) What Do We Expect from Our Philosophies of Art? A Comparison of the Aesthetics of Susanne Langer and Maurice Merleau-Ponty. *Journal of Aesthetic Education* 52 (4): 94–115.
Guerlac, Suzanne (1991) The Sublime in Theory. *MLN* 106 (5): 895–909.
Gupta, Abhijit (1996) *The Publishing History of Novels by Women in Late Nineteenth-Century England*. PhD diss., University of Cambridge.
Gurney, Edmund (1880) *The Power of Sound*. London: Smith, Elder.
Guyer, Paul (2014) *A History of Modern Aesthetics*, vol. 2: *The Nineteenth Century*. Cambridge: Cambridge University Press.
H. (1859) The Royal Academy. *Athenaeum*, 30 April: 581–2.
Haekel, Ralf, ed. (2017) *Handbook of British Romanticism*. Berlin: De Gruyter.
Hahn, Daniel (2015) Evenings at Home. In Daniel Hahn, ed., *The Oxford Companion to Children's Literature*. 2nd edn. Oxford: Oxford University Press.
Hamilton, Susan (2006) *Frances Power Cobbe and Victorian Feminism*. New York: Palgrave Macmillan.
Hamilton, Susan (2023) Frances Power Cobbe and Periodical Philosophy. In Lydia Moland and Alison Stone, eds., *The Oxford Handbook of American and British Women Philosophers in the Nineteenth Century*. Oxford: Oxford University Press.
Hannah, Heather (2018) *Male Use of a Female Pseudonym in Nineteenth-Century British and American Literature*. PhD diss., Murdoch University.
Harness, William (1824) Celebrated Female Writers. No. 1. Joanna Baillie. *Blackwood's Edinburgh Magazine* 16: 162–78.
Harris, Janice (1986) Not Suffering and Not Still: Women Writers at the *Cornhill Magazine*, 1860–1900. *Modern Language Quarterly* 47 (4): 382–92.
Haskins, Katherine (2012) *The Art-Journal and Fine Art Publishing in Victorian England, 1850–1880*. Aldershot: Ashgate.
Hegel, G. W. F. (1975) *Aesthetics: Lectures on Fine Art*. 2 vols. Trans. T. M. Knox. Oxford: Clarendon Press.
Heyse, J. C. A. (1849) *Theoretisch-praktische deutsche Grammatik, oder Lehrbuch der deutschen Sprache*. 5th ed. 2 vols. Hannover: Hahn.
Higgins, David (2007) 'Isn't She Painted *Con Amore?*' *Fraser's Magazine* and the Spectacle of Female Genius. *Romanticism on the Net* 46. www.erudit.org/en/journals/ron/1900-v1-n1-ron1782/016139ar.

Hirschman, Albert O. (1977) *The Passions and the Interests*. Princeton, NJ: Princeton University Press.
Hoberman, Ruth (2016) Venus in the Museum: Women's Representations and the Rise of Public Art Institutions. In Holly A. Laird, ed., *The History of British Women's Writing, 1880–1920*. Basingstoke: Palgrave Macmillan.
Hoeckley, Cheryl (2005) Introduction to Jameson, *Shakespeare's Heroines*. Peterborough, Ontario: Broadview Press.
Hoeckley, Cheryl (2011) Anna Jameson. In Gail Marshall, ed., *Jameson, Cowden Clarke, Kemble, Cushman: Great Shakespeareans Volume VII*. London: Bloomsbury.
Holcomb, Adele M. (1983) Anna Jameson: The First Professional English Art Historian. *Art History* 6 (2): 171–87.
Holcomb, Adele M. (1987–88) Anna Jameson on Women Artists. *Woman's Art Journal* 8 (2): 15–24.
hooks, bell (1981) *Ain't I a Woman: Black Women and Feminism*. Boston, MA: South End Press.
Horne, R. H. (1844) *The New Spirit of the Age*. New York: Riker.
Horrocks, Jamie (2013) Vernon Lee, Oscar Wilde, and the Dialogue of 'New Aesthetics'. *Nineteenth Century Prose* 40 (1): 201–70.
Hosmer, Harriet (1864) The Process of Sculpture. *Atlantic Monthly* 14: 734–7.
Houghton, Walter, ed. (1966–87) *Wellesley Index to Victorian Periodicals 1824–1900*, vols. 1–4. Toronto: University of Toronto Press.
Hughes, Linda (2016) 'Given in Outline and No More': The Shared Life Writing of Anna Jameson and Ottilie von Goethe. *Forum for Modern Language Studies* 52 (2): 160–71.
Hughes, Linda (2022a) *Victorian Women Writers and the Other Germany*. Cambridge: Cambridge University Press.
Hughes, Linda (2022b) Vernon Lee: Slow Serialist and Journalist at the Fin de Siècle. *Victorian Literature and Culture* 50 (1): 173–202.
Hume, David [1757] (2017) Tragedy. In *Four Essays*, ed. Jonathan Bennett. www.earlymoderntexts.com.
Hume, David [1777] (1889) My Own Life. In Hume, *Essays, Moral, Political, and Literary*, vol. 1, ed. T. H. Green and T. H. Grose. London: Longmans, Green, and Co.
Hurston, Zora Neale [1937] (2009) *Their Eyes Were Watching God*. New York: HarperCollins.
Hyman, John, and Katerina Bantinaki (2021) Depiction. In *Stanford Encyclopedia of Philosophy*, ed. Edward N. Zalta. https://plato.stanford.edu/archives/fall2021/entries/depiction.
Ierna, Carlo (2022) 'Women Were Seen as Too Irrational to be Philosophers'. *Ad Valvas*, 3 October. https://advalvas.vu.nl/en/science-education/women-were-seen-too-irrational-be-philosophers/
Innis, Robert (2009) *Susanne Langer in Focus: The Symbolic Mind*. Bloomington, IN: Indiana University Press.
Insch, Audrey (1958) English Blank Verse Tragedy from 1790 to 1825. PhD diss., University of Durham.
Irigaray, Luce [1980] (1991) The Crucified One: Epistle to the Last Christians. In Luce Irigaray, *Marine Lover of Friedrich Nietzsche*, trans. Gillian C. Gill. New York: Columbia University Press.
Israel, Kali (1999) *Names and Stories: Emilia Dilke and Victorian Culture*. New York: Oxford University Press.
Jacek, Mydla (2014) Joanna Baillie's Theatre of Sympathy and Imagination. In Agnieszka Pantuchowicz and Slawomir Maslon, eds., *Reciprocities*. Katowice: Wydawnictwo Uniwersytetu Śląskiego.
James, Felicity (2010) A Life of Dissent: Harriet Martineau and Unitarianism. In Gina Luria Walker and G. M. Ditchfield, eds., *Intellectual Exchanges: Women and Rational Dissent. Enlightenment and Dissent* 26. London: Queen Mary Centre for Religion and Literature in English.
James, Felicity and Ian Inkster, eds. (2011) *Religious Dissent and the Aikin-Barbauld Circle, 1740–1860*. Cambridge: Cambridge University Press.

James, Henry [1877] (1879) *The American*. London: Macmillan.
James, M. R. (1986) *The Ghost Stories of M. R. James*, ed. Michael Cox. Oxford: Oxford University Press.
James, Susan (1997) *Passion and Action: The Emotions in Seventeenth-Century Philosophy*. Oxford: Oxford University Press.
James, William (1884) What is an Emotion? *Mind* 9: 188–205.
Jameson, Anna (1826) *The Diary of an Ennuyée*. London: H. Colburn.
Jameson, Anna (1832) *Characteristics of Women: Moral, Poetical, and Historical*. 2 vols. London: Saunders and Otley.
Jameson, Anna [1832] (2005) *Shakespeare's Heroines*, ed. Cheri L. Larsen Hoeckley. Peterborough, Ontario: Broadview Press.
Jameson, Anna (1833) *Characteristics of Women: Moral, Poetical, and Historical*. 2 vols. New edn. London: Saunders and Otley.
Jameson, Anna (1834) *Visits and Sketches at Home and Abroad*. 2 vols. New York: Harper and Brothers.
Jameson, Anna (1834–53) Correspondence with Annabella Byron. Bodleian Libraries, Archive of the Noel, Byron, and Lovelace Families (CMD ID 13844): Papers of Anne Isabella, Lady Noel Byron (1792–1860), 1792–1860: correspondence with Anna Jameson, fols. 30–292. Cited by folio number with my estimated dates in square brackets.
Jameson, Anna (1840) *Social Life in Germany: Illustrated in the Acted Dramas of Her Royal Highness The Princess Amelia of Saxony*. London: Saunders and Otley.
Jameson, Anna (1845) *Memoirs of the Early Italian Painters, and of the Progress of Painting in Italy*. 2 vols. London: Knight.
Jameson, Anna (1846) *Memoirs and Essays Illustrative of Art, Literature and Social Morals*. London: Bentley.
Jameson, Anna (1848) *Sacred and Legendary Art*. 2 vols. London: Longman, Brown, Green and Longmans.
Jameson, Anna (1849a) Some Thoughts on Art. Part I. *The Art-Journal*, 1 March 69–71.
Jameson, Anna (1849b) Some Thoughts on Art. Part II. *The Art-Journal*, 1 April 103–5.
Jameson, Anna (1850) *Legends of the Monastic Orders*. London: Longman, Brown, Green and Longmans.
Jameson, Anna (1852) *Legends of the Madonna*. London: Longman, Brown, Green and Longmans.
Jameson, Anna [1854] (1855) *A Commonplace Book of Thoughts, Memories, and Fancies*. London: Longman, Brown, Green and Longmans.
Jameson, Anna, and Elizabeth Eastlake (1864) *The History of Our Lord as Exemplified in Works of Art*. 2 vols. London: Longman, Green, Longman, Roberts, and Green.
Janowitz, Anne F. (2004) *Women Romantic Poets: Anna Barbauld and Mary Robinson*. Northcote House: Tavistock.
Jefferson, Ann (2014) Julia Kristeva and Female Genius. In Ann Jefferson, *Genius in France: An Idea and Its Uses*. Princeton: Princeton University Press.
Jeffrey, Francis (1803) *A Series of Plays*, by Joanna Baillie. Vol. II. [Review] *Edinburgh Review* 2: 269–86.
Jenkins, Roy (1958) *Sir Charles Dilke: A Victorian Tragedy*. London: Collins.
Johns, Alessa (2010) Anna Jameson in Germany: 'A.W.' and Women's Translation. *Translation and Literature* 19 (2): 190–5.
Johns, Alessa (2014) *Bluestocking Feminism and British-German Cultural Transfer, 1750–1837*. Ann Arbor: University of Michigan Press.
Johnson, Claudia L. (2001) 'Let Me Make the Novels of a Country': Barbauld's *The British Novelists* (1810/1820). *Novel: A Forum on Fiction* 84 (Spring): 163–79.
Johnson, Maurice L. (1904) A Priestess of Humanity. *Westminster Review* 161: 653–6.
Johnson, Robert Vincent (1969) *Aestheticism*. London: Methuen.
Johnston, Judith (1997) *Anna Jameson: Victorian, Feminist, Woman of Letters*. Aldershot: Scolar Press.

Johnstone, Christian Isobel (1833) Miss Martineau's Berkeley the Banker. *Tait's Edinburgh Magazine* 3: 92–6.
Journal of Blacks in Higher Education (1996) Lost and Found: The Strange Case of the Resurrection of Edmonia Lewis' 'The Death of Cleopatra'. *Journal of Blacks in Higher Education* 13: 32–3.
Kandola, Sondeep (2010) *Vernon Lee*. London: Northcote House.
Kane Lew, Laurie (1996) Cultural Anxiety in Anna Jameson's Art Criticism. *Studies in English Literature, 1500–1900* 36 (4): 829–56.
Kant, Immanuel [1790] (1987) *Critique of Judgment*, trans. Werner S. Pluhar. Indianapolis: Hackett.
Kanwit, John Paul M. (2013) *Victorian Art Criticism and the Woman Writer*. Columbus, OH: Ohio State University Press.
Katzav, Joel (2020) Women Philosophers in the *Philosophical Review. DigressionsandImpressions*, 10 March. https://digressionsnimpressions.typepad.com/digressimpressions/2020/03/women-philosophers-in-the-philosophical-review-1900-1970-guest-post-by-joel-katzav.html.
Kemble, John (1839) Mrs Jameson's *Winter Studies and Summer Rambles*. [Review] *British and Foreign Review* 8: 134–53.
King, William, ed. (1903) *Woman: Her Position, Influence, and Achievement Throughout the Civilized World*. Springfield: King-Richardson.
Knight, Richard Payne (1805) *An Analytical Inquiry into the Principles of Taste*. London: Payne and White.
Korsmeyer, Carolyn (1995) Gendered Concepts and Hume's Standard of Taste. In Peggy Zeglin Brand and Carolyn Korsmeyer, eds., *Feminism and Tradition in Aesthetics*. University Park, PA: Pennsylvania State University Press.
Korsmeyer, Carolyn (2004) *Gender and Aesthetics: An Introduction*. New York: Routledge.
Korsmeyer, Carolyn, and Peg Brand Weiser (2021) Feminist Aesthetics. *The Stanford Encyclopedia of Philosophy*, Winter 2021 Edition. https://plato.stanford.edu/archives/win2021/entries/feminism-aesthetics.
Kovačević, Ivanka (1975) *Fact into Fiction: English Literature and the Industrial Scene, 1750–1850*. Belgrade: Leicester University Press.
Kravetz, Rachel (2017) *The Art of Cognition: British Empiricism and Victorian Aesthetics*. PhD diss., City University of New York.
Krawczyk, Scott (2009) *Romantic Literary Families*. New York: Palgrave Macmillan.
Kristeller, Paul Oskar (1951) The Modern System of the Arts: A Study in the History of Aesthetics (I). *Journal of the History of Ideas* 12 (4): 496–527.
Krisuk, Jennifer J. (2014) Reclaiming Spaces of Learning in Anna Jameson's *Diary of an Ennuyée*. *Women's Writing* 22 (4): 1–17.
Lacan, Jacques [1972–73] (1985) Seminar XX, Encore, 1972–73, trans. Jacqueline Rose. In Juliet Mitchell and Jacqueline Rose, eds., *Feminine Sexuality: Jacques Lacan and the école freudienne*. New York: Norton.
Landon, Letitia Elizabeth (1832) On the Ancient and Modern Influence of Poetry. *New Monthly Magazine* 35: 466–71.
Landow, George (1971) *Aesthetic and Critical Theory of John Ruskin*. Princeton: Princeton University Press.
Lanzoni, Susan (2009) Practicing Psychology in the Art Gallery: Vernon Lee's Aesthetics of Empathy. *Journal of the History of the Behavioral Sciences* 45 (4): 330–54.
Larson, Janet (2003) Where is the Woman in this Text? Frances Power Cobbe's Voices in 'Broken Lights'. *Browning Institute Studies* 31 (1): 99–129.
Larson, Kenneth (1987) The Origins of the 'Schlegel-Tieck' Shakespeare in the 1820s. *German Quarterly* 60 (1): 19–37.
Leavis, F. R. [1948] (1950) *The Great Tradition*. 2nd edn. London: Chatto & Windus.
LeCourt, Sebastian (2018) *Cultivating Belief: Victorian Anthropology, Liberal Aesthetics, and the Secular Imagination*. Oxford: Oxford University Press.
Lee, Vernon (1881) *Belcaro: Being Essays on Sundry Aesthetical Questions*. London: Satchell.

Lee, Vernon (1884) *Miss Brown*. 2 vols. Edinburgh: Blackwood.
Lee, Vernon [1885] (2023) The Ethics of Aesthetics: Notes on a New Book by Walter Pater, trans. Colton Valentine. *Victorian Literature and Culture* 51 (2): 296–305.
Lee, Vernon (1886) *Baldwin: Being Dialogues on Views and Aspirations*. London: T. Fisher Unwin.
Lee, Vernon (1889) Orpheus in Rome: Irrelevant Talks on the Uses of the Beautiful. *Contemporary Review* 55: 828–49.
Lee, Vernon (1896a) Art and Life. Part I. *Contemporary Review* 69: 658–70.
Lee, Vernon (1896b) Art and Life. Part II. *Contemporary Review* 69: 813–25.
Lee, Vernon (1896c) Art and Life. Part III. *Contemporary Review* 70: 59–73.
Lee, Vernon (1901a) Art and Usefulness. Part I. *Contemporary Review* 80: 362–74.
Lee, Vernon (1901b) Art and Usefulness. Part II. *Contemporary Review* 80: 512–27.
Lee, Vernon (1909) *Laurus Nobilis: Chapters on Art and Life*. London: Bodley Head.
Lee, Vernon (1913) *The Beautiful: An Introduction to Psychological Aesthetics*. Cambridge: Cambridge University Press.
Lee, Vernon (1923) *The Handling of Words and Other Studies in Literary Psychology*. London: John Lane.
Lee, Vernon (1924) Introduction to C. Anstruther-Thomson, *Art and Man: Essays and Fragments*. London: John Lane.
Lee, Vernon (1926) *The Poet's Eye: Notes on Some Differences Between Verse and Prose*. London: Hogarth Press.
Lee, Vernon (1932) *Music and its Lovers: An Empirical Study of Emotional and Imaginative Responses to Music*. London: Allen & Unwin.
Lee, Vernon (2017) *Selected Letters of Vernon Lee, 1856–1935*, Vol. I, 1865–1884, ed. Amanda Gagel. London: Routledge.
Lee, Vernon (n.d.) *Letters Home*. Vernon Lee Collection, Colby College. https://digitalcommons.colby.edu/vernonlee.
Lee, Vernon, and C. Anstruther-Thomson (1897a) Beauty and Ugliness. I–III. *Contemporary Review* 72: 544–69.
Lee, Vernon, and C. Anstruther-Thomson (1897a) Beauty and Ugliness. IV–VII. *Contemporary Review* 72: 669–88.
Liao, Shen-Yi (2023) The Art of Immoral Artists. In Carl Fox and Joe Saunders, eds., *The Routledge Handbook of Philosophy and Media Ethics*. New York: Routledge.
Lim, Jessica Wen Hui (2019) Barbauld's Lessons: The Conversational Primer in Late Eighteenth-Century British Children's Literature. *Journal for Eighteenth-Century Studies* 43 (1): 101–20.
Livesey, Ruth (2007) *Socialism, Sex, and the Culture of Aestheticism in Britain, 1880–1914*. Oxford: Oxford University Press.
Lloyd, Christopher (2001) Lady Callcott's Honeymoon, 1827–8: Art-Historical Reflections in Germany and Italy. In Carol Richardson and Graham Smith, eds., *Taste and Travel in the Nineteenth Century*. Edinburgh: VARIE.
Lochhead, Marion (1961) *Elizabeth Rigby, Lady Eastlake*. London: Murray.
Lockhart, John Gibson (1829) *An Introduction to the Life of Sir Walter Scott*. www.gla.ac.uk/schools/critical/aboutus/resources/stella/projects/starn/prose/the-waverley-novels/life-of-scott.
Loesberg, Jonathan (2001) Ethics, Aesthetics, and Unreadable Acts in George Eliot. In Suzy Anger, ed., *Knowing the Past: Victorian Literature and Culture*. Ithaca, NY: Cornell University Press.
Loske, Alexandra (2017) Mary Philadelphia Merrifield: Color History as Expertise. *Visual Resources* 33 (1–2): 11–26.
Ludley, David A. (1991) Anna Jameson and D. G. Rossetti: His Use of Her Histories. *Woman's Art Journal* 12 (2): 29–33.
Lyotard, Jean-François (1982) Presenting the Unpresentable: The Sublime. *Artforum* 20 (8): 64–9.
Macleod, Jock (2016) Reconstructing W. H. Allen's 'Eminent Women'. *Publishing History* 76: 7–33.

Macpherson, Geraldine (1878) *Memoirs of the Life of Anna Jameson*. Boston: Roberts Brothers.
Maginn, William, and Lockhart, John Gibson (1824) Maxims of Mr ODoherty. Part One. *Blackwood's Edinburgh Magazine* 15: 599–605.
Mahoney, Kristin (2016) Ethics and Empathy in the Literary Criticism of Vernon Lee. *Nineteenth-Century Prose* 43 (1–2): 193–210.
Maltz, Diana (1999) Engaging 'Delicate Brains': From Working-Class Enculturation to Upper-Class Lesbian Liberation in Vernon Lee and Kit Anstruther-Thomson's Psychological Aesthetics. In Talia Schaffer and Kathy Alexis Psomiades, eds., *Women in British Aestheticism*. Charlottesville: University Press of Virginia.
Maltz, Diana (2006) *British Aestheticism and the Urban Working Classes, 1870–1900*. London: Palgrave Macmillan.
Mann, Bonnie (2006) *Women's Liberation and the Sublime: Feminism, Postmodernism, Environment*. Oxford: Oxford University Press.
Mannocchi, Phyllis F. (1983) 'Vernon Lee': A Reintroduction and Primary Bibliography. *English Literature in Transition, 1880–1920* 26 (4): 231–67.
Mansfield, Elizabeth (1996) *Art, History and Authorship: The Critical Writings of Emilia Dilke*. PhD diss., Harvard University.
Mansfield, Elizabeth (1997) Victorian Identity and the Historical Imaginary: Emilia Dilke's 'The Renaissance of Art in France'. *Clio* 26 (2): 167–88.
Mansfield, Elizabeth (1998) Articulating Authority: Emilia Dilke's Early Essays and Reviews. *Victorian Periodicals Review* 31 (1): 75–86.
Mansfield, Elizabeth (2000) The Victorian *grand siècle*: Ideology as Art History. *Victorian Literature and Culture* 28 (1): 133–47.
Marchand, Leslie Alexis (1941) *The Athenaeum: A Mirror of Victorian Culture*. Chapel Hill, NC: University of North Carolina Press.
Martin, Kirsty (2013) Vernon Lee's Empathy. In *Modernism and the Rhythms of Sympathy*. Oxford: Oxford University Press.
Martineau, Harriet (1822a) Female Writers on Practical Divinity. No. I. Mrs More. *Monthly Repository* 17: 593–6.
Martineau, Harriet (1822b) Female Writers on Practical Divinity. No. II. Mrs More and Mrs Barbauld. *Monthly Repository* 17: 746–50.
Martineau, Harriet (1825) *Devotional Exercises*. London: R. Hunter.
Martineau, Harriet (1832a) *Illustrations of Political Economy No. I: Life in the Wilds*. 2nd edn. London: Charles Fox.
Martineau, Harriet (1832b) *A Manchester Strike*. London: Charles Fox.
Martineau, Harriet (1834) *Illustrations of Political Economy No. XXV: The Moral of Many Fables*. London: Charles Fox.
Martineau, Harriet [1832] (1836a) Characteristics of the Genius of Scott. In *Miscellanies*, vol. 1. Boston: Hilliard, Gray and Co.
Martineau, Harriet [1832] (1862) For Each and For All. In *Miss Martineau's Popular Tales*. London: Routledge.
Martineau, Harriet [1833] (1836b) Achievements of the Genius of Scott. In *Miscellanies*, vol. 1. Boston: Hilliard, Gray and Co.
Martineau, Harriet (1836c) *Miscellanies*. 2 vols. Boston: Hilliard and Gray.
Martineau, Harriet (1853) Literature. *Villette*. By Currer Bell. [review] *Daily News*, February 3: 2.
Martineau, Harriet (1861) What Women are Educated For. *Once a Week*, 10 August: 175–9.
Martineau, Harriet (1869) *Biographical Sketches*. New York: Leypoldt and Holt.
Martineau, Harriet (1877) *Autobiography*, ed. Maria Weston Chapman. 3 vols. Boston: Osgood.
Martineau, Harriet (1990) *Selected Letters*, ed. Valerie Sanders. Oxford: Oxford University Press.
Martineau, Harriet (2007) *Collected Letters*, ed. Deborah Logan. 5 vols. London: Pickering and Chatto.
Martineau, Harriet, and Henry George Atkinson (1851) *Letters on the Laws of Man's Nature and Development*. London: J. Chapman.

Marx, Karl [1843–44] (1992) A Contribution to the Critique of Hegel's Philosophy of Right. Introduction, trans. Rodney Livingstone and Gregor Benton. In Karl Marx, *Early Writings*, ed. Lucio Colletti. Harmondsworth: Penguin.
Marx, Karl [1859] (2000) Preface to *A Critique of Political Economy*. In Karl Marx, *Selected Writings*, ed. David McLellan. Oxford: Oxford University Press.
Maxwell, Catherine (2009) *Second Sight: The Visionary Imagination in Late Victorian Literature*. Manchester: Manchester University Press.
Maxwell, Catherine (2018) Vernon Lee's Handling of Words. In Michael D. Hurley and Marcus Waithe, eds., *Thinking Through Style: Non-Fiction Prose of the Nineteenth Century*. Oxford: Oxford University Press.
Maxwell, Catherine, and Patricia Pulham, eds. (2006) *Vernon Lee: Decadence, Ethics, Aesthetics*. London: Palgrave Macmillan.
McCarthy, William (2008) *Anna Letitia Barbauld: Voice of the Enlightenment*. Baltimore, NJ: Johns Hopkins University Press.
McCarthy, William (2015) Uncollected Periodical Prose by Anna Letitia Barbauld. *Studies in Bibliography* 59 (1): 225–48.
McCarthy, William, and Elizabeth Kraft, eds. (2001) *Anna Letitia Barbauld: Selected Poetry and Prose*. Peterborough, Ontario: Broadview Press.
McCarthy, William, and Olivia Murphy, eds. (2014) *Anna Letitia Barbauld: New Perspectives*. Lanham, MD: Rowman & Littlefield.
Mee, Jon (2003) *Romanticism, Enthusiasm and Regulation: Poetics and the Policing of Culture in the Romantic Period*. Oxford: Oxford University Press.
Mellor, Anne K. (2002) *Mothers of the Nation: Women's Political Writing in England, 1780–1830*. Bloomington: Indiana University Press.
Melnyk, Julie, ed. (1998) *Women's Theology in Nineteenth-Century Britain*. London: Routledge.
Merrifield, Mary (1851) The Harmony of Colours. *The Art-Journal*, 1 January 1–8.
Merrifield, Mary (1854) *Dress as a Fine Art*. Boston: Jewett.
Merrill, Lisa (2003) 'Old Maids, Sister-Artists, and Aesthetes': Charlotte Cushman and her Circle of 'Jolly Bachelors' Construct an Expatriate Women's Community in Rome. *Women's Writing* 10 (2): 367–83.
Meynell, Alice (1899) Joanna Baillie. *Pall Mall Gazette*, 25 January: 3.
Miles, Alfred H. (1907) Anna Laetitia Barbauld: Critical and Biographical Essay. In Alfred H. Miles, *The Sacred Poets of the Nineteenth Century*. London: Routledge.
Miles, Melissa (2008) Sun-Pictures and Shadow-Play: Untangling the Web of Gendered Metaphors in Lady Elizabeth Eastlake's 'Photography'. *Word & Image* 24 (1): 42–50.
Milman, Henry Hart (1836) Joanna Baillie's *Dramas*. *Quarterly Review* 55: 487–513.
Mitchell, Rosemary (2008) Eastlake [née Rigby], Elizabeth, Lady Eastlake (1809–1893). *Oxford Dictionary of National Biography*. www.oxforddnb.com/view/10.1093/ref:odnb/9780198614128.001.0001/odnb-9780198614128-e-8415.
Mitchell, Sally (2004) *Frances Power Cobbe: Victorian Feminist, Journalist, Reformer*. Charlottesville VA: University of Virginia Press.
Moir, George (1834) Mrs Jameson's *Characteristics and Sketches*. [Review] *Edinburgh Review* 60: 180–201.
Monckton Milnes, Richard, ed. (1848) *Life, Letters, and Literary Remains, of John Keats*. 2 vols. London: Moxon.
Monsam, Angela (2017) A Vivisecting Dramatist: The Anatomy of Theater in Joanna Baillie's 'Introductory Discourse' and *De Monfort*. *European Romantic Review* 28 (6): 751–72.
Moore, Catherine E. (1986) 'Ladies…Taking the Pen in Hand': Mrs Barbauld's Criticism of Eighteenth-Century Women Novelists. In Mary Anne Schofield and Cecilia Macheski, eds., *Fetter'd or Free? British Women Novelists, 1670–1815*. Athens, OH: Ohio University Press.
Morgan, Benjamin (2012) Critical Empathy: Vernon Lee's Aesthetics and the Origins of Close Reading. *Victorian Studies* 55 (1): 35–56.
Morgan, Benjamin (2017) *The Outward Mind: Materialist Aesthetics in Victorian Science and Literature*. Chicago: University of Chicago Press.

Morley, Simon (2010) Introduction to Simon Morley, ed., *The Sublime*. Cambridge, MA: MIT.
Murdoch, Iris [1992] (2003) *Metaphysics as a Guide to Morals*. London: Vintage.
Murphy, Margueritte (2008) Pure Desire: Changing Definitions of 'l'art pour l'art' from Kant to Gautier. *Studies in Romanticism* 47 (2): 147–60.
Murray, Julie (2003) Governing Economic Man: Joanna Baillie's Theatre of Utility. *ELH* 70 (4): 143–65.
Myers, Victoria (2004) Joanna Baillie's Theatre of Cruelty. In Thomas Crochunis, ed., *Joanna Baillie: Romantic Dramatist*. London: Routledge.
Naden, Constance [1884] (1891) Evolution of the Sense of Beauty. In *Further Reliques of Constance Naden*. London: Bickers and Son.
Needler, G. H., ed. (1934) *Letters of Anna Jameson to Ottilie von Goethe*. Oxford: Oxford University Press.
Nelson, Charmaine (2007) *The Color of Stone: Sculpting the Black Female Subject in Nineteenth-Century America*. Minneapolis: University of Minnesota Press.
Newman, Sally (2005) The Archival Traces of Desire: Vernon Lee's Failed Sexuality and the Interpretation of Letters in Lesbian History. *Journal of the History of Sexuality* 14 (1/2): 51–75.
Nietzsche, Friedrich [1886] (1999) An Attempt at Self-Criticism. In *The Birth of Tragedy and Other Writings*, trans. Ronald Speirs. Cambridge: Cambridge University Press.
Nochlin, Linda (1971) Why Are There No Great Women Artists? In Vivian Gornick and Barbara K. Moran, eds., *Woman in Sexist Society*. New York: Basic Books.
Norton, Rictor, ed. (2000) *Gothic Readings, 1764–1840*. Leicester: Leicester University Press.
Norton, Robert E. (1991) The Aesthetic Education of Humanity: George Eliot's 'Romola' and Schiller's Theory of Tragedy. *Journal of Aesthetic Education* 25 (4): 3–20.
Nunn, Pamela Gerrish (1987) *Victorian Women Artists*. London: The Women's Press.
Nünning, Ansgar (2015) 'The Extension of our Sympathies': George Eliot's Aesthetic Theory and Narrative Technique as a Key to the Affective, Cognitive, and Social Value of Literature. In Hanna Meretoja, Saija Isomaa, Pirjo Lyytikäinen, and Kristina Malmio, eds., *Values of Literature*. Leiden: Brill.
Nussbaum, Martha (1990) *Love's Knowledge: Essays on Philosophy and Literature*. New York: Oxford University Press.
O'Neill, Eileen (1998) Disappearing Ink: Early Modern Women Philosophers and Their Fate in History. In Janet A. Kourany, ed., *Philosophy in a Feminist Voice*. Princeton, NJ: Princeton University Press.
O'Neill, Eileen (2005) Early Modern Women Philosophers and the History of Philosophy. *Hypatia* 20 (3): 185–97.
O'Neill, Eileen (2019) Introduction to Eileen O'Neill and Marcy Lascano, eds. *Feminist History of Philosophy: The Recovery and Evaluation of Women's Philosophical Thought*. New York: Springer.
O'Neill, Eileen, and Marcy Lascano, eds. (2019) *Feminist History of Philosophy: The Recovery and Evaluation of Women's Philosophical Thought*. New York: Springer.
Oliphant, Margaret (1892) *The Victorian Age in Literature*. 2 vols. New York: Lovell.
Omega (John Neal) (1824) Men and Women: Brief Hypothesis concerning the Difference in their Genius. *Blackwood's Edinburgh Magazine* 16: 387–94.
Onslow, Barbara (2000) *Women of the Press in Nineteenth-Century Britain*. London: Palgrave Macmillan.
Oražem, Claudia (1999) *Political Economy and Fiction in the Early Works of Harriet Martineau*. Berlin: Peter Lang.
Østermark-Johansen, Lene (2015) The Book Beautiful: Emilia Dilke's Copy of Walter Pater's *Studies in the History of the Renaissance*. Brasenose College Library and Archives, https://brasenosecollegelibrary.wordpress.com/2015/06/11/the-book-beautiful-emilia-dilkes-copy-of-walter-paters-studies-in-the-history-of-the-renaissance-by-lene-ostermark-johansen.
Palmer, Caroline (2009) *Women Writers on Art and Perceptions of the Female Connoisseur, 1780–1860*. PhD diss., Oxford Brookes University.

Palmer, Caroline (2013) Colour, Chemistry and Corsets: Mary Philadelphia Merrifield's Dress as a Fine Art. *Costume* 47 (1): 3–27.
Palmer, Caroline (2017) 'A Fountain of the Richest Poetry': Anna Jameson, Elizabeth Eastlake and the Rediscovery of Early Christian Art. *Visual Resources* 33 (1–2): 48–73.
Palmer, Caroline (2019) 'A Revolution in Art': Maria Callcott on Poussin, Painting, and the Primitives. *19: Interdisciplinary Studies in the Long Nineteenth Century* 28. doi: https://doi.org/10.16995/ntn.833.
Parisot, Eric (2020) The Aesthetics of Terror and Horror: A Genealogy. In Angela Wright and Dale Townshend, eds., *The Cambridge History of the Gothic*, vol. 1. Cambridge: Cambridge University Press.
Parker, Roszika, and Griselda Pollock (1981) *Old Mistresses: Women, Art and Ideology*. London: Routledge.
Pater, Walter (1868) Poems by William Morris. *Westminster Review* 34: 300–12.
Pater, Walter (1873) *Studies in the History of the Renaissance*. London: Macmillan.
Pater, Walter (1887) Vernon Lee's 'Juvenilia'. *Pall Mall Gazette*, 5 August: 5.
Peacock, Sandra J. (2002) *The Theological and Ethical Writings of Frances Power Cobbe, 1822–1904*. Lewiston: Edwin Mellen.
Peterson, Linda H. (2009) *Becoming a Woman of Letters: Myths of Authorship and Facts of the Victorian Market*. Princeton: Princeton University Press.
Pollock, Griselda (1988) *Vision and Difference: Femininity, Feminism, and Histories of Art*. London: Routledge.
Pollock, Griselda (1999) *Differencing the Canon: Feminism and the Writing of Art's Histories*. London: Routledge.
Pollock, Griselda (2012) Art History and Visual Studies in Great Britain and Ireland. In Matthew Rampley, Thierry Lenain, Hubert Locher, Andrea Pinotti, Charlotte Schoell-Glass, and C. J. M. Zijlmans, eds., *Art History and Visual Studies in Europe: Transnational Discourses and National Frameworks*. Leiden: Brill.
Pollok, Anne (2022) Layers of Meaning, Layers of Telling: How German Women Intellectuals Constructed Female Identity. *Blog of the APA*, 9 February. https://blog.apaonline.org/2022/02/09/layers-of-meaning-layers-of-telling-how-german-women-intellectuals-constructed-female-identity.
Price, Fiona (2009) *Revolutions in Taste 1773–1818: Women Writers and the Aesthetics of Romanticism*. London: Routledge.
Price, Fiona (2023) The Aesthetics of the Romantic Period and Women's Writing. In Lydia Moland and Alison Stone, eds., *The Oxford Handbook of American and British Women Philosophers in the Nineteenth Century*. Oxford: Oxford University Press.
Price, John Vladimir, ed. (1999) *Aesthetics: Sources in the 19th Century*. 8 vols. Bristol: Thoemmes.
Priestley, Joseph (1806) *Memoirs, to the Year 1795*. Northumberland: Binns.
Priestley, Joseph [1782] (1820) On Habitual Devotion. In *The Theological and Miscellaneous Works of Joseph Priestley*, ed. J. T. Rutt, vol. 15. London: G. Smallfield.
Priestley, Joseph [1783] (1812) *A General View of the Arguments for the Unity of God; and Against the Divinity and Pre-Existence of Christ*. New, corrected edn. London: J. Johnson and D. Eaton.
Psomiades, Kathy (1999) 'Still Burning from this Strangling Embrace': Vernon Lee on Desire and Aesthetics. In Richard Dellamora, ed., *Victorian Sexual Dissidence*. Chicago: Chicago University Press.
Pugin, Augustus (1841) *The True Principles of Pointed or Christian Architecture*. London: Weale.
Purinton, Marjean (1994) *Romantic Ideology Unmasked*. Newark: University of Delaware Press.
Radford, Colin (1975) How Can We Be Moved by the Fate of Anna Karenina? *Proceedings of the Aristotelian Society* Supp. 49: 67–80.
Raven, James (2000) Historical Introduction. In James Raven and Antonia Forster, with Stephen Bending, *The English Novel, 1770–1829*, vol. 1: *1770–1799*. Oxford: Oxford University Press.

Raysor, Thomas, ed. (1950) *The English Romantic Poets: A Review of Research*. New York: Modern Language Association of America.
Reid, Thomas (1973) *Lectures on the Fine Arts*, ed. Peter Kivy. The Hague: Nijhoff.
Reuter, Martina (2017) Jean-Jacques Rousseau and Mary Wollstonecraft on the Imagination. *British Journal for the History of Philosophy* 25 (6): 1138–60.
Reynolds, Joshua [1769] (1891) *Discourses on Art*, ed. Edward Gilpin Johnson. Chicago: McClurg.
Richardson, Alan (2004) A Neural Theatre: Joanna Baillie's 'Plays on the Passions'. In Thomas Crochunis, ed., *Joanna Baillie: Romantic Dramatist*. London: Routledge.
Richetti, John (1998) *The English Novel in History, 1700–1780*. London: Routledge.
Rio, Alexis-François (1836) *De la poésie chrétienne*. Paris: Debécourt.
Roberts, Caroline (2002) *The Woman and the Hour: Harriet Martineau and Victorian Ideologies*. Toronto: University of Toronto Press.
Roberts, Helene (1970) British Art Periodicals of the Eighteenth and Nineteenth Centuries. *Victorian Periodicals Newsletter* 9: 1–181.
Robertson, David Allan (1978) *Sir Charles Eastlake and the Victorian Art World*. Princeton, NJ: Princeton University Press.
Robinson, Ainslie (2000) Stalking through the Literary World: Anna Jameson and the Periodical Press, 1826–1860. *Victorian Periodicals Review* 33 (2): 165–77.
Robinson, Ainslie (2003) The History of our Lord as Exemplified in Works of Art: Anna Jameson's *coup de grâce*. *Women's Writing* 10 (1): 187–200.
Rorty, Amélie Oksenberg (1992) The Psychology of Aristotelian Tragedy. In Amélie Oksenberg Rorty, ed., *Essays on Aristotle's Poetics*. Princeton, NJ: Princeton University Press.
Ross, Stephanie (2022) Review of Babette Babich, ed., *Reading David Hume's 'Of the Standard of Taste'*. *Notre Dame Philosophical Reviews*. https://ndpr.nd.edu/reviews/reading-david-humes-of-the-standard-of-taste.
Roy, Wendy (2003) 'Here is the Picture as Well as I Can Paint It': Anna Jameson's Illustrations for *Winter Studies and Summer Rambles*. *Canadian Studies* 177 (Summer): 97–119.
Rubery, Matthew (2010) Victorian Print Culture, Journalism and the Novel. *Literature Compass* 7 (4): 290–300.
Ruskin, John [1843] (1848) *Modern Painters*, vol. 1. 4th edn. New York: Wiley.
Ruskin, John (1846) *Modern Painters*, vol. 2. 3rd edn. London: Smith, Elder.
Ruskin, John (1849) *The Seven Lamps of Architecture*. London: Smith, Elder, and Co.
Ruskin, John (1851) Pre-Raphaelitism. London: Smith, Elder, and Co.
Ruskin, John (1853) The Nature of Gothic. In John Ruskin, *The Stones of Venice*, vol. II. London: Smith, Elder and Co.
Ruskin, John (1855) *Lectures on Architecture and Painting*. London: Smith, Elder, and Co.
Ruskin, John (1856a) *Modern Painters*, vol. 3. London: Smith, Elder, and Co.
Ruskin, John (1856b) *Modern Painters*, vol. 4. London: Smith, Elder, and Co.
Ruskin, John [1864] (1866) Traffic. In *The Crown of Wild Olive*. London: Smith, Elder, & Co.
Ruskin, John (1865) Of Queens' Gardens. In John Ruskin, *Sesame and Lilies: Two Lectures*. London: Smith, Elder, and Co.
Ruskin, John (1870) *Lectures on Art*. Oxford: Clarendon.
Ruskin, John (1972) *Ruskin in Italy: Letters to his Parents, 1845*, ed. Harold I. Shapiro. Oxford: Oxford University Press.
Russell, Anne E. (1991) 'History and Real Life': Anna Jameson, Shakespeare's Heroines and Victorian Women. *Victorian Review* 17 (2): 35–49.
Rutt, John Towill, ed. (1831) *Life and Correspondence of Joseph Priestley*. 2 vols. London: Hunter.
Salmonson, Jessica Amanda, ed. (1989) *What Did Miss Darrington See? An Anthology of Feminist Supernatural Fiction*. New York: Feminist Press.
Samalin, Zachary (2021) *The Masses Are Revolting: Victorian Culture and the Political Aesthetics of Disgust*. Ithaca, NY: Cornell University Press.
Sanders, Valerie (1986) *Reason over Passion: Harriet Martineau and the Victorian Novel*. Hassocks: Harvester.

Sanders, Valerie (2001) 'Meteor Wreaths': Harriet Martineau, 'L.E.L.', Fame and *Fraser's Magazine*. *Critical Survey* 13 (2): 42–60.
Sanders, Valerie (2002) Harriet Martineau and Elizabeth Gaskell. *The Gaskell Society Journal* 16: 64–75.
Sanders, Valerie, and Gaby Weiner, eds. (2017) *Harriet Martineau and the Birth of Disciplines: Nineteenth-Century Intellectual Powerhouse*. London: Routledge.
Sandner, David, ed. (2004) *Fantastic Literature: A Critical Reader*. Westport, CT: Greenwood.
Schaffer, Talia (2000) *The Forgotten Female Aesthetes: Literary Culture in Late-Victorian England*. Charlottesville, VA: University of Virginia Press.
Schaffer, Talia, and Kathy Alexis Psomiades, eds. (1999) *Women and British Aestheticism*. Charlottesville, VA: University of Virginia Press.
Schlegel, August Wilhelm (1796) Etwas über William Shakespeare bei Gelegenheit *Wilhelm Meisters*. *Die Horen* 6 (4): 57–112
Schlegel, August Wilhelm (1797) Über Shakespeare's Romeo und Julia. *Die Horen* 10 (6): 18–48.
Schlegel, August Wilhelm (1828) *Kritische Schriften*, vol. 1. Berlin: Reimer.
Schlegel, August[us] Wilhelm (1815) *A Course of Lectures on Dramatic Art and Literature*, trans. John Black. 2 vols. London: Baldwin.
Schlegel, Caroline (1797a) Letter to [August] Wilhelm Schlegel. Letter #186. *Caroline Schelling: Briefe aus der Frühromantik*, trans. Douglas Stott. www.carolineschelling.com/letters/volume-1-index/letter-186.
Schlegel, Caroline (1797b) Letter to [August] Wilhelm Schlegel. Letter #187. At *Caroline Schelling: Briefe aus der Frühromantik*, trans. Douglas Stott. www.carolineschelling.com/letters/volume-1-index/letter-187.
Schlegel, Friedrich [1797] (2002) *On the Study of Greek Poetry*, trans. Stuart Barnett. Albany: SUNY Press.
Schlegel, Friedrich [1798] (1991) Athenaeum Fragments. In Schlegel, *Philosophical Fragments*, trans. Peter Firchow. Minneapolis: University of Minnesota Press.
Schlegel, Friedrich (1849) *Aesthetic and Miscellaneous Works*, trans. E. J. Millington. London: Bohn.
Schopenhauer, Arthur [1844] (1977) *Die Welt als Wille und Vorstellung*. 2nd edn. In *Zürcher Werke in zehn Bänden*, vol. 3. Zürich: Diogenes.
Schurch, Millie (2022) 'And Breathes a Spirit Through the Finish'd Whole': Empiricism, Poetry and Devotion in Anna Letitia Barbauld's Poetic Epistemology. *European Romantic Review* 33 (6): 777–800.
Scott, Patrick (1975) Victorian Religious Periodicals: Fragments that Remain. *Studies in Church History* 11: 325–39.
Scott, Walter (1894) *Familiar Letters of Sir Walter Scott*, ed. David Douglas. 2 vols. Boston: Houghton Mifflin.
Shaftesbury, Anthony Ashley Cooper (1709) *The Moralists, A Philosophical Rhapsody*. London: Wyat.
Shanley, Mary Lyndon, and Carole Pateman, eds. (1990) *Feminist Interpretations and Political Theory*. Cambridge: Polity.
Sheldon, Julie (2009) Chronological Bibliography of Works by Elizabeth Eastlake. In Julie Sheldon and Elizabeth Eastlake, *The Letters of Elizabeth Rigby, Lady Eastlake*. Liverpool: Liverpool University Press.
Sheldon, Julie (2022) Eastlake, Lady Elizabeth. In Lesa Scholl and Emily Morris, eds., *The Palgrave Encyclopedia of Victorian Women's Writing*. Cham: Springer.
Sheppard, Sarah (1841) *Characteristics of the Genius and Writings of L. E. L.* London: Longman, Brown, Green, and Longman.
Siegel, Eli (1969) So, What is Bitterness? Anna Jameson and Hedda Gabler. *Aesthetic Realism Foundation: Lectures*. https://aestheticrealism.org/lectures/so-what-is-bitterness.
Siegel, Jonah (2016) Victorian Aesthetics. In Juliet John, ed., *The Oxford Handbook of Victorian Literary Culture*. Oxford: Oxford University Press.

Sigourney, Lydia (1840) Essay on the Genius of Mrs Hemans. In Felicia Hemans, *Works*, ed. Harriet Browne. Philadelphia: Blanchard and Lea.
Slagle, Judith Bailey (2002) *Joanna Baillie: A Literary Life*. Madison, WI: Fairleigh Dickinson University Press.
Slagle, Judith Bailey (2013) Joanna Baillie and the Anxiety of Shakespeare's Influence. *Borrowers and Lenders* 8 (1). https://openjournals.libs.uga.edu/borrowers/article/view/2203/2103.
Slights, Jessica (1993) Historical Shakespeare: Anna Jameson and Womanliness. *English Studies in Canada* 19 (4): 387–400.
Slingerland, Jean Harris, ed. (1989) *Wellesley Index to Victorian Periodicals 1824–1900*, vol. 5. Toronto: University of Toronto Press.
Small, I. C. (1977) Vernon Lee, Association and 'Impressionist' Criticism. *British Journal of Aesthetics* 17 (2): 178–84.
Smith, Adam (1759) *The Theory of Moral Sentiments*. London: A. Millar.
Spencer, Herbert [1862] (1937) *First Principles*. London: Watts.
Spencer, Herbert (1872) Aesthetic Sentiments. In *Principles of Psychology*, vol. II. London: Williams & Norgate.
Spender, Dale (1986) *Mothers of the Novel: One Hundred Good Women Writers Before Jane Austen*. New York: Thorsons.
Stabler, Jane (2002) *Burke to Byron, Barbauld to Baillie, 1790–1830*. London: Palgrave Macmillan.
Stecker, Robert (2019) *Intersections of Value: Art, Nature, and the Everyday*. Oxford: Oxford University Press.
Stephen, Leslie (1893) Harriet Martineau. In Leslie Stephen, ed., *Dictionary of National Biography*, vol. 36. London: Smith, Elder and Co.
Stewart, Lindsey (2023) Black Women's Intellectual Traditions: 'These Flowers Growing Out My Mind'. In Lydia Moland and Alison Stone, eds., *The Oxford Handbook of American and British Women Philosophers in the Nineteenth Century*. Oxford: Oxford University Press.
Stone, Alison (2022) *Frances Power Cobbe*. Cambridge: Cambridge University Press.
Stone, Alison (2023) *Women Philosophers in Nineteenth-Century Britain*. Oxford: Oxford University Press.
Stott, Douglas (2009–22) Caroline and the Translation of Shakespeare. At *Caroline Schelling*. www.carolineschelling.com/caroline-and-shakespeare.
Strachey, Lytton [1918] (2009) *Eminent Victorians*. Oxford: Oxford University Press.
Strachey, Ray (1928) *The Cause: A Short History of the Women's Movement in Britain*. London: Bell.
Strychacz, Thomas (1993) *Modernism, Mass Culture, and Professionalism*. Cambridge: Cambridge University Press.
Styler, Rebecca (2010) *Literary Theology by Women Writers of the Nineteenth Century*. London: Routledge.
Ternant, Andrew de (1922) Marat in England. *Notes and Queries* 12 S XI (15 July): 53.
Teukolsky, Rachel (2009) *The Literate Eye: Victorian Art Writing and Modernist Aesthetics*. New York: Oxford University Press.
Teukolsky, Rachel (2020) *Picture World: Image, Aesthetics, and Victorian New Media*. Oxford: Oxford University Press.
Thackeray, Anne (1883) *A Book of Sibyls: Mrs Barbauld, Miss Edgeworth, Mrs Opie, Miss Austen*. London: Smith, Elder and Co.
Thomas, Clara (1967) *Love and Work Enough: The Life of Anna Jameson*. Toronto: University of Toronto Press.
Thomas, David Wayne (2004) *Cultivating Victorians: Liberal Culture and the Aesthetic*. Philadelphia: University of Pennsylvania Press.
Thomas, Zoe (2022) *Women Art Workers and the Arts and Crafts Movement*. Manchester: Manchester University Press.
Tieck, Ludwig (1830) Vorrede. In Ludwig Tieck, *Shakspeare's dramatische Werke*, vol. 3. Berlin: Reimer.

Townley, Sarah (2011) Vernon Lee and Elitism: Redefining British Aestheticism. *English Literature in Transition* 54 (4): 523–38.
Tuchman, Gaye (1989) *Edging Women Out: Victorian Novelists, Publishers and Social Change.* London: Routledge.
Tuchman, Gaye, and Nina E. Fortin (1984) Fame and Misfortune: Edging Women Out of the Great Literary Tradition. *American Journal of Sociology* 90 (1): 72–96.
Tuckerman, H. T. (1852) Essay. In Felicia Hemans, *Poems, with an Essay on her Genius,* ed. Rufus W. Griswold. Philadelphia: Ball.
Tumelson III, Ronald A. (2006) Ferdinand's Wife and Prospero's Wise. In Peter Holland, ed., *Shakespeare Survey 59: Editing Shakespeare.* Cambridge: Cambridge University Press.
Tylor, Edward Burnett (1871) *Primitive Culture.* 2 vols. London: Murray.
Underwood, Ted, David Bamman, and Sabrina Lee (2018) The Transformation of Gender in English-Language Fiction. *Journal of Cultural Analytics* 3 (2). https://doi.org/10.22148/16.019.
Valentine, Colton (2023) On Vernon Lee's Walter Pater and Translating the Victorians. *Victorian Literature and Culture* 51 (2): 293–305.
VanArsdel, Rosemary (2010) *Victorian Periodicals: Aids to Research: A Selected Bibliography.* 10th edn. The Research Society for Victorian Periodicals. https://rs4vp.org/resources/vanarsdel-bibliography.
Vicinus, Martha (2003) Laocoöning in Rome: Harriet Hosmer and Romantic Friendship. *Women's Writing* 10 (2): 353–66.
Vickery, Amanda (1993) Golden Age to Separate Spheres? A Review of the Categories and Chronology of English Women's History. *The Historical Journal* 36 (2): 383–414.
Vickery, Amanda (2016) Hidden from History: The Royal Academy's Female Founders. *RA Magazine* (summer). www.royalacademy.org.uk/article/ra-magazine-summer-2016-hidden-from-history.
Walker, Alice [1983] (2004) *In Search of Our Mothers' Gardens.* New York: Harcourt.
Waller, Susan (1983) The Artist, the Writer, and the Queen: Hosmer, Jameson, and 'Zenobia'. *Woman's Art Journal* 4 (1): 21–8.
Walpole, Horace (1862–71) *Anecdotes of Painting in England,* incorporating notes from George Vertue. 5 vols. Strawberry Hill: Farmer.
Warner, Marina (1976) *Alone of All Her Sex: The Myth and Cult of the Virgin Mary.* New York: Knopf.
Watkins, Daniel P. (2012) *Anna Letitia Barbauld and Eighteenth-Century Visionary Poetics.* Baltimore, MD: Johns Hopkins University Press.
Watt, Ian P. (1957) *The Rise of the Novel.* Berkeley, CA: University of California Press.
Webb, R. K. (1960) *Harriet Martineau: A Radical Victorian.* New York: Columbia University Press.
Weeks, Charlotte (1883) Women at Work: The Slade Girls. *Magazine of Art* 6: 324–39.
Wellek, René (1931) *Immanuel Kant in England. 1793–1838.* Princeton: Princeton University Press.
Whalen, Melissa (2013) The Suffering Stage: Joanna Baillie, Spectacle, and Sympathetic Education. *European Romantic Review* 24 (6): 665–81.
Wheeler, Michael (1999) *Ruskin's God.* Cambridge: Cambridge University Press.
Wilcox, John (1953) The Beginnings of *l'Art pour l'Art. Journal of Aesthetics and Art Criticism* 11 (4): 360–77.
Wilson, John (1829) Monologue, or Soliloquy on the Annuals. *Blackwood's Edinburgh Magazine* 26: 948–76.
Wilson, John (1833) Characteristics of Women. No. I. Characters of the Affections. *Blackwood's Edinburgh Magazine* 33: 124–42.
Wilson, John (1836) Dramas, by Joanna Baillie. *Blackwood's Edinburgh Magazine* 39: 9–16.
Wilde, Oscar [1895] (1920) *The Importance of Being Earnest.* Boston: Baker.
Wilhelm, Isaac, Sherri Lynn Conklin, and Nicole Hassoun (2018) New Data on the Representation of Women in Philosophy Journals: 2004–2015. *Philosophical Studies* 175: 1441–64.

Willard, Mary Beth (2021) *Why It's OK to Enjoy the Work of Immoral Artists*. London: Routledge.
Williamson, Lori (2005) *Power and Protest: Frances Power Cobbe and Victorian Society*. London: Rivers Oram Press.
Wilson, Carol Shiner, and Joel Haefner, eds. (1994) *Re-Visioning Romanticism: British Women Writers 1776–1837*. Philadelphia: University of Pennsylvania Press.
Wilson, John (1829) Monologue, or Soliloquy on the Annuals. *Blackwood's Edinburgh Magazine* 26: 948–76.
Winckles, Andrew, and Angela Rehbein, eds. (2017) *Women's Literary Networks and Romanticism*. Liverpool: Liverpool University Press.
Winter, Alison (1995) Harriet Martineau and the Reform of the Invalid in Victorian England. *The Historical Journal* 38 (3): 597–616.
Wolff, Janet (1993) *The Social Production of Art*. 2nd edn. London: Palgrave.
Woolf, Virginia [1928] (1995) *Orlando: A Biography*. Wordsworth Classics.
Woolf, Virginia [1929] (2014) *A Room of One's Own*. Harmondsworth: Penguin.
Wordsworth, William (1800) Preface to *Lyrical Ballads* vol. 1. 2nd edn. London: Longman and Rees.
Wreford, Henry (1866a) A Negro Sculptress. *Athenaeum*, 3 March: 302.
Wreford, Henry (1866b) Lady-Artists in Rome. *The Art-Journal*, 1 June: 177.
Wreford, Henry (1870) The Studios in Rome. *The Art-Journal*, 1 May: 77–8.
Wu, Duncan, ed. (2012) *Romanticism: An Anthology*. 4th edn. Oxford: Blackwell.
Wykes, David L. (2011) The Revd John Aikin Senior: Kibworth School and Warrington Academy. In Felicity James and Ian Inkster, eds., *Religious Dissent and the Aikin-Barbauld Circle, 1740–1860*. Cambridge: Cambridge University Press.
Yonge, Charlotte (1869) Children's Literature of the Last Century, Part I. *Macmillan's Magazine* 20: 229–38.
York, Lorraine (1986) 'Sublime Desolation': European Art and Jameson's Perceptions of Canada. *Mosaic* 29 (1): 43–56.
Zorn, Christa (2003) *Vernon Lee: Aesthetics, History, and the Victorian Female Intellectual*. Athens, OH: Ohio University Press.

Index

Note: Tables and figures are indicated by an italic '*t*' and '*f*', following the paragraph number; 'n.' after a paragraph number indicates the footnote number.

Since the index has been created to work across multiple formats, indexed terms for which a page range is given (e.g., 52–53, 66–70, etc.) may occasionally appear only on some, but not all of the pages within the range.

Abrams, Meyer 49
Academy (journal) 9–10, 174–5, 185, 187
Adams, Kimberly 20, 125 n.5, 137, 138 n.13
Addison, Joseph 26, 40–1
aesthetic experience
 arts/aesthetic experience distinction 15
 Cobbe: tertiary receptive art (aesthetic experience) 15, 161, 164–9, 191, 224
 Lee: aesthetic experience and altruism 216–18
 Lee: aesthetic experience and sense of harmony 216, 218–20
 Lee: aesthetic experience and spiritual development 216–17
aesthetic moralism 236
 art and moral purposes 1, 14
 Dilke on 173
 Lee on 209
 shift from moralism towards aestheticism 14–15
 see also Martineau's aesthetic moralism
Aesthetic Movement 26, 182–3, 236 n.14
Aesthetic Review (journal) 9–10
aestheticism
 aestheticism/moralism divide 19
 art for art's sake 200
 'decadent' strands 200
 'missionary' strands 200
 Pater, Walter and 23–4, 173, 182–3
 pursuit of beauty defines art as art 15
 shift from moralism towards aestheticism 14–15
 see also art for art's sake; Dilke's aestheticism; Lee's aestheticism
aesthetics, *see* art, the aesthetic, and the beautiful; beauty; women philosophers of art
Aikin, Arthur 59 n.5
Aikin, John (Barbauld's brother) 79
 Barbauld and 6–7, 35–6
 Evenings at Home (co-authored) 29, 37

Jameson and 29
 Miscellaneous Pieces, in Prose (co-authored) 35–7
 Monthly Magazine (journal) 6–7, 38, 38 n.8
 'On the Pleasure derived from Objects of Terror' 35–6, 39
Aikin, John (Sr, Barbauld's father) 37
Aikin, Lucy (Barbauld's niece) 35–6, 39 n.10, 70 n.16
Albrecht, Thomas 19
Alison, Archibald 179–80, 180 n.6
Allen, Walter 54–5
Allingham, William: 'Eastern Hermit' 4–5
Álvarez, María Begoña Lasa 12–13
analytic aesthetics 2
analytic philosophy 2, 200–1
Anderson, Antje 25 n.26, 144
Annual Review (journal) 59 n.5
anonymity and pseudonymity
 anonymity in journals 4–6, 8–9, 38 n.8
 Baillie and 28–9, 59, 71 n.21
 Barbauld and 4–5, 28–9, 38 n.8
 Cobbe and 28–9
 Dilke and 28–9, 174–5, 185
 disappearance of women philosophers of art and 232
 Jameson and 28–9
 Lee's pseudonymity 24–5, 28–9, 29 n.30, 31, 31 n.35, 199
 Martineau and 4–5, 28–9
 novels 51 n.18
 pseudonymity in journals 4–8
Anstruther-Thomson, Clementina 19–20, 32–3, 247, 250
 Art and Man 248
 'Beauty and Ugliness' (co-authored) 200–1, 248
 Lee and 248
 physicality of aesthetic responses 248
Aquinas, Thomas 67

274 INDEX

Arendt, Hannah 32
Aristotle 20–1, 58–9
Armstrong, Isobel 23 n.24, 35 n.4, 94 n.15
Arnold, Matthew 17, 19, 233
art, the aesthetic, and the beautiful 224–31
 aesthetic–art–beauty equations 15
 aesthetic/artistic elision 224–5
 aesthetic/the beautiful elision 226
 aesthetic conservatism 228, 230–1
 art's educative powers 224
 arts/aesthetic experience distinction 15
 Baillie and the picturesque 227
 Barbauld on 224, 226–7
 beauty's pre-eminence 226–8, 244
 Cobbe: *poiesis* (creative art-making) 162, 224
 Dilke on 191, 223–5, 227–8
 Dilke on the picturesque 189
 Ellis on 244
 Jameson on concept of art 224
 Lee on 225–8
 Lee on concept of art 224
 natural beauty: theory on 225–6, 244
 on the sublime 226–8, 231, 244
 see also beauty; sublime, the
art expert 13 n.15
art for art's sake
 Aesthetic Movement 26
 aestheticism and 200
 Cobbe on 1, 14, 167, 169, 171–2, 182–3, 223
 l'art pour l'art 167, 169, 172, 182–3
 Lee on 199–200, 212
 Oxford English Dictionary on 182–3
 Pater, Walter 182–3, 205
art hierarchies 229–30
 aesthetic conservatism and 228, 230–1
 crafts 229–30
 see also canons; Cobbe on hierarchy of the arts
Art-Journal 9–10, 127, 155, 160
 Hall, Samuel Carter and 127
 as illustrated monthly 127
 Jameson and 12–13, 127, 230
Art-Treasures (1857 exhibition, Manchester) 12
Astell, Mary 21 n.21
Athenaeum (journal) 5, 9–10, 60, 100, 160
 Dilke, Charles Wentworth and 30, 113–14, 123–5
 Jameson's *Sacred Art* 30, 123–5
 on Lee 197
 Martineau and 30 n.32, 113–14
Atkinson, Henry George 115
Austen, Jane 7, 82, 233–4
 canon of British novelists and 55, 60–1
Austin, Sarah 233

Baillie, Joanna
 Baillie/Jameson comparison 112–13
 compared to Shakespeare 59
 critique of 92, 94 n.15
 drama, theory of 58
 drama as moral writing 60–3, 67, 69, 84
 education 8
 fame 58–62
 as genius 59–62, 149–51
 influences by 66, 111
 Jameson, Baillie, and Martineau on virtue and emotions 110–15
 performance and critique of her plays 61–3, 73, 75–6
 as philosopher of art 58, 62, 222
 as Romantic dramatist 1, 61–2, 66, 69–71
 twentieth-century disappearance 60–1, 237
 twenty-first century and 62
 see also Baillie on passions; Baillie's *Plays on the Passions*; Baillie's relationships; Baillie's theory of tragedy; Baillie's writings
Baillie, Matthew (Baillie's brother) 67–8
Baillie on passions 66–8
 comic variants of passions 63, 74–5
 Jameson/Baillie comparison 112
 opposing pairs 67
 self-control 58–9, 63
 tragedy and 58–9, 62–3, 67
 tragic variants of passions 65–6, 74–5
 see also Baillie's *Plays on the Passions*; Baillie's theory of tragedy
Baillie's *Plays on the Passions* 58, 63–6, 70–1, 111–12, 152–3
 anonymity 59
 Basil 71, 73–4
 comic passions/comedies 63, 74–5
 De Monfort 65, 68–9, 71–5, 111–12
 design of 63–4, 64*t*, 66
 Dream, The 74
 Election, The 74–5
 Ethwald 71
 gothic, the 71, 86–7, 112 n.12
 'Introductory Discourse' 58, 63, 66–70
 Orra 65–6, 71–2, 74–5
 passions 63–6
 reviews of 59 n.5, 60
 Romiero 71, 73, 73 n.23
 Second Marriage, The 74–5
 signed edition 59
 structure of plays 65–6, 74–5
 'To the Reader' 61 n.7
 tragic passions/tragedies 63, 65–6, 74–5

Baillie's relationships (and influences)
 Baillie/Barbauld relationship 29, 39, 59–60, 70, 70 n.16, 71 n.21
 Baillie/Callcott relationship 241
 Baillie/Jameson relationship 29, 60, 110–12, 111 n.10, 112 n.12, 121, 125 n.4, 130
 Baillie/Martineau relationship 1, 29–30, 59–60, 87
 influences on Baillie 18, 62, 67–8, 70 n.17
 Scott, Walter and Baillie 87
 Smith, Adam and Baillie 24, 67–70
Baillie's theory of tragedy 1, 16, 29, 58, 76–7, 222
 art and religion 14–15, 223
 art practice and theory of art 62–3, 66, 73
 concept-driven drama 62–3, 92, 230–1
 good *vs* bad choices 58–9, 63, 65–6, 72–3, 75–7
 Greek tragedies 73–4, 95 n.16
 moralism 62–3, 67, 71–2, 76–7, 223
 optimist theory of tragedy 76–7
 as original and interesting 58
 paradox of tragedy 70–3
 passions and tragedy 58–9, 62–3, 67, 75–6
 peripeteia 59, 65–6
 philosophical theory of tragedy 62–3
 religious convictions 14–15, 14 n.16
 self-control 58–9, 63, 72, 75–6
 on sympathy/sympathetic curiosity 14, 27–9, 58–9, 68–73, 76, 86–8
 theory of tragedy as moral theory 58–9, 76–7
 'tragic' condition in Baillie's tragedies 75–6
 voluntarism/free will 58–9, 62–3, 73–7
 see also Baillie on passions; Baillie's *Plays on the Passions*
Baillie's writings 6–7, 59
 anonymity 28–9, 59, 71 n.21
 Dramatic and Poetical Works 59–60
 journal contributions 6–7, 59–60
 letters 62, 67–8
 Miscellaneous Plays 59
 originality of Baillie's literary practice 63–4
 plays 62
 tragedies 16, 39, 58
 see also Baillie's *Plays on the Passions*
Bain, Alexander 180
Barbauld, Anna Letitia
 birth and family background 37
 canon of British novelists 22, 50–1, 55–7, 60–1, 224, 229, 240
 Dissent 37–8
 education 37
 fame 35
 from Enlightenment towards Romantic aesthetics 1, 49
 as genius 79–80, 149–50
 influence by 38, 44–5, 49–50, 61–2
 married to Rochemont Barbauld 37
 moral virtue of fiction 43, 71 n.21
 as most qualified art critic and judge of her time 13
 neo-Stoicism 71 n.19, 81, 88
 novel, theory of 39, 42–3, 50–7, 223
 paradox of fiction 14, 26, 39–44, 70–2
 'paradox of the heart' 40
 as philosopher of art 35–6, 222
 political period 38, 38 n.8
 on realism and novel 52–4
 on sympathy 14, 26, 29, 39–45, 53, 70–1, 86–8
 on tragedy 14
 twentieth-century disappearance 35, 235–6
 as versatile all-round writer and intellectual 36
 as 'the voice of the Enlightenment' 36
 world history 38–9
 see also Barbauld: devotion/devotional taste; Barbauld's relationships; Barbauld's writings
Barbauld: devotion/devotional taste 14–15, 36, 44–50, 222
 aesthetic side of religion 46–7, 49
 art and religion 14–15, 36, 46, 49–50, 223
 children's writings and 38–9, 49–50
 devotion as aesthetic category 37, 44–6
 devotional feeling *vs* theological doctrine 49–50
 imagination and devotion 46–7, 49–50, 223
 Jameson's *Sacred Art* and 126–7, 136–7
 nature and the everyday world 46, 50, 136
 sects *vs* establishments 48–9
 on the sublime 35–6, 47–50, 136–7, 226–7
 'Thoughts on the Devotional Taste' 29–30, 37, 44–50
Barbauld, Rochemont (Barbauld's husband) 37
Barbauld's relationships (and influences)
 Aikin, John and 6–7, 35–6
 Barbauld/Baillie relationship 29, 39, 59–60, 70, 70 n.16, 71 n.21
 Barbauld/Cobbe relationship 50
 Barbauld/Jameson relationship 29, 136
 Barbauld/Martineau relationship 1, 29–30, 38, 45 n.13, 49 n.17, 78–81, 87–8
 Burke, Edmund and Barbauld 24, 47, 72 n.22
 Coleridge, Samuel Taylor and Barbauld 238–9
 influences on Barbauld 18

Barbauld's relationships (and influences) (*cont.*)
 Kant, Immanuel and Barbauld 47 n.14
 Priestley, Joseph and Barbauld 35, 37, 45–6, 47 n.14, 48–9
Barbauld's writings 1, 6–7, 16, 35–6
 'Address to the Deity' 45 n.12
 'Against Inconsistency in our Expectations' 81
 anonymity, pseudonymity, and initials 4–5, 28–9, 38 n.8
 British Novelists, The 36, 38, 50–1, 54–5, 71 n.21
 children's writings 37–9, 49–50
 Devotional Pieces 37, 45 n.13
 Eighteen Hundred and Eleven 29, 38–9, 60
 'Enquiry into those Kinds of Distress which Excite agreeable Sensations' 37, 39–43, 70, 87
 Evenings at Home (co-authored) 29, 37–8, 87 n.9, 136
 Female Speaker, The 47 n.15
 Hymns in Prose for Children 37–8, 50
 journal contributions 6–7, 38
 Lessons for Children 37, 49–50
 Miscellaneous Pieces, in Prose (co-authored) 35–7, 39, 87
 Monthly Magazine (journal) 38
 'On the Death of Mrs Martineau' 79
 'On the Origin and Progress of Novel-Writing' 38, 51–4
 'On the Pleasure derived from Objects of Terror' (attributed) 35–6
 'On the Province of Comedy' 39
 'On Romances' 37, 39–41, 39 n.10
 poems 16
 Poems 37, 70 n.17
 'Solomon Sympathy' 43–4
 'Summer Evening's Meditation, A' 47–8
 'Thoughts on the Devotional Taste' 29–30, 37, 44–50, 80
Barrett Browning, Elizabeth 19, 22, 114, 162
 Aurora Leigh (poem) 153, 233
 as genius 153–5
Battersby, Christine 149–50
Baudissin, Wolf 118
Baumgarten, Alexander 17–18
beauty
 beauty's pre-eminence 226–8, 244
 Cobbe: art as pursuit of beauty 169–70
 Cobbe: beauty and goodness 14, 170, 222
 Cobbe: God as source of beauty 14–15, 161–2, 164–5, 169–70, 223, 244
 Dilke: beauty and pictures 187–9
 Hegel on 162
 ideal beauty 177–8, 188

Jameson: art beauty as different from natural beauty 172
Jameson: beauty as central aesthetic value 142–3
moral beauty 177–8, 193
Naden on 248–9
natural beauty 162–5, 168–9, 172, 225–6, 242–4
nineteenth century: associations between women, the arts, and beauty 10–11
Pater on 205–6, 208
physical beauty 177–8, 193
Ruskin on 145 n.18, 178 n.5, 204
sensory beauty 14, 177–8, 181–2, 184, 213
see also art, the aesthetic, and the beautiful; Dilke's aestheticism; Lee's aestheticism
Beauvoir, Simone de 21 n.21, 32
Behn, Aphra 55
Berry, Mary 82 n.4
Blackwood's Magazine 101
Blind, Mathilde 233–4
Bonheur, Rosa 22
 as genius 152 n.5, 153–5
 Horse Fair, The (painting) 153
Booth, Alison 105, 152 n.6
Braddon, Mary Elizabeth 44
Brake, Laurel 4, 235
Brand, Peggy Zeglin 2, 20–1
Brigham, Linda 62
Brontë, Anne 96
Brontë, Charlotte 8, 19, 233–4, 244–5
 Jane Eyre 33
 Martineau's criticisms of 96
 Villette 96
Brontë, Emily 96
 Wuthering Heights 98–9
Browning, Robert 19
Budgell, Eustace 151
Bulwer-Lytton, Edward 92, 94 n.15, 149–50
Burke, Edmund 36
 Baillie and 72 n.22
 Barbauld and 24, 47, 72 n.22
 masculine sublime/feminine beautiful dichotomy 150–1, 227
 paradox of fiction 41–3, 72 n.22
 Philosophical Enquiry into the Origin of Our Ideas of the Sublime and Beautiful 127–8
 Wollstonecraft, Mary and 32
Burney, Fanny 55
Byron, Annabella 29, 31–2, 34
 Jameson and 111 n.10, 112–13
Byron, Lord (George Gordon Byron) 60–1, 82

Callcott, Augustus (Callcott's husband) 241 n.2
Callcott, Maria (née Dundas) 32–3, 250
 as art critic 240–1
 artworks and travelling 11–12, 12 n.14, 240–1
 Callcott/Baillie relationship 241
 Callcott/Jameson relationship 241 n.1
 Continuation of the Essays on the History of Painting 241
 Essays Towards the History of Painting 240–1
 knowledge on technical side of painting 241–2
 writings 240–1
Campbell, Thomas 73, 75–6
Candido, Joseph 103–4
canons 229–30
 aesthetic conservatism 228, 230–1
 Barbauld: canon of British novelists 22, 50–1, 55–7, 60–1, 224, 229, 240
 British Romanticism: canon 60–1
 Dilke and 22, 229
 exclusion of women from 56, 60–1, 230, 240
 female canons 144, 229
 female credentials and canonical artists 231
 feminist aestheticians on 55–6, 230
 flexibility of 57
 importance of 56
 Jameson's *Sacred Art* 22, 144–7, 229
 Lee and 229
 male canons 22, 55–6, 60–1, 144, 229
 novel: canons of 50–1, 55–6, 60–1, 229
 as provisional formations for particular purposes 56–7, 229, 240
 as structurally exclusive 56
Carlson, Ashley 32 n.40
Carlyle, Thomas 20, 49, 232–3
Channing, William Ellery 120 n.29
Chapman, Maria Weston 149–50
Cherry, Deborah 160, 230
Child, Lydia Maria 158–9
Clarke, Meaghan 13 n.15, 20
Clayton, Eleanor Creathorne 22, 144
Clewis, Robert 228 n.5
Cobbe, Frances Power
 artworks viewing 11–12
 birth (Ireland) 12
 cosmopolitan intellectual culture 12
 fame 148
 feminism 22, 22 n.22, 33–4, 148
 as moral philosopher 148
 as philosopher of the arts 148–9, 222
 physical appearance 10
 on secularism 30–1
 travelling 11–12, 153
 twentieth-century disappearance 148, 237
 see also Cobbe on art, religion and morality; Cobbe on art-forms; Cobbe on female genius; Cobbe on hierarchy of the arts; Cobbe's relationships; Cobbe's writings
Cobbe on art, religion and morality 169–72, 223
 art for art's sake 1, 14, 167, 169, 171–2, 182–3, 223
 'art for morality's sake' 169
 art as pursuit of beauty 169–70
 art as religious art 162–3, 172
 beauty and goodness 14, 170, 222
 Darwin's theory of evolution and 171–2
 God as source of beauty 14–15, 161–2, 164–5, 169–70, 223, 244
 God as source of goodness 14–15, 161–2
 God as ultimate artist 162
 human/natural evils as neither beautiful nor fit subject-matter for art 170
 middle way between moralism and aestheticism 1, 169, 172
 moral limits on the subject-matters 171
 poiesis (creative art-making) 162, 224
 relations among God, nature, beauty, and art 163, 244
 on the sublime 227
Cobbe on art-forms 165–9, 166t
 architecture 161, 167–9
 hierarchy of the arts and 166t
 music 161, 165–7, 169
 painting 161, 168–9
 poetry 161, 165–6
 poetry as highest-ranked art-form 165–6, 169
 primary creative art 165, 167–9
 sculpture 161, 168–9
 secondary reproductive art 165, 167–9
 tertiary receptive art 15, 166–9
 unstable hierarchy 169
Cobbe on female genius 1, 22, 148, 151–61
 Barrett Browning, Elizabeth as genius 153–5
 Bonheur, Rosa as genius 152 n.5, 153–5
 Coleridge's idea of genius and 152, 155, 161
 Hosmer, Harriet as genius 153–8, 160
 Jameson/Cobbe comparison 157
 originality 152, 155
 power and strength 152–8, 160
 Romantic idea of genius 152, 155
 'What Shall We Do With Our Old Maids?' 148–9, 161–2
 women as prevented from achieving genius 152–3
 see also female genius

Cobbe on hierarchy of the arts 1, 148, 161–5, 229–31
　architecture 167–8
　art, the aesthetic, and the beautiful 191
　art as 'man's copy' of God's works 162
　gendered hierarchy 164
　'Hierarchy of Art, The' 148–9, 161
　hierarchy of arts and art-forms and 166*t*
　Italics 164
　music 165, 167
　painting 168–9
　poetry 165
　primary creative art 161–5, 168–9
　primary creative art: standards for evaluation of 163
　sculpture 168, 227
　secondary reproductive art 161, 163–5, 167–9
　tertiary receptive art (aesthetic experience) 15, 161, 164–9, 191, 224
　unstable hierarchy 164–5, 169
Cobbe's relationships (and influences)
　Cobbe/Barbauld relationship 50
　Cobbe/Jameson relationship 1, 14, 30, 156, 172
　Cobbe/Lee relationship 30–1
　Coleridge, Samuel Taylor and Cobbe 152, 155, 161, 165–6
　Darwin, Charles and Cobbe 171–2
　Hegel, G. W. F. and Cobbe 148, 161–2
　influences on Cobbe 152
　Kant, Immanuel and Cobbe 18, 152, 161
Cobbe's writings 16, 148
　anonymity 28–9
　Daily News (newspaper) 12
　Echo (newspaper) 7–8
　Essay on Intuitive Morals 28–9
　Fraser's Magazine 148–9
　'Hierarchy of Art, The' 148–9, 161, 169
　journal contributions 6–7, 148
　'Morals of Literature, The' 171
　on philosophy of art 148–9
　Pursuits of Women, The 148–9
　signed works 8, 24–5, 28–9, 148–9
　Studies New and Old of Ethical and Social Subjects 148–9
　'What Shall We Do With Our Old Maids?' 148–9, 161–2
Cohen, Paula Marantz 6
Colby, Vineta 216 n.15, 236–7
Coleridge, Samuel Taylor 17, 60–2, 222
　Barbauld and 238–9
　Cobbe and 152, 155, 161, 165–6
　Principles of Genial Criticism Concerning the Fine Arts 161

Collins, Wilkie 3, 96
　Woman in White, The 96–9
Collins, William 38 n.8
Colón, Christine 63, 67–8
Conrad, Joseph 60–1
Contemporary Review (journal) 3, 9–10
　Lee's contributions 211, 213–14, 216, 248
Cooper Willis, Irene 29 n.30
Corman, Brian 54–5
Cornhill Magazine 3, 5–6, 201–2
Cory, Annie 19
Costelloe, Timothy M. 17–19, 40, 205 n.9, 211
Courtemanche, Eleanor 92 n.14
Cousin, Victor 169

Dabby, Benjamin 7, 103 n.3, 109 n.8
Daily News (newspaper) 12
Danto, Arthur 20–1
Darwin, Charles 171–2, 207, 219 n.18
David, Deirdre 91
De Staël, Germaine 108 n.7
Demoor, Marysa 5
Descartes, René 23, 66–7, 177–8
Devereaux, Mary 2
Dickens, Charles 38 n.8, 78, 94
　Daily News (newspaper) and 12
　Little Dorrit 98–9
　moral virtue of fiction 43
　Sketches from Boz 6–7
Dilke, Charles (Dilke's second husband) 30, 174–5, 183, 192
Dilke, Charles Wentworth 30, 113–14, 123–5
Dilke, Emilia
　on aesthetic moralism 173
　anti-theoretical stance 175, 192–3
　artworks viewing 11–12
　canons and 22, 229
　cosmopolitan intellectual culture 12
　death 173
　Dilke, Charles (second husband) 30, 174–5
　fame 173, 234
　French art and 173, 195, 229
　library 12
　metaphysics: hostility to 175, 192
　as most qualified art critic and judge of her time 13
　names and signatures 174–5
　National Art Training School 11, 174
　Pattison, Mark (first husband) 174–5, 183, 192
　as philosopher of art 173–5, 192, 195–6, 222, 234
　Presidency of the Women's Trade Union League 174–5

INDEX 279

Royal Academy and 11, 11 n.11
secular orientation 177, 195
travelling 11–12
twentieth-century disappearance 173, 237
see also Dilke/Jameson relationship; Dilke on uses of pictures; Dilke's aestheticism; Dilke's aestheticism/historicism relationship; Dilke's historicism; Dilke's relationships; Dilke's writings
Dilke/Jameson relationship 1, 30, 174, 177, 194–6
 art and religion 194–5
 different historicisms 195
 Dilke's critique of Jameson 30, 177, 194
 explanation *vs* interpretation 194
 French *vs* Italian Renaissance 195
 Renaissance 183–4, 194
 see also Dilke's relationships
Dilke on uses of pictures 187–91
 beauty and pictures 187–9
 central uses of pictures 190
 picturesque, the 189
 poetical value/the poetic 189–90
 subordinate uses of pictures 190
 'Use of Looking at Pictures, The' 173–4, 187–91
Dilke's aestheticism 1, 15, 25, 30–1, 177–84, 222–3, 230–1
 aestheticism, distinguished from decadence 30–1, 182, 212–13
 ahistorical aspect of beauty and art 181–2
 anti-moralist case concluded 182
 'Art and Morality' 173, 177–83, 185
 art and religion 14–15, 177, 181–4, 194–5, 203
 art's progressive historical separation from religion and morality 180–2, 185
 associationism 179–80
 on beauty 177–82, 188–9
 beauty: components of 188–9
 beauty: sensualist account of 178–82, 185, 187, 223
 beauty as art's purpose 185
 beauty's pre-eminence 226
 conceptual clarification: distinction between art, the aesthetic, and the beautiful 191, 223–5
 critique of Laprade, moralism, and idealism 177–8
 German/continental influences and 18
 ideal beauty 177–8, 188
 as ignored in literature on Aesthetic Movement 182–3
 Lee/Dilke comparison 30–1, 203, 209, 212–13
 moral/aesthetic value distinction 176–7, 180, 185–6, 191
 on naturalism 183–4
 nucleus of beauty 178–80
 Pater/Dilke comparison 183
 Pater, Walter and 23–4, 173, 182–3, 183 n.9, 210 n.10, 222
 positivism 181, 184
 on Renaissance 30–1, 181–4, 184 n.10, 186, 192, 203
 restrictions 182
 secular modernity 177
 sensory beauty 177–8, 181–2, 184, 213
 shift from moralism towards aestheticism 14, 173
 on the sublime 227–8
 virtue and beauty 180
 see also Dilke's aestheticism/historicism relationship
Dilke's aestheticism/historicism relationship 185
 combining aestheticism and historicism 190–1
 distinction between the historical and the aesthetic 187–91
 Grimm, Hermann and 187
 historicism as motivation for aestheticism 177, 185
 Pater, Walter and 186
 Ruskin, John and 185–7
 tensions between 174, 185–7
 'Use of Looking at Pictures, The' 174, 187–90
 see also Dilke's aestheticism; Dilke's historicism
Dilke's art history 1, 173–4, 192–3, 232–4
 distinction between poetic and historical value 193
 Renaissance of Art in France, The 174–5, 192–3
 transition from philosophy to art history 192, 195–6
Dilke's historicism 173, 175–7, 186, 229
 'Art-Idea, The' 175
 empiricism 175–6
 'ideal realism' 177
 materialist historicism 1, 174–5, 195
 positivism 175–6, 186
 right approach to art as historical and explanatory 174, 194
 Taine, Hippolyte and 175–7
 see also Dilke's aestheticism/historicism relationship
Dilke's relationships (and influences)
 Dilke/Eliot relationship 174
 Dilke/Lee relationship 30–1
 Dilke's references to other women 30, 174, 194

Dilke's relationships (and influences) (*cont.*)
 Grimm, Hermann and Dilke 187
 influences on Dilke 175–6, 195–6
 Marx, Karl and Dilke 195–6
 Pater, Walter and Dilke 23–4, 173, 182–3, 183 n.9, 210 n.10, 222
 Ruskin, John and Dilke 174, 178 n.5, 182, 184–7
 Taine, Hippolyte and Dilke 175–7
 see also Dilke/Jameson relationship
Dilke's writings 6 n.4
 Academy, (journal) 174–5, 185, 187
 anonymity, pseudonymity, and initials 28–9, 174–5, 185
 art exhibitions, reviews on 12–13, 174–5, 190
 'Art-Idea, The' 175
 Art in the Modern State 173
 'Art and Morality' 173, 177–83, 185
 Claude Lorrain 173
 Dilke Papers (Charles) 6 n.4
 gender-neutrality 174
 journal contributions 6–7, 174–5
 Pattison Papers (Mark) 6 n.4
 on philosophy of art 173–5
 'Religious Art in the Nineteenth Century' 177
 Renaissance of Art in France, The 173–5, 192–3, 233
 'review-essay' 4, 174–5, 177, 185–7
 Saturday Review (journal) 174–5
 short stories 16
 signed works 174–5, 185
 'Use of Looking at Pictures, The' 173–4, 187–91
 Westminster Review (journal) 174–5, 177, 186–8
Dissent 37–8
Duthie, Peter 62, 67–8

Easley, Alexis 5
Eastlake, Charles (Eastlake's husband) 100, 145–6, 244–5
Eastlake, Elizabeth (née Rigby) 33–4, 244–7, 250
 artworks and travelling 11–12
 essay on Ruskin 244–7
 essays 5, 244–5
 fame 244–5, 250
 Five Great Painters 244–5
 Jameson's *Sacred Art: The History of Our Lord* (co-authored) 33, 123–5, 145–6, 244–5
 journal articles 244–5
 'Madame de Staël' 244–5
 'Music' 244–5
 as philosopher of art 244–5
 on photography 230, 244–7
 politics 33–4, 57
 writings 244–5
Edgeworth, Maria 54–5, 80, 233
Edinburgh Review (journal) 3, 101, 150
Eliot, George (Mary Ann Evans) 19–20, 32, 32 n.38, 233
 artworks and travelling 11–12
 canon of British novelists and 60–1
 'Clerical Scenes' (*Scenes of Clerical Life*) 96
 Eliot/Dilke relationship 174
 Eliot/Martineau relationship 79, 94–8
 Middlemarch 97–8, 174
 Mill on the Floss, The 95
 moral virtue of fiction 43
 'Natural History of German Life, The' 95
 realism 79, 94–8
 on sympathy 95–6
Elisabeth of Bohemia 23, 67
Ellet, Elizabeth 22, 120 n.28, 144
Ellis, Sarah Stickney 12 n.14, 33–4, 242–4, 250
 'Apology for Fiction, An' 242
 art and symbolism 243
 art's history 243–4
 Beautiful in Nature and Art, The 33, 242–4
 critique of 231
 feminism and 32 n.40
 on natural beauty 242–4
 as philosopher of art 242
 Pictures of Private Life 242
 Poetry of Life, The 242
 politics 33–4, 57, 231
 on the sublime 244
Eminent Women book series 233, 236–7
Enlightenment 1, 195
 Barbauld as 'the voice of the Enlightenment' 36
 Scottish Enlightenment 68, 70, 80
 Unitarianism and 37
Evangelista, Stefano 19–20
evolution/evolutionary theory 17–18, 195–6
 Cobbe and 171–2
 Darwin's theory of evolution 171, 207, 219 n.18
 Lee and 207, 216–17, 219 n.18
 Naden's 'evolution' of the sense of beauty 248–9

Feldman, Paula 238 n.16
female genius
 Baillie as 59–62, 149–51
 Barbauld as 79–80, 149–50
 as commonly recognized 22–3
 as contested idea 150–1, 161

exclusion of women as geniuses 150–6
feminist critique of ideas of genius 152–3
Hemans, Felicia as 150, 156–7
Jameson as 101, 149, 151
Jameson on 156–7
Landon, Letitia as 150
Lewis, Edmonia as 158–60
Martineau as 149–51
mixed discourse of 150
power and 156–7
power-with-grace as distinct feminine genius 157
race and 158–61
Romantic ideology and 150–2
Woolf, Virginia on 237
see also Cobbe on female genius; genius; Lewis, Edmonia
Female School of Art 11
Female School of Design 11
feminism 21–2
 Cobbe and 22, 22 n.22, 33–4, 148
 critique of ideas of genius 152–3
 Ellis, Sarah Stickney and 32 n.40
 feminist aestheticians/aesthetics 2, 20–3, 27–8
 feminist aestheticians on artistic canons 55–6, 230
 feminist art history and women artists 231–2
 first-wave feminists and women's literary contributions 233
 Jameson and 22, 22 n.22, 33–4, 105, 125–6
 Merrifield, Mary 242
 nineteenth-century women authors and 20–1, 61–2
 twenty-first century feminist perception of the nineteenth century 61–2
 women philosophers of art and 21–2, 33–4
fiction
 Barbauld: paradox of fiction 14, 26, 39–44
 Burke: paradox of fiction 41–3
 Hume: paradox of fiction 26, 40–1
 Jameson: paradox of moral fiction 116
 moral limitations of 43–4
 moral virtue of 43, 71 n.21
 partial sympathy and 43–4
 print culture and 7–8
 reaction to rise of specialization and 233
Fraser, Hilary 20, 24–5, 25 n.26, 130 n.11, 137, 148 n.2, 184 n.10, 230–1
Fraser's Magazine 3, 9–10
 Mill's *Utilitarianism* 4, 148–9
French Revolution 35–6, 38, 195
Friend, Stacie 2
Fry, Roger 19

Gallagher, Catherine 95 n.16
Garnett, Richard 233–4
Garritzen, Elise 231
Gaskell, Elizabeth
 Jameson and 119
 Martineau and 94, 95 n.17, 97
 moral virtue of fiction 43
 North and South 119
 Ruth 97
Gaull, Marilyn 61–2
gender
 as contested idea in nineteenth century 22–3
 gender neutrality 24–5, 31
 sexism 233–4, 238
 see also female genius
General Practical School of Art 11
genius
 British discourses of 151
 as contested idea 22–3, 161
 Kant on 150–2
 as male preserve 59–60, 150–1
 originality and 150–1
 race and 160–1
 see also female genius
Gentileschi, Artemisia 120, 120 n.28, 156–7
Gerard, Alexander 151
ghost stories 7–8, 65–6, 75, 203
Gibson, John: bust of Anna Jameson by 101, 101f
Gillett, Robert 117
Gjesdal, Kristin 2–3
Goethe, Johann Wolfgang von 102–3, 231
 Faust 203–4
Goethe, Ottilie von 118 n.24, 144
gothic, the
 Baillie and 71, 86–7, 112 n.12
 Barbauld and 86–7
Gregory, Jessica 6 n.4
Gregory, John 46
Grimm, Hermann 187
Grosskurth, Phyllis 237–8
Grüner, Ludwig 145–6
Gruyer, François-Anatole 194
Guardian (newspaper) 7
Guerlac, Suzanne 228 n.4
Guyer, Paul 19

Hannah, Heather 5 n.3
Harness, William 59–60
Hartley, David 45, 84
Haywood, Eliza 55
Hazlitt, William 17

Hegel, G. W. F. 58, 111, 196 n.15
　on art and religion 132
　Cobbe and 148, 161–2
　Jameson and 129–30, 132, 138
Hemans, Felicia 60–1, 94 n.15, 151–3
　Casabianca 152–3
　as genius 150, 156–7
Herford, Laura 11, 11 n.10
Higgins, David 150
Hirschman, Albert 66–7
Hoeckley, Cheryl 105, 117 n.21
Holcomb, Adele 102
Hölderlin, Friedrich 58
Horne, Richard Henry 115
Hosmer, Harriet 22, 153 n.8, 164
　as genius 153–8, 160
　Jameson and 153 n.8, 155 n.11
　Zenobia in Chains (sculpture) 153, 154f,
　　155, 157–8
Hughes, Linda 117 n.22
Hume, David 20–1, 21 n.20, 58, 67–8
　Martineau and 87 n.8
　paradox of tragedy 26, 40–1
Hurston, Zora Neale 158–9
Huxley, Thomas Henry 196 n.15
Hypatia (journal) 2

idealism
　Dilke's critique of 177–8
　ideal beauty 177–8, 188
　shift from idealism towards materialism and
　　empiricism 195–6
Ierna, Carlo 2–3
Illustrated London News 153–5
Insch, Audrey 62–3
Israel, Kali 195 n.14

Jacek, Mydla 62
James, Henry 60–1, 236–7
　American, The 236, 236 n.14
James, Susan 66–7
James, William 200–1
Jameson, Anna 101f
　art and ethics 1, 14, 102–5, 122
　art history 232–3
　art and religion 14–15, 172, 194–5
　artworks viewing and
　　travelling 11–12, 123–5
　birth (Ireland) 12
　Christianity 1, 14–15, 115, 126, 139,
　　139 n.14, 195
　as connoisseur of art/art-critic 10–13, 26, 102,
　　123, 125
　cosmopolitan intellectual culture 12

　critique of 1, 14, 28, 30–1, 110 n.9, 114–15,
　　202–3
　death 102, 114–15, 123–5
　education 8–9
　educational programme on art and culture
　　123, 125, 131, 144
　fame 100–1, 103–4, 104 n.6, 115, 123–5, 222,
　　234, 238–9
　on female genius 156–7
　on female genius: Jameson/Cobbe
　　comparison 157
　feminism 22, 22 n.22, 33–4, 105, 125–6
　financial instability 34
　as genius 101, 149, 151
　German Romantic influences 1, 18, 104,
　　117–19, 121–2, 130, 132
　influence by 100, 103–4, 125, 127, 130
　Jameson/Baillie comparison 112–13
　Jameson/Martineau comparison 103, 105–6,
　　112–13, 115, 122
　marriage 31, 31 n.36, 34, 238
　moral turn in mid-nineteenth-century British
　　aesthetics 79
　as most qualified art critic and judge of her
　　time 13, 31
　as nodal figure 31, 34
　obituary 102
　as philosopher of art 19, 222
　on sacred art 14–15, 28
　scholarship on 102
　travelling 11–12
　twentieth-century disappearance 20, 101–2,
　　237, 239
　virtue ethics 1, 115
　visual arts 123
　see also Jameson's *Characteristics of
　　Women*; Jameson's relationships; Jameson's
　　Sacred Art; Jameson's 'Some Thoughts on
　　Art'; Jameson's writings
Jameson, Robert (Jameson's husband) 238
Jameson's *Characteristics of Women* 103–7, 231
　aesthetic wholes and moral examples 115–22
　American editions 104
　art and ethics 102, 104–5
　bad characters/moral badness 120–1
　British editions 104
　characters of the affections 108–9
　characters of intellect 107, 109
　characters of passion and imagination 107–9
　characters as positive examples and warnings
　　105–9
　Cleopatra (*Antony and Cleopatra*) 120–1
　critique of 114–15
　Desdemona (*Othello*) 109

INDEX

dialogue (introduction) 105–7, 109–10, 116
 as first fully developed work of criticism 103–4
 German translations 104, 104 n.6
 historical characters 109–10
 Imogen (*Cymbeline*) 108–9, 121
 Jameson, Baillie, and Martineau on virtue and emotions 110–15
 Juliet (*Romeo and Juliet*) 107–9, 121
 Lady Macbeth (*Macbeth*) 105–6, 109–12, 120
 original title 'Characteristics' 104–6
 paradox of moral fiction 116
 passions/affections distinction 109
 Portia (*The Merchant of Venice*) 105–7, 109, 116, 118
 moral philosophy 105–6, 122
 moral psychology 105–10, 119–20, 122
 Romeo and Juliet 108, 121
 Shakespeare criticism 100, 103–6, 118–20
 as *Shakespeare's Heroines* 103–4
 on sympathy 110–11
 taxonomy of female characters 107–10
 women's virtues 107, 125–6
Jameson's relationships (and influences)
 Aikin, John and Jameson 29
 Byron, Annabella and Jameson 111 n.10, 112–13
 Gaskell, Elizabeth and Jameson 119
 Hegel, G. W. F. and Jameson 129–30, 132, 138
 Hosmer, Harriet and Jameson 153 n.8, 155 n.11
 influences on Jameson 29, 121, 130, 130 n.11, 136, 241 n.1
 Jameson/Baillie relationship 29, 60, 110–12, 111 n.10, 112 n.12, 121, 125 n.4, 130
 Jameson/Barbauld relationship 29, 136
 Jameson/Callcott relationship 241 n.1
 Jameson/Cobbe relationship 1, 14, 30, 156, 172
 Jameson/Eastlake relationship 33, 123–5, 145–6, 244–6
 Jameson/Lee relationship 1, 31, 202–4, 236–7
 Jameson/Martineau relationship 1, 29–30, 103–4, 110 n.9, 112–15, 128–30
 Ruskin, John and Jameson 28, 100, 102, 126–7, 130, 144–7, 238–9
 Schlegel, August Wilhelm and Jameson 104, 108, 118–19, 118 n.24, 121, 130
 Schlegel, Friedrich and Jameson 127, 129–30
 Tieck, Ludwig and Jameson 118–19, 118 n.24
 see also Dilke/Jameson relationship
Jameson's *Sacred Art* (*Sacred and Legendary Art*) 14–15, 30, 103–4, 123–7, 223
 art, ethics, and religion 126–7, 140–3, 223
 art and 'social civilization'/Religion and Civilization 127–8, 131–2, 223

artist's role 136
artwork's spiritual content 138, 140, 204
Athenaeum (journal) 30, 123–5
Barbauld's devotional taste and 126–7, 136–7
on Bernini's *The Ecstasy of St Teresa* 143
canon 22, 144–7, 229
Catholic church/popular religion distinction 139
Christianity 126, 139, 139 n.14, 202–3
'coarseness' of artworks 142–3
Cobbe on 163
Council of Trent and religious art 133
critique of 28, 30, 125–6, 144–5, 163, 194
devotional/historical distinction 126–7, 134, 135t
ecumenical approach 140
educational/decoding purpose of 123, 131–7
female figures in Christian art 125–6
female virtue 125–6
German Romantic influences 130, 132, 147
Greek polytheism/mythology 133, 141
Hegel, G. W. F. and 132, 138
historicism 126–7, 139, 142, 146, 195
legends/'legendary literature' 126, 131–4, 138, 140–1, 202–3
meaning of artworks 135–6
monasticism and art 141–2
on naturalism 184
organizing framework and taxonomy of 124t, 126–7
picturesque, the 137, 226–7
popular Christianity 126, 132–3, 138–9, 141–2, 147, 202–3
on Raphael 139, 143–6, 184, 202–3
religion and aesthetics 137–40, 184, 204
religious art as *expressive of meaning* 140
on Renaissance 123, 145–7, 184, 194
Ruskin and 28, 126–7, 130, 144–7, 222, 229
'secularism' charge 137–8, 138 n.13
signed work 123–5
'Some Thoughts on Art' and 126–7, 131
on the sublime 136–7, 226–7
success 123–5, 147
sympathy with the spiritual in Art 138
theology/religion and official doctrine/popular spirituality distinctions 126, 133–4
value of art as a whole 125–6
virtues and the virtuous 125–6, 141–2
Volume 1 (*Legendary Art*) 123–5
Volume 1: Introduction 126–8, 131–4, 137–8, 140–1

Jameson's *Sacred Art* (*Sacred and Legendary Art*) (cont.)
 Volume 2 (*Sacred and Legendary Art*) 123–5
 Volume 3 (*Legends of the Monastic Orders*) 123–5, 138
 Volume 4 (*Legends of the Madonna*) 123–5
 Volumes 5–6 (*The History of Our Lord*, co-authored) 33, 123–5, 145–6, 244–5
Jameson's 'Some Thoughts on Art' 103, 126–30
 on aesthetic education 127–9
 Art-Journal 127
 artwork's spiritual content 127–8, 130
 British moralism 130
 Christian art as 'Gothic' art 127
 Greek and Gothic art 127–8, 130
 Greek/Gothic art distinction 129
 Jameson's *Sacred Art* and 126–7, 131
 on Martineau's moralism 128–30
 prints 127
 on Schlegel's 'finite' claim 129–30
 signed work 127
 theoretical influences on 130, 130 n.11
Jameson's writings 14, 26, 222
 anonymity 28–9
 art-historical writing 16
 Art-Journal (contributions) 12–13, 127, 230
 Beauties of the Court of King Charles the Second 103 n.3
 Commonplace Book 29–30, 102, 112, 112 n.12, 139 n.14, 156, 172
 Companion to the Most Celebrated Private Galleries of Art in London 123
 Diary of an Ennuyée 16, 28–9, 103 n.3, 108 n.7, 225
 Essays on the Lives of Remarkable Painters 123
 fiction/non-fiction blending 16
 Handbook to the Public Galleries of Art in or near London 123
 'House of Titian, The' 139, 195
 journal contributions 6–7
 letters 111 n.10
 Memoirs of Celebrated Female Sovereigns 103 n.3, 153 n.8
 Memoirs of the Early Italian Painters 123, 136, 241 n.1
 Memoirs and Essays Illustrative of Art, Literature and Social Morals 102
 Memoirs of the Loves of the Poets 103 n.3
 'Revelation of Childhood, A' 29
 signed works 8, 24–5, 28–9, 104, 123–5, 123 n.2, 127
 travel writing 16
 Visits and Sketches 144, 156

Winter Studies and Summer Rambles 226–7
Writings on Art of Anna Jameson (edited by Estelle May Hurll) 125
see also Jameson's *Characteristics of Women*; Jameson's *Sacred Art*; Jameson's 'Some Thoughts on Art'
Jarves, Jackson 175
Jeffrey, Francis 92
Jewsbury, Geraldine 5
Johns, Alessa 117, 226 n.2
Johnson, Maurice 148
Johnston, Judith 29, 102, 107, 137, 233
Johnstone, Christian 82 n.6
Johnstone, John 82 n.6
journals 3–10, 230
 anonymity 4–6, 8–9, 38 n.8
 art, articles on 9–13
 art books, reviews on 9–10
 art exhibitions, reviews on 12–13
 art journals 12–13
 art prints 12–13, 127
 book reviews and 4
 digitization 5–6
 initialled publication 4–6
 men's contributions 5–6, 8, 17
 modernist rejection of Victorian periodicals culture 235
 non-specialist/general nature of 4, 6, 15–17
 payment for periodical writing 9
 'personalised criticism' 4–5
 post-Victorian reduction in women authors 7
 pseudonyms/pseudonymity 4–8
 research into 5–6
 'review-essay' 4, 82
 signature/signed works 4–5, 8
 specialism 4–5
 women's contributions 4–11
 women's contributions on philosophy 6–7, 9, 250
 Victorian Periodicals Newsletter 5
 Victorian Periodicals Review 5
 Wellesley Index to Victorian Periodicals 5–6
 see also print culture

Kant, Immanuel 17–21, 111, 196 n.15
 Barbauld and 47 n.14
 Cobbe and 18, 152, 161
 Critique of Judgement 219–20
 on genius 150–2
 Lee and 219–20
Keats, John 19, 60–1, 97 n.20
Kemble, Fanny 111–12, 121 n.30, 144
Kemble, John 101

King, William: *Woman: Her Position, Influence, and Achievement* 26
 on Baillie 60
 on Jameson 26
Kingsford, Anna 4–5
Knight, Richard Payne 127–8
Korsmeyer, Carolyn 20–1, 21 n.20
Kraft, Elizabeth 61–2
Kravetz, Rachel 19, 102

Landon, Letitia 60–1, 159
 as genius 150
 Romance and Reality 150
Landseer, Charles 112, 121
Langer, Susanne 2
Laprade, Victor 177–8
Leavis, F. R. 60–1
LeCourt, Sebastian 19
Lee, Vernon
 analytic philosophy 200–1
 artworks viewing 11–12
 birth 12
 canons and 229
 critique of 6
 empathy 200–1
 fame 197
 gender neutrality 24–5, 31
 as philosopher of art 19–20, 197–8, 222
 psychological aesthetics 200–1
 secularism 30–1
 travelling 11–12
 twentieth-century disappearance 197–8
 'Vernon Lee' (pseudonym) 24–5, 28–9, 29 n.30, 31, 31 n.35, 199
 see also Lee's aestheticism; Lee's anti-Ruskinism; Lee's qualified aestheticism; Lee's relationships; Lee's 'true aestheticism'; Lee's writings
Lee's aestheticism 14–15, 30–1, 199–200, 222–3
 art beauty *vs* religion and the supernatural 14–15, 30–1, 201–4, 223, 230–1
 art for art's sake 199–200, 212
 art for beauty's sake 200–1, 205, 213, 220–1, 223
 art for life's sake 14, 200–1, 211, 220, 223–4
 art and morality 200–1, 205–13, 220
 'art-philosophy' 1, 17, 197–9, 236–7
 artistic and aesthetic value, and beauty 204
 beauty: objective and relational conceptions 207–8
 beauty and goodness 201, 206–8, 210–11, 215–16
 beauty's pre-eminence 226
 on decadence 1, 30–1, 199–200, 212–13, 215–16
 Dilke/Lee comparison 30–1, 203, 209, 212–13
 'Faustus and Helena' 201–4
 good/bad art 203–4
 Lee as morally engaged and aestheticist 216 n.15
 Pater, Walter and 17, 24, 205, 208, 210 n.10
 on Renaissance 30–1, 184 n.10, 203
 on the sublime 227–8
 utilitarianism 209–10, 211 n.12, 216
 see also Lee's qualified aestheticism; Lee's 'true aestheticism'
Lee's anti-Ruskinism 205–11
 on aesthetic moralism 209
 art and morality 205–11
 beauty and goodness 201, 206–8, 210–11
 beauty as separated from morality 201, 207–8
 beauty and virtue 207
 Pater, Walter and 205–7, 211
 'Ruskinism' 201, 205–6, 208, 210–11
 value pluralism 208
 see also Lee's aestheticism
Lee's qualified aestheticism 211–16
 aestheticism and non-literary arts 213, 215–16
 art for beauty's sake 213
 beauty and goodness 201, 210–11, 215
 'Dialogue on Poetic Morality' 201, 211–12
 happiness: expanded sense of 215–16
 moralism and literature 213–16
 'On Novels' 201, 213–14
 'Orpheus in Rome: Irrelevant Talks on the Uses of the Beautiful' 201, 214–15
 see also Lee's aestheticism
Lee's relationships (and influences)
 Anstruther-Thomson, Clementina and 248
 anti-Victorian aestheticist circles 236–7
 influences on Lee 17, 200–1, 205, 219 n.18
 Kant, Immanuel and 219–20
 Lee/Dilke relationship 30–1
 Lee/Jameson relationship 1, 31, 202–4, 236–7
 Lee/Martineau relationship 30–1
 Pater, Walter and Lee 17, 24, 205, 207–8, 210 n.10, 211, 217
Lee's 'true aestheticism' 1, 201, 216–21
 aesthetic experience and altruism 216–18
 aesthetic experience and sense of harmony 216, 218–20
 aesthetic experience and spiritual development 216–17
 art for beauty's sake 221

Lee's 'true aestheticism' (*cont.*)
 art for life's sake 201, 220
 'Art and Life' 216–17
 beauty and goodness 216
 human beings are organic wholes 219–20
 Kant and 219–20
 metaphysical aestheticism 221
 organic harmony/organicism 14–15, 220–1
 Pater, Walter and 217
 physiology and modern aesthetics 219
 see also Lee's aestheticism
Lee's writings 1, 197
 1896 1
 Althea 214
 anonymity and initials 199
 'Art and Life' 200–1, 216, 224
 'Art and Usefulness' 200–1, 229 n.6
 Baldwin (dialogue collection) 213
 'Baldwin' (Lee's mouthpiece) 30–1, 209, 211–15
 Beautiful, The 200–1, 208, 225
 'Beauty and Ugliness' (co-authored) 200–1, 225, 248
 Belcaro: Being Essays on Sundry Aesthetical Questions 201–2, 205, 207–8, 211
 'Child in the Vatican, The' 207
 Contemporary Review (journal) 211, 213–14, 216, 248
 'Culture-Ghost' 199
 'Dialogue on Poetic Morality' 211–13, 212 n.13
 dialogues 30–1, 211
 essays 199
 'Faustus and Helena: Notes on the Supernatural in Art' 201–4
 fiction 197–8
 fiction/non-fiction blending 16, 197–8, 211
 ghost stories 203–4
 Handling of Words, The 225
 journal contributions 6–7, 197, 198t, 199, 229
 'Lady Tal' 236 n.14
 Laurus Nobilis: Chapters on Art and Life 200–1
 Miss Brown 199–200, 236–7, 236 n.14
 'On Novels' 201, 213–14
 'Orpheus in Rome: Irrelevant Talks on the Uses of the Beautiful' 201, 214–15
 pseudonymity 24–5, 28–9, 29 n.30, 31, 31 n.35, 199
 'Ruskinism' 201, 205–6, 208, 210–12
 stories 16
 vast oeuvre 197, 199–200
Lew, Laurie Kane 144
Lewis, Edmonia (sculptor)
 Death of Cleopatra (sculpture) 158–60
 Forever Free (sculpture) 158–9
 as genius 158–60
 Hagar (sculpture) 159
 neoclassicism 160
Literary World (American journal) 148
Livesey, Ruth 182 n.7, 200
Lyotard, Jean-François 228 n.4

McCarthy, William 35–6, 43–4, 61–2, 235–6, 238–9
McHugh, Conor 4–5
Macmillan's Magazine 3
Macpherson, Geraldine 115 n.20
Magazine of Art 9–10
Maginn, William 150
Mahoney, Kristin 200–1
Maltz, Diana 200
Manley, Delia 55
Mann, Bonnie 21 n.20
Mansfield, Elizabeth 173 n.2, 195–6
Marchand, Leslie 123–5
Martineau, Harriet
 associationist theory of mind 84
 atheism 30–1, 81, 115, 223
 causal determinism 95 n.16
 criticism of 95, 128–9
 on devotion 49 n.17, 80–1
 fame 78, 87, 112–13, 115
 female role models for 80
 as genius 149–51
 influences by 79, 95 n.17
 Jameson, Baillie, and Martineau on virtue and emotions 110–15
 Jameson/Martineau comparison 103, 105–6, 112–13, 115, 122
 moral turn in mid-nineteenth-century British aesthetics 79
 as philosopher of art 79, 222
 on political economy 78, 81
 realism 78, 85–8, 97–8
 theory of literature and art 78
 Unitarianism 79–80
 working people: depiction of 94
 see also Martineau's aesthetic moralism; Martineau's *Illustrations of Political Economy*; Martineau's relationships; Martineau's writings
Martineau, Sarah Meadows (Martineau's grandmother) 79
Martineau, Thomas (Martineau's father) 79
Martineau's aesthetic moralism 25, 78, 115, 222–3
 aesthetic as always subordinated to the moral 79
 art and religion 14–15, 223

art's moral purpose 1, 14, 16, 78–9, 88, 223
bad art 14, 79, 94–9
good art 79
Illustrations of Political Economy 78, 81, 85, 88–9, 93, 98–9
Jameson on Martineau's moralism 128–30
literature and practical moral philosophy 83–5
moral purpose of literature 81–5, 88, 98
moral virtue of fiction 43
problem: subordination of the aesthetic to the moral 98–9
on sympathy and class boundaries 85–9, 98
theory of art and art practice 79
Martineau's *Illustrations of Political Economy* 78, 82, 87, 112–13, 230
aesthetic moralism 78, 81, 85, 88–9, 93, 98–9
aesthetic moralism: tensions within 79, 92–4
art's moral purpose 88, 92–3
Barbauld's devotional aesthetic 80–1
birth control 89
criticism of 91–2, 94 n.15, 99
'For Each and For All' 85, 90
from Barbauld to Martineau's *Illustrations* 79–81
Life in the Wilds 80–1
Manchester Strike, A 89–94, 92 n.14, 95 nn.16, 17, 97
moral case for realism and not romance 85, 88, 92–3
moral exemplification, and general laws as moral principles 88, 92–3
'Moral of Many Fables, The' 90
moral purpose before aesthetic detail 93–4
political economy laws as part of moral laws 81, 88–9, 92–4
realism 79, 85, 94, 230–1
on sympathy and class boundaries 88–91, 94
sympathy with the virtuous 93–4
wooden characters: criticisms of 92 n.14, 92
as work of practical moral philosophy 85
Martineau's relationships (and influences)
Gaskell, Elizabeth and Martineau 94, 95 n.17, 97
Hume, David and Martineau 87 n.8
influences on Martineau 18, 29–30, 81
Martineau/Baillie relationship 1, 29–30, 59–60, 87
Martineau/Barbauld relationship 1, 29–30, 38, 45 n.13, 49 n.17, 78–81, 87–8
Martineau/Eliot relationship 79, 94–8
Martineau/Lee relationship 30–1
Martineau/Jameson relationship 1, 29–30, 103–4, 110 n.9, 112–15, 128–30

Priestley, Joseph and Martineau 81
Scott, Walter and Martineau 78, 81–6, 98, 105–6
Martineau's writings 16, 78
'Achievements of the Genius of Scott' 82–4, 97, 105–6
anonymity, pseudonymity, and initials 4–5, 28–9
Athenaeum (journal) 30 n.32, 113–14
Autobiography 30–1, 87, 149–50
Biographical Sketches 114–15
'Characteristics of the Genius of Scott' 82–3, 86, 97, 105–6
Deerbrook 78 n.1
Devotional Exercises 45 n.13
'Female Writers on Practical Divinity' 29–30, 80, 87
Forest and Game Law Tales 78 n.1
Illustrations of Taxation 78 n.1
journal contributions 4, 6–7
Letters on the Laws of Man's Nature and Development 30–1, 115
'Letters on Mesmerism' 113–14
Miscellanies 82
Monthly Repository (journal) 80
philosophical essays 80
'Philosophical Essays' 82
Playfellow 78 n.1
Poor Laws and Paupers Illustrated 78 n.1
'review-essay' 4, 82
signed works 8, 80
Society in America 87
Tait's Edinburgh Magazine 82
see also Martineau's *Illustrations of Political Economy*
Marx, Karl 31 n.37, 141, 195–6
Mason, Emily 10
Maxwell, Catherine 210 n.10, 227–8
Mee, Jon 48 n.16
Mellor, Anne 35 n.4
Melnyk, Julie 49
Merrifield, Mary 32–3, 250
as art critic 240–1
Dress as a Fine Art 10, 230, 241–2
feminism 242
'Harmony of Colours, The' 241–2
knowledge on technical side of painting 241–2
as philosopher of art 19, 241–2
methodological issues 23–8
contributions by present study 18–19, 23
methodological divides 23–6
omissions 32–4, 240, 244–5
past-/present-centred approaches 25–8

methodological issues (*cont.*)
 past-centred approach 25–8
 sources and previous scholarship 18–23
 women/men *vs* inter-women relations 23–5
Meynell, Alice 4–5, 26, 60
'Michael Field' (Katherine Bradley and Edith Cooper) 19–20
Miles, Alfred 70 n.16
Mill, John Stuart 2, 6, 21 n.21, 231
 Utilitarianism 4, 148–9
modernism 1, 224
 aestheticists and modernist turn against Victorianism 236
 disappearance of women philosophers of art and 60–1, 234–7
 exaltation of artistic purity and autonomy 60–1, 235
 separation of art from religion and morality 235–6
 Victorian periodicals culture: rejection of 235
 Victorian world: repudiation of 234–7
Molesworth, Mary 38
Monthly Magazine (journal) 6–7
 Aikin, John and 6–7, 38, 38 n.8
 Barbauld and 38
Monthly Review (journal) 100
moral philosophy
 Cobbe as moral philosopher 148
 Jameson on 105–6, 122
 Martineau: literature and practical moral philosophy 83–5
 see also morality
moral psychology
 Jameson on 105–10, 119–20, 122
morality
 aestheticism/moralism divide 19
 Baillie: drama as moral writing 60–3, 67, 69, 84
 Baillie's theory of tragedy 62–3, 67, 71–2, 76–7, 223
 Baillie's theory of tragedy as moral theory 58–9, 76–7
 Jameson: art and ethics 1, 14, 102–5, 122
 Jameson's *Sacred Art*: art, ethics, and religion 126–7, 140–3, 223
 Lee: art and morality 200–1, 205–13, 220
 modernism: separation of art from religion and morality 235–6
 moral beauty 177–8, 193
 moral turn in mid-nineteenth-century British aesthetics 79
 moral virtue of fiction 43, 71 n.21
 novels and 51–4
 religion and 13

 shift from moralism towards aestheticism 14–15
 women philosophers of art on art, morality, and religion 13–15, 25, 27–8, 222–4
 see also aesthetic moralism; Cobbe on art, religion and morality; Dilke's aestheticism
Morgan, Benjamin 17–20
Morley, Simon 228 n.4
Morris, William 17, 62, 182–3
Mosse, Kate 7
Murdoch, Iris 2, 75 n.24
Myers, Victoria 72

Naden, Constance 19–20, 32–3, 247, 250
 beauty: sensualist account of 249
 'Evolution of the Sense of Beauty, The' 248–9
 evolutionary theory and beauty 248–9
Nassar, Dalia 2–3
National Art Training School 11, 174
National Gallery 12
Neal, John 153–5
neo-Stoicism
 Barbauld and 71 n.19, 81, 88
New York Times (newspaper) 102, 125
Nietzsche, Friedrich 58, 76
nineteenth century (1790–1914) 1
Nineteenth Century (journal) 3
nineteenth-century Britain
 art museums and opening-up of collections 12–13
 cosmopolitan intellectual culture 12, 18
 female artistic achievements 61–2
 German culture and 117
 intellectual movement away from idealism towards materialism and empiricism 195–6
 moral turn in mid-nineteenth-century British aesthetics 79
 'pictorial turn' in culture 12–13
 print culture 3–10, 13
 women/arts/beauty associations 10–11
 women philosophers of art 2–3, 17, 222, 239–40, 250
 women's writing on art: context 3–13
 see also journals
Nochlin, Linda 152 n.5, 231
novel
 anonymity 51 n.18
 Barbauld: canon of British novelists 22, 50–1, 55–7, 60–1, 224, 229, 240
 Barbauld on realism 52–4
 Barbauld's theory of novel 39, 42–3, 50–7, 223
 canons of 50–1, 55–6, 60–1, 229

INDEX

entertainment as end 52–4
history of 50–2, 54–5
low-quality novels 51, 54
male canons 55
morality and 51–4
pseudonymity 51 n.18
rise of 51
women as authors of 51, 55–6
women as novel-readers 51
Nunn, Pamela 10

Oliphant, Margaret 145–6
O'Neill, Eileen 2–3, 21, 25–6
Oražem, Claudia 4

Paley, William 47 n.14
Pall Mall Gazette 60
Palmer, Caroline 13 n.15, 20
paradox
 Baillie: paradox of tragedy 70–3
 Barbauld: paradox of fiction 14, 26, 39–44, 70–2
 Burke: paradox of fiction 41–3, 72 n.22
 Hume: paradox of tragedy 26, 40–1
 paradox of moral fiction 116
 'paradox of tragedy' 40
Parker, Roszika 231–2
Pater, Walter 17, 19, 197
 aestheticism 23–4, 173, 182–3
 art for art's sake 182–3, 205
 on beauty 205–6, 208
 Dilke and 23–4, 173, 182–3, 183 n.9, 186, 210 n.10, 222
 Lee and 17, 24, 205–8, 210 n.10, 211, 217
 Marius the Epicurean 205
 Pater/Dilke comparison 183
 Ruskin and 205
 Studies in the History of Renaissance 17, 173, 182–3, 186, 205–6
 Studies as *The Renaissance: Studies in Art and Poetry* 183
Pattison, Mark (Dilke's first husband) 174–5, 183, 192, 210 n.10, 233
Penny Magazine 123, 123 n.2
Petersen, Linda 149–50
Philosophical Review (journal) 7
philosophy
 early modern women and 6
 journals: women's contributions on philosophy 6–7, 9, 250
 as 'male terrain' 62
 nineteenth-century women (Britain) 6, 18
 twentieth-century women 6
 twenty first-century women 7

women and 21
women and *pre-specialist public sphere* 6
philosophy of art
 avant-garde art criticism: masculine status 7
 male-focused art canons 22
 men's contributions 17–21
 men's contributions as co-created by their female contemporaries 222
 Victorian aesthetic theory as interdisciplinary discussion 17–18
 'Victorian critics' 17–18
 see also women philosophers of art
picturesque, the
 Baillie and 227
 Dilke on 189
 Jameson on 137, 226–7
 preference for the picturesque over the sublime 226–7, 226 n.1
Plato 20–1, 177–8, 211, 219
politics
 Barbauld's political period 38, 38 n.8
 Dilke and 175
 Eastlake, Elizabeth 33–4, 57
 Ellis, Sarah Stickney 33–4, 57, 231
Pollock, Griselda 55–6, 231–2
Pollok, Anne 234
Pre-Raphaelites 100, 144–7, 174
Price, Vladimir 33
Priestley, Joseph
 associationist theory of mind 45, 84
 Barbauld and 35, 37, 45–6, 47 n.14, 48–9
 on devotion 45–6, 66–7, 81
 Dissent 37–8
 Martineau and 81
 'On Habitual Devotion' (sermon) 45–6
 on passions 66–7
print culture
 fiction 7–8
 nineteenth-century (Britain) 3–10, 13
 non-fiction 7–8
 payment for book writing 9
 'pictorial turn' in culture 12–13
 poetry 7–8
 women's contributions 7–9
 see also journals
Pugin, Augustus 130 n.10
Pulham, Patricia 210 n.10

Quarterly Review (journal) 3, 33, 233–4, 244–5
Queen, The (journal) 155

race and genius 158–61
Radcliffe, Ann 55, 227

Radford, Colin 40
realism
 Barbauld: on realism and novel 52–4
 Eliot, George on 79, 94–8
 Martineau on 78–9, 85–8, 92–4, 97–8, 230–1
Reid, Thomas 177–8, 180
relationships
 female authors/male interlocutors 23–4, 26
 hostility 113–14
 letters 29–32
 nineteenth-century: women's scholarly competence depending on male historians 231
 public/private writing gap 29
 relationships between women 23–5, 27
 sources on 31–2
 women as referenced less than men 28, 232
 women's intellectual relations 28–32
 women's references to other women 28–32
 see also Baillie's relationships; Barbauld's relationships; Cobbe's relationships; Dilke's relationships; Jameson's relationships; Lee's relationships; Martineau's relationships
religion
 Baillie's theory of tragedy: art and religion 14–15, 223
 Dilke on art and religion 14–15, 177, 181–4, 194–5, 203
 Hegel on art and religion 132
 Jameson and Christianity 1, 14–15, 115, 126, 139, 139 n.14, 195, 202–3
 Lee: art and religion 14–15, 30–1, 201–4, 223, 230–1
 modernism: separation of art from religion and morality 235–6
 morality and 13
 Renaissance: art and religion 184
 Ruskin: art and religion 184
 women philosophers of art on art, morality, and religion 13–15, 25, 27–8, 222–4
 see also Barbauld: devotion/devotional taste; Cobbe on art, religion and morality; Jameson's *Sacred Art*
Renaissance
 art and religion 184
 Dilke on 30–1, 181–4, 184 n.10, 186, 192, 194, 203
 Jameson on 123, 145–7, 184, 194
 Lee on 30–1, 184 n.10, 203
 Pater on 183
 Ruskin on 145, 184
 Victorians and 184 n.10
Reynolds, Joshua 143

Richardson, Samuel 41, 54–5
Richetti, John 55
Rio, Alexis-François 130 n.11
Roberts, Caroline 149–50
Robertson, David 146 n.19
Robinson, Ainslie 125 n.5, 137
Robinson, Mary 60–1, 212, 213 n.14
Romanticism
 Baillie as Romantic dramatist 1, 61–2, 66, 69–71
 Barbauld: from Enlightenment towards Romantic aesthetics 1, 49
 British Romanticism 49, 62, 222
 British Romanticism: canon 60–1
 female Romantic poets and feminine gushing 94 n.15
 Jameson: German Romantic influences 1, 18, 104, 117–19, 121–2, 130, 132, 147
 Romantic idea of genius 150–2, 155
Ronniger, Jane 9–10
Ross, Stephanie 21 n.20
Rossetti, Dante Gabriel 100, 146 n.19
Roy, Wendy 226–7
Royal Academy
 Dilke, Emilia and 11, 11 n.11
 life classes 11
 women in 11, 11 n.10
Ruskin, John 19, 197, 222
 'art-philosophy' 17
 art and religion 184
 on beauty 145 n.18, 178 n.5, 204
 on Callcott 241 n.2
 Dilke and 174, 178 n.5, 182, 184–7
 Eastlake's critique of 244–7
 on Gothic art 130
 Jameson and 100, 102, 238–9
 Jameson's *Sacred Art* and 28, 126–7, 130, 144–7, 222, 229
 'Kata Phusin' (pseudonym) 4–5
 Lectures on Art 185
 Modern Painters Volume 2 130, 163 n.16, 178 n.5
 Modern Painters Volume 3 28, 126–7, 144
 moral turn in mid-nineteenth-century British aesthetics 79
 'Nature of Gothic, The' 130
 Pater and 205
 on 'poetic' 140
 on poetry 165–6
 Pre-Raphaelites 144–5, 147
 on Raphael 145
 on Renaissance 145, 184
 Seven Lamps of Architecture, The 130
 sexism 238–9

Stones of Venice, The 130
see also Lee's anti-Ruskinism
Russell, Anne 117 n.21
Russell, William Clark 4–5

Sablé, Madeleine de 233
Samalin, Zachary 19
Sand, George (Amantine Lucile Aurore Dupin) 8, 182, 233
Sanders, Valerie 78, 98
Saturday Review (journal) 3, 174–5
Schaffer, Talia 26
Schiller, Friedrich 18–19
Schlegel, August Wilhelm
 Course of Lectures on Dramatic Art and Literature 118
 Jameson and 104, 108, 118–19, 118 n.24, 121, 130
Schlegel, Caroline 108, 118, 121
Schlegel, Friedrich 129
 Christian art as 'Gothic' art 127
 Jameson and 127, 129–30
 'On the Limits of the Beautiful' 129 n.9
Schopenhauer, Adele 112–13
Schopenhauer, Arthur 58, 76, 148, 161
Scott, Patrick 5
Scott, Walter 59
 Baillie and 87
 Martineau and 78, 81–6, 98, 105–6
Sévigné, Marie de 233
Shaftesbury, Anthony Ashley Cooper 47, 67–8
 Moralists, The 47 n.15
Shakespeare, William 8–9, 22
 Baillie, compared to Shakespeare 59
 Jameson: Shakespeare criticism 100, 103–6, 118–20
 'Schlegel–Tieck' Shakespeare 118–19
Shelley, Mary 228 n.5, 233
Shelley, Percy 19, 60–1, 222
Siddons, Sarah 111–12, 111 n.11
Sidgwick, Henry 2
Siegel, Eli 238
Siegel, Jonah 19
Slade School of Art 11
Slagle, Judith 70 n.16
slavery
 abolition of 158
 Barbauld on 38–9
 Jameson on 140–1
 Landon, Letitia on 159
 Lewis, Edmonia on 158–60
Slights, Jessica 117 n.21
Smith, Adam
 Baillie and 24, 67–70

on sympathy 68
Theory of Moral Sentiments, The 68
Smith, Charlotte 55, 60–1
Smith, Eleanor 11–12
Spectator (journal) 3, 78, 100
Spencer, Herbert 6, 181, 196 n.15
Spender, Dale 55–6
spheres
 art in the public sphere 12–13
 masculine 'public' sphere 31–2
 'separate spheres' 7, 25
 women and *pre-specialist public sphere* 6
Stabler, Jane 227
Stephen, Leslie 98–9
Strachey, Lytton 234
Strachey, Ray 100
Styler, Jane 137
sublime, the 15, 21 n.20, 231
 Barbauld on 35–6, 47–50, 136–7, 226–7
 Burke: masculine sublime/feminine beautiful dichotomy 150–1, 227
 Cobbe on 227
 Dilke and 227–8
 Ellis on 244
 Jameson on 136–7, 226–7
 Lee and 227–8
 masculine sublime/feminine beautiful dichotomy 150–1, 227–8
 preference for the picturesque over the sublime 226–7, 226 n.1
 as transgressive, radical force 228, 228 n.4
sympathy
 Baillie on sympathy/sympathetic curiosity 14, 27–9, 58–9, 68–73, 76, 86–8
 Baillie/Barbauld comparison 70–2
 Barbauld on 14, 26, 29, 39–45, 53, 70–1, 86–8
 Eliot, George on 95–6
 imagination and 68
 Jameson on 27–8, 110–11
 Jameson's *Sacred Art*: sympathy with the spiritual in Art 138
 Martineau: on sympathy and class boundaries 85–91, 94, 98
 Martineau: on sympathy with the virtuous 93–4
 partial sympathy 43–4
 realism and 95
 Smith, Adam on 68

Taine, Hippolyte 175–7
Tait, William 82
Tait's Edinburgh Magazine 82, 82 n.6, 149
Taylor, Jane 50
Taylor Mill, Harriet 21 n.21

Teukolsky, Rachel 12–13, 19, 161, 235, 246 n.7
Thackeray, William 4–5, 101
Thomas, Clara 102, 237
Thomas, David 19
Tieck, Dorothea 118
Tieck, Ludwig 118–19, 118 n.24
 'Schlegel–Tieck' Shakespeare 118
tragedy 13
 Barbauld on 14
 Nietzsche on 76
 'paradox of tragedy' 40
 Schopenhauer on 76
 see also Baillie's theory of tragedy
Trimmer, Sarah 50
Tuchman, Gaye 4–5
Tuckwell, Gertrude 11–12
Tumelson, Ronald 103–4
Tyrwhitt, John 176

Underwood, Ted 7–8
Unitarianism 37, 67–8, 79–80, 236

Ventrella, Francesco 13 n.15
Vickery, Amanda 7
Vico, Giambattista 66–7
virtue ethics
 Dilke: virtue and beauty 180
 Jameson on 1, 115
 Jameson's *Sacred Art*: virtues and the virtuous 125–6, 141–2

Wagner, Adolph 104, 104 n.6
Walker, Alice 158–9
Walpole, Horace 55, 127–8
Watt, Ian 54–5
Westminster Review (journal) 3, 9–10, 95
 Dilke's contributions 174–5, 177, 186–8
Wilde, Oscar 17, 62, 197
 Importance of Being Earnest, The 235–6
Wilson, John 3, 59–60, 101
Wollstonecraft, Mary 21 n.21, 32, 36, 62, 83, 233
women
 aesthetic objectification of 10
 aesthetic sensitivity 10–11
 art museums and opening-up of collections 12–13
 as artists 11
 canons: exclusion of women from 56, 60–1, 230, 240
 female canons 144, 229
 female credentials and canonical artists 231
 hampered intellectual participation 8
 professional exclusion of 9
 social role 25

women/arts/beauty associations 10–11
women as authors of novels 51, 55–6
women as novel-readers 51
writing on art: context 3–13
writings by 9
see also feminism; women philosophers of art; women philosophers of art: disappearance; women's education
women philosophers of art 15–18, 21, 250
 art, morality, and religion 13–15, 25, 27–8, 222–4
 'art-philosophy' 17–18, 25, 197–8
 art practice and theory of art 16–17, 62–3, 66, 73, 79, 197–8
 character and evolution of women's thinking about art 13–18
 cosmopolitan intellectual culture 18
 differences between male/female writing on art 25 n.26
 distinctive *kind* of philosophy of art 16–17, 62, 250
 female social role and 25
 'feminine voice' 24–5
 feminism and 21–2, 33–4
 general reflections and particular interpretations 17, 82
 history of aesthetics and 2
 nineteenth century: interdisciplinary conversation 3
 nineteenth-century Britain 2–3, 17, 222, 239–40, 250
 nineteenth-century Britain: context 3–13
 nineteenth-century Germany 2–3
 non-specialist manner 15–17, 232
 patriarchal constraints and 231
 privileged upperclass white women 11–12, 34
 twentieth-century women philosophers of art 2, 7
 see also philosophy; philosophy of art; women philosophers of art: disappearance
women philosophers of art: disappearance 231–9
 Baillie's twentieth-century disappearance 60–1, 237
 Barbauld's twentieth-century disappearance 35, 235–6
 citations, followers, and authority 232
 Cobbe's twentieth-century disappearance 148, 237
 Dilke's twentieth-century disappearance 173, 237
 disparaging and patronizing mentions of women 237–8
 exceptionality 233–4

Jameson's twentieth-century
 disappearance 20, 101–2, 237, 239
Lee's twentieth-century disappearance
 197–8
literature 233–4
modernism 60–1, 234–7
nineteenth-century: 'pivotal era' for women's
 disappearance from philosophy and its
 history 2–3
professional specialization 232–3
sexism 233–4, 238
twentieth-century: forgetting
 nineteenth-century women philosophers
 of art 2–3, 35, 230, 237–8, 238 n.16, 250
women as neglected by philosophers 2, 20, 23
women as 'unknown unknowns' 20

women's education
 arts 10–13, 25
 home education 8, 11
 informal education 8–12, 25
 languages 10
 university education: exclusion of 6, 8,
 10, 232
Woolf, Virginia 7–8, 237
Wordsworth, William 17, 60–1, 222
 Baillie's influence on 66 n.11
Wreford, Henry 160

Yonge, Charlotte 50
York, Lorraine 226–7

Zorn, Christa 216 n.15, 236 n.12